Non-Cinema

Thinking Cinema

Series Editors:
David Martin-Jones, University of Glasgow, UK
Sarah Cooper, King's College, University of London, UK
Volume 6

Titles in the Series:
Afterlives: Allegories of Film and Mortality in Early Weimar Germany by Steve Choe
Deleuze, Japanese Cinema, and the Atom Bomb by David Deamer
Ex-centric Cinema by Janet Harbord
The Body and the Screen by Kate Ince
The Grace of Destruction by Elena del Rio

Non-Cinema:
Global Digital Film-making and the Multitude

William Brown

BLOOMSBURY ACADEMIC
NEW YORK • LONDON • OXFORD • NEW DELHI • SYDNEY

BLOOMSBURY ACADEMIC
Bloomsbury Publishing Inc
1385 Broadway, New York, NY 10018, USA

BLOOMSBURY, BLOOMSBURY ACADEMIC and the Diana logo are trademarks of
Bloomsbury Publishing Plc

First published in the United States of America 2018

Copyright © William Brown, 2018

For legal purposes the Acknowledgments on pp. viii–ix constitute an extension
of this copyright page.

Cover design by Eleanor Rose
Cover image: *La Vida Util*, 2012, Directed by: Federico Veiroj Jorge Jellinek
Cinekdoque / Collection Christophel / ArenaPAL

All rights reserved. No part of this publication may be reproduced or transmitted
in any form or by any means, electronic or mechanical, including photocopying,
recording, or any information storage or retrieval system, without prior
permission in writing from the publishers.

Bloomsbury Publishing Inc does not have any control over, or responsibility for,
any third-party websites referred to or in this book. All internet addresses
given in this book were correct at the time of going to press. The author
and publisher regret any inconvenience caused if addresses have
changed or sites have ceased to exist, but can accept no
responsibility for any such changes.

A catalog record for this book is available from the Library of Congress.

ISBN: HB: 978-1-5013-2729-2
ePDF: 978-1-5013-2726-1
eBook: 978-1-5013-2727-8

Series: Thinking Cinema

Typeset by Deanta Global Publishing Services, Chennai, India
Printed and bound in the United States of America

To find out more about our authors and books visit www.bloomsbury.com and
sign up for our newsletters.

For Ariadne

Contents

Acknowledgements	viii
Introduction: What is Non-Cinema?	1
1 Digital Dreams in Afghanistan	15
2 The Iranian Digital Underground, Multitudinous Cinema and the Diegetic Spectator	33
3 Digital Entanglement and the Blurring of Fiction and Documentary in China	55
4 Digital Darkness in the Philippines	87
5 Digital Acinema from Afrance	113
6 A Certain Compatibility: The British Digital Wave	137
7 Non-Cinema in the Heart of Cinema	163
8 Globalization and Erasure: Digital Non-Cinema in Uruguay	185
9 Cinema out of Control: These are Not Films	213
10 Farewell to Cinema; Hello to Africa	237
Conclusion	265
Bibliography	271
Index	291

Acknowledgements

This book has been about seventeen years in the making, having been conceived as one half of a wildly over-ambitious single project about cinema in the digital era, and the other half of which came to be *Supercinema: Film-Philosophy for the Digital Age* (Berghahn, 2013). In some senses, then, all acknowledgements made in *Supercinema* apply equally to this book. So you can go read that tome, too, if you want to see who was on my mind in late 2012.

I might otherwise confess that as an entangled entity that does not know exactly where he or she begins or ends, I (if I exist) find it hard to understand how I could single anyone out for acknowledgement, since every encounter that I have shapes my life, which shapes my thoughts, which eventually translates into the shape of this book (and the other things I find myself doing). Nonetheless, I would like to thank a few people who really have been indispensable to the realization of this project. Foremost among these are the Thinking Cinema series editors, Sarah Cooper and David Martin-Jones, alongside Katie Gallof, Susan Krogulski, Erin Duffy and Lauren Crisp at Bloomsbury, as well as Leeladevi Ulaganathan at Deanta Global. I would like to thank Khavn de la Cruz, Basir Mujahed, Wu Wenguang and Andrea Luka Zimmerman for giving me access to their work as well as images from their wonderful films. Much gratitude must also be expressed to Jonathan Beller, Francesco Casetti, Akira Mizuta Lippit, Lúcia Nagib and John Ó Maoilearca for agreeing to read this book's manuscript for the purpose of possible endorsements. I wish also to thank Gwen Strauss and the Museum of Fine Arts in Houston, Texas, through which I received a Brown Foundation Fellowship to work on this book at the Dora Maar House in Ménerbes, France, in September 2015. I highly recommend scholars (and other artists) to look up and to apply for this scheme.

Beyond that, here are the names (in alphabetical order) of some people who may or may not know that they shaped what follows: Kaveh Abbasian, Mathew Abbott, Stacey Abbott, May Adadol Ingawanij, Denize Araújo, Anna Backman Rogers, Caroline Bainbridge, Alice Bardan, Andrés Bartolomé Leal, Martine Beugnet, Lucy Bolton, Warren Buckland, Robert Burgoyne, Jenny Chamarette, Michael Chanan, Ruby Cheung, Laura Cull Ó Maoilearca, Miriam De Rosa, Jacques de Villiers, David Deamer, Elena del Río, Constanza del Río, Celestino

Deleyto, Kate Dangerfield, Chris Darke, Reidar Due, Steven Eastwood, David Edgar, Clifton Evers, Victor Fan, David H. Fleming, Sarah Forgacs, Elisabetta Girelli, Michael Goddard, Francesca Hardy, Mary Harrod, James Harvey, Matthew Holtmeier, Tanya Horeck, Kate Ince, Dina Iordanova, Seung-hoon Jeong, Deborah Jermyn, Tina Kendall, Joe Kickasola, Andrew Klevan, Lars Kristensen, Gillian Leslie, Nikolaj Lübecker, Antonia Manoochehri, Bill Marshall, Ewa Mazierska, Cezar Migliorin, Thure Munkholm (rest in peace), Vladimir Najdovski, Laura U. Marks, Douglas Morrey, Mike Ott, Agnieszka Piotrowska, Patricia Pisters, Murray Pomerance, Lisa Purse, Robert Pyrah, Davina Quinlivan, Judith Rifeser, Jamie Rogers, Pablo Romero Fresco, Claudio Rossi, Richard Rushton, Eva Sancho Rodríguez, Kathleen Scott, Robert Sinnerbrink, Iain Robert Smith, David Sorfa, Rob Stone, Paul Sutton, Aaron Taylor, Michael Temple, Muriel Tinel-Temple, Leshu Torchin, Jasmin Nadua Trice, Eddy Troy, Hunter Vaughan, Chelsea Wessels, Catherine Wheatley and Michael Witt. I am sure I've forgotten a load of people, for which apologies. I'd also like to thank Alexandra Brown, Joanna Brown, John Brown, Ariadne Bullen, Cordelia Bullen, Matthew Bullen, Oliver Campbell, Siobhan Campbell, Annette Hartwell, Tom Maine, and numerous other friends.

Finally, I would equally like to thank all of those with whom I have made my own films (perhaps especially *En Attendant Godard*, *The New Hope* and ~~*This is Cinema*~~) and the students who have taken my Guerrilla Filmmaking module at the University of Roehampton from 2011 to the present. Many of you have helped me to develop the ideas with which this book deals – including the student (here unnamed) who hated *Film Socialisme* so much that he kept banging on about it on social media for over a year afterwards (as well as giving *Citizen Kane* the most pithy, one-word review that I have ever seen: 'meh'). Such encounters also are important.

If, as I claimed above, I do not know where I begin and end, perhaps the shortcomings of this book will help me to learn, since they are all mine, perhaps are all me, and for which I must therefore apologize in advance. Now read the book.

Introduction: What is Non-Cinema?

For Jonathan Beller, cinema is co-extensive with capital.[1] In an era when the measure of reality is visibility (if you are not visible, then you are as good as non-existent), and in an era when gaining and maintaining attention not only helps to constitute reality but also profitability (the more people pay attention to you or your products, the more money you make), then we can see how capital has in large part come to take on the characteristics of cinema (and vice versa). Contrasted against this visibility, I shall in this book explore two linked forms of invisibility. First, there are those who are not seen or who are invisible, and who as a result are cast as unreal, barbarian, useless and/or as not valid. And then there are, in contrast to the products of capital (which are as visible as possible), the invisible workings of capital itself, the very invisibility of which helps capital to function as such. For, when the workings of capital are made visible – from workers in sweatshops to humans carrying out data entry – we have to face up to the reality (already known, but just not seen) of exploitation, as well as to the reality (again, patently known but not seen) of the sheer boring nature of much work. Capital functions more smoothly when these things are kept hidden.

These two types of invisibility are linked because, simply put, it is invisible people who carry out the invisible labour of sweatshops: both the work and the workers are occulted, kept in the shadows. And as they become unreal by virtue of not being visible, so do the machinations of capital become 'unreal' by virtue of being invisible – even if the products of capital come to be our only reality because they are all that we can see. As a result of this invisibility, even though we know about sweatshops and even though we know that work is boring, we can be in denial of such things; without visual evidence, the exploitative workings of capital are not objectively real or true, and thus are unproven. What is by contrast visible, real, true and evident is a lifestyle of commodities and of consumption, a world of rapid movement as opposed to stasis, repetition and boredom, a world of warm lighting and light skin tones, a world of clear sound rather than the cacophony of the factory or even the street. And even though cinema has exited the theatre as a post-cinematic age has dawned, involving home viewing, smart

television, online videos and more, it nonetheless is the techniques developed in the cinema (framing, lighting, cutting, make-up and so on) that proliferate on the near-ubiquitous screens of modernity and which, via smartphones, sit in the palm of nigh everybody's hands in the contemporary world.

Non-cinema, then, involves an attempt to challenge the limits of cinema and, by extension, the limits of what is constituted as real in our world of cinema-capital. Non-cinema is for this reason a point where aesthetics meets politics or, put differently, it is a point where we examine the ideology of cinema as a form: what does cinema typically exclude or occult, how are these exclusions linked to the formal/technological constraints of cinema, and what do these exclusions mean? In identifying what cinema excludes and/or occults (including the workers and the workings both of capital and of cinema itself), then we can begin to understand how non-cinema is or might be perceived as portraying the weak, the poor and/or what Enrique Dussel might term the barbarian, as well as being weak, poor and/or barbarian itself.[2] And yet, just as that which is invisible – together with invisibility itself – is crucial to capital, I shall argue that barbarian (non-)cinema is in fact an important part of the cinematic ecology as a whole. I therefore attempt in *Non-Cinema: Global Digital Film-making and the Multitude* to demonstrate that barbarian cinema, typically characterized as poor, is in fact rich. But that if that 'poor' cinema, or what Hito Steyerl might characterize as the 'wretched of the screen', is considered outside of cinema, then it can and perhaps must appropriate its status as non-cinema in order to demonstrate that non-cinema also exists and is important.[3] Indeed, if cinema as defined by capital is about both homogeneity and hegemony (the repetition that is the pursuit of box office returns that in turn reinforce power), then non-cinema is about heterogeneity, the unusual, the minor, the multitudinous.

Non-cinema has perhaps always existed. However, in the digital age increasing numbers of people have in their grasp the tools to produce films – and they are doing so. The films may have pixelated images, poor lighting, poor sound, poor acting, obviously false sets, or they may be shot on location with amateur actors. They may also represent people, things and thoughts that do not normally find their way into mainstream cinema. Indeed, if cinema *qua* cinema-capital involves the occultation of labour as part of the project of presenting itself as objectively real, then non-cinema makes clear the labour that goes into its making, thereby demonstrating what we shall, after Niels Bohr and Karen Barad, term its entangled status.[4] That is, where cinema claims to offer objective access to (and thus separation from) the world, non-cinema conveys

entanglement: humans coexist with a universe defined not by objectivity or even by subjectivity; they are with the world and help to constitute it just as the world helps to constitute them.

As a result of humans' entangled (as opposed to detached) nature, we can begin to understand that the actions of humans have consequences not just on a world that is separate from them, but on a world that is with them. That is, entanglement suggests that humans change themselves as they change the world, and so if non-cinema conveys entanglement, it is also ethical. It is ethical not in the sense that it is morally perfect, always getting everything right, even if it endeavours – or tries, or *essays* – to treat the world as we might treat ourselves (with care and respect). Rather, it is ethical because it acknowledges its imperfections, and because it acknowledges that it is an attempt, or an *essay*, rather than a success. Non-cinema, as a digital-era continuation of what Julio García Espinosa termed imperfect cinema, conveys entanglement, then, but it also demonstrates and respects the otherness and the difference of the world, and otherness and difference more generally.[5] For, while entanglement suggests withness, non-cinema does not separate itself from or exclude that which does not conform to its worldview. Rather, it includes but does not via homogenization destroy difference. Entangled and ethical, non-cinema involves becoming wise about others, or becoming otherwise.

It may be ironic that it is in the digital age that an intensification of non-cinema takes place, since computers have cemented the grip of capital such that we live in what Gilles Deleuze calls a control society. That is, we live in a world where humans who do not conform to capital are increasingly rare. This suggests a diminution of otherness as there is a shift through computerization away from simply disciplining human behaviour to outright controlling it – not least by perpetually forcing humans to maintain their attention on screens.[6] It may also be paradoxical that machines that run uniquely using quantification (1s and 0s) can help us to achieve not access to a world measured or quantified objectively (the separation of human from world that is cinema-capital), but to a world experienced qualitatively (with experience significantly connoting a shift away from only the visual and towards a more multi-sensory entanglement with films and the world more generally). While paradoxical, however, it does seem that contemporary digital tools can help us not just to make visible hidden aspects of the world, but to help us to experience, or at least to understand the existence of those things which are not and perhaps cannot be visible. In this sense, where cinema-capital separates and excludes, non-cinema encourages us

to experience the 'whole', a whole that goes beyond simply the visible, and which thus is a whole that we cannot see, but the effects of which we can feel – much like a black hole, or a black (w)hole.

We know as humans that there are things that we cannot see and yet which, like black holes, are real. Rather than limiting itself to only that which is visible or in light (i.e. rather than limiting ourselves to cinema), non-cinema is a tool for helping to reveal that which we cannot see, and this includes darkness itself. As the late Amos Vogel puts it:

> What we know of the world comes to us primarily through vision. Our eyes, however, are sensitive only to that segment of the spectrum located between red and violet; the remaining 95 per cent of all existing light (cosmic, infra-red, ultra-violet, gamma, and X rays) we cannot see. This means that we only perceive 5 per cent of the 'real' world; and that even if we supplement our primitive vision with our equally primitive senses of hearing, smell and touch, we are neither able to know everything nor even realise the extent of our ignorance.
>
> It is thus no longer possible for an artist creating within this historical period to portray reality along mimetic lines (art as the imitation of reality) or to view it as a coherent, fully intelligible construct, capable of apprehension through his sense organs and in its documentary aspects, a valid representation of the universe.[7]

Non-cinema thus includes the otherwise excluded and the invisible, be they invisible because overlooked or invisible because the machines that we have made (cameras) do not so readily register them, be that in terms of space (and especially colour) or in terms of time (because we can only record for so long and/or because of the speed at which they move). To include the previously excluded means that non-cinema involves what Dussel might term an ethical liberation of the poor: bringing about a just world in which all humans (and perhaps also non-humans) are treated equally.[8]

However, being ethical does not mean to replace one morality with another, or suddenly to validate only non-cinema at the expense of cinema. As antimatter exists alongside matter, we must recognize the reality and the contribution of both cinema and non-cinema, and see that there is as much that is cinematic in non-cinema as there are non-cinematic aspects in cinema – with digital technology functioning here, then, as the prism through which non-cinema becomes visible. In other words, non-cinema has always been with cinema, but the digital functions as a tool to show us how this is so. Indeed, non-cinema reveals the entangled, becoming reality that allows cinema to exist. To reiterate,

then: it is not that non-cinema should replace cinema, but it is for cinema to recognize that non-cinema is important and, after Dussel, to commiserate with it, or to share in its poverty.[9] That is, cinema is level with non-cinema, its equal, rather than above it in a self-fashioned hierarchy.

In this way, *Non-Cinema: Global Digital Film-making and the Multitude* is not a replacement of my last book, *Supercinema: Film-Philosophy for the Digital Age*.[10] In that book I tried to demonstrate that there can be philosophical profundity in even 'vapid' Hollywood blockbusters. With this book, however, I endeavour to show, or I encourage people to see, that there is philosophical profundity in even the 'poorest' films. Surely my efforts in this endeavour are imperfect, and I shall fail. Nonetheless, we can continue to change through learning and through next time – with shades of Samuel Beckett – failing better.[11] As Enrique Dussel might put it, it is inevitable that there will always be exclusions and that we cannot see the '(w)hole', but if we learn anything from this inevitable failure, it is that we must always be vigilant to learn where we have erred and become ever-more inclusive, in a bid to see whole, to immanentize the possibility of change, or to produce what I shall call hope.[12] It is fine to love Hollywood. But one should try to find room to love all cinema, as one might try to find room (or energy and will) to love all humans, all life, all matter, all existence. As François Laruelle's non-philosophy is a project to move beyond 'philosophy of' – with 'of' here signalling an act of separation, or what Laruelle might term a decision – then non-cinema involves an attempt to move beyond an exclusive love 'of', and towards an inclusive love, via the creation not of 'images of' but, after Jean-Luc Godard, just images.[13]

What I am proposing is not a spectacular revolution, then, since spectacular revolutions tend simply to replace one morality or hierarchy with another – with spectacular revolution's complicity with the society of the spectacle being evident in its very spectacularness. As Laruelle suggests in relation to Marxism, or what he proposes as non-Marxism: there is no final confrontation between the forces of capital and its other, but, as Karl Marx and Friedrich Engels put it in *The Communist Manifesto*, the fall of the bourgeoisie (the capitalist class par excellence) 'and the victory of the proletariat are equally inevitable'.[14] As much is made clear by the fact that it is the supposedly most advanced tool of capitalism, digital technology, that is helping to bring this about. Non-cinema, thus, is not 'against' cinema; it is cinema. It is cinema's future, it is the creation of the conditions in which cinema can have a future. And if the liberation of the poor is impossible, then let us at the very least continue to work towards it, to try, to essay, and to encourage ourselves and others to do the same.

If cinema is coterminous with capital, then non-cinema is not anti-capitalism per se, but perhaps the maturation of capitalism, a progression into adulthood that we shall see is evident in Godard's recent, or 'late' films. But adulthood involves seeing reality unadulterated, including the impure (that which is pure cannot reproduce), the dirty, the improper, the scatological and the eschatological. As John Ó Maoilearca proposes, after Laruelle, that all thoughts are equal, so might I propose that all films are equal, just as all humans are equal and just as humans are equal to non-humans and perhaps to matter and the non-matter that is antimatter.[15] In this way, while non-cinema sounds like a negative ('non-'), it is, I wish to suggest, a positive, a way of seeing positive in the negative.

If all films are equal, what constitutes a film? Heretically, heuristically, I shall propose that every video on YouTube and Vimeo, every Vine video, every WhatsApp video, every Snapchat video, every moving image art installation, every moving image advert, every Skype conversation – these are all films, even if they are non-cinema. And yet, this begs the question: why use the term non-cinema if a term like new media might simply help us to get around the issue, leaving cinema behind? The reason for persisting with the term cinema is because we still live in a world in which kinocentrism prevails. Be it on television, a computer screen or a cinema screen, our very lives are validated by our ability to turn them into images, still and moving, and which conform to the iconography (the lighting standards, the mise en scène, the costumes, the make-up, the body shape, the locations, the framing and the colours) of cinema and the other media that use the techniques developed in cinema to sell particular products and more generally a lifestyle that involves the consumption of products. That is, our lives are validated by cinema-as-capitalism. What non-cinema thus draws out that a term like new media does not is the fact that a line of flight away from cinema-capital and into new media is fine for personal escape (were it not for the fact that new media are also overrun by advertising), but it does not necessarily involve the ethical liberation of the poor. Non-cinema makes clear the processes of exclusion that take place in a cinematic society, making it untenable for that society to continue in the way that it has done until now. New media one can simply ignore; by contrast non-cinema is in some senses to bring the necessarily social, or entangled, emotion of shame into play: I can only feel shame when I am seen by others, with shame thereby affirming both imperfection and otherness.[16] It is to show that when people speak of cinema, they generally mean an exclusive 'cinema of' – a process of separation that contradicts the logic of

entanglement and the multitude, and which also is realized in the exclusive process of fabricating the imagined communities of nations.

But does a certain old-fashioned auteurism linger in this non-cinema, as the references to Godard might suggest? Quite possibly. At least, there are definite limitations in the examples that I use in this book. Most are feature-length films that have played on cinema screens. I have barely discussed short films, gallery films or various other types of film that could have been explored in relation to non-cinema. What is more, there are many more examples both from the nations that I have discussed and from numerous more that I have not discussed. But as one cannot see – but perhaps can sense – the enormity of reality itself, perhaps I offer here only the tip of the iceberg, not so as to keep hidden the rest of its mammoth structure, but precisely to demonstrate that there is so much more to come. All films are equal. In a world of thinking, learning and becoming, we can learn from anything and everything – if we are prepared to do so. Rather than seeking reasons not to learn, let us open ourselves up to total learning.

Philippe Grandrieux says of his film *La Vie nouvelle/The New Life* (France, 2002) that 'the sun remains hidden, we never show it. But it's there as something we chase, which dazzles and blinds us, which gives us an appetite to live'.[17] If we chase the sun, it is because we live in darkness. If the sun blinds us, then this only reveals that without the sun we are blind anyway. Or rather, if we chase the sun, then we also need darkness, we also need not to see but to feel. This is made clear by the human mechanism of blinking: if we did not blink, our eyes would go dry from the heat of the sun and we would indeed go blind. Darkness is necessary. Perhaps it is for this reason that in Chris Marker's film, *La Jetée* (France, 1962), the only moving image that we see is of a woman not looking, but blinking. In a world that is obsessed with the visual and with an attention economy predicated on movement that grabs our attention, it is exemplary that Marker would make a film (about time travel, no less) in which there is no movement, except to show someone not looking. *La Jetée* is, thus, a pre-digital example of non-cinema through its emphasis on the moment of blindness that is essential for seeing, and through its use of still images that point to how we must get beyond movement and the demands of the attention economy in order to see that other invisible phenomenon that is often excluded from vision under capital, namely time itself.

Non-Cinema: Global Digital Film-making and the Multitude is comprised of ten chapters, each analysing various examples of contemporary digital film-making from around the world, and each incorporating various

philosophical ideas – not so much to establish a philosophy of non-cinema as to suggest non-cinema as philosophy. The first chapter, 'Digital Dreams in Afghanistan', looks at micro-budget action films made by Afghans and the Afghan diaspora. Drawing upon Michael Hardt and Antonio Negri's concept of the multitude, I suggest that in their aspiration towards cinema, or being/becoming cinematic, they demonstrate that Afghanistan is a nation that lies beyond cinema, in the realm of non-cinema.[18] By extension Afghanistan may be a nation with a people, but these digital film-making practices elude both the nation and the concept of a unified national people, existing instead in the realm of, and giving expression to, the multitude.

I then continue in 'The Iranian Digital Underground, Multitudinous Cinema and the Diegetic Spectator' to suggest that if state-backed, official cinema creates a sense of national identity in Iran, then it is the underground and unofficial work of film-makers like Bahman Ghobadi that gives expression not to the nation but to the multitude – with multitude here being linked to the philosophy of witness that is characteristic of Jean-Luc Nancy, especially his concept of being singular plural.[19] I then extend the witness of multitudinous film-making beyond the people that we see onscreen and into the relationship between film and spectator. Analysing the role that the traditional theatrical form of *ta'ziyeh* plays in the work of the late Abbas Kiarostami, I suggest that the spectator of non-cinema does not detachedly observe films (as happens in cinema), but actively participates in them. That is, where the diegesis of the film begins and ends becomes unclear, suggesting that the spectator, too, might be diegetic.

The third chapter, 'Digital Entanglement and the Blurring of Fiction and Documentary in China', follows on from this second chapter by elaborating via the work of feminist physicist Karen Barad how the blurring of fiction and documentary suggests not separation but something related to witness, namely entanglement.[20] That is, we are not detached from the world (one of capitalism's founding myths), but active participants with it. I establish this theory through the documentaries of Wu Wenguang and Ai Weiwei, both of whom blur fiction and documentary by entangling themselves with their subjects, in the process challenging the norms of cinema-making. I also look briefly at work by Andrew Y-S. Cheng and Lou Ye to demonstrate how this entanglement extends beyond documentaries and into digital fiction film-making.

'Digital Darkness in the Philippines' also draws upon physics, in particular David A. Grandy's work on light, in order to elaborate the role that darkness

plays in non-cinema, especially via a consideration of the work of punk digital film-maker Khavn de la Cruz.[21] Khavn prefaces each of his films with the words 'this is not a film by Khavn de la Cruz', while also producing subversive movies that do not so much bring to light as demonstrate the keeping in darkness of vast swathes of the Philippines. In other words, there is a synthesis that takes place in Khavn's work of the digital as a non-cinematic format and the treatment of 'squatterpunks' who lie beyond the normal remit of cinema, in darkness that can often literally consume the frame in Khavn's films.

Having considered the role of darkness in the work of Khavn de la Cruz, 'Digital acinema from afrance' considers the role that dark skin plays in non-cinema, looking at how the black lives depicted in the work of Alain Gomis suggest a link between cinema as a form and cinema as an exclusion of blackness. Black lives are not officially French, but somehow non-French, or a-french/afr-ench, an idea also found in the early digital films of Rabah Ameur-Zaïmeche, and which can be applied to women's lives in the work of Virginie Despentes and Coralie Trinh Thi. The idea of a-france also recalls Jean-François Lyotard's 1978 notion of acinema, a concept that has been applied to digital auteur Philippe Grandrieux.[22] The chapter ends, then, by analysing Grandrieux's 'sombre' cinema to discuss the links between acinema and non-cinema, but especially the way in which the latter might explore not just darkness and dark skin, but the dark potential for violence that lies within us all.

In 'A Certain Compatibility: The British Digital Wave', I argue that Michael Winterbottom's treatment of the British weather, together with his ongoing investigation of Steve Coogan as a star who can never quite progress from television to cinema, suggests not a confirmation of François Truffaut's suggestion that cinema and Britain are incompatible, but that non-cinema and Britain are entirely compatible, especially in the digital age.[23] Furthermore, I characterize Winterbottom's work as a digital-era continuation of what García Espinosa calls 'imperfect cinema' as a result of its essayistic tendencies. Finally, I explore how the essay-film itself plays an integral part in non-cinema, as this form has not coincidentally exploded since the advent of lightweight digital cameras. I do this through a consideration of work first by Mark Cousins and Mania Akbari and then by Andrea Luka Zimmerman, arguing how the former use landscapes and the latter animals in order to suggest a non-cinema that pushes beyond the anthropocentrism of cinema and into the non-human realm. That is, as humans multitudinously are with each other, they are also with other species and with the world more generally.

The focus of 'Non-cinema in the Heart of Cinema' is Giuseppe Andrews, a film-maker who for years made digital movies on his trailer park in Ventura, California, with tiny budgets and a cast of barbarian characters overlooked by conventional cinema. In the shadow of cinema's heartland, Los Angeles, Andrews's non-cinema is defined by a scatological but comic interest in both bodily effluence and the effluence of society more generally ('trailer park trash'). Drawing on philosophies of comedy, carnival and scatology, then, I demonstrate how those excluded from cinema and from society more generally are not geographically separated from cinema and capital's home, but in fact are right on its doorstep.

'Globalisation, Erasure, Poverty: Digital Non-Cinema in Uruguay' takes us to the south of the Americas, where we explore the way in which a nation like Uruguay is perhaps not even able to produce cinema as a result of its small size, with Uruguay either disappearing from films made there, or Uruguay being eliminated from cinema as its films are remade in the global north. Here I also draw more fully on Dussel to propose that non-cinema makes clear cinema's exclusions, and that non-cinema thus engages in the ethical pursuit of the liberation of the poor. The chapter culminates in a consideration of *La vida útil/A Useful Life* (Uruguay/Spain, 2010), Federico Veiroj's paean to the Montevideo cinematheque, which is all but disappearing in the age of the blockbuster. If the blockbuster has taken over cinema, then perhaps it is in non-cinema, or in a cinephilia that includes not just certain types of cinema, but cinema and non-cinema, that hope for cinema's future survives.

It is with the all-pervading mainstream aesthetic in mind that 'Cinema out of Control: These are Not Films' explores the adoption by certain film-makers of ever-smaller, ever-more uncinematic technologies, such as the smartphone camera. Concentrating in particular on *In Film Nist/This is Not a Film* (Jafar Panahi and Mojtaba Mirtahmasb, Iran, 2011) and *Film Socialisme* (Jean-Luc Godard, Switzerland/France, 2010), the chapter suggests that the smartphone film may (for the time being) take us beyond cinema and into non-cinema, and that this process involves a socialist, or democratic, principle: all films – be they rich or poor – are equal.

Finally, Chapter 10 says 'Farewell to Cinema; Hello to Africa'. Looking at Godard's *Adieu au langage/Farewell to Language* (Switzerland/France, 2014), I continue the previous chapter's shift away from a national to a technological context, proposing that this 3D film might not only bid good bye to language, but perhaps also to cinema as its images extend beyond the separating

mechanism of the frame and out into the audience. Through its digitally shot consideration of nature, animals and hair, Godard's film is also an example of floccinaucinihilipilification, or a celebration of that which might typically be overlooked as useless (in contrast to capitalism's need for everything to be useful). Furthermore, in this film (as well as in *Film Socialisme*), Godard repeatedly makes reference to Africa as we see how the cinematic global north has achieved its position of power through the exclusion of the uncinematic global south. It is perhaps logical, then, that I turn my attention finally to Nollywood, the enormous video industry based in Nigeria, and which churns out more films than Hollywood and Bollywood combined. Digital and 'poor' in various respects, Nollywood signals not just the exclusion of a continent by cinema-capital, but the irrepressible return of that continent in the form of non-cinema. Perhaps the most significant hub of non-cinema, Nollywood also constitutes a viable alternative to the hegemony and the homogeneity of cinema-capital, with Africa emerging not as stuck in the past, but as cinema's, and perhaps the world's, very future.

With the obligatory synopsis out of the way, then, I should like to end this introduction by returning briefly to Chris Marker. In *Sans soleil/Sunless* (France, 1983), his monumental treatise on, among other things, Africa, animals, the digital and darkness, Marker commences the film by musing on how black leader, an image perhaps of the black whole, in which the insistent visuality of cinema-capital is suspended, might be a moment of happiness. Happiness lies not in light, then, but in darkness.

In his travels, the cameraman Sandor Krasna meets Japanese animator Hayao Yamaneko, who digitally modulates film images such that they change colour – the kind of visible labour or manipulation that demonstrates the entanglement of the image maker and their subjects: these are not images that give the impression of detached observation; these are images that are specifically created and thus are not objective, but redolent of entanglement. During a sequence featuring such manipulated images – of humans and a menagerie of other animals with which we also are entangled – the narrator (Alexandra Stewart) reads at the film's end one of Krasna's letters explaining how these are images 'already affected by the moss of time'. Time, here, is change – and the manipulation that Yamaneko does is thus to expose the images to time, or to expose time itself (helping us to understand another phenomenon that lies beyond the realm of the visible), with the so-called digital Zone in which these images find themselves being perhaps time itself. Thus the images are 'freed from the lie' or the Bazinian myth that

cinema 'mummifies' time and produces images that cannot change.[24] Cinema is not fixed in its being, but rather is becoming. *Contra* Bazin, then, the question, is not what is cinema, but what cinema at any given moment in time is not – and why. For this shapes and also is shaped by what we consider to be human and what we consider to be real.[25]

Krasna travels to a post office to await a letter and on the way takes 'the measure of the unbearable vanity of the West that has never ceased to privilege being over non-being'. In asking us to think about non-being, Marker asks us by definition to think about the future – that which is not, but that which may yet come to be, or become. Indeed, Krasna likens Yamaneko's 'electronic graffiti' to profiles drawn on prison cell walls: 'A piece of chalk to follow the contour of what is not, or is no longer, or is not yet, the handwriting each one of us will use to compose his own list of things that quicken the heart.' A list of things that quicken the heart: an attempt/essay to put love into language. 'To offer, to erase', the voice continues. 'In that moment poetry will be made by everyone, and there will be emus in the Zone.'

What Marker describes is a world in which everyone will be taking part in the poiesis, the ongoing process of creation that is reality – perhaps consciously so by making cine-poems with their digital devices. To create, then, is consciously to take part in reality. It is to become conscious of one's entangled status with the world. Perhaps it is a paradox that digital technology, the ultimate product of capitalism, brings us closer to the realization of capitalism's own undoing (what for Marx and Engels was its very destiny). In finally allowing us to think outside of capital, to include non-being with being, to make non-cinema instead of cinema, the age of everyone writing digital cine-poetry gives to humans a future. Maybe we are on the verge of ecological collapse – a collapse that may also take humans beyond capital in the sense that we all perish. Nonetheless, in looking at *Sans soleil* – one of the earliest digital films about a world without a sun, that is, in darkness – we look not just at our past, but also at our future – a future without capital, a future without cinema. In this way, non-cinema gives us a future – not a future already mapped out, under control, and without risk. For, such a future is not a future at all. It is not a specific (vision of the) future that non-cinema offers us, but the prospect of a future that is not controlled, maybe even a future out of control. In this way, non-cinema gives us hope. Non-cinema is, perhaps, the new hope.

Let seven billion cine-poems bloom.

Notes

1. Jonathan Beller, *The Cinematic Mode of Production: Attention Economy and the Society of the Spectacle* (Lebanon, NH: Dartmouth College Press, 2006).
2. Enrique Dussel, *Ethics of Liberation in the Age of Globalization and Exclusion*, trans. Eduardo Mendieta, Camilo Pérez Bustillo, Yolanda Angulo and Nelson Maldonado-Torres (Durham, NC: Duke University Press, 2013), 1–52.
3. Hito Steyerl, *The Wretched of the Screen* (New York: Sternberg Press, 2012). See also Francesco Casetti, *The Lumière Galaxy: Seven Key Words for the Cinema to Come* (New York: Columbia University Press, 2015), 117–21.
4. See Karen Barad, *Meeting the University Halfway: Quantum Physics and the Entanglement of Matter and Meaning* (Durham, NC: Duke University Press, 2007).
5. Julio García Espinosa, 'For an Imperfect Cinema', trans. Julianne Burton, *Jump Cut*, 20 (1979), 24–6.
6. Gilles Deleuze, 'Postscript on the Societies of Control', *October*, 59 (Winter 1992), 3–7.
7. Amos Vogel, *Film as a Subversive Art* (London: C.T., 2005), 12–19.
8. Enrique Dussel, *Ethics and Community*, trans. Robert Barr (Maryknoll: Orbis, 1988).
9. Dussel, *Ethics and Community*, 63.
10. William Brown, *Supercinema: Film-Philosophy for the Digital Age* (London: Berghahn, 2013).
11. Samuel Beckett, *Nohow On: Company, Ill Seen Ill Said, Worstward Ho* (New York: Grove Press, 1995), 89.
12. See Enrique Dussel, *Twenty Theses on Politics*, trans. George Ciccariello-Maher (Durham, NC: Duke University Press, 2008), esp. 123.
13. François Laruelle, *Principles of Non-Philosophy*, trans. Nicola Rubczak and Anthony Paul Smith (London: Bloomsbury, 2013).
14. Karl Marx and Friedrich Engels, *The Communist Manifesto* (London: Penguin, 2004), 18. See also François Laruelle, *Introduction to Non-Marxism*, trans. Anthony Paul Smith (Minneapolis: Univocal Press, 2013).
15. See John Ó Maoilearca, *All Thoughts Are Equal: Laruelle and Non-Human Philosophy* (Minneapolis: University of Minnesota Press, 2015).
16. See Tarja Laine, *Shame and Desire: Emotion, Intersubjectivity, Cinema* (Brussels: Peter Lang, 2007).
17. Nicole Brenez, 'The Body's Night: An Interview with Philippe Grandrieux', trans. Adrian Martin, *Rouge*, 1 (2002), http://www.rouge.com.au/1/grandrieux.html.
18. Michael Hardt and Antonio Negri, *Multitude: War and Democracy in the Age of Empire* (London and New York: Penguin, 2004).

19 Jean-Luc Nancy, *Being Singular Plural*, trans. R. Richardson and A. O'Byrne (Stanford: Stanford University Press, 2000).
20 Barad, *Meeting the University Halfway*.
21 David A. Grandy, *The Speed of Light: Constancy + Cosmos* (Princeton: Princeton University Press, 2009).
22 Jean-François Lyotard, 'Acinema', *Wide Angle*, 2 (1978), 52–9.
23 François Truffaut, *Hitchcock* (New York: Simon & Schuster, 1986), 124.
24 André Bazin, *What is Cinema? Volume One*, trans. Hugh Gray (Berkeley: University of California Press, 1967), 14–15.
25 Bazin, *What is Cinema?*

1

Digital Dreams in Afghanistan

'This film ... is not for you', gruffed the storeowner of the Al Madinah greengrocers on Uxbridge Road in London when I bought *Anjam/End* (Basir Mujahid, Afghanistan, 2008) on DVD in 2012. Even though 'not for me', I soon after returned to the store to buy a second film, *Ehsaas/Emotion* (Farid Faiz, Australia/Germany/UK/Afghanistan, 2006). As low-budget action films from Afghanistan and the Afghan diaspora, *Anjam* and *Ehsaas* were a revelation to me, greatly different to the cinema about and/or from Afghanistan that I had seen prior to these films, and with which I shall engage presently.

'A country without an image': Afghanistan as non-nation

Prior to *Anjam* and *Ehsaas* my knowledge of cinema from Afghanistan was limited to three basic categories: films, predominantly American, set there (e.g. *The Kite Runner*, Marc Forster, USA/China, 2007); documentaries, predominantly western, about aspects of Afghan life (e.g. *Out of the Ashes*, Tim Albone/Lucy Martens/Leslie Knott, UK, 2010, about the emergence of the Afghan national cricket team); and a few films made there. This latter group was confined to films made or produced by the prolific Makhmalbaf family, including *Kandahar* (Mohsen Makhmalbaf, Iran/France, 2001), *Panj é asr/At Five in the Afternoon* (Samira Makhmalbaf, Iran/France, 2003), *Lezate divanegi/ Joy of Madness* (Hana Makhmalbaf, Afghanistan/Iran, 2003), *Sag-haye velgard/ Stray Dogs* (Marzieh Meshkini, Iran/France/Afghanistan, 2004), *Buda as sharm foru rikht/Buddha Collapsed Out of Shame* (Hana Makhmalbaf, Iran/France, 2007), *Asbe du-pa/Two-Legged Horse* (Samira Makhmalbaf, Iran, 2008) and *Osama* (Siddiq Barmak, Afghanistan/Ireland/Japan, 2003).

Mark Graham has described the latter as 'burqa films', arguing that western viewers see in films like *Kandahar* and *Osama* that which reaffirms their

understanding of Afghanistan as backward and barren. Of *Kandahar* in particular, he says that 'instead of portraying Afghans in humanizing, domestic settings, the film situates itself in the bleak and public spaces of refugee camps, squalid villages, and barren deserts. To do otherwise would flout viewer expectations.'[1] This is problematic, since 'for many Westerners, the Afghanistan of these movies *is* Afghanistan.'[2] More than simply being received as 'authentic', though, Graham also suggests that the films are designed for westerners, and thus are complicit in this reception. This can be seen by the way in which *Kandahar* is told predominantly through the eyes of characters from the West, especially Nafas (Nelofer Pazira), a Canadian journalist who has travelled to Afghanistan in order to prevent her sister from committing suicide. And it can also be seen in *Osama* by the way in which it opens with footage shot by a foreign journalist of the Taliban breaking up a demonstration being held by women – before showing us an oppressive, patriarchal Kabul that is a 'dead zone of barren and unremitting rubble', instead of 'a once beautiful city of flowers, trees, gardens, thriving businesses, modern high-rises, and exuberant crowds'.[3] This use of the outsider offering a way into Afghan culture demonstrates how the films construct what Kamran Rastegar, in relation to *Osama*, would term a 'global audience', and as a result both films to certain degrees 'fall within Orientalist discourse'.[4] That is, with the work of Edward W. Saïd in mind, the films do not properly represent Afghanistan, but instead offer to western audiences what they expect to see, namely veiled women who need rescuing.[5] For Graham this is made clear by the fact that Makhmalbaf uses the Arabic term *burqa* to talk about the veil, as opposed to the Dari term *chadari*: Makhmalbaf cannot but convey his own (Iranian) views on Afghanistan, rather than understanding the country from 'within'.[6]

It is not my aim here to seek out whether films like *Kandahar* and *Osama* objectively are 'reliable' or 'true' – even if a case can be made both for their unreliability, which, broadly speaking, is Graham's argument, and for their reliability (various of the actresses involved in *Osama* have described, for example, how the events in the film are 'true' to their own life experiences).[7] Rather, I wish to suggest that if these films at least in part perpetuate the western image of Afghanistan, and if these films constitute Afghan cinema, then these films also reveal an important link between cinema, the nation and the West, namely that the concept of the nation is a western invention in which the reality of what is otherwise (after Benedict Anderson) an 'imagined community' is constituted through images/cinema.[8] If one does not have an image or a cinema, or if one is invisible, then one is not really a nation and one does not really exist.

Makhmalbaf seems implicitly to be aware of this when he says that 'Afghans ... are indeed invisible, just like their country is on the world stage. Afghanistan, he writes, is "a country without an image".[9] In trying to provide an image/a cinema of and for that country, Makhmalbaf in some respects negates Afghanistan's non-cinematic/invisible status, while also negating its status as a non-nation (a nation without an image is not a nation if having an image is precisely what constitutes a nation). Krista Geneviève Lynes says that when the opening handheld sequences shot by the foreign journalist in *Osama* are brought to an abrupt close by a member of the Taliban, this marks 'a foreclosure of a bottom-up perspective of the reality of life under the Taliban'.[10] Similarly, *Kandahar* opens with an eclipse, suggesting that the film consciously is about light, visibility and/or the absence of both. That is, both moments suggest that one cannot film Afghanistan because Afghanistan defies/denies cinema; it is non-cinematic. In effect, Afghanistan is veiled from view; to lift that veil would be to negate Afghanistan, since the veil itself is what constitutes Afghanistan's (non-cinematic) reality.

If Afghanistan is not cinematic – and yet if *Osama* and *Kandahar* are films about Afghanistan – then we get a sense here of how *Osama* and *Kandahar* do not capture the nation but construct the nation by giving to it an image. It is not just that these films are made for western viewers or that they are films 'for me', unlike *Anjam* and *Ehsaas*. Rather, they show how the nation is a western construct and how the nation is an image, with image-making and cinema thus also reinforcing as well as being a key part of western ideology. *Anjam* and *Ehsaas*, meanwhile, are 'not for me'. They were supposed to remain invisible. In this way, neither *Anjam* nor *Ehsaas* is cinema in the way that *Kandahar* and *Osama* are. They are not films made to render Afghanistan comprehensible to westerners by virtue of providing a cinematic image of/as the nation. Rather, they constitute a non-cinema that, I wish to argue, does something profound on a political level, and which is tied to the films' digital and 'impoverished' aesthetics – in contrast to the visual beauty of Makhmalbaf and Barmak's films.

'Barmak estimates that the entire history of Afghan cinema in the twentieth century amounts to about forty films.'[11] This suggests both that Barmak sees Afghanistan as not having particularly strong historical ties to cinema (forty is a low number), and that Barmak has a relatively exclusive definition of cinema. For, there are numerous films like *Anjam* and *Ehsaas*, suggesting that Afghanistan in fact has produced many films – even if these circulate not in theatrical venues, but online and on DVD. In other words, Afghanistan

might not have strong links with cinema (only forty films, including *Osama*), but Afghanistan does have strong links with non-cinema (numerous films like *Anjam* and *Ehsaas*).

Anjam and *Ehsaas*

Anjam tells the story of two brothers, Rostam (Basir Mujahid) and Jawad (Aryan Khan), whose war-injured father was killed in a seeming hit-and-run car accident when they were young. Brought up by their mother, Rostam now works for his uncle, Sikander, a criminal involved in the drugs and firearms trades. Rostam is a kick-ass dude who wears a leather jacket and packs several guns when he's not impressing his cousin, Lina, whom he rescues at one point from a kidnapping attempt. Meanwhile Jawad is a martial arts specialist who's maybe the best cop in Kabul, and who wants to go steady with Frishta, a girl whom he meets in a shopping mall.

Although both Rostam and Jawad still live at home with their mother (and try to keep their respective love lives secret from each other), Jawad knows nothing of Rostam's criminal life until late on in the film, when Rostam is betrayed by his uncle for refusing to help a Pakistani criminal to send a suicide bomber into Kabul (the subtitles read: 'those Pakis [sic], I can't kill my people'). Framed by his uncle, Rostam is outed in the newspaper as a criminal, prompting Jawad and Rostam to fight in a hospital over the body of their mother, who has died at the shock of discovering Rostam's criminality. Rostam sends a thug to attack Jawad, but Jawad defeats him in the mud of a Kabuli plain (the scene foreshadows a muddy courtyard battle in *The Raid 2: Berandal*, Gareth Evans, Indonesia/USA, 2014). However, Jawad comes to forgive Rostam when the latter explains that he had no choice but to become a criminal, because it was the only way that he could pay to support their fatherless family. Together, then, the brothers track down Sikander (via a fight in a snooker hall), who confesses in an out-of-the-way estate to having killed their father (Jawad: 'If al [sic] uncles are like you, then no one can trust him'). A climactic battle ensues, with Rostam eventually blowing Sikander up with a bazooka as he flees in a car. The police arrive – but instead of evading arrest, Rostam chooses to stay. 'You did what you wanted', the brothers say to each other, and the film ends.

Ehsaas, meanwhile, opens with a man waking up in a jungle, before telling the story of Nazir (Fahim Faiz), a strong guy who works a dead-end job in a

scrapyard in Melbourne, Australia. He lives at home with his put-upon mother (Suraya Bahrami) and his alcoholic father (Farid Faiz), in his spare time going to the gym, kickboxing, and generally hanging out with his buddies, Navid (Navid Faiz) and Akmal (Akmal Akbar). Nazir has a nemesis at the gym: John (D. Antonio Vaqueroz), who turns up at regular intervals and initiates group fights with Nazir and friends. These take place at the gym, at a beach-side café where Navid's love interest Gheeti (Sutara Ariyan) works, and in a pool hall.

When Nazir's mother is fired from her job at a car service, Nazir loses his cool and gets into a fight with the police. Realizing that he needs to get money for his family, he falls in with Tania (Daniella Malinowski), who introduces him to Cobra (Beghan Sahil – who also did the graphic design for the film), a yellow-eyed drug dealer who gets Nazir to do his dirty work (with Nazir taking over from John for a while as Cobra's number one heavy). However, when Nazir's mother refuses the money that Nazir makes by working for Cobra, Nazir has a crisis of conscience, and refuses to do any more criminal work. Cobra therefore tries to kill Nazir, since no one is allowed to leave after they have started working for him. Fighting breaks out, with Nazir killing various henchmen before eventually being shot and, in a scene that repeats the film's opening, being left for dead in a jungle. Somewhat anticlimactically, Nazir then wakes up and wanders home.

While these synopses hopefully indicate the kind of low-budget action films that *Anjam* and *Ehsaas* are, some further description and a sense of the films' form will help to clarify the point. Both movies are replete with well-worn clichés from the sorts of cheap-ish action films that made stars of Jean-Claude Van Damme and Steven Seagal in the 1980s. Fights break out for no obvious reason (John just dislikes Nazir, for example), and the fights in both films are replete with meat-packing punch effects that are often ill-timed (they do not coincide with blows landing) and plain unrealistic. Sand is thrown into the face of an adversary such that they cannot see momentarily (Sikander to Rostam in *Anjam*), while doing the splits is clearly a sign of martial arts proficiency, as per many a Van Damme movie (Jawad in *Anjam*). Characters often wear shades (Rostam), bandannas (Nazir), and other slightly camp costumes, while it is de rigueur for the characters to stand around the most expensive cars to which the budget could stretch. While the films do have plots, both of which focus on family matters filtered through a nationalist paradigm (as I shall explain shortly), really both films seem to be excuses for fights and whatever special effects the film-makers could, on their limited budgets, achieve (squibs, explosions, clearly plastic blades cleaving enemies in twain, and so on). The acting might charitably be described as flat (especially in *Ehsaas*), with

emoting often being relegated to 'evil laughter', 'whimsical stares into the distance' and other tropes that are already the stuff of innumerable bad movie parodies. Finally, while on the whole competently shot, the images clearly carry the grain of low-budget digital cameras, as well as the white skies that signify digital overexposure. These suggest a lack of budget, as does the generally 'slow' editing rhythm (not enough money or time to do more set-ups), while the occasionally baffling cut suggests a lack of formal training in film-making.

Before we can simply say that these are amateur films that involve poor acting and the repetition of well-known clichés, however, we must also acknowledge that the Hollywood action film is not the only influence on *Anjam* and *Ehsaas*. The song and dance sequences from both films are straight out of popular Hindi cinema, especially the number between Jawad and Frishta in *Ehsaas*, which is set in various locations and which involves numerous costume changes – as per many a Bollywood song. Indeed, while not remakes, both films take their titles from earlier Bollywood movies, including the Shah Rukh Khan vehicle *Anjaam* (Rahul Rawail, India, 1994) and *Ehsaas: The Feeling* (Manesh Manjrekar, India, 2001), starring Sunil Shetty. In other words, *Anjam* and *Ehsaas* are not 'mere' imitations of Hollywood films, a fact also made clear by the local elements in the films' mise en scène. *Anjam* is set in Kabul, *Ehsaas* in Melbourne – and since both are shot on location, one cannot help but pick up on elements of those worlds. For example, *Ehsaas* features Nazir, Navid and Akmal standing in front of various Melbourne monuments, including a statue of Edward VII, while many of the places and the props that we see in *Anjam* (mobile phones, computers, domestic spaces dressed to look like office spaces) are quite different from those that feature in the Makhmalbaf films mentioned above. That is, *Anjam*'s hotels, large estates and numerous vehicles are very different from the ruins and horse-drawn carts of the latter films. Unlike *Osama* and *Kandahar*, *Anjam* does show us the 'once beautiful city of flowers, trees, gardens, thriving businesses, modern high-rises, and exuberant crowds', as opposed to the 'dead zone of barren and unremitting rubble'. What is more, *Ehsaas*, despite its Australian setting, also has domestic spaces in which we see typical Afghan curtains, decorations and the like. In addition to the Bollywood influence, then, the films' many local aspects mean that they are not straight imitations of Hollywood, a fact also made clear by the Dari dialogue and, in *Ehsaas*, by the way in which characters often turn to the camera to deliver key lines, something that would be unusual for both Hollywood and Bollywood films. For example, when describing how hard she works to stay afloat in Australia, Nazir's mother turns to the camera and says: 'Humans die in their country once, but in this strange country they die everyday.'

Such moments clearly break the so-called 'fourth wall' of the film, making the viewer keenly aware that not only is this film a construct, but that it is also one with a 'message' – a message that in both films has a 'nationalist' dimension. *Anjam* involves Rostam refusing to do terrorist work for a Pakistani, with the film culminating in Rostam's relatively jingoistic line: 'A tru afghan we will never do what a forigner say' [*sic*]. Meanwhile, in *Ehsaas*, lines like 'There is no life in a foreign country everyone is in their own thoughts. No one cares about each other, neither does a child or wife' are fairly commonplace. Furthermore, when Gheeti is introduced working her shift in the beach-side Rotunda Café (where John attacks Nazir), she is criticized for the skirt, T-shirt, pink boob tube and baseball cap combo that she is wearing ('it looks as if you know nothing about our afghans in Afghanistan' [*sic*]). Meanwhile, it seems clearly schematic that it is the white girl Tania who leads Nazir astray. In other words, there is a clear pro-Afghan dimension to these films, which I should like to discuss presently in relation to 'trash' cinema, amateur cinema and the concept of the minor.

The popular stutter of a people without cinema

Jeffrey Sconce argues that the promotion of 'trash' cinema, or what he terms 'paracinema', can constitute a 'counter-cinematic' movement.[12] Sconce introduces the work of Bertolt Brecht into his account of paracinema, suggesting that films by directors like Edward D. Wood Jr might 'answer Brecht's famous call for an anti-illusionist aesthetic' far more effectively than would films like *Tout Va Bien* (Jean-Luc Godard and Jean-Pierre Gorin, France/Italy, 1973).

I have already mentioned how *Ehsaas* regularly 'breaks the fourth wall', but I would like to go further by suggesting that *Anjam* and *Ehsaas* constitute what Brecht would term a 'popular cinema' – not because the films have enjoyed immense popularity or commercial success (which they seem to aim for through their employment of tropes from popular genres, especially the action film), but because they are made by 'the people'. The 'amateur' nature of the films becomes important here. Writing on the theatre, Brecht figured the amateur as equally important to culture as the professional, saying that 'it mustn't be imagined that there is no point in discussing amateur efforts in the arts if nothing of benefit to the arts results'.[13] Patricia R. Zimmermann, in her seminal discussion of amateur cinema, further explains how Brecht saw the 'popular' as 'the active participation of people in the development of culture'.[14] In the absence of a film industry in

Afghanistan, it is perhaps inevitable, therefore, that this development of culture would be driven by amateurs, and thus be a popular cinema by 'the people' regardless of how many people watch these films and/or how much money they make.

In being popular in the Brechtian sense, I wish also to suggest that *Anjam* and *Ehsaas* constitute a 'minor' cinema in the sense suggested by Gilles Deleuze and Félix Guattari. Writing on the work of Franz Kafka, Deleuze and Guattari suggest that a minor literature represents, and perhaps even constitutes, a 'people to come'. Minor literature, Deleuze and Guattari argue, can 'express another possible community' by 'forg[ing] the means for another consciousness and another sensibility'.[15] The way in which this happens is through the minor literature 'disrupting' the 'major' language against which the minor opposes itself, or, better, in the context of which it struggles to come into being. In his solo writings, Deleuze furthermore suggests that the 'people is missing' in mainstream cinema, and that minor cinema, or what Deleuze refers to as modern political cinema, can thus equally figure a 'people to come'.[16] In other words, minor literature and cinema can both bring together people who share a particular identity that is otherwise hidden within or at the margins of a 'major' community. Since that community is at present hidden, it perhaps necessarily is a community, or people, that does not yet exist – and which is, therefore, 'to come'. If *Anjam* and *Ehsaas* are 'popular' in the Brechtian sense, then they are also films that are by/for the 'people' – and thus they help to define a 'people to come'.

But which 'people' is this? Well, broadly speaking, we are talking about the Afghan people, as per the aforementioned proclamations made in *Anjam* and *Ehsaas* about what constitutes properly 'Afghan' attitudes and behaviour. However, a people to come is not necessarily a people united by a specifically *national* identity, as Deleuze suggests. Indeed, Deleuze refers to Québecois film-maker Pierre Perrault and to black American film-maker Charles Burnett in his discussion of contemporary political/minor cinema, since both directors come from places and/or groups (Québec and black America) that are minorities within the context of Canada and the United States respectively.[17] Furthermore, various scholars define minor cinemas as standing in opposition to, rather than as reinforcing, a national cinema.[18] Indeed, only Mette Hjort seems to have used the term in relation to a fully fledged national cinema (Danish cinema), arguing that it is a minor cinema in relation to Hollywood, which constitutes the 'major' discourse that Danish cinema disrupts.[19] In other words, to say that the Afghan

cinema of *Anjam* and *Ehsaas* is a minor cinema might seem contradictory, because unlike the works of Perrault, Burnett and the other film-makers who represent the term for Deleuze, both of these films aspire to be 'major' in the sense that they refer at least in part (though not uniquely) to mainstream (action) cinema, and because it is a national cinema that is presented as minor, and not a minor cinema working within a particular national context.

However, when we consider that Afghanistan historically has had little to no cinema (Barmak's forty films), then perhaps we can see how *Anjam* and *Ehsaas* do constitute a 'minor cinema' of sorts. As mentioned, Makhmalbaf argues that 'Afghans ... are invisible [and that] Afghanistan is thus "a country without an image"'. Why is Afghanistan without an image? In part, this might be because Afghanistan has never been colonized, even if for centuries it has been at the centre of the so-called 'Great Game' between civilizations. If, as Ziauddin Sardar and Merryl Wyn Davies attest, 'cinema is the engine of empire', then in never properly being, or becoming, part of the British (or any other) empire, Afghanistan has never become cinematic. In effect, Afghanistan is, or at least historically has been, non-cinematic.[20]

Is it that *Anjam* and *Ehsaas* signal the 'becoming cinematic' of Afghanistan? The answer that I wish to propose is a complex one, but which can basically be summarized – in a positive sense – as 'no'. We can understand how 'no' might be a positive answer by re-comparing *Anjam* and *Ehsaas* to *Kandahar* and *Osama*. As 'festival films' made for western viewers, *Kandahar* and *Osama* might typically be thought of as examples par excellence of 'minor cinema'. Indeed, Dudley Andrew seems to suggest that festival cinema and minor cinema are synonymous terms.[21] However, I wish to propose that *Anjam* and *Ehsaas* are more properly minor by virtue of their technical, aesthetic and industrial limitations than are *Kandahar* and *Osama*, as we shall see by returning to the work of Deleuze and Guattari and their commentators.

In choosing Kafka as the focus of their study of minor literature, Deleuze and Guattari deliberately choose a Jewish Czech writer who does not write in Czech in order to assert his identity, but who writes in German, the 'mainstream' language during his period of writing. As Deleuze and Guattari put it:

> Kafka marks the impasse that bars access to writing for the Jews of Prague and turns their literature into something impossible – the impossibility of not writing, the impossibility of writing in German, the impossibility of writing otherwise. The impossibility of not writing because national consciousness, uncertain or oppressed, necessarily exists by means of literature The impossibility of

writing other than in German is for the Prague Jews the feeling of an irreducible distance from their primitive Czech territoriality. And the impossibility of writing in German is the deterritorialisation of the German population itself, an oppressive minority that speaks a language cut off from the masses, like a 'paper language' or an artificial language; this is all the more true for the Jews who are simultaneously a part of this minority and excluded from it … . In short, Prague German is a deterritorialised language, appropriate for strange and minor uses.[22]

Translating this into cinematic terms, to make 'minor' cinema is not to make a cinema that deliberately opposes the mainstream (as applies to Hjort's analysis of Danish cinema, for example); if this were the definition of minor literature, then Kafka would have written in Czech or Yiddish. Instead, minor cinema, like Kafka with German, takes the language of the mainstream – and disrupts it.

Now, we could argue that *cinema itself* is the language of a globalized mainstream culture, no matter what genre, form or style that cinema is. Indeed, such an argument would in part chime with Jonathan Beller's twinning of cinema with the global expansion of (neoliberal) capital.[23] Nonetheless, since within a globalized, cinematic culture, the dominant form of cinema is Hollywood, while more specifically in Afghanistan many viewers also watch films from Bollywood, that *Anjam* and *Ehsaas* mimic (rather than reject) Hollywood action films and (in the case of *Anjam*) Bollywood musical numbers does not diminish, but rather enhances their credentials as minor cinema. The local mise en scène and the 'bad'/trashy film-making techniques only serve to make this clear: the films deterritorialize mainstream cinema ('Afghan action cinema is a deterritorialised language'), making it strange. They mark the impasse that bars access to film-making for Afghans, turning their cinema into something impossible, even a 'non-cinema'.

In the context of a globalized, cinematic culture, the films mark the impossibility of Afghanistan itself: even though the films are filled with nationalist statements, they mark the way in which Afghanistan is not a capitalist, and thus not a cinematic, society (Afghanistan has never been colonized), meaning that Afghanistan does not exist as part of the (globally cinematic) world. The only cinema that comes from Afghanistan (Barmak's forty films) is made for western eyes, thereby reinforcing the way in which cinema is western. The films that come from Afghanistan and which are not made for western eyes (*Anjam* and *Ehsaas*) cannot be cinema. Where *Kandahar* and *Osama* try to 'reveal' or to 'unveil' Afghanistan, it is the very Hollywood aspects of *Anjam* and *Ehsaas* that suggest the ways in which there is nothing to unveil; there is no Afghanistan

hidden away that can be brought to light, or made visible – at least not one that would be recognizable to (western/ized, or cinematic) eyes, because Afghanistan is not cinematic. Instead of an unveiling, then, there can only be an invention of a people – a mimicking of the already visible (Hollywood/Bollywood), which paradoxically demonstrates the way in which Afghanistan is, precisely, invisible. Afghanistan cannot be rediscovered; it is a people to come. Or, better expressed, it is a multitude, as I shall explain shortly.

In an essay published subsequent to his collaboration with Guattari on Kafka, Deleuze says that

> a great writer is always like a foreigner in the language in which he expresses himself, even if this is his native tongue. At the limit he draws his strength from a mute and unknown minority that belongs only to him. He is a foreigner in his own language: he does not mix another language with his own language, he carves out a nonpreexistent foreign language *within* his own language. He makes the language itself scream, stutter, stammer, or murmur.[24]

Meanwhile, Dana Polan has also argued that the minor language makes the major seem unfamiliar by making it 'stutter'.[25] The various misspelt subtitles that I have quoted above make clear (as a result of their linguistic nature) the 'stuttering' that takes place in *Anjam* and *Ehsaas*, which also is visible/audible through the 'bad' acting, the poor quality of the sound, the amateur lighting, the shaky camerawork, and the jarring edits. Meanwhile, *Osama* and *Kandahar* speak too clearly the 'language' of (festival) cinema. Put another way, *Anjam* and *Ehsaas* are films made with what Hamid Naficy would call an 'accent', with all 'accented cinema', as Naficy defines it, being minor cinema (even if not all minor cinema is accented cinema).[26]

Afghanistan is not a singular entity, but rather a highly complex nation that consists of various ethnicities (Pashtun, Tajik, Uzbek, Hazara and more) and languages (Dari, Pashto, Uzbek, Turkmen, Arabic and more). What is more, as *Ehsaas* makes clear, Afghanistan is not confined to a people inhabiting a particular geographical area; instead, there are Afghans in many different locations, including Melbourne (where the film was shot) and London (where music was added for the film). As a film made by diasporic Afghans living in Australia and the UK, *Ehsaas* is an example of what Naficy terms 'accented cinema', particularly in its adoption of tropes from the Hollywood action film. For, as Naficy reminds us, 'accent refers only to pronunciation, while dialect refers to grammar and vocabulary as well'.[27] In cinematic terms, this suggests a desire

to speak the mainstream language (copying the tropes of action cinema), rather than simply to construct a different one. Like its characters when they speak English in the film, *Ehsaas* itself speaks 'cinematically' with an accent, disrupting the mainstream language of Hollywood – and in many ways broadening it, as the hard-to-translate term *ehsaas* itself makes clear; meaning something like 'emotion' or 'feeling', the film's title generally remains untranslated ('a man who has everything and no *ehsaas* has no mother', says one of the characters towards the end of the film). In being both a complex nation and in being a nation that exceeds its own geographical boundaries, to speak of an Afghan people is problematic. In this sense, let us move beyond the concept of people in analysing *Ehsaas* and *Anjam* and introduce the concept of the multitude.

A multitudinous non-cinema

Writing of the people to come in relation to modern political cinema, Deleuze asserts that

> there will no longer be conquest of power by a proletariat, or by a united or unified people. The best third world filmmakers could believe in this for a time: [Glauber] Rocha's Guevarism, [Youssef] Chahine's Nasserism, black American cinema's black-powerism. But this was the perspective from which these authors were still taking part in the classical conception, so slow, imperceptible and difficult to site clearly. The death-knell for becoming conscious was precisely the consciousness that there were no people, but always several peoples, an infinity of peoples, who remained to be united, or should not be united, in order for the problem to change. It is in this way that third world cinema is a cinema of minorities, because the people exist only in the condition of the minority, which is why they are missing.[28]

It is clear in this passage that when Deleuze refers to 'people' he really means 'peoples'. Nonetheless, Italian philosopher Paolo Virno opposes people and multitude as concepts, drawing his definition of the former not from Deleuze, but from Thomas Hobbes, who sees it as a singular concept, while Virno also draws his definition of the latter from one of Deleuze's main influences, Baruch Spinoza:

> The two polarities, people and multitude, have Hobbes and Spinoza as their putative fathers. For Spinoza, the *multitudo* indicates a *plurality which persists as*

such in the public scene, in collective action, in the handling of communal affairs, without converging into a One, without evaporating within a centripetal form of motion. Multitude is the form of social and political existence for the many, seen as being many: a permanent form, not an episodic or interstitial form. For Spinoza, the *multitudo* is the architrave of civil liberties.[29]

For Virno, Hobbes believes that the state is the force by which the people will be united, and that the multitude is both 'anti-state' and 'anti-people', in that it impedes state sovereignty.

If we allow Virno's compatriot Giorgio Agamben now to take up the reins of this argument, he points out that the concept of the state, and by extension the concept of the people, is implicitly exclusive, if not plain contradictory. Agamben argues how in European languages at least, the term 'people' refers both to the poor and to those who are supposed to constitute political subjects. That is, the term refers simultaneously to political subjects *and* to those who are (in Agamben's words, de facto if not de jure) excluded from politics. Furthermore, if in the Gettysburg Address Abraham Lincoln spoke of a government 'of the people, by the people, for the people ... the repetition implicitly opposes the first "people" to another "people"'.[30] That is to say, for Lincoln to articulate the 'popular' nature of the government is tacitly to admit the historical exclusion of this self-same people for whom the government reputedly has been established. For Agamben, political 'compassion' (a concept to which I shall return in relation to the thinking of Enrique Dussel), whereby those in power claim (condescendingly?) to look after the 'misfortunate' people, is indicative of a split between *zoë* and *bios*, between bare life and political existence, between people and People. In other words, Agamben helps to articulate shortcomings in the concept of the people, which he himself relates to the sovereign power of the state. Where Hobbes would insist that only the state can unify the people, Agamben points out the way in which the state in fact excludes the people, or the poor, for the benefit of the People, or political subjects. In recognizing the impossibility of a united or unified people, Deleuze, too, seems to understand that the people exists only in *potential*; that is, they are missing, and thus their futurity emerges – they are to come. Furthermore, when Brecht describes 'popular' theatre (a theatre by/of/for the people), he, too, in validating the amateur, seems to distinguish it from an official theatre of the People, as Agamben might put it. Nonetheless, Virno's evocation of the multitude might conceivably open up spaces for an alternative to the people, as well as tidying up any possible confusion around the use of that term. What is more, a cinema of the multitude can serve as a political

project of its own, as my consideration of *Anjam* and *Ehsaas* hopefully implies. Afghanistan may not 'exist' and it may have to be invented, but what must be invented is perhaps not a people in a strictly nationalistic, ethnic, geographical or any other sense – but a multitude. Perhaps everyone has some *ehsaas* in them, even if some people are not familiar with the term.

Michael Hardt and Antonio Negri, who have perhaps taken multitudinous thinking to its furthest point, argue that

> there are no final ends or teleological goals written in history. Human faculties and historical teleologies exist only because they are the result of human passions, reason, and struggle. The faculty for freedom and the propensity to refuse authority, one might say, have become the most healthy and noble human instincts, the real signs of eternity. Perhaps rather than eternity we should say more precisely that this multitude acts always in the present, a perpetual present. The first multitude is *ontological* and we could not conceive our social being without it.[31]

In other words, it is not that the multitude is a goal towards which we should aim; we are always already the multitude. However, Hardt and Negri rightly separate this 'first' multitude from a second one, which they characterize as *political*, and which requires 'a political project to bring it into being on the basis of … [cultural, legal, economic and political] conditions'.[32] The difference between the ontological and the political multitude can be understood as not just a case of being (ontology), but of *realizing* (both in the sense of coming to acknowledge and in the sense of making real). Again, the would-be Hollywood aesthetics of *Anjam* and *Ehsaas* help to make this clear: theirs is not a rejection of Hollywood, but an appropriation thereof that belies the way in which Hollywood is, as it were, as Afghan as is the rubble and despair of *Kandahar*.

Is the framing of *Anjam* and *Ehsaas* within a discourse of multitude at the last a way of demonstrating the ubiquity and global hegemony of Hollywood and of the neoliberal capital that it, and what Guy Debord might generally term the society of the spectacle, represents?[33] Acknowledging the possibility that my very writing on *Anjam* and *Ehsaas* might indeed negate their revolutionary potential precisely by creating a framework through which we can understand them (if these films are 'not for me', then perhaps they should remain so), I would like to end this chapter by arguing why I believe that this is not the case. This is not simply an issue of whether a westerner can understand a foreign culture, or, indeed, use the critical tools of European philosophy eurocentrically to read into

that culture something that really only applies to European culture. On that note, Lynes might, via anthropologist Lila Abu-Lughod, argue that to reinforce the 'East is East and West is West and never the twain shall meet' mentality in fact 'artificially divides the world into separate spheres – recreating an imaginative geography of West versus East'.[34] Graham makes a similar point in relation to Iran and the West: 'The boundaries between Iran and the West remain as illusory today as they were a millennium ago when Shia Persia was teaching the Catholic West how to do algebra, geometry and Greek-style philosophy'.[35] Globalization might today be the homogenization of the world by neoliberal capitalism, but in another sense the world has always been globalized.

Anjam and *Ehsaas* do not necessarily testify to the Americanization or the Hollywoodization of Afghanistan, therefore; nor do they truly speak of the making-cinematic (and thus making-capitalist) of Afghanistan; nor, even, do they speak of clear aspirations to become cinematic or capitalist (even if, on the surface, this appears to be the case). Not only do both films involve stories that involve a rejection of capitalism (figured in both as getting rich quick via criminality – for Rostam and for Nazir respectively). But both films also function outside of cinema in many senses of the word: shot digitally (and thus without film), distributed digitally (on DVD and online) and exhibited digitally (via DVD players and/or on computer screens), *Anjam* and *Ehsaas* circulate outside of cinema according to many definitions of what cinema is or might be. These are not even festival films (they are too 'bad' for most festivals), but something different again.

Furthermore, while the concept of the minor is clearly useful in helping us to understand these films, perhaps it is beneficial to part ways with the concept of the people and to think of them in relation to the multitude. If, for Virno and Agamben, the people suggests exclusion (these films are not for me), the multitude suggests inclusion (I have nonetheless seen, enjoyed, and now am writing about these films). More pressingly, the political dimension of the multitude is aligned with what I am terming non-cinema. If, after Beller, cinema and capital are coterminous, then perhaps the concept of people is also intertwined within a history and discourse of colonialism, imperialism and capitalism, particularly in the Hobbesian sense that Virno discusses; it is also, as Hardt and Negri might argue, an aspect of Empire, as opposed to the concept of multitude that they use to oppose it. As Hardt and Negri suggest, we may exist ontologically as a multitude anyway.[36] But politically to realize that (we exist as a) multitude perhaps must involve a paradoxical rejection of cinema, the creation

of a non-cinema that indeed is in many respects 'non-cinematic' in a technical/aesthetic/industrial sense, but which also is deeply cinematic, perhaps even the future of cinema, a cinema to come. As Karl Marx predicted that the very destiny of capital is to dissolve itself, so, too, might cinema – as capital – be destined to dissolve itself, to become non-cinema.

With his forty-film history of Afghan cinema, Barmak might not esteem *Anjam*, *Ehsaas* and its like to be 'cinematic'. However, Afghan non-cinema consists of many more films, with that non-cinema being a more appropriate form for an uncolonized and thus non-cinematic (non-)nation, a country without an image, a (non-)nation beyond capital, beyond spectacle. While festival films like *Osama* and *Kandahar* (laudably?) endeavour to unveil Afghanistan and to bring it to light, this process perhaps only serves the purposes of the society of the spectacle. By deliberately presenting us with Hollywood-style action films that cannot be taken as realistic portrayals of Afghanistan, *Anjam* and *Ehsaas* (with the latter not even being filmed there!) paradoxically bring us closer to Afghanistan – by demonstrating how Afghanistan does not exist. They do not bring it to light, but demonstrate that the country is invisible, or exists in darkness (Afghanistan is not behind the veil; it is the veil). Afghanistan exists at the limit of capital and at the limit of cinema; it is – impossibly – non-cinematic. In this sense, to make non-cinema can be seen as a positive 'no' in relation to the onslaught of globalized neoliberalism, of globalized cinema.

Having argued that the non-cinematic nature of Afghan 'non-cinema' points perhaps to the destiny of cinema (or at least gives us hope that the future of the world and the future of cinema is not necessarily neoliberally capitalist in nature, and about the future realization of the multitude that exists anyway), I shall in subsequent chapters demonstrate how 'non-cinema' can be found in all manner of territories, including in the western world, where the grip of capital/cinema is supposedly strongest. Before heading west, however, I shall in the next chapter turn to non-cinematic aspects of Afghanistan's neighbour, Iran.

Notes

1 Mark Graham, *Afghanistan in the Cinema* (Chicago: University of Illinois Press, 2010), 62.
2 Graham, *Afghanistan in the Cinema*, 5.
3 Ibid., 90.

4 Kamran Rastegar, 'The Iranian Mediation of Afghanistan in International Art House Cinema after September 11, 2001', in *Globalizing Afghanistan: Terrorism, War, and the Rhetoric of Nation Building*, ed. Zubeda Jalalzai and David Jefferess (Durham, NC: Duke University Press, 2011), 145–64. See also Graham, *Afghanistan in the Cinema*, 66.
5 See Edward W. Saïd, *Orientalism* (London: Vintage, 1978).
6 Graham, *Afghanistan in the Cinema*, 79. See also William Brown, 'Lost in Transnation', in *Cinemas, Identities and Beyond*, ed. Ruby Cheung and D. H. Fleming (Cambridge: Cambridge Scholars Press, 2009), 16–32.
7 See Krista Geneviève Lynes, *Prismatic Media, Transnational Circuits: Feminism in a Globalized Present* (New York: Palgrave Macmillan, 2013), 162–4.
8 See Benedict Anderson, *Imagined Communities: Reflections on the Origin and Spread of Nationalism* (London: Verso, 2006).
9 Graham, *Afghanistan in the Cinema*, 81.
10 Lynes, *Prismatic Media, Transnational Circuits*, 158.
11 Graham, *Afghanistan in the Cinema*, 88.
12 Jeffrey Sconce, '"Trashing" the Academy: Taste, Excess, and An emerging Politics of Cinematic Style', *Screen*, 36:4 (1995), 371–93.
13 Bertolt Brecht, *Brecht on Theatre: The Development of an Aesthetic*, ed. and trans. John Willett (New York: Hill and Wang, 1964), 150.
14 Patricia R. Zimmermann, *Reel Families: A Social History of Amateur Film* (Bloomington: Indiana University Press, 1995), 85.
15 Gilles Deleuze and Félix Guattari, *Kafka: Towards a Minor Literature*, trans. Dana Polan (Minneapolis: University of Minnesota Press, 1986), 17.
16 Gilles Deleuze, *Cinema 2: The Time-Image*, trans. Hugh Tomlinson and Robert Galeta (London: Continuum, 2005), 208.
17 Deleuze, *Cinema 2*, 207–15.
18 For considerations of Québecois in relation to Canadian cinema, see Bill Marshall, *Québec National Cinema* (Montreal: McGill-Queen's University Press, 2001), and 'Cinemas of Minor Frenchness', in *Deleuze and the Schizoanalysis of Cinema*, ed. Ian Buchanan and Patricia MacCormack (London: Continuum, 2008), 89–101. For work on minor Hong Kong in relation to mainland Chinese cinema, see Yau Ka-Fai, 'Cinema 3: Towards a Minor Hong Kong Cinema', *Cultural Studies*, 15:3–4 (2001), 543–63. And for a discussion of Scottish in relation to British cinema, see David Martin-Jones, '*Orphans*: A Work of Minor Cinema from Post-Devolutionary Scotland,' *Journal of British Cinema and Television*, 1 (2004), 226–41.
19 Mette Hjort, *Small Nation, Global Cinema: The New Danish Cinema* (Minneapolis: University of Minnesota Press, 2005).
20 Ziauddin Sardar and Merryl Wyn Davies, *American Terminator: Myths, Movies and Global Power* (New York: Disinformation, 2004), 24. Also quoted in Graham, *Afghanistan in the Cinema*, 84.

21 Dudley Andrew, 'The Roots of the Nomadic: Gilles Deleuze and the Cinema of West Africa', in *The Brain is the Screen: Deleuze and the Philosophy of Cinema*, ed. Greg Flaxman (Minneapolis: University of Minnesota Press, 2000), 226.
22 Deleuze and Guattari, *Kafka*, 16–17.
23 Beller, *The Cinematic Mode of Production*.
24 Gilles Deleuze, *Essays Critical and Clinical*, trans. Daniel W. Smith and Michael A. Greco (London: Verso, 1998), 109–10.
25 Dana Polan, 'Translator's Introduction', in Deleuze and Guattari, *Kafka*, xxvii.
26 Hamid Naficy, *An Accented Cinema: Exilic and Diasporic Filmmaking* (Princeton: Princeton University Press, 2001), 26.
27 Naficy, *An Accented Cinema*, 22.
28 Deleuze, *Cinema 2*, 211–12.
29 Paolo Virno, *A Grammar of the Multitude: For an Analysis of Contemporary Forms of Life*, trans. Isabella Bertoletti, James Cascuito and Andrea Casson (New York: Semiotext(e), 2004), 21.
30 Giorgio Agamben, *Homo Sacer: Sovereign Power and Bare Life*, trans. Daniel Heller-Roazen (Stanford: Stanford University Press, 1998), 177.
31 Hardt and Negri, *Multitude*, 221.
32 Ibid., 221.
33 Guy Debord, *The Society of the Spectacle*, trans. Donald Nicholson-Smith (New York: Zone Books, 1995).
34 Quoted in Lynes, *Prismatic Media, Transnational Circuits*, 141.
35 Graham, *Afghanistan in the Cinema*, 64.
36 Michael Hardt and Antonio Negri, *Empire* (Cambridge, MA: Harvard University Press, 2000).

2

The Iranian Digital Underground, Multitudinous Cinema and the Diegetic Spectator

After the founding of the Islamic Republic following the revolution of 1979, the late Ayatollah Khomeini famously said that

> we are not opposed to cinema, to radio or to television. The cinema is a modern invention that ought to be used for the sake of educating the people, but as you know it was used instead to corrupt our youth. It is the misuse of cinema that we are opposed to, a misuse caused by the treacherous policies of our rulers.[1]

Nonetheless, numerous film-makers from Iran have achieved international recognition since the 1970s, including, inter alia, Dariush Mehrjui, Bahram Beyzai, Sohrab Shahid-Saless, Parviz Kimiavi, Amir Naderi, Abbas Kiarostami, Rakhshan Bani-Etemad, Majid Majidi, Tahmineh Milani, the Makhmalbaf family, Rafi Pitts, Mohamad Rasoulof, Bahman Ghobadi, Jafar Panahi and Asghar Farhadi, whose *Jodaeiye Nader az Simin/A Separation* (Iran, 2011) and *Forushande/The Salesman* (Iran/France, 2016) have both won Oscars for Best Foreign Language Film.

With Iranian cinema in such rude health, it might seem odd for me to suggest that elements of contemporary Iranian film-making are better understood not as cinema, but as non-cinema. That the concept of non-cinema is appropriate for understanding elements of contemporary Iranian film-making is nonetheless made clear by the title of Jafar Panahi's *This is Not a Film*: Panahi is actively engaged in making something that disavows its status as cinema, or which is non-cinema. I shall look more closely at *This is Not a Film* in the penultimate chapter, where I consider the role of smartphone cameras in/as non-cinema. However, Panahi clearly signals the relevance of non-cinema to the wider Iranian context, and with this in mind I shall focus on Bahman Ghobadi's *Kasi az gorbehaye irani khabar nadareh/No One Knows About Persian Cats* (Iran, 2009)

as an example of 'underground' film-making/non-cinema in Iran. For, *Persian Cats* is a film that largely circulates outwith the official cinema circuits in Iran, having received no domestic production or exhibition permits. As a result – and following on from the discussions of the minor and the multitude in the last chapter – I shall argue that *Persian Cats* is an example of Iranian non-cinema, and one which has as its main concern a sense of 'withness', or social inclusion instead of the process of exclusion that I define as characteristic of cinema, nationalism and capital. I shall then extend this concept of 'withness' to Abbas Kiarostami's *Dah/Ten* (France/Iran, 2002), *Five Dedicated to Ozu* (Iran/Japan/France, 2003) and *Shirin* (Iran, 2008), which draw upon the Persian theatrical tradition of *ta'ziyeh* in order to extend withness/inclusion beyond the film's diegesis and to include the spectator. In this way, I shall argue that non-cinema crystallizes a relationship with the film spectator that is different to the one theorized for the viewer of 'classical' fiction cinema, and that this changed relationship can be understood through the concept of the 'diegetic spectator'.

What is Iranian cinema?

Hamid Naficy defines *all* post-revolutionary Iranian cinema as 'postal'. For Naficy, the term

> denotes not a complete political and aesthetic break but a movement out of a closed doctrinal milieu towards more expansive thematic and stylistic horizons. The art-house and experimental cinemas [of Iran] are also 'postal' in the way some films reject the exclusionary high culture, authoritarian certainties, and politicised aesthetics of modernism for the more nuanced, open, ambiguous, self-reflexive, self-inscriptional, intertextual, pluralist, playful, and humanist ethics and aesthetics of postmodernism. Finally, the art-house films are post-national and postcinema, in that they exist outside the originating nation and outside traditional movie houses: they live in transnational, international, and global mediascapes – film festivals, commercial movie houses, art-house venues, galleries, museums, television, video distribution, and cyberspace.[2]

If all post-revolutionary cinema in Iran is 'postal', it would seem that not all are 'postal' in the same way. For while some cinema is postal simply by virtue of being post-revolutionary, the art house and experimental aspects of contemporary Iranian cinema are 'postcinematic' because they exist 'outside of traditional movie houses', and they are 'post-national' because they exist 'outside

the originating nation'. Naficy does not make it clear but in referencing a 'postal card' that was created to publicize the International Festival of Films Made in Exile, held in Gothenburg in Sweden in 1993, he implies that some Iranian cinema is also post-nationally 'postal' because it is delivered from film-makers in exile as if it were a letter from abroad (Naficy does not make the connection, but this also recalls how *This is Not a Film* was delivered by post, hidden on a pen drive inside a cake, to the Cannes Film Festival for its initial screening in 2011).[3] Both the post-cinematic and the post-national cinema of Iran overlap with my definition of non-cinema, as we shall explore in more detail shortly. However, even if all post-revolutionary Iranian cinema is 'postal', not all contemporary Iranian cinema is post-cinematic, or non-cinema. Indeed, as signalled above, Iran has a thriving film scene that constitutes the Iranian cinema against which Iran's non-cinema must be defined.

I have analysed elsewhere how popular films like *Marmoulak/The Lizard* (Kamal Tabrizi, Iran, 2004) and *Atash Bas/Cease Fire* (Tahmineh Milani, Iran, 2006) can help us to overcome some of the negative stereotypes that persist about Iran, in particular what Hamid Dabashi might term the 'analytically ludicrous and politically catastrophic' image of that country as being characterized by 'an Islamist, nationalist, or socialist absolutism'.[4] Given that they are popular, funny and deal with political issues (respectively the clergy and gender), *The Lizard* and *Cease Fire* suggest a sophisticated audience that is multicultural and pluralist – a far cry from the 'lame and lazy reductionism [that] distorts the inner grace and overriding power of a thriving culture that outsmarts its tyrant rulers'.[5] Nonetheless, even if *The Lizard* and *Cease Fire* are films that 'outsmart' Iran's 'tyrant rulers' – by virtue of existing and being popular in spite/because of their subversive content – they also make clear that Iran has a thriving mainstream. Furthermore, the very 'outsmarting' that they achieve makes clear that Iranian cinema is a state-backed, national cinema in which film-makers must gain authorization from the country's Ministry of Culture and Islamic Guidance (MCIG) in order to make their movies. This is not a cinema without nuance: *The Lizard* and *Cease Fire* clearly demonstrate that 'subversive' material can get past or be condoned by the censors (although there is some confusion over whether *The Lizard* was banned, with Saeed Zeydabadi-Nejad reporting that it was, while Nacim Pak-Shiraz suggests it was not).[6] But this is a different cinema to that of directors like Ghobadi, Kiarostami and Panahi, whose work is underground by virtue of being made without authorization from the MCIG, and/or which is marginalized both by the MCIG (which might only show a film

on a handful of screens and at unpopular times) and by audiences for various different reasons.

Indeed, Roxane Varzi declares that 'Iranians in Iran [are] both savvier and less trustful [of film images] than American audiences'.[7] Perhaps this can help us to understand why certain films, for example those by the likes of Kiarostami, are not popular in Iran, because these films do not provide us with an accurate image of that country, but rather they exoticize Iran, and thus in some senses are not films for Iranian audiences, but *film-e sefareshi* (films to order, i.e. for foreign audiences) and *film-e jashvarehi'i* (festival films).[8]

I hope in this chapter to sidestep the value judgements that Iranian film scholars often seem compelled to make (e.g. Shahab Esfandiary condemns the later work of Mohsen Makhmalbaf while praising Dariush Mehrjui; Hamid Dabashi derides Mehrjui while praising Makhmalbaf).[9] And I am not interested in proposing that x or y film provides us with a more authentic insight into 'the real Iran'. However, I would like to propose the political and philosophical relevance of *No One Knows About Persian Cats* and the Kiarostami films – and I can do this by working with and not against the possibility that these films are not 'Iranian' and perhaps not even 'cinema', since this helps me to argue that the concept of the nation and cinema are both tools for capital.

That said, if in the last chapter I suggested that *Anjam* and *Ehsaas* exemplified a non-cinema that stood in contrast to 'cinematic' festival films like *Kandahar* and *Osama*, which primarily appeal to foreign audiences, then how can I now propose also as non-cinema films that are accused in Iran of being precisely *film-e sefareshi* and/or *film-e jashvarehi'i*? To answer this question, I must make both an important link and an important distinction. The link is the shared 'post-cinematic' digitality of all of these films. More importantly, though, the difference is that Afghanistan has no film industry, while Iran has a thriving one. More than this: the thriving Iranian film industry exemplifies a capitalist dimension in that country, and in contradistinction to which the underground and art house works of Ghobadi and Kiarostami exist.

To suggest that capitalism, cinema and the nation are all interlinked is, in the context of Iran, a controversial claim for at least two reasons. First, to assert that Iran is a country that has adopted commercial values, and which by extension is capitalist, is to go against much of the rhetoric of a nation that ostensibly prides itself on Islamic – and often specifically non-western (i.e. non-commercial) – values. Indeed, the Islamic Republic was founded in part as a rejection of western, capitalist values as they had developed under Shah Reza Pahlavi, with

cinema itself deemed to be a symptom of *gharbzadegi*, a term coined in 1962 by Jalal Al-I Ahmad, and which translates as *Westoxication*.[10] 'Westoxication' took/takes Iranians' fascination with the West to be a disease – hence Ayatollah Khomeini's scepticism regarding cinema as outlined at this chapter's outset, for it was a tool used to promote western, commercial values, for entertainment and not educational purposes.[11] Capitalism, therefore, is a western disease in opposition to which the Islamic Republic was founded. As Esfandiary puts it, Iran is 'a country where resisting the "western cultural invasion" has long been an official cultural policy'.[12]

What is more, while cinema itself might be 'Westoxic' from a certain Iranian perspective, its film industry shows 'little evidence of the well-known consequences of globalisation, such as market liberalisation, foreign investment and ownership, mergers, vertical integration, etc'.[13] In other words, while it might be absurd to argue that Iran as a whole is capitalist, it might be more absurd yet to suggest that its film industry is capitalist, even if film is itself a western, that is capitalist, invention. Nonetheless, Christopher Gow writes about how there was in Iran increasing levels of privatization under the governments of Ali Akbar Hashemi Rafsanjani (1989–97) and Seyyed Mohammad Khatami (1997–2005), while Esfandiary contends that commercial advertising culture has become more prominent in Iran since the 1990s and that there is now a prevalent post-revolution consumer culture.[14] Indeed, when writing about Ebrahim Hatamikia's film, *Ajans-E Shiseh-I/The Glass Agency* (Iran, 1999), Esfandiary suggests that 'even under an Islamic Republic, a globally dominant culture of capitalism is growing that recognises no value apart from the value of capital'.[15]

In short, then, if there is a commercial cinema in Iran, and if it is state-sanctioned, in that all films must be approved by the MCIG, then Iranian national cinema takes on a commercial/capitalist dimension – not least because the nation itself is tied to capital. As Jonathan Beller equates cinema with capital, so might we understand Iran's commercial/mainstream cinema as embracing various values that are, for want of a better word, capitalist.[16] *Cease Fire* in particular shows a world of nice cars, luxury apartments and smart suits, as well as a tendency to be profligate in dispensing with those possessions.[17] In contrast to this, a cinema that does not engage with the world of luxury items, a cinema that is not commercial, is perhaps a non-cinema. Within the context of Iran, such a cinema would either be made without national/official/government authority – as is/was the case with *No One Knows About Persian Cats* – or it would be made transnationally, as per Kiarostami's films. Let us look at Ghobadi's film presently.

The Iranian underground

No One Knows About Persian Cats is a film made without permits from the MCIG.[18] As such, it is an 'underground' film that cannot circulate domestically via official channels – that is in cinemas. Instead, if it is to be seen at all in its homeland, it must eke out an existence via what Ramon Lobato calls the 'shadow economies' of pirate DVDs and unofficial screenings, or what Lobato elsewhere refers to as 'subcinema'.[19] *Persian Cats* is also shot digitally, lending to it a formal quality that we do not find so often in mainstream, official cinema. For these preliminary reasons (underground/unofficial, circulating via pirate networks, digital), we might characterize *Persian Cats* as non-cinema. However, the film also reflects consciously on its digital and underground construction, suggesting that its makers also know that they are creating works that do not conform to the regular standards of cinema – in Iran and perhaps elsewhere.

The film tells the story of Negar (Negar Shaghaghi) and Ashkan (Ashkan Kooshanejad), two young Tehrani musicians who are trying both to get a visa and to find band members to take to London for a forthcoming gig. They are taken under the wing of Nader (Hamed Behdad), an entrepreneurial grafter, who promises to help them. More than following a specific narrative, the film instead becomes a tour of Tehran's underground music scene, as we, with the three main protagonists, see groups perform folk, indy, metal, blues, rap and also traditional Persian music at different points in the film. When the passports do not materialize, Nader goes to an illegal party and gets drunk. As Ashkan and Negar prepare for a secret gig in order to raise money for their travels, music producer Babak phones Negar to tell them of Nader's whereabouts. They go to find him, Ashkan entering the party as Negar waits outside in a dark alley. Ashkan finds Nader passed out and tries to revive him, only for the police to conduct a raid, which leads Ashkan, in trying to escape, to fall from a window and to be hospitalized, perhaps to die.

Persian Cats takes advantage of the lightweight cameras used to make it in order to produce a singularly handheld and documentary-like aesthetic. We see long tracking shots that take us into, through and out of locations in Tehran, and which help to situate the film in a palpably real world. This is in particular prominent when the camera shakes as it follows Negar, Ashkan and Nader through dark alleys and/or corridors, either on foot or on Nader's motorbike in search of other musicians and spaces where they can rehearse, record or perform. The grain of the image, particularly in low light conditions, together with the

mobility of the camera and the ability to take it to what seem to be genuine locations, combine to suggest an unmistakably digital aesthetic.

We shall return to the theme of underground film-making in the next chapter, but here the unauthorized nature of the film is reflected in the unauthorized, illegal events that we see taking place. While many viewers might consider playing music in a band to be innocuous, *Persian Cats* is not just an underground film, but it is also about underground music, largely emphasizing, though not confined to, musicians who embrace western music styles that are outlawed in Iran. Indeed, we learn that both Nader and Ashkan have recently been to prison for their music, while other bands that they encounter constantly fear that someone will report them if they play too loud. The 'underground' nature of the film is even given literal visualization by the goings-underground of Negar, Ashkan and Nader as they see local music producer Babak (Babak Mirzakhani) in his underground studio, as they search for visas and passports via local forger Mash David (actor not specified), and as they prepare for their own gig towards the film's end (although various of the groups that they encounter perform not underground, but in a pigsty on a farm – the noxious air of which makes one of the band members ill; in a sealed rooftop shack, where the power constantly seems to be cut; several storeys up a building still under construction; and, when Nader demonstrates his own musical talent with his band Darkub, in an open field).

In some senses, the long tracking shots in which we follow Negar and Ashkan underground – especially the first time they visit Mash David and walk through a courtyard and then a loud workshop before coming to his 'office' up a small ladder – bring to mind the famous sequence from Martin Scorsese's *Goodfellas* (USA, 1990), when Henry (Ray Liotta) takes Karen (Lorraine Bracco) into the Copacabana nightclub via the kitchen. There Scorsese and director of photography Michael Ballhaus create an unbroken, five-minute sequence shot in which we see how Henry has, thanks to the power that he has gained via his mafia existence, equally gained access to spaces that might otherwise have been closed to him. In *Persian Cats*, meanwhile, this sequence, perhaps significantly broken into two shots rather than being a single tracking shot, ironically conveys the need for Negar and Ashkan to exist underground, in the shadows, as it were – the cut demonstrating that while they would wish to have access and power like Henry, they in fact do not. Scorsese's is a cinematic avowal of economic power as mobility (even if criminal), while Ghobadi's is a defiant demonstration of a desire for power that in fact belies a complete lack thereof, and which is therefore somehow 'non-cinematic'.

If the comparison to *Goodfellas* seems far-fetched, it is nonetheless supported by the fact that *Persian Cats* is deeply self-conscious as a film. *Persian Cats* opens with director Ghobadi himself singing in Babak's basement studio, as the latter discusses with a female singer about how Ghobadi sings to console himself as a result of the fact that his last film is being sold on the streets and that he cannot get a permit to make a new film (in real life, Ghobadi had spent two years trying to make a film called *60 Seconds About Us*, for which he never received a permit).[20] Not only does the presence of Ghobadi and a discussion of his own career blur the boundary between fiction and documentary, a blurring that continues as non-professional actors, with the exception of Hamed Behdad as Nader, play versions of themselves throughout the film, but it also self-consciously references the likely way in which an unauthorized film like *Persian Cats* will circulate: on the streets, via illegal pirate copies. Indeed, Nader is, among other things, a DVD pirate, and we often see him peddling DVDs to the likes of Mash David (who comically moans that he does not want romantic comedies, only action films). Nader's pet birds are called Monica Bellucci, Scarlett O'Hara and Rhett Butler (the latter two apparently are big fans of Bollywood), while Al Pacino, Nicolas Cage and Marlon Brando are all name-dropped in the film, with Nader even comparing himself to the latter in the build-up to his own musical performance, especially the Brando of *The Wild One* (Laslo Benedek, USA, 1953), since they are both motorbike-riding mavericks.

After Ashkan and Negar see indy rock band the Yellow Dogs in the rooftop shack, Ashkan receives a call saying that Nader has been arrested. We cut to Ashkan arriving at a courthouse where through an ajar door, he spies Nader flagrantly lying to an unseen judge about how the 1,800 DVDs found in his apartment are his own, and that, among other things, he has boycotted American films since the United States imposed a trade embargo on Iran. Arguably such self-conscious references seek to heighten the appeal of *Persian Cats* to western audiences; but they also suggest not only the familiarity of Iranians with western culture (as also featured via the music references – posters of the Beatles, songs with English lyrics, a T-shirt for the Strokes, discussions about Sigur Rós), but they also help to highlight how far Ghobadi is from such films and cinematic figures. The film's unhappy ending perhaps helps to convey this, in that Ashkan and Negar do not leave Tehran (Ashkan might die in hospital; Negar, in what might be a dream shot, throws herself backwards from the roof of a tower block), and so whatever dreams they have of being able to perform their music (in the West or otherwise) are stifled. Indeed, the film features numerous

musical sections filmed and edited in the style of music video montages. These montages clearly interrupt the film's narrative, such that these interruptions almost become the story. It is significant that these interruptions take on the form of a non-cinematic genre, namely the music video montage, since if the interruptions 'become' the film, then cinema is replaced by the non-cinematic. More important, though, is that even these music video montages are themselves interrupted, in that we barely get to hear a song through to completion. While the film embraces the non-cinematic if it is not allowed properly to be cinema (neither film-maker nor musicians have authorization to perform), it also is still stifled almost at every turn.

In addition to these interruptions, many of the music sequences feature brief sections of black leader in between the music video montages of contemporary Tehran. These are especially noticeable during the performance of 'Ekhtelaaf' by Iranian rapper Hichkas (whose real name is Soroush Lashkari), during which we see shots of contemporary Tehran, its architecture and people on the streets (often seen from above – as if mimicking some sort of state surveillance system). The moments of black leader continue as Hichkas raps about how in Tehran 'everything entices your soul, but you realise that you're not human, just trash', during which the video comes increasingly to represent the overlooked members of Iranian society (a task that in Ghobadi's other films takes on an ethnic dimension as he seeks to represent the country's minority Kurdish population, to which he belongs).[21] If this is a film that in part gives voice to Iran/Tehran's 'inhuman trash', then formally it seems to do so by embracing the equally 'non-cinematic' aesthetics of not just the music video, but also digital video (DV). 'Today it's money first', raps Hichkas, 'and God second', suggesting that Iran truly has become a capitalist society.[22] Furthermore, the black leader makes clear the impossibility of representing that which is non-cinematic, in the sense of under- or unrepresented, and which perhaps also is unrepresentable because unlikely to make a profitable film. Numerous faces of poor and homeless Tehranis (many of whom look directly at Ghobadi's camera, even if only briefly) feature in the film, especially during the song 'Tonight', sung by Babak's blues band, Mirza. The musicians – including two sisters (Mahsa and Marjam Vahdat) who sing and play the daf – a traditional Persian, or more specifically Kurdish, frame drum that is also the subject of Ghobadi's short film, *Daf* (Iran, 2003) – all seem to operate in darkness, struggling to reach the light that is cinema. Rather than simply bring to light these people, though, Ghobadi in some senses embraces darkness, asking us to contemplate that darkness itself. This becomes

clear during the party from which Ashkan tries to rescue Nader at the film's end: a 'strobe' effect is created by having black lines flash across the frame, always obscuring partially our view. What was temporal (instants of black leader) has become spatial (strips of black within the frame), suggesting the invasion of darkness everywhere. The film ends with a song in which Negar sings about waiting for the sun to come out again: the characters embrace darkness as an act of defiance, but nonetheless they are still deprived of light.

Being singular plural

At one point we see Negar reading Kafka's *Metamorphosis* in her room at night. The bureaucratic hoops through which she must go to get her visa are Kafka-esque, as is the pervasive paranoia that characterizes the film. The judge during Nader's trial remains invisible, while at one point Negar and Ashkan get pulled over by a traffic cop on a motorbike, who sadistically takes from them a dog. The cop also remains out of frame, an authoritarian and repressive voice. Both instances remind us of Kafka's parable, told by a priest to lead character K in *The Trial*,[23] where a man waits and waits to see the law but is never given access to it. *Persian Cats* also denies us access to the law, which here simply operates as it wishes, with no explanation or justification. In other words, Kafka seems to be a looming influence on *No One Knows About Persian Cats*. Perhaps wanting to be an indy singer in contemporary Iran feels like waking up as the *ungeheures Ungeziefer*, or monstrous vermin, that main character Gregor Samsa becomes in Kafka's *Metamorphosis*.[24]

The references to Kafka clearly lend to *Persian Cats* a 'minor' quality, with the insistent paranoia – that the police are coming – meaning that the action of the film constantly pauses, or 'stutters' – as per the discussion of minor cinema via Gilles Deleuze and Félix Guattari in the last chapter. This stuttering is conveyed by the constant interruptions of the music video form into the film's narrative (and which themselves are cut short), as well as by the numerous jump cuts that the film features, thereby depriving it of the smoothness of movement that we might otherwise expect from an authorized film. The creation of a stuttering 'minor cinema', therefore, helps us to think what Deleuze terms 'a people to come' as Ashkan and Negar are not accorded the rights of people, since they have been 'hidden [forced underground] by the mechanisms of power and the system of majority'.[25] Furthermore, this Iranian underground film functions to

sow the seeds for a new 'cinema to come', a cinema that, since it does not yet exist, is presently non-cinema.

In the last chapter, I progressed from the minor to the multitude via the work of Paolo Virno, Giorgio Agamben and Michael Hardt and Antonio Negri. Here, however, I would like to engage with the work of Jean-Luc Nancy in order to introduce a concept linked to multitude, namely 'withness'. For Nancy puts forward a conception of existence whereby we, as humans, are *with* each other in the world. To paraphrase his argument, the whole notion of being a subject (which he defines as 'being') is predicated upon the fact that there are others in the world. Otherness traditionally might be understood as the division between subject and object. However, by opening ourselves up to others, by challenging the boundary between subject and object, we can work our way towards what Nancy terms 'Being'. Being involves *both* the singular (being a subject) and the plural (others), such that there is, as the title of his essay suggests, Being Singular *and* Plural. Because we are always with others, and can only be so for our 'being' or status as a subject to exist, we can reach a point of thinking in which there is no exclusion of others from self, but only a greater sense of Being: we are *with* others, not against them, and we are with the world, never separated from it.[26]

We can relate Nancy's work to the concept of the multitude as elaborated in the last chapter. For, if I argued that there is an ontological multitude (we are many), which must be politically realized, then in order to do this we must transcend subjective being and begin to recognize, and think in terms of, that which we are already, namely Being Singular Plural. Being Singular Plural thus connects to multitude, in particular as Antonio Negri understands it in relation to art. For Negri, art involves labour not just on the part of the maker, but also on the part of the viewer, with art thus involving change/becoming, or action.[27] Art is 'multitude in action', Negri suggests; or it is a realization of Being Singular Plural in that it fundamentally involves withness and change, with my singular self becoming other, that is pluralizing, just as the multitude itself is both singular (a multitude) and plural (composed of difference).

For Negri, the labour that is art does not involve exploitation, but instead is 'liberated labour, and the value produced is, consequently, an exceedance of being freely produced'.[28] In relation to cinema, all cinema involves labour, both by the makers and by the viewers, but in mainstream cinema that labour is hidden; the viewer is not encouraged to acknowledge what cognitive and 'immaterial' labour they are doing, while the techniques of mainstream cinema seek to hide the work that has gone into its making (with many viewers being blind, for

example, to edits made in mainstream films).[29] 'Non-cinema', then, makes its own labour clear (in *Persian Cats* this is shaky cameras, a lack of continuity edits, some perhaps amateurish acting), as well as that of the viewer, thereby making it art for the very reason that in working/labouring, we contribute to the ongoing creation of the world and ourselves, and we sense/realize our multitudinous being singular plural. I should like to extend this theorization of withness further by looking at Kiarostami's work and proposing the concept of the diegetic spectator. However, first I shall briefly consider his films *Ten* and *Five Dedicated to Ozu* as examples of multitudinous non-cinema.

Kiarostami's non-cinema

Vered Maimon has suggested that Kiarostami's is a minor cinema, with digital technology playing a key role in this process. For Maimon, Kiarostami's

> shift from film to video [in films like *Ten*] is inseparable from the invention of forms of collaboration. The use of digital cameras enables [Kiarostami] ... to create films with limited crews, no sets, no professional actors and no scripts. Most importantly, it enables [Kiarostami] ... to work outside the pressure of production time and budget. Video enables time: time for observation and for the slow unfolding of stories which evolve out of the process of working together and which are then restaged.[30]

Maimon interestingly seems to be getting at something akin to what I am terming non-cinema: a cinema outside of institutional cinema (free from production time and budget). However, where Maimon sees the minor as helping us to understand Kiarostami, I would also suggest that we see in the work of Kiarostami a multitudinous (non-)cinema

For example, *Ten* tells the story of a female taxi driver in Tehran (Mania Akbari), who in ten separate sequences drives various people around the city, including several times her son, Amin (Amin Maher), with whom she argues as he criticizes her for not being a good mother. The film is shot uniquely from two angles: a view of the driver and a view of her passengers, both taken from the car's dashboard using DV cameras. The driver and her passengers discuss various of the gender inequalities that plague Iran, including the notion that a woman must lie and say that she has been beaten if she wants to get a divorce and so on. One of the driver's passengers is a prostitute (Roya Arabshahi)

who, shrouded in darkness, explains that life only boils down to sex and trade, while another has recently split with her partner and has shaved her head, which she reveals to us by taking off her chador towards the film's end.

Shi'a women should be veiled at all times in Iranian cinema, since the cinema screen is deemed to be a public space (meaning that many Iranian films are unrealistic as women wear their chador in domestic settings, something that would not necessarily happen in real life).[31] Furthermore, Hamid Naficy explains how Iranian film-makers should not incorporate into their films close-ups of women or exchanged gazes, meaning that women are often shown in long or medium shots.[32] Finally, women are not supposed to be touched by men in Iranian cinema, with Gönül Dönmez-Colin reporting that

> women's issues have always been controversial in post-revolutionary Iranian cinema and served as a border not to be crossed. However, in the last few years ... an unprecedented number of films dealing with the plight of women in a patriarchal society have reached occidental audiences, a phenomenon often attributed to the moderate regime of President Khatami.[33]

It likely was as a result of Khatami's 'moderate regime' that *Ten* was not censored at the time of its release.[34] Nonetheless, the film depicts a woman not wearing her veil. At another key instant, the driver reaches over to the woman with the shaved head and wipes a tear from her eye. Although this moment does not involve cross-gender touching, Kiarostami nonetheless presents a community of women who, without political subjectivity (they do not have rights equal to those of men, and thus are not fully political subjects), constitute a multitudinous ontology. Furthermore, that this takes place within the context of a world in which life is trade, and in which women specifically are commodities, the emotional as opposed to transactional nature of their relationship suggests an anti-capitalist femininity. Perhaps it is no surprise that the driver barely charges anyone for giving them a ride; the driver's concern, as well perhaps as the concern of *Ten* itself, is not commercial, but different to that. If state-authorized cinema and capitalism go hand in hand, then *Ten* becomes a kind of non-cinema, which is enabled by digital technologies, the 1s and 0s of which are echoed in the film's title (10).

Kiarostami's subsequent *Five Dedicated to Ozu* consists of five long takes in which we see a piece of driftwood dancing on some waves, a seaside pier with passers-by, a beach, a badling of ducks wandering back and forth along a beach, and then a pond at night shot in almost complete darkness. Filmed with a static

camera, each sequence lasts ten minutes or more in order to give to the film its 74-minute running time. While elsewhere I have argued that the film is as complex as any Hollywood puzzle film, I wish here simply to state that *Five* also is an example of non-cinema for various reasons.[35] First, it is a film that, owing to the length of some of its takes (longer than the 10 minutes of an analogue film reel), could only have been made thanks to digital technology. Secondly, in showing a more or less black screen during the final sequence, the film also is engaging with the limits of representation and is showing to us that very uncinematic thing, darkness itself. Thirdly, *Five* is a film that not only has played theatrically, but it is also as much a gallery installation as it is a film for the cinema, as its run at the Modern Museum of Art (MoMA) in New York in 2007 makes clear. Finally, and most importantly for the present consideration of multitude, the film seems to want to extend the conception of multitude from beyond the human, as we perhaps get in *Ten*, and to include the natural world, including the sea, ducks, beaches and other humans. That is, in inviting us to contemplate such things at such great length, the film perhaps wants us to consider the important constituent role that animals and even non-living things play in our reality. Multitude here, then, extends into a post-human realm where all matter, including that which we cannot see/which is in darkness, forms part of our ontology – and it is up to us politically to realize the importance of the world with which we live in helping to sustain us (potentially the film also recalls the Islamic concept of *Vahdat dar Kesrat*, or Unity in Diversity, which does not give up belief in a 'single truth,' but which also 'recognises diversity and difference').[36] This lends to the film an ecological edge, in that it seemingly encourages us to respect and not to mistreat our environment. Furthermore, by divesting itself of narrative, and even of human figures as protagonists, *Five* clearly puts itself forward as a non-commercial film, in effect rendering it a non-film, or non-cinematic.

Ta'ziyeh and the diegetic spectator

If multitude is about inclusion, then are 'multitudinous' films simply those that depict multitudes – or can a film not just depict but also involve a sense of 'withness'? And if so, how does it do this? As we see the driver reach over and touch her passenger in *Ten*, suggesting not separation in different frames but connection and continuity, so, too, might non-cinema also involve/include/ touch its spectators.

Phenomenological approaches to film, as typified by the likes of Vivian Sobchack and Laura U. Marks, investigate the way in which cinema touches us as much as we detachedly look at and hear it.[37] Cognitive film studies, meanwhile, which arose as a reaction against the 1970s *Screen* theory of the film spectator as being passive to the (patriarchal) ideological messages of mainstream movies, suggests that viewers of mainstream films are in fact very active, often filling in narrative and other gaps that the film leaves.[38] Both are useful frameworks for film studies. However, while we do think and feel while watching films, I wish more radically to suggest the spectator's involvement in a film by suggesting that she and the film are mutually dependent, or what playfully I shall term *diegetic*. Diegesis generally refers to the world that we see in a film – and I should clarify that I am not proposing that the spectator is part of the fictional world that a film may present to us. However, from the Greek δια-/*dia-*, meaning through, across and/or one with another, and ἥγησις/*hḗgēsis*, meaning to lead, the term diegesis conveys a sense of 'leading one another through'. This is not a question of being an active or passive spectator (the terms that characterized both *Screen* and early cognitive film theory). Nor is it a question of highlighting our affective and/or emotional responses to film over our intellectual response (one of the achievements of phenomenological film theory). Rather, it is about our relationship with the film, the witness that exists between film and spectator, and which we can understand through the traditional Persian theatrical form of *ta'ziyeh*.

As Khatereh Sheibani and Nacim Pak-Shiraz both explain, *ta'ziyeh* is a form of 'popular passion play that portrays the events and atrocities experienced by Imam Hussein and his followers in Karbala in 61 Hijty (AD680)'.[39] More important than the content, however, is the form of *ta'ziyeh*: characters wear stock costumes, typically involving black and white, and the acting is done in a very self-conscious style. Indeed, 'audience participation is one of the main features of *ta'ziyeh*', with viewers being reminded constantly that these are actors playing roles, not only because each actor is referred to as a *khan*, or 'reader', but also through 'various distancing techniques such as speaking to the audience'.[40] Although it elicits powerful emotions, 'as a non-realistic theatrical mode, *ta'ziyeh* is not interpreted as reality' and the viewer is regularly reminded 'that this is a performed event'.[41]

In another example of Kiarostami working in a non-cinematic context, he staged in May 2005 an installation called *A Look to Tazieh* at the Victoria and Albert Museum in London. As Pak-Shiraz says,

the installation consisted of three screens – two large screens on each side of a relatively smaller [sic] television screen in the middle. The television screen played scenes of *ta'ziyeh* performed in a remote rural area. The two large screens on either side showed spectators watching *ta'ziyeh*.[42]

A Look to Tazieh undoubtedly demonstrates that Kiarostami is influenced by this tradition. What is more, Pak-Shiraz demonstrates how *ta'ziyeh* has elements in common with the distancing techniques, or *Verfremdungseffekt*, endorsed by Bertolt Brecht – even if Kiarostami claims that *ta'ziyeh*, and not Brecht, has the greater influence on him.[43] In showing on two screens the audience in *A Look to Tazieh*, Kiarostami makes clear that the 'idiosyncrasies of *ta'ziyeh* are not limited to its performative aspects, but, more importantly, lie in the effect it has on its spectators'.[44] In other words, the film works on the spectator as the spectator is actively involved with the film.

If traditionally we believe the diegeses of cinema to be separate from the viewer (and thus that the viewer is a detached observer, even if according to the cognitive paradigm doing active cognitive work, and even if according to the phenomenological paradigm being touched by the film), then non-cinema paradoxically demonstrates that the viewer is inseparable from that diegesis, hence the term 'diegetic spectator'.

We shall develop this concept further via a consideration of entanglement in the next chapter. However, I should like to end this one with a brief analysis of *Shirin*, which is a crystallization of the diegetic spectator. During *Shirin*'s 92-minute duration, we see a series of women who themselves watch a film the sound from which we hear, but which we never see. The film that the women watch tells the story of Shirin and Khosrow, lovers whose union seems forever to be deferred as a result of circumstance and whimsical desire. As we see the women react to the film, so are we reminded of the work and involvement that spectators do while watching movies. Furthermore, by having these spectators fill the visual diegesis of *Shirin*, the film encourages us to reflect on our own diegetic involvement with films (not least because we have to imagine what it is that the women are seeing).

Esfandiary quotes Thomas Elsaesser in suggesting that 'a cinema that does not have the assent and love of a popular audience and cannot reach an international public may not have much of a future as cinema'.[45] He then quotes Paul Willemen in arguing that 'what may be cinema in one country may not be so in another' (Esfandiary 2012: 54). In Iran, audiences and critics alike occasionally accuse some works of not meriting the name cinema (e.g. Mohsen

Makhmalbaf's earliest films were considered not to be cinema because they were not technically good enough).[46] However, the lack of assent and love from a wide audience might productively help us to conceptualize non-cinema and why it is an important, if not vital, aspect of the cinematic landscape. Regularly going against the state, shot digitally, circulating often via informal economies, and with a non-commercial/anti-capitalist and multitudinous ethos and aesthetic, Iranian non-cinema not only demonstrates the multitude that is, but it also helps us to understand that we are part of that multitude, that we are with the films that we watch, with each other and with the world. The digital aesthetic, the use of darkness onscreen, the involvement of the spectator: all of these stand in contrast to cinema as we typically understand it, and thus help to constitute a non-cinema.

Although featuring numerous female Iranian film stars and Juliette Binoche (all of whose black costumes constitute a nod to *ta'ziyeh*?), *Shirin* operates only on the margins of the commercial circuits where films like *Cease Fire* flourish. Indeed, that so many stars could not make a commercial success of Kiarostami's film makes clear his ambivalent relationship with cinema, while also demonstrating that film-makers can perhaps never be free from commercial considerations (with the festival and art house circuit simply operating at a different economy of scale to mainstream blockbusters, be they from Iran, Hollywood or elsewhere). *Shirin* therefore clearly is still 'cinema' in the sense of being a product of a capitalist film-making system. Nonetheless, the film draws out the non-cinematic elements that are in all films giving us hope that cinema will not always be a commercial enterprise geared solely towards making profit. Furthermore, while nuanced, the MCIG demonstrates how Iranian cinema is a cinema that suffers censorship, and outside or on the margins of which underground and transnational art productions try to operate. This in turn points to the commercial censorship that exists throughout the globe when it comes to cinema; Iran may have the MCIG, but many film industries simply will not back films that run the risk of not making any money. As a result, film-makers find it ever harder to gain backing and recognition for their work, perhaps especially within a national context. Perhaps it is by actively embracing non-cinema, by rejecting the nation and by being a transnational film-maker working abroad (who has small audiences in a wide number of places, as opposed to a small audience only in one place) that film-making can create for itself a future.

Having considered how Abbas Kiarostami's *Shirin* draws on the Persian theatrical tradition of *ta'ziyeh* in order to suggest a 'withness' between film and

spectator, I shall now extend this concept of withness further by considering how underground film-making in contemporary China is a cinema defined not only by withness, but also by entanglement.

Notes

1 Hamid Naficy, 'Islamizing Film Culture in Iran: A Post-Khatami Update', in *The New Iranian Cinema: Politics, Representation and Identity*, ed. Richard Tapper (London: I. B. Tauris, 2002), 29.
2 Hamid Naficy, *A Social History of Iranian Cinema, Volume 4: The Globalizing Era, 1984-2010* (Durham, NC: Duke University Press, 2012), 176.
3 Naficy, *A Social History of Iranian Cinema, Volume 4*, 410.
4 Hamid Dabashi, *Iran: A People Interrupted* (London: The New Press, 2002), 125. See also William Brown, '*Cease Fire*: Rethinking Iranian Cinema through its Mainstream', *Third Text*, 25:3 (2011), 335–41, and William Brown, 'There are as Many Paths to the Time-Image as There are Films in the World: Deleuze and *The Lizard*', in *Deleuze and Film*, ed. David Martin-Jones and William Brown (Edinburgh: Edinburgh University Press, 2012), 88–103.
5 Dabashi, *Iran*, 125.
6 See Saeed Zeydabadi-Nejad, *The Politics of Iranian Cinema: Film and Society in the Islamic Republic* (London: Routledge, 2009), 90; and Nacim Pak-Shiraz, *Shi'i Islam in Iranian Cinema: Religion and Spirituality in Film* (London: IB Tauris, 2011), 81.
7 Roxane Varzi, *Warring Souls: Youth, Media, and Martyrdom in Post-Revolution Iran* (Durham, NC: Duke University Press, 2006), 237.
8 For a discussion of Kiarostami's unpopularity in Iran, see Pak-Shiraz, *Shi'i Islam in Iranian Cinema*, 173; for issues of exoticization, see Mehrnaz Saeed-Vafa and Jonathan Rosenbaum, *Abbas Kiarostami* (Chicago: University of Illinois Press, 2003); for considerations of Iranian 'festival' cinema, see Zeydabadi-Nejad, *The Politics of Iranian Cinema*, 152.
9 See Shahab Esfandiary, *Iranian Cinema and Globalization: National, Transnational and Islamic Dimensions* (Bristol: Intellect, 2012), 83–112; and Hamid Dabashi, 'Dead Certainties: The Early Makhmalbaf', *The New Iranian Cinema*, ed. Tapper, 133–5.
10 See Khatereh Sheibani, *The Poetics of Iranian Cinema: Aesthetics, Modernity and Film after the Revolution* (London: I. B. Tauris, 2011), 96; and Pak Shiraz, *Shi'i Islam in Iranian Cinema*, 42.
11 For an historical overview of *gharbzadegi*, see Brad Hanson, 'The "Westoxication" of Iran: Depictions and Reactions of Behrangi, al-e Ahmad, and Shariati', *International Journal of Middle East Studies*, 15:1 (1983), 1–23.

12 Esfandiary, *Iranian Cinema and Globalization*, 5.
13 Ibid., 8.
14 See Christopher Gow, *From Iran to Hollywood and Some Place In-Between: Reframing Post-Revolutionary Iranian Cinema* (London: I. B. Tauris, 2011), 15; and Esfandiary, *Iranian Cinema and Globalization*, 139.
15 Esfandiary, *Iranian Cinema and Globalization*, 175.
16 See Beller, *The Cinematic Mode of Production*.
17 See Brown, 'Cease Fire.' The way in which *film farsi* elements are present in films like *The Lizard* and *Cease Fire* might also help to clarify the increasingly capitalist dimensions of contemporary Iranian popular cinema. The *film farsi* tradition was popular before the Islamic Revolution, and it was characterized by sympathy towards the western/capitalist technologies and values that the revolution sought to overthrow. For more, see Pedram Partovi, 'Martyrdom and the "Good Life" in the Iranian Cinema of Sacred Defense', *Comparative Studies of South Asia, Africa and the Middle East*, 28:3 (2008), 515.
18 Montana Woyczuk, 'In Sight: An Interview with Bahman Ghobadi', *BOMB – Artists in Conversation*, 21 April 2010, http://bombmagazine.org/article/4375/. Accessed 10 February 2015.
19 See Ramon Lobato, *Shadow Economies of Cinema: Mapping Informal Film Distribution* (London: British Film Institute, 2012); and 'Subcinema: Theorising Marginal Film Distribution,' *Limina: A Journal of Historical and Cultural Studies*, 13 (2007), 113–20.
20 See Frenetic Films, *No One Knows About Persian Cats* Press Kit (2010). http://www.frenetic.ch/films/724/pro/NO%20ONE%20KNOWS-presskit-de.pdf. Accessed 12 February 2015.
21 Ghobadi's feature films *Zamani barayé masti asbha/A Time for Drunken Horses* (Iran, 2000), *Gomgashtei dar Aragh/Marooned in Iraq* (Iran, 2002) and *Niwemang/Half Moon* (Austria/France/Iran/Iraq, 2006) all feature predominantly Kurdish characters living near Iran's border with Iraq – as the title of *Marooned in Iraq* suggests. Both that film and *Half Moon* are also about Kurdish musicians. Finally, *Fasle kargadan/Rhino Season* (Iran/Iraq/Turkey, 2012) is about Kurdish-Iranian poet Sahel (played by Behrouz Vossoughi), who was imprisoned in Iran for thirty years. The film tells the story of Sahel seeking his wife, Mina, who presumes that he is dead. Given that Nader has named a bird after her in *Persian Cats*, it is perhaps ironic that Mina is played by Monica Bellucci.
22 Some reviewers of *Persian Cats* suggest that the characters are 'desperate to escape Iran' (see Peter Bradshaw, '*No One Knows About Persian Cats*', *The Guardian*, 25 March 2010, http://www.theguardian.com/film/2010/mar/25/no-one-knows-about-persian-cats.). While Bradshaw's view is in part true, it should also be emphasized that the film does not depict Iranians who hate their country. Hichkas,

for example, refuses to leave Iran because he feels that Tehran is where he needs to be, while the heavy metal group, Nikaein, have stopped singing in English in order better to reach their Iranian audience. Negar asserts quite forcefully in discussion with new band members Koori (Koorosh Mirzaei), from the Yellow Dogs, and Arash (Arash Farazmand), a founding member of the Free Keys and who latterly joined the Yellow Dogs, that she wants to return to Iran if they get to go abroad to tour – meaning that it is only Ashkan who seemingly wants to flee definitively. Furthermore, the film clearly features Darkub and the Vahdat sisters' more traditional Persian performances (Darkub's replete with backing dancers wielding knives in balletic fashion). In other words, *Persian Cats* is not about Iran seeking simply to become a 'western' nation (as Hichkas's rejection of the money-first, God-second principle might suggest), but about Iranians being free to use western styles and to adapt them to their own situation.

23 Kafka, Franz (2008), *The Trial* (trans. John Williams), London: Wordsworth.
24 See Franz Kafka, *The Trial*, trans. John Williams (London: Wordsworth, 2008), and *Metamorphosis and Other Stories*, trans. Michael Hofmann (London: Penguin, 2007).
25 Deleuze, *Cinema 2*, 209.
26 Nancy, *Being Singular Plural*, 1–99.
27 Antonio Negri, *Art and Multitude*, trans. Ed Emery (Cambridge: Polity Press, 2012), xii.
28 Negri, *Art and Multitude*, 48.
29 For a consideration of 'immaterial labour', see Maurizio Lazzarato, 'Immaterial Labour' (trans. Paul Colilli and Ed Emory), in *Radical Thought in Italy: A Potential Politics*, ed. Paolo Virno and Michael Hardt (Minneapolis: University of Minnesota Press, 2006), 132–46. For more on 'edit blindness', see Tim J. Smith and John M. Henderson, 'Edit Blindness: The Relationship between Attention and Global Change Blindness in Dynamic Scenes', *Journal of Eye Movement Research*, 2:2 (2008), 1–17. For a consideration of what edit blindness means for film theory, see William Brown, 'Resisting the Psycho-Logic of Intensified Continuity', *Projections: The Journal for Movies and Mind*, 5:1 (2011), 69–86.
30 Vered Maimon, 'Beyond Representation: Abbas Kiarostami's and Pedro Costa's Minor Cinema', *Third Text*, 26:3 (2012), 334.
31 See Azadeh Farahmand, 'Perspectives on Recent (International Acclaim for) Iranian Cinema', *The New Iranian Cinema*, ed. Tapper, 99.
32 Hamid Naficy, 'Veiled Vision/Powerful Presences: Women in Post-revolutionary Iranian Cinema', in *Life and Art: The New Iranian Cinema*, ed. Rose Issa and Sheila Whitaker (London: British Film Institute, 1999), 57.
33 Gönül Dönmez-Colin, *Women, Islam and Cinema* (London: Reaktion, 2004), 163.
34 See Geoff Andrew, 'Drive, he said', *Sight & Sound*, October 2002, 31.

35 See William Brown, 'Complexity and Simplicity in *Inception* and *Five Dedicated to Ozu*', in *Hollywood Puzzle Films*, ed. Warren Buckland (London: AFI/Routledge, 2014), 125–40.
36 See Esfandiary, *Iranian Cinema and Globalization*, 120.
37 See Vivian Sobchack, *The Address of the Eye: A Phenomenology of Film Experience* (Princeton: Princeton University Press, 1992), and Laura U. Marks, *The Skin of the Film: Intercultural Cinema, Embodiment and the Senses* (Durham, NC: Duke University Press, 2000).
38 For early examples of cognitive film theory, see David Bordwell, *Narration in the Fiction Film* (London: Routledge, 1985), and Edward Branigan, *Narrative Comprehension and Film* (London: Routledge, 1992).
39 Sheibani, *The Poetics of Iranian Cinema*, 157.
40 Pak-Shiraz, *Shi'i Islam in Iranian Cinema*, 138–9 and 147.
41 Sheibani, *The Poetics of Iranian Cinema*, 164–5.
42 Pak-Shiraz, *Shi'i Islam in Iranian Cinema*, 159.
43 Ibid.
44 Ibid., 164.
45 Esfandiary, *Iranian Cinema and Globalization*, 51.
46 See Esfandiary, *Iranian Cinema and Globalization*, 71–2.

3

Digital Entanglement and the Blurring of Fiction and Documentary in China

If you want to know the taste of a pear, you must change the pear by eating it yourself. If you want to know the theory and methods of revolution, you must take part in revolution. All genuine knowledge originates in direct experience.[1]

Like Iran, China also has a thriving underground film scene that came into being largely on account of the production possibilities offered by DV cameras and non-linear editing software. The aim of this chapter is not simply to provide further examples of digital underground film-making – except this time from a different national context. Instead, the aim here is to enrich our understanding of what I am terming non-cinema by developing the concept of entanglement and looking at how this applies to several documentaries, including Wu Wenguang's *Fuck Cinema* (China, 2005) and the politically engaged, activist film work of Ai Weiwei. The chapter will then end with brief considerations of two further films, both set in or around Shanghai, namely Andrew Y-S. Cheng's *Wo men hai pa/Shanghai Panic* (China, 2002) and Lou Ye's *Suzhou he/Suzhou River* (Germany/China/France, 2000). The aim here will be to demonstrate that entanglement does not just apply to documentary but also to fiction films. Furthermore, a brief analysis of the role of electric light in *Suzhou River* will help us to progress to the next chapter, which focuses on the role that darkness plays in contemporary Philippine film-making. Before discussing how the above films are instances of non-cinema, however, I shall briefly introduce China's contemporary film-making scene.

China with capitalistic characteristics?

As per Iran, the association of China with capitalism might seem strange, since the Communist Party of China has ruled the nation since 1949. Indeed, Arif

Dirlik reminds us that 'any representation of China's present historical path as capitalist is not just descriptive but also prescriptive: in other words, such representation is intended to shape the reality that it innocently pretends to describe'.[2] Dirlik proceeds to argue that 'Chinese socialism, always strongly nationalistic in its orientation, appears today more transparently than ever as a disposable instrument in "the search for wealth and power"'.[3] Dirlik's suggestion is that it is incorrect to say that China is capitalist, since really China uses capitalism for its own ends, with the nation remaining the chief concept:

> The capitalist world order into which China seeks admission to realise its national goals demands as the price of admission the reshaping of Chinese society in its own image. China, on the other hand, seeks to admit capitalism into its socialism only on condition that capitalism serve, rather than subvert, national autonomy and a national self-image grounded in the history of the socialist revolution.[4]

It is because the concept of the nation remains central to Chinese identity that socialism/communism was introduced in the first place: 'Socialism in China was not a response to an internal capitalism, but to a capitalism that was introduced from the outside, and appeared from the beginning as an alien force.'[5]

If for Dirlik the nation is above capitalism in the hierarchy of influences and ideas, China has nonetheless re-accorded capitalism some space over the last thirty-five years following the coming to power of Deng Xiaoping in 1979. Writing in 1989 (the year of the Tiananmen Square massacre), Dirlik concludes his essay on a speculative note: 'To call this [contemporary Chinese] condition "capitalism" would be fatuous because it remains to be seen what the incorporation of socialist systems into the capitalist world order will imply for capitalism itself.'[6] However, I might take issue with Dirlik and suggest that China's socialist systems have effected little change since 1989, during which period the grip of neoliberal economic policy has strengthened almost universally. Furthermore, China has emerged as a, if not the, major world economic power. The correction to make, then, is not that China's socialism might affect capitalism, but that China is capitalist in spite of socialism. In a later essay, Dirlik, writing with Zhang Xudong, seems to acknowledge as much:

> While Chinese leaders like to speak of 'using capitalism to develop socialism', the current reality may well be the reverse: the use of 'socialism' to achieve capitalist development. Under the guise of socialism, China has become a source of cheap labour, with far-reaching implications for economics globally.[7]

In other words, Dirlik and Zhang seem to suggest that in China socialism has been a tool for keeping wages to a minimum, while continuing to pursue economic expansion, thereby elevating surplus value via the growing disparity between how much it costs to produce a product and how much one sells it for. I wish to suggest that China is capitalist for the simple reason, articulated in previous chapters, that the nation is a capitalist concept. In the post-Tiananmen environment, during which time China has opened itself up to globalized capital, the revelation of China not as a newcomer to capital but as an alacritous forerunner in the capitalist world system has only become clearer. As Lu Tonglin puts it: 'In the process of globalisation, China has become a frenzied mixture of Communist ideology and global capitalism, and it is global capitalism that seems to work best for the Communist state.'[8] And: 'In 2002 ... mainland China alone attracted 75 per cent of foreign investments in Asia. The inflow of money has brought with it the value system of global capitalism, which has gradually become an important part of official discourse in China.'[9] In short, China is today a capitalist power par excellence.

Quoting Dai Jinhua, Yomi Braester uses the double meaning of the term *guangchang*, meaning both 'square' and 'mall', to sum up 'the transition from the period molded by Tiananmen Square to the time defined by the new consumer culture', in that China is now arguably a giant mall, the incident in Tiananmen Square having perhaps signalled the last moment when citizens collectively protested against the privatization of the Chinese economy.[10] With the rise of consumer culture, there has been a concomitant rise in what Li Yang describes as the worship of money, with David H. Fleming quoting Deng Xiaoping in saying: 'To make money is glorious!'[11]

And yet, this worship of consumer culture and money, as driven by advertising and mainstream/official cinema (about which more shortly) comes at a cost. Lin Xiaoping, for example, reminds us that 'in this new era of Chinese capitalism there is no longer any job security for the working class, not to mention their children who have no education or professional skills'.[12] Quoting Maurice Meisner, Lin continues: 'In less than two decades, China has been transformed from a relatively egalitarian society to one where the gap between the wealthy and impoverished is among the widest and most visible in the world.'[13]

This gap between the rich and the poor is a consistent theme of contemporary Chinese independent cinema. For this reason, the independent work of Jia Zhangke, perhaps the best known Chinese director to have emerged since the 1990s, is interpreted 'not only as resistance to censorship in China

but more importantly as resistance to Americanization in the Chinese film industry'.[14] Indeed, Jia's documentaries depict a 'society completely converted to consumerism', while fiction films like *Xiao Wu/Pick Pocket* (China/Hong Kong, 1997) and *Tian zhu ding/A Touch of Sin* (China/Japan/France, 2013) show how many people are disenfranchised and cast into poverty and other forms of exclusion, including prison, while a few others become rich via corruption that is legitimized by a positive (and deceptive) media image.[15]

The digital generation

There are various terms used to describe contemporary Chinese film-making outside of mainstream 'official' cinema. Fleming notes, for example, that Sixth Generation, underground, independent, urban and d-generation are all terms commonly used, to which list we might add the 'forsaken generation' and the 'iGeneration'.[16] Meanwhile, the fact that much of this work is in a documentary mode means that we also should acknowledge China's New Documentary Movement (*xin jilupian yundong*), in which Wu Wenguang plays a key role.

There are various competing claims regarding what these terms mean and how well they apply or not to the contemporary digital film-making scene, with Li Yang, director of *Mang Jing/Blind Shaft* (China/Germany/Hong Kong, 2003), even claiming that there is no Sixth Generation at all.[17] Bearing in mind, then, that various film-makers like Jia Zhangke, Zhang Yuan and Wang Xiaoshuai have gradually moved from underground to overground film-making, the 1990s and 2000s nonetheless saw an underground boom, with directors working independently/outside of the state-run film system, and thus working without permits, engaging with the contemporary world and taking on taboo subjects, including 'prostitution, incest, child abuse, drug addiction, decadent life styles, and extreme poverty'.[18] As Zhang Yingjin puts it: 'Many Chinese independent directors make it their mission to articulate the voices of the weak.'[19] That is, they depict those excluded by consumer society, as per the brief description of Jia's work above.

Digital technology has played – and continues to play – a key role in this movement/moment. For, the ready availability of digital film-making equipment means not only that it is easier to make a film, but also that one can make the kind of film that normally would not get made, that is, for which one would not get a permit. In other words, digital technology leads in some senses logically towards

underground film-making on taboo topics. While such films, by virtue of being underground/shot without permit, do not get screened in official locations in China, there are nonetheless numerous (digitally enabled) film clubs and 'subcinematic' modes of distribution that give life to them domestically.[20] What is more, many underground Chinese films achieve international recognition via the film festival and art house circuits. Familiar issues of self-orientalism/self-exoticization for the purposes of foreign audiences thus arise, together with a lack of local popularity signifying potential inauthenticity.[21] However, while such issues must be borne in mind (as per the Afghan and Iranian contexts already discussed), my focus here is on the role that DV has played in contemporary Chinese film-making, regardless of whether it cleanly belongs to one of the above groups.

Wu Wenguang and Jia Zhangke have both been evangelical with regard to the possibilities opened up by DV. Jia has written about how the 'age of the amateur will return' as a result of DV, by which he means that the technology will allow for alternative modes of expressing oneself and which will stand in stark contrast to the increasing homogenization of the world that takes place as a result of globalization.[22] Wu, meanwhile, speaks at length of the freedom that DV allows him:

> I have become an individual with a DV camera, filming anything I please that happens to wander into my line of vision, whether or not it has anything to do with the 'theme' of the film. I then edit the material however I like, rather than having to follow a careful plan. Finally, when the film is finished, I have a few screenings and discussions in universities, bars, film festivals, libraries, and so on. Because this approach does not cost much money, I do not really care whether or not it turns a profit. Maybe this is what is meant by 'individual filmmaking'. The result of this way of doing things is that I have moved farther and farther away from 'professionalism', television, film festival competitions and awards. But I have moved closer and closer to myself, my own inner world. As a result I have finally come to understand that 'independent filmmaking' and 'free cinema' are not just so-called standpoints that can be realized through 'manifestos' or 'position statements', or the attitude that you can live off one or two films for the rest of your life. Given the 'investigative' and commercial imperatives that filmmakers are surrounded by these days, if I brag emptily about my relationship to documentaries, I can only speak about DV. I should also say that I want to thank DV; it was DV that saved me, that allowed me to maintain a kind of personal relationship to documentary making, and made it far more than just an identity.[23]

If Wu 'can only speak about DV' as opposed to speaking about documentary and/or fiction, we get the sense that DV film-making transcends the distinction between the two, producing a form that is unique and, as I shall argue, 'non-cinema'. This 'non-cinema' aspect of the digital is grasped by the non-theatrical exhibition that Wu mentions, and about how it stands in contrast to professional (i.e. capitalist) film-making, with globalized capital also being evoked/challenged in Jia's praise for the amateur, or what Dai Jinhua might term the turn towards individual film-making.[24]

If DV transcends the fiction/documentary binarism, then what is the result? Wu speaks about the influence of Frederick Wiseman and Ogawa Shinsuke on his documentary film-making practice, a fact echoed by Ying Qian, who adds that making observational documentaries, *à la* Wiseman and Ogawa, was 'politically safer' in the aftermath of the Tiananmen Square massacre in 1989 than making interventionist and/or activist films.[25] However, while the early films of the so-called New Documentary Movement contained Wiseman-esque observational aspects, these quickly went by the wayside via the introduction of DV, which brought about significantly more interventionist films. As Zhang Yingjin puts it, 'Self-erasure disappeared from Chinese documentary practice (after an initial rejection of voice-of-God narration and a turn to observation and interviews), so now "the personal" returns, especially in DV film-making.'[26] Thus, whether or not it really constitutes a movement, much documentary work in China is marked by a combination of digital aesthetics (handheld DV cameras) and a 'personal' style that sees the film-maker not just present in their films, but intervening in various ways, with the films themselves functioning as interventions.[27] In other words, the films do not observe reality in a detached, 'scientific' (Wiseman-esque) fashion; they take part in reality's becoming, thus suggesting/reflecting what I shall call entanglement. We shall see imminently how this is manifested in *Fuck Cinema* and the films of Ai Weiwei. First, however, let us make a philosophical detour into the concept of entanglement, and how, like the concepts of multitude and being singular plural, it relates to/modifies our understanding of objectivity.

Entangled realism

In *Meeting the Universe Halfway: Quantum Physics and the Entanglement of Matter and Meaning*, Karen Barad draws upon the work of physicist Niels Bohr in

order to demonstrate that *we are a part of that nature that we seek to understand.*[28] Bohr had, like other physicists of his era, come to understand that photons, among other microscopic phenomena, simultaneously have momentum and a position. This is a commonly accepted truth today, but it nonetheless bears some explanation. Humans cannot measure both the position and the momentum of a particle at the same time. The more accurately we discover its position (where it is), the less we can know about its momentum (in which direction it is going), and, conversely, the more we know about where it is going, the less we are able to pin down where it is (since it is going somewhere). Furthermore, determining whether microscopic phenomena such as electrons behave in a particle- or in a wave-like manner is equally difficult, for the more the phenomenon behaves like a particle (particles are 'localised objects that occupy a given location at each moment in time' – not dissimilar to having a position), the less it is like a wave (waves 'are not even properly entities but rather disturbances in some medium or field' – a bit like having momentum).[29] Again, the converse is also true: the more something is like a wave, the less it is like a particle.

What is also well known is that in both cases – determining whether a phenomenon is a particle or a wave, or determining the position and/or momentum of a phenomenon – the apparatus used to measure one or the other also determines the behaviour of the phenomenon being measured. That is, if we seek to measure a phenomenon's position, the phenomenon takes on the qualities of a particle and has a position (it becomes localized/occupies a given location). Similarly, if we seek to measure a phenomenon's momentum, it becomes more wave-like, having not only a direction, but also becoming a disturbance in a medium or field (much like a wave moves in a circle outwards when we drop a stone into some calm water; the wave has a direction – it moves outwards – but the ripples are also better understood as disturbances in the medium of the water).

For a physicist like Werner Heisenberg, our inability to know both the position and momentum of a phenomenon, as well as our inability to know whether a phenomenon is a particle or a wave, demonstrates that humans cannot know such things and thus always will be uncertain in their observations. It is for this reason that Heisenberg uses the term 'uncertainty principle' to describe our ability to understand the world. What is important to understand here, though, is not that humans cannot accurately measure the world and thus will be uncertain about it, but that for Heisenberg there remains a world beyond the human and which could be measured 'objectively' were it not for our own existence. For

Bohr, however, it is not that we cannot know the position and momentum of a phenomenon (we are not forever uncertain), but rather that phenomena 'do not *have* determinate values of position and momentum simultaneously'.[30] In Heisenberg's reckoning, humans necessarily disturb that which they are trying to measure, as if there were an objective measurement to be made beyond the human. For Bohr, meanwhile, the disturbance created by the human takes centre stage and becomes the nature of reality. To use Bohr's own term, humans and the world that surrounds them are complementary. They are inextricably entangled.

The ramifications of Bohr's discovery are not to be underestimated, and Barad eloquently explains them over the course of her monograph. What Bohr's conception of reality completely undermines is 'the belief that the world is populated with individual things with their own independent sets of determinate properties'.[31] Instead we are part of a universe in which there is only entanglement and complementarity, and which is always only ever coming into existence, or becoming:

> The point is not simply to put the observer or knower back *in* the world (as if the world were a container and we needed merely to acknowledge our situatedness in it) but to understand and take account of the fact that we too are part of the world's differential becoming. And furthermore, the point is not merely that knowledge practices have material consequences but that *practices of knowing are specific material engagements that participate in (re)configuring the world*. Which practices we enact matter – in both senses of the word. Making knowledge is not simply about making facts but about making worlds, or rather, it is about making specific worldly configurations ... objectivity cannot be about producing undistorted representations from afar; rather, objectivity is about being accountable to the specific materialisations of which we are a part.[32]

Now, we might contend that what happens at the microscopic level does not hold true at the mid- or macro-scales on which humans consider themselves to function. However, as Barad herself points out, 'Quantum mechanics is not a theory that applies only to small objects; rather, quantum mechanics is thought to be the correct theory of nature that applies at all scales.'[33] For this reason, my use of the word phenomena above was deliberate, since the term gets us away from subject–object binarisms and the belief that subject and object are separate, unentangled phenomena that do not affect or complement each other. As Barad explains: 'Phenomena do not merely mark the epistemological inseparability of "observer" and "observed"; rather, *phenomena are the ontological inseparability of intra-acting "agencies." That is, phenomena are ontological entanglements.*'[34]

In relation to cinema, to suggest that film-maker and subject are not separate but entangled, that camera and filmed object are not separate but entangled, and that even film viewer and film are not separate but entangled, all of which are the logical consequence of Barad's argument, is to make three bold assertions. For cinema has on the whole been understood to fit into a history of objectivity and of detached, unobserved observation – a history that is perhaps the very history of capitalism itself. The film-maker tries to avoid making her presence felt as the camera objectively captures what is before it. And as we then watch these images unobserved, in some respects, this myth of objective detachment can be seen in popular interpretations of how the analogue photographic and cinematic image is indexical, as well as in related theories of how objectivity is linked to realism. That is, as a direct imprint of light from the world on to a polyester strip covered with molecules of silver halide, the photographic and cinematic image both have a 'direct' link with reality, thus supposedly guaranteeing the veracity of what is in the image (photographs as evidence of existence). In turn, a history of cinematic realism has developed in which the presence of the film-maker is not revealed, be that a fiction or a documentary film. Now, clearly there are long-standing debates on precisely these topics. But entanglement leads us towards a different understanding of cinema in which the camera helps to constitute what is before it, just as what is before it helps to constitute the camera, with the (now-diegetic) viewer also playing a constitutive role in the film.

This is only made clearer in the digital age. The digital image supposedly does not have the same indexical relationship with reality that the analogue image does. Concomitantly, the digital image is not dressed up with the same theories of objectivity and realism as the analogue image. Indeed, when Lev Manovich suggests that in the digital era the kino-eye has become the kino-brush, the painterly brush suggests entangled involvement and interpretation as opposed to the detached observation of the eye.[35] However, if entanglement is an apt concept to describe reality, then the kino-brush that is the digital camera is not less realistic than the supposedly objective images of the analogue kino-eye, but in fact more realistic. For, realism lies not in objectivity, but in entanglement; realism lies not in detachedly observing the world, but in being part of the process of that world's becoming; to paraphrase Karl Marx, realism lies not in interpreting the world, but in changing it.

Realism is in some senses, then, a question of visible labour, and of participation in the world – or what in previous chapters we have called the multitude, especially as it relates to art; realism is, in some senses, activism. To

pick up a camera and to record is, in Barad's language, to acknowledge that one is part of the world, that one is becoming as the world is becoming, and that one is, therefore, involved in the creation of new worlds. Realism, in an entangled universe, consists not of detachment, but of quite its opposite, of self-conscious entanglement – an entanglement of film-maker, camera and subject/object, such that a clear distinction between these can no longer easily be drawn, and, in a way that reinforces the notion of the diegetic spectator posited in the last chapter, an entanglement of film and viewer.

Objectivity and ethics

Lorraine Daston and Peter Galison have traced the history of objectivity to the middle of the nineteenth century, arguing that photography and cinematography played a major role in the rise of the concept.[36] Aligned to this objective truth is a concomitant sense that man is not entangled with but separate from the world, and thus able impartially to look upon it/to be objective. This ability to look objectively upon the world is also, then, linked to the increased grip that science and technology have over the world. In short, the scientific ability to measure also depends on the invention of objectivity, since, as opposed to Bohr's concept of complementarity, science believes that objective measurement is possible. Furthermore, as objectivity comes to the fore with industrialization, I would add that measurement is also central to capitalism, in that it involves the regulation of space and time as measurable entities, while value also emerges as measurable specifically via the medium of money. Under such a matrix of objectivity–technology–measurement–science–capital, even human bodies can be objectively measured according to work performance; as a result, the human can be treated as an object, a process that in turn gives rise to exploitation and slavery as the other person is rendered a mere object and so need not be treated as a subject.

A sense of objectivity can been seen in André Bazin's foundational theoretical writings about cinema, where the ontology of the photographic image is understood as being based not upon the medium's application as entertainment, but upon its supposedly indexical relationship with reality.[37] If after Daston and Galison cinema plays a role in the rise of objectivity as a concept, however, then it is a circular argument to suggest that cinema is objective: cinema cannot help to create objectivity and yet also be a powerful medium as a result of its essential

objectivity. Indeed, the very concept of being, of a fixed essence (from the Latin *esse*, to be), is itself linked to the concept of objectivity, meaning that Bazin's question ('what *is* cinema?') was always already a question formulated within the matrix of objectivity–science–capital–cinema, and thus a question destined in some respects to find an answer that suited the conditions of its creation (the essence of cinema is the objective recording of reality). In his defence, I do not think that it is cinema's supposed objectivity that Bazin specifically considers to be its essence; for Bazin, cinema connects us to reality more than it detaches us therefrom. Nonetheless, in an entangled universe of becoming, cinema 'is' not. The question to ask, then, is not 'what is cinema?' but what, at any given moment in time, cinema is not – and why. If the ascription to cinema of an essence is also a process of exclusion (cinema is this and not that), then we might also ask not what cinema is, but what cinema can become.

In a universe that is becoming and with which we humans are, like all matter, complementary, we might equally ask ourselves to what extent we are conscious of the exclusions that we make, and thus are in denial of our complementary relationship with the universe. In other words, we might ask ourselves to what extent we choose, then, consciously to take part in the world. Raised to be detached observers of the world, and thus in the terminology of *Screen* theory passive to it, even if actively interpreting the world and the films within it that we see (the basic argument of cognitive film theory), humans believe that they do not affect the world that surrounds them and that their actions do not have real consequences (the world is 'excluded'). As humans under capital treat other humans as objects (the biopolitical exclusion of slaves, women, the insane, the ill and so on), so do they treat the world at large as an object, from which they are detached. To exclude the world and various others in this way is to choose not to believe/to take part in the world, since such an attitude is in denial of the fact that those other humans and the world more generally participate in our reality.

Conversely, to choose to believe and consciously to take part in the world, to take on responsibility for being entangled with the world, chimes with Gilles Deleuze's famous argument that ethics is based upon choosing to choose to believe in the world. For Deleuze, no longer believing in the world is a 'modern fact' and it has led humans to feel disconnected not just from the world, but from their own lives, such that we do not believe in love or death, and such that we view the world as a bad movie.[38] Cinema, then, is part of the process of detaching humans from the world. 'Only belief in the world can reconnect man to what he sees and hears. The cinema must film not the world, but belief in this world,

our only link', Deleuze continues.[39] In light of the foregoing argument, we might interpret this famous passage from Deleuze anew: cinema is not objective and so there is no point simply filming the world as if from an objective perspective; instead, to film 'belief' in this world is to film one's participation in the world. Ethical film-making, then, is not necessarily film-making that pursues one specific morality, but it is film-making that self-consciously and conscientiously engages with the world. Drawing on Emmanuel Lévinas, Barad argues that 'we (but not only "we humans") are always already responsible to the others with whom or which we are entangled', suggesting that film-making and film viewing, as much as simply being in and with the world, are ethical acts.[40]

If, however, cinema has been railroaded by capital in the name of so-called objectivity, then perhaps 'ethical' film-making is not to create cinema, but to create non-cinema. Much as the question to ask at all moments is what cinema is not and why (what exclusions are taking place and for what reason?), so might ethical film-making involve not a presumption about cinema's essence as an objective recording of reality, but an ongoing and permanent investigation into the limits of cinema, what is being excluded from it and why. Always to be asking why about cinema's exclusions is, as mentioned, to create an activist, political cinema – of the sort exemplified in China by Wu Wenguang and Ai Weiwei – as we shall see presently.

Fuck Cinema

Wu's film has three strands. First, it follows Wang Zhutian, an aspiring film-maker who is hawking around Beijing a handwritten script based upon his life experiences, and who is getting nowhere in the Chinese film industry. Secondly, the film sees young Chinese women, who often have travelled to Beijing in search of fame, auditioning for a role as a hostess (or, more exactly, a prostitute) in a would-be film the full details of which we never discover. Finally, the film also follows Xiao Wu, a bootlegger and vendor of pirated DVDs, as he goes about his business in Beijing.

Wu apparently stumbled across the topic of *Fuck Cinema* 'unexpectedly, rather than deliberately selecting it'.[41] Nonetheless, while the film has three seemingly disparate strands that do not at any point overlap, it clearly is a thematically unified and deliberately constructed film 'about those who have the power to produce images and those who do not'.[42] Wang has seemingly sacrificed various

things in order to pursue his dream of becoming a film-maker in Beijing, including ties with his family; the women undergo the often disturbing probing of the camera and those unseen figures who audition them in order to get a part; and Xiao Wu peddles all manner of bootleg films around town to all manner of clients in order to get by. Crucially, the film is also about Wu Wenguang. For while the film is about Wang's and the female auditionees' powerlessness to produce/be in images, and while also seemingly about Xiao Wu's power in reproducing images illegally, the film is also about – and interrogates – Wu's own process of producing images.

The film opens with Wang in close-up reading a letter, seemingly from his brother, imploring him to contact his mother, who is worried sick about him. In a move that blurs the fiction/documentary border, Wu does not make clear whether Wang is reading a real letter, or a letter from his script. More than this, though, since Wang's script is in part about his own experiences, it is also unclear how much or to what extent he distinguishes his real life from his would-be film. All that we know is that Wang pursues his dream of becoming a famous film-maker with Quixotic determination, as if cinema alone would validate him as real.

Wang's thrall towards cinema is also clear when, through Wu's engineering, Wang meets Sixth Generation film-maker Zhang Yuan in a hotel room where Zhang is editing a movie (and smoking and eating). Wang all but throws himself upon Zhang (having ditched a meeting with a lesser known producer, Wang Peng, in order to see him), promising that he would do anything to work with him, including simply being an extra. This prompts some contempt and mockery from Zhang, who asks Wang about the worst things that he has done (Wang discusses having begged), while questioning Wang's sincerity as a would-be film-maker since neither is Wang conscientious enough to have a pager (an essential tool if one wants to get into the film industry), nor does he go by his real name (Wang confesses during this scene that his real name is Ling Zongnan). In other words, we see Wang humiliated in this and other scenes as he pursues his goal to become a film-maker, and as he pursues his and Wu's shared goal of making a film about his life.

I am careful to suggest that the goal of making *Fuck Cinema* is Wu's and Wang's combined. For, in a scene towards the end of the film that has garnered much attention, Wang reads to Wu a letter in which he outlines how Wu has exploited him. Wang recognizes that Wu has given him access to Zhang Yuan and other film-makers, such as Ning Ying, but where for Wang this is about his

life, Wang sees Wu as making the film simply 'for fun'. Wang protests that he goes hungry and homeless (he lives on the roof of a student accommodation block), and that he is slicing off his own flesh (metaphorically speaking) for the entertainment of Wu (and by extension those who will watch his film). Here, an ethical dilemma clearly is posed: should Wu be filming Wang? The answer is not clear-cut: Wu might well bring to Wang some visibility that will help him with his career, and Wang clearly has been complicit in allowing this to happen, although the more it appears that Wu's presence does not really help Wang, the more resentful Wang becomes (it is not that Wu does not help Wang; it is that Wu's help does not have the results that Wang wishes for). In other words, Wu is not to blame entirely, but Wang's despair is heightened by the fact that Wu seems to risk far less than Wang in filming him. And yet, the fact that Wu includes within his film a sequence in which Wang upbraids him for his cruelty suggests not simply that Wu is cruel (which is of course Wang's perspective), but that Wu also acknowledges and takes on board his role in Wang's unhappiness. This is the ethical dimension of *Fuck Cinema*; it is not that Wu has simply exploited Wang in a voyeuristic and detached manner; instead, he is entangled with him, and while he is flawed and may well have helped in making Wang unhappy, the film also demonstrates that Wang himself is and has been complicit in this process. We might dream of a utopian world in which we never do harm to anyone or anything else; but in the real world, entanglement perhaps by definition leads to both joy and hurt through our involvement with others – and, to use Deleuze's terms, rather than deny love and death because separate from the world, we should choose to take part in the world both for better and for worse.

Wu's entanglement in *Fuck Cinema* is made clear in the film's second scene when Wu accompanies Wang to a meeting with a producer called Yang. Yang reads and offers both encouraging and negative feedback on Wang's script, but seems far more enthusiastic about having renowned film-maker Wu Wenguang in his midst. Yang directly addresses Wu, even offering him a cigarette, which the latter obligingly takes: Wu's hand appears onscreen and takes the cigarette, thereby making clear that Wu, although often silent, is far from being a detached observer.

Nonetheless, during the auditions of the actresses, the women rarely pay attention to the camera, even though it moves very close to them at times, and even though it lingers on the shape of their breasts and waist as they are asked to stand in profile. While the women are auditioning to play a hostess/prostitute, the film's probing of their bodies would seem to suggest that they already are 'prostitutes' in the sense that the camera deliberately treats them like objects to be

looked at – and they willingly comply with the wishes of the camera/film-maker by not reacting or interacting with the camera that approaches and scrutinizes them. Again, we might consider this to be unethical/cruel film-making, not least because here we do not have input from the actresses about their feelings towards the camera; the camera objectifies them and their subjectivity is not given room for appearance. And yet, if we bear in mind the title of the film, *Fuck Cinema*, we get a sense not that Wu's film is trying to 'fuck' these women as a camera might in a commercial film, but that the film is railing against the institution of cinema, which is an institution that objectifies – but which crucially also 'naturalizes' objectification such that these women (as well as Wang) allow themselves to be objectified in the name of a cinema that will validate their existence if they can appear onscreen (which is their shared ambition).

Much as the 'most ancient profession in the world' (a phrase coined by Rudyard Kipling in his 1888 story, 'On the City Wall') involves the objectification of women, so is cinema in the business of objectifying humans by putting them onscreen. Much as the capitalist logic of business has been naturalized such that we think it normal to consider other humans and the world as a whole as objects to be manipulated/exploited, rather than beings with whom we interact, so has cinema naturalized the desire to become cinematic, to become an object, since in becoming cinematic/an object, we attain a reality that under neoliberalism garners more attention (to use the language of Jonathan Beller) and thus is validated as more real, as more economically useful, than that which does not attract attention.

Wu's objectifying treatment of the hopeful women of *Fuck Cinema* might make viewers uncomfortable, but it also points to the capitalist logic that underlies both their objectification (which Wu's camerawork precisely *works* to make so obvious) and their complicity in that objectification. It is not that we should judge negatively these women for unthinkingly allowing their objectification even when they condemn prostitution/the objectification of women (as per a number of the interviewed women when asked to comment on the topic). Equally, it is not that Wu's film is without flaws (one wonders that the film might have benefitted from some interviews with the women under different circumstances, such that we get a better sense of them, as we do Wang and Xiao Wu). Rather, the film definitely raises issues regarding objectification both as a process and the role that cinema plays in naturalizing that process, with becoming cinematic, paradoxically, being the key to becoming recognized as a real subject, much as becoming cinematic validates a nation as real on the world stage. The paradox lies in the fact that becoming a subject in fact involves

becoming an object – something objectively to be looked at, rather than someone with whom we interact in an entangled fashion. If cinema in this way induces wishing to become an object for the purposes of becoming a subject in the capitalist world, with the poor like Wang coming from the country and leading an abject, bare life of homelessness and poverty in a fruitless and unlikely bid to become real, then fuck cinema indeed.

Xiao Wu, the central figure of the film's third strand, arguably does 'fuck cinema' via his bootlegging. However, Wu's film equally presents Xiao Wu as a victim of the cinematic logic of capital/the capitalist logic of cinema. As Pang Laikwan makes clear,

> the so-called tactics in piracy are neither humanistic nor democratic in nature but are carried out in their own system of exploitation, through which some gangster tycoons earn astronomical profits. Most frighteningly, piracy demonstrates the potent penetrating power of Capital, which is now gained by the pirates instead of the Hollywood studios, to break down boundaries blocking Capital's expansion.[43]

In other words, piracy serves capital/cinema by expanding its reach into places that legitimate business practices cannot penetrate. Xiao Wu (in some senses not unlike his homonym from Jia Zhangke's film of the same name) is hardly raking it in via his illegal business practices. As Pang says, 'Piracy by no means creates a self-empowerment of the people', and Xiao Wu, like Wang and the women at the auditions, seems to be beholden to a capitalist image culture in which illegal DVD piracy is his best hope of making a living.[44]

The final shot of *Fuck Cinema* sees Xiao Wu cycling away from Wu who tries to keep up with him on foot. As Xiao Wu disappears from the scene, we get a sense in which he, like Wang and the women, pursues cinema, but that they also are not cinematic enough for cinema (perhaps precisely because they pursue it too readily). Perhaps real empowerment can come, if not necessarily in this film, from *not* wishing to become cinematic (not wishing to become an object to be looked at, a spectacle), and instead by moving away from the camera, by becoming non-cinema.

Fuck Cinema and/as non-cinema

Zhang Yingjin argues that art, politics, capital and marginality constitute the four axes of contemporary Chinese cinema, but that 'all four players now

revolve around the market'.[45] Given the dominance of the market at all times in contemporary Chinese film production, marginality has become an 'ineffective player', meaning that the other three axes dominate.[46] Nonetheless, in a later text, Zhang suggests that 'marginality constitutes a set of new tactics that permit independent Chinese filmmakers to open up new spaces for tackling social issues, exploring individual subjectivities, and envisioning different futures'.[47] To embrace the margins – something that Wu and various other contemporary Chinese film-makers do – is, then, to embrace a form of cinema that stands in contrast to the market, and which I argue constitutes a form of non-cinema.

The rise of DV has led to *minzhuhua*, or the democratization of image production; Ying Qian similarly surveys the evolution of a people's, activist cinema; and Valerie Jaffee charts the growing interest in amateur art (*yeyu yishu*).[48] This cinema is not professional and it is not the cinema of which Wang Zhutian dreams, as Wu 'steadfastly refuses to work with either "the system" in China or overseas corporate players such as the television stations. Instead he maintains a very low-budget production system and shows his films at independent venues, such as cafés, bars, and universities in China, and at film festivals and museums overseas'.[49] While Wu's cinema does, or did, get taken up at festivals as an example of international art cinema, his resolution to avoid commercial concerns at as many steps as possible signals his desire to function outwith the professional, official and capitalist system of cinema in China – and perhaps further afield. Wang Qi points out how Wu had made an earlier, 'nice' version of *Fuck Cinema* called *I Love Cinema*, which was 90 minutes long and fit for broadcasting – but Wu was unhappy with the cut and so gave Wang Zhutian a more prominent role in the film, such that it now runs at just under three hours.[50] Similarly, Matthew David Johnson and Bérénice Reynaud both point out how Wu saw DV as a way to do away with professional cinema.[51] And as Wu moved from observation to participation, so has he moved into not making films at all, having completed only one film, *Zhi Liao/Treatment* (China, 2010) since *Fuck Cinema*.[52]

In *Jiang Hu: Life on the Road* (China, 1999), Wu follows around on tour a group of performing farmers. In the film, Wu famously

> becomes one with his subjects, and they become one with him. He cooks for them and they eat what he cooks, incorporating it into their bodies as they come on- and offstage from their performance. At the same time as he hands food around, Wu also hands his camera around, and the subjects become the filmmakers and the filmmaker becomes the subject.[53]

In giving the camera to others, Wu extends the logic of producing non-cinema, by not making the films himself. This logic is manifested in his *China Village Self-Governance Film Project: Villagers' Documentary Films* (China, 2005), in which he gets villagers to make their own movies, thereby 'exporting' the DV aesthetic that he had previously found in his personal work.[54] Wang Qi also notes how in Wu's *Dress/Video* project (1997) he incorporates the audience into the film, thus 'revealing the three sides surrounding the production and reception of a documentary – the subject, the film-maker, and the audience – as integral components of one media construct'.[55] In other words, Wu not only deliberately seeks to work outside of cinema-capital, but he also seeks to incorporate, or make clear the diegetic role of, the spectator in (some of) his work.

If Wu Wenguang asks us to 'fuck cinema', thus moving into the terrain of non-cinema via his entanglement with his subjects (and in a move away from the objective nature of cinema as capital), the artist Ai Weiwei similarly uses what I shall term non-cinema in order to function as a film activist. In this process he is not alone, but I shall look at various of his films, especially *Lao ma ti hua/Disturbing the Peace* (China, 2009), in order to demonstrate how this is so.

Ai Weiwei and non-cinema

Ai Weiwei is an internationally recognized artist. He helped to design the Bird's Nest, the National Stadium that was the architectural centrepiece of the 2008 Beijing Olympics; he conceived the famous *Sunflower Seeds* piece, consisting of millions of handcrafted porcelain sunflower seeds, which occupied the Turbine Hall of London's Tate Modern between October 2010 and May 2011; in 2011 he was arrested by the Chinese police for 81 days, supposedly for 'economic crimes', but also in part for the subversive nature of some of his works; the next year he was the subject of a high-profile documentary, *Ai Weiwei: Never Sorry* (Alison Klayman, USA, 2012); and he had a major retrospective at London's Royal Academy of Arts in late 2015. He is also a prolific user of social media, especially as a blogger, on Twitter and on Instagram. It is remarkable, then, that his work as a (prolific) documentary film-maker has received such little attention.

The Internet Movie Database (IMDb) credits Ai with having directed nine films since 2004, five of which have been made since the Beijing Olympics in 2008, including *Tong hua/Fairytale* (China, 2008), *Disturbing the Peace* (China, 2009), *Fei chang bao qian/One Recluse* (China, 2010), *Fei chang yi han/So Sorry*

(China, 2012), and *Eerduosi 100/Ordos 100* (China, 2012). Some of these films have received limited distribution in the West, particularly at the International Film Festival Rotterdam, which routinely plays his work, and which hosts several of his films in their entirety on its YouTube channel. Ai also has his own YouTube channel that hosts these and various other film works – from the very brief (*Love is in my Blood* is a 35-second film featuring Ai's middle finger with a drop of blood on it) to the very long (*One Recluse* is a three-hour documentary about Yang Jia, a young man who killed six police officers in the Zhabei district of Shanghai in 2008). What is more, Ai's YouTube channel includes numerous works that are not listed on the IMDb (e.g. *The Crab House* is an hour-long film about a studio that Ai and colleagues built as part of the 2010 Shanghai World Expo). Not all films on Ai's YouTube channel have English subtitles, though many do; furthermore, films on his YouTube channel are not necessarily uploaded in chronological order (*So Sorry*, nominally completed in 2012, was uploaded – without English subtitles – before *Disturbing the Peace*, a film from 2009, with the subtitled version of *So Sorry* being uploaded a month after *Disturbing the Peace*).

In other words, outside of Rotterdam and a handful of other festivals, and beyond the few gallery-based screenings that Ai's films sometimes have (e.g. the five feature films mentioned above were screened at Clark House in Mumbai in 2012), online seems to be the easiest place to watch Ai's films.[56] However, with the IMDb only listing some of his films, and with Rotterdam only hosting a few others, it seems hard to tell which of Ai's films we could classify as 'official' – and which not. In other words, to encounter Ai Weiwei's film work is to be confronted by a wealth of material (at the time of writing, Ai has 48 videos online, totalling roughly 40 hours of footage), the 'status' of which – is it a film or not? – remains ambiguous. This instability regarding how 'official' his films are, together with the online nature of Ai's work, moves his work superficially in the direction of non-cinema, as does Ai's questionable status as director of the films (Ai is often as much the subject of as he is a camera-wielding presence within his films, with artist and long-time mentee Zhao Zhao perhaps equally responsible as director; like Andy Warhol, to whom he has been compared, Ai operates via a 'factory' system of collaborative production). However, it is upon the aesthetic and activist dimensions of Ai's work that I should here like to concentrate.

Like the films of Wu and others, Ai's films have a visually chaotic and 'amateur' style. The low grade of the DV images alone signifies a not-quite-cinematic quality, a sense that is intensified when put into combination with

entire sequences that are, for example, shot without any lighting. There are two such moments in *Disturbing the Peace*, in which Ai seeks to release from detainment one of his employees while visiting Chengdu to support Sichuan earthquake activist Tan Zuoren, who with Ai is trying to investigate the cheap 'tofu construction' of architecture that collapsed too easily during the 2008 earthquake there, thus leading to unnecessary deaths. The first moment takes place when the police break into the room in which Ai and various of his colleagues are staying at 3.00 am in Chengdu, the second when a camera is smuggled, while recording, into a police station inside a bag. During the former we only hear the sounds of an altercation between Ai, his collaborators and the police, and during the latter we get to study the interior of a holdall for several seconds. Undoubtedly such shots serve to heighten the seeming immediacy and authenticity of the film (or what scholars of Chinese cinema might term their *xianchang*/on-the-spot-ness), but they also might be deemed to lack artistic merit.[57] This is further signalled by extended sequences, the repetitive nature of which might try the patience of many an audience member. In *Disturbing the Peace*, there is a protracted interview, for example, between Ai, his colleagues and two local police officers, Xu Hue and Xu Jie, who seemingly try to dodge without respite the questions that the former are putting to them regarding the detainment of their friend and collaborator Liu Yanping. Furthermore, in *One Recluse*, the film ends with an hour-long talking head interview with Yang Jia's mother several months after his execution has taken place. Although there is editing – via dissolves – both of these sequences nonetheless exhibit a continued 'amateur' aesthetic that runs against the faster pace of mainstream cinema, rendering it, arguably, non-cinematic.

Activist non-cinema against the mainstream

Without wishing to rehearse oft-given histories of the rise of big budget (*dapian*) cinematic spectacles from and in China, it seems apparent that Ai deliberately places his work in opposition to the 'official' mainstream. In *One Recluse*, for example, we briefly see footage from the opening ceremony of the Beijing Olympics in 2008, famously directed by Zhang Yimou. Having arguably been a subversive film-maker earlier in his career (*Ju Dou*, China/Japan, 1990, was, for example, banned in mainland China), Zhang has since become perhaps the archetypal director of films embodying Chinese cinema's dream of 'marching

toward the world' via big budget spectacles to rival Hollywood productions.[58] Given that Yang Jia's (mis)trial was postponed until after the Olympics supposedly in order to avoid any scandal during that time, there is a sense here in which not only does Ai want to show the 'real' China that the country does not officially want to be made visible, but this visual nod to the Olympics also gives us a sense in which Ai is constructing his film as somehow 'authentic' and/ or 'true' in opposition to the big budget spectacle of Zhang's opening ceremony and his cinema more generally – even if, ironically, Ai was also involved in the design of the Bird's Nest.

Furthermore, *Disturbing the Peace* is, as mentioned, about the 2008 Sichuan earthquake, an event that also features in *Tang shan da di zhen/Aftershock* (Feng Xiaogang, China, 2010), which is (loosely speaking) about the rescue of a child in the 1976 Tangshan earthquake, a rescue that culminates in the child's return to China from Canada in 2008 in order to help rescue people from the Sichuan disaster. Feng's flag-waving *dapian* blockbuster toes the party line of an inclusive, helpful government and of citizens embarking on a concerted volunteer rescue operation, even returning from abroad as a result of their commitment to the nation. As such, it is a film that plays the 'main melody' of official Chinese discourse, or is what Ying Xiao terms a 'leitmotif' film.[59] This runs counter to the unofficial story of the earthquake presented in Ai's films (and much of his artwork more generally); rather than a supportive government, Ai shows precisely the lack of government concern in the construction of shoddy architecture, the collapse of which in the earthquake led to the loss of thousands of lives. Ai's non-mainstream films, then, are not only examples of *minjian* (unofficial, folk cinema), but I wish to suggest that they also become 'non-cinematic' when placed alongside the 'official' cinema that Feng puts forward in his film.[60]

Ai Weiwei's are by no means the only activist, 'non-cinematic' films to have been made about the Sichuan earthquake. *Shei sha women de haizi/Who Killed Our Children* (Pan Jianlin, China, 2008) is, for example, about the collapse of school dormitories during the disaster, while Ai Xiaoming has also made several films about the event, including: *Women de wawa/Our Children* (China, 2009), also about the collapse of student dormitories; *Gongmin diaocha/An Investigation by Citizens* (China, 2009), which like *Disturbing the Peace* is about Tan Zuoren, and which uses both Tan's and Ai Xiaoming's footage; *Hua weishenme zheme hong/Why Are the Flowers So Red?* (China, 2010), which, coincidentally enough, covers Ai Weiwei's trip to Sichuan; and *Wangchuan* (China, 2010), which deals with poor construction standards.[61] In an interview, Ai Xiaoming herself suggests

that 'the year 2008 was a very important turning point for "social cinema" and for civil-rights campaigns in China. The Sichuan earthquake in May was a critical event; the documentary wave you [interviewers Chang Tieh-Chih and Ying Qian] describe is in many ways the earthquake's aftershock.'[62] Furthermore, the period is one in which 'the national is structured into China's programme of globalization as Beijing celebrates its spectacular success with the 2008 Olympic Games and Shanghai prepares itself strategically for the 2010 World Exposition, both enterprises blessed with the influx of global capital'.[63] In other words, while DV technology led to the explosion of individual, amateur film-making in the 2000s (with *Fuck Cinema* functioning as our key example), in 2008, there is a shift, such that increasing numbers of people express their entangled nature in contemporary Chinese politics through activist film-making.

As Margherita Viviani argues, '*hao gongmin* is the concept of the "docile good citizen"', which people in the aftermath of the earthquake and against the supposedly unifying celebration of the Olympics reject, 'opting instead for a more independent and active concept of citizenship that (re)claims the right to speak, discuss and intervene directly in the public sphere'.[64] Viviani continues:

> This right to participate in public life is expressed by most of the filmmakers as 'citizen rights' (*gongminquan*), a term that could be considered equal to 'citizenship'. This also implies that people are no longer passive information receivers, but rather active 'citizens' (*gongmin*) involved in a self-generated, bottom-up process of information dissemination.[65]

Rather than receivers of objective information (the cinematic myth of objectivity, which works in the services of capital), viewers are now active, entangled participants, seeking to be part of the becoming of the world. In *Why are the Flowers So Red*, this entanglement even takes on a self-reflexive quality, implying once again the diegetic spectator, as groups of people watch *Disturbing the Peace*, and then discuss the role of the citizen in relation to the state and so on.[66]

Ai himself also seems to suggest an entangled, ethical world view when he says:

> I think that competing with nature is basically a Western idea. As a Chinese, you're always part of your surroundings. Nature can be a man-made or an industrial postmodern society. I believe that you're always part of it and consciously or unconsciously you're in there, trying to build up some kind of relationship, which means that consciousness and awareness will be useful to others. That's our condition.[67]

Ai Xiaoming speaks at length about the influence of Ai Weiwei on her film-making practice, especially his 'direct attitude towards conflict', in which the film-maker neither runs away nor hides the camera, but instead films 'to the end, facing the opponent's camera' (a phenomenon we regularly see in *Disturbing the Peace* as the police film Ai Weiwei and his colleagues, just as they film the police).[68] Both Ai Xiaoming and Ai Weiwei, then, suggest an activist non-cinema of entanglement, in which DV plays a key role in production and DVD and the internet a key role in distribution, exhibition and reception.

Ai's non-cinema becomes even more palpable when we consider that on his YouTube channel he has uploaded *4851* (China, 2009), a 96-minute film that simply lists via a credit scroll the names of all of the students discovered to have perished in the earthquake, and *Remembrance* (China, 2010), a film in which the names of the victims are spoken over a black screen for three and a half hours – before the film then continues with a silent black screen for nearly another four hours. Unwatchable and, arguably, unscreenable, the films suggest the impossibility of cinema to include these people, who have been literally excluded from Chinese society as a result of the poor construction work that led to their death. Ai makes political art that bears little resemblance to official, mainstream cinema, but which instead asks questions about what is included and what is excluded in Chinese cinema and Chinese society alike by embracing a digital, non-cinematic and entangled aesthetic.

Panic on the streets of Shanghai

Thus far, we have looked primarily at two documentary films, *Fuck Cinema* and *Disturbing the Peace*, and the ways in which they foreground entanglement. However, if there is as stated a blurring between fiction and documentary in contemporary Chinese cinema, then it behoves us to end this chapter by looking briefly at two examples of fiction films, both set in Shanghai, and which also blur these boundaries, namely *Shanghai Panic* and *Suzhou River*.

Shanghai Panic tells the story/stories of four disaffected twenty-somethings, Bei (Lei Zhinan), Fifi (Yang Yuting), Casper (He Weiyan) and Kika (Mian Mian). Bei initially believes that he might have AIDS, although once he is confirmed as HIV negative he begins an abortive relationship with his old friend Jie (Zhou Zijie). Bei pimps out Fifi, a prostitute who rips off a policeman (Wang Shiyuan) who at one point had arrested her, before seemingly also starting a relationship

with him. Casper is a lesbian whose girlfriend (Zhou Liang) we occasionally see, although she seems to spend most of her time stoned on a sofa, crying. And Kika is a mother separated from her ex-husband, Coco (Zhao Ke), and who seems to own, or at least has access to, a series of properties across Shanghai. While there is something of a story arc for each character, however, little actually happens beyond the main characters smoking and chatting about life, or going on an early sortie to a nightclub where they take Ephedrine.

Shi Liang argues that while representations of lesbians and homosexuals in contemporary Chinese cinema have begun to take place, 'hooliganism' has been removed from depictions of homosexual behaviour, meaning that homosexuality remains in some respects 'censored'.[69] The hooliganism of which Shi speaks is in part a reference to the 'hooligan' literature that sprang up in the 1980s and 1990s and which had at its centre the author Wang Shuo. Indeed, *Shanghai Panic* is based on *We Are Panic* (a literal translation of the film's Chinese title, *Wo men hai pa*), a novel by Mian Mian (who plays Kika), and who herself is something of a 'hooligan' author (she belongs to a group called the 'Beauty Writers', who according to Sheldon H. Lu have followed in Wang Shuo's wake).[70] However, if Shi feels that hooligan behaviour is missing from Chinese films about homosexuals and lesbians, this seems far from being the case with *Shanghai Panic*: the characters get high, drink and smoke to excess, keep irregular hours, seem not to have stable jobs, casually break the law and lead emotionally chaotic lives.

Furthermore, the form of the film is far more 'hooligan'-like than the restrained and 'smooth' depiction of homosexuality that we see in, say, *Dong gong xi gong/East Palace, West Palace* (Zhang Yuan, China, 1996). The film features seemingly improvised and amateurish performances, and we often catch characters (especially Kika) looking directly into the camera, seemingly to check whether their performance is appropriate. It is not uncommon to see the shadow of the camera on walls and/or characters, while at times the microphone attached to the camera dips into frame, masking a section of the top of the image. Regularly the characters are competing with background noise on the soundtrack, and on several occasions one of the actors' or crew members' mobile phones sets off the sound of signal static that lasts for several seconds. In other words, the film feels like a documentary, especially like those of Wu Wenguang, who is thanked in the film's credits – and even though a fiction, it still conveys a sense of entanglement through the aspects of the film that might typically be thought of as 'bad', and yet which reinforce the way in which the

film's 'hooligan' gay and lesbian characters typically are excluded from Chinese cinema and society more generally.

Drinking in Shanghai

About two-thirds of the way through *Shanghai Panic*, we see a montage of seemingly random elements of Shanghai (a Kodak sign, men in robes walking towards a skyscraper, a dog on a leash – upon whose owner we freeze frame, a monorail theme park ride, a Shanghai skyline at night, and a fence and the sky) accompanied by a voice-over (Kika's), that is delivered as if from nowhere. Kika says:

> Shanghai easily crafts the illusion that it allows you to reach all of your dreams. Actually you can quickly be extinguished, or through rapid assimilation become a ubiquitous part of Shanghai instead of yourself. Because I am Shanghainese, this is my home. I can't leave. The only thing I can do is to keep from falling into this game about reaching dreams.

The inclusion of the Kodak sign is perhaps key here, since it points to the power of images in helping to instil those dreams in the first place, a fact also driven home by Kika's use of a camcorder to look at images of her son and Coco.

A similar depiction of the lower class Shanghai life that cinema typically excludes is Lou Ye's acclaimed *Suzhou River*, which tells the story of a videographer (whom we never see, since we only see the scenes in which he features from the perspective of the camera that he is holding), who falls for a woman, Meimei (Zhou Xun), who works in a bar dressed as a mermaid, and who herself is mistaken by a courier called Mardar (Jia Hongshen) for his old love, Moudan (also played by Zhou Xun). Mardar had betrayed Moudan in order to extort money from her father, a local businessman/crook who, among other things, imports vodka from Poland. Discovering his betrayal, Moudan threw herself into the Suzhou River, setting Mardar in search of her for evermore. Believing Meimei to be Moudan, Mardar blights the videographer/narrator's relationship with her, such that the videographer pays to have Mardar beaten up. Nonetheless, Mardar eventually finds the real Moudan working in a supermarket across town, but the two die in a motorbike accident after getting drunk. The film ends with Meimei leaving the videographer, asking him if he will look for her as Mardar did Moudan.

Suzhou River has been interpreted as a reworking of Alfred Hitchcock's *Vertigo* (USA, 1958), while also being a film that seeks to 'touch that edge, the edge of film, to see how far it could go'.[71] In other words, the film challenges mainstream cinema – as can be seen via a comparison to vodka brand Grey Goose's 2014 'Fly Beyond' advertising campaign, which appeared in cinemas and on other platforms. Directed by Nicolas Winding Refn, the advert depicts a fictional history of Grey Goose, showing the company's founder François Thibault (played by himself) struggling to manage the perceptions of local French people who protest that one cannot make vodka in Cognac. However, the advert tells us, as the brand's popularity grew abroad, so the French came to be happy with the existence of Grey Goose. As we see the brand's popularity growing abroad, we see a woman order a Grey Goose at a skyscraper bar in New York, and a smartly dressed Chinese couple carrying a bottle of Grey Goose in a lift in Shanghai. This latter shot is recognizable as taking place in Shanghai because beyond the couple we see the Oriental Pearl Tower, a famous landmark in the city and, appropriately enough, a tower used for broadcasting television (that is, for disseminating official images of Shanghai specifically and China more generally).

In *Suzhou River*, we also briefly get glimpses of the Oriental Pearl Tower, but rather than being brightly lit as per Refn's advert, it is distant and shrouded in smog. Although the characters drink Zubrowka, vodka nonetheless reflects in Lou's film the aspirational spirit that the Grey Goose advert also seeks to convey. However, where we have a smart and wealthy couple carrying a Grey Goose bottle in a bright and clean Shanghai in the advert (you can achieve your dreams if you drink Grey Goose), in *Suzhou River* we have relatively impoverished youngsters drinking to forget their worries in a dirty city that cares little for them. Like the characters of *Shanghai Panic*, they cannot leave or 'fly beyond' to a more 'cinematic' life, but rather are stuck alongside the Suzhou River, which Gary G. Xu explains is often dubbed the 'armpit of Shanghai' (Xu 2007: 80). The videographer perhaps aspires to a Hitchcockian cinema of objective detachment, but instead gets entangled with the seedy underside of the city.

Practical lighting

'Humans (like other parts of nature) are *of* the world, not *in* the world, and surely not outside of it looking in' – although I personally prefer the spatial metaphor

with rather than *of* in order to convey our entanglement with the universe (we are with the world).[72] Contemporary digital non-cinema in China may have been enabled by the country's contemporary 'postsocialist market economy, which developed rapidly in the 1990s to full complicity with transnational capitalism and which values the idea of entrepreneurship.'[73] Nonetheless, the examples given in this chapter demonstrate how capitalism and the market economy perhaps bring with them the seeds of their own destruction, just as the digital machines that make these films, a product of capitalism par excellence, suggest an entangled, participatory universe that paradoxically runs counter to the cinematic society that produced them.

Writing of Zhang Yimou's *dapian* blockbuster, *Ying xiong/Hero* (China/Hong Kong, 2002), which tells the story of a rebel who renounces his rebel ways for the benefit of allowing the Emperor to unify the Chinese nation, Dai Jinhua writes that it was 'designed for the world market, and … its identification with political power structures was not simply a domestic manoeuvre.'[74] 'What makes Chinese cinema continuously vibrant', continues Dai, 'is certainly not the over-blown, colourful balloons like *Hero*.'[75] With *Fuck Cinema, Disturbing the Peace, Shanghai Panic* and *Suzhou River* as examples, Chinese cinema can indeed be understood as continuously vibrant, precisely through the ongoing exploration not of what cinema is, but of what it is not, and of how both fiction and documentary film-makers can engage with what is not included in the 'official' history of neoliberal and cinematic capital – and why.

Lu Hongwei comments on the role of light and lighting in *Suzhou River* but neither she nor any other scholar comments on how there is a light bulb, often central and foregrounded in the frame, in most shots of the film.[76] It is with a brief reference to the presence of the light bulbs that I should like to end this chapter, thereby creating a link to the next chapter, in which we look at the role of darkness in contemporary Philippine film-making. For, the insistent appearance of the light bulbs in *Suzhou River* brings to our consciousness the work that lighting does in the film, and perhaps the work of light more generally. Lights that are visible within the frame are referred to as 'practicals' by film professionals in the English-speaking world. It is as though Lou deliberately wants to make clear to us the practicalities of film-making by showing the bulbs to us so insistently. By making visible this key but unacknowledged/invisible ingredient of photography and cinematography, namely light itself, Lou paradoxically makes clear the work of cinema, presenting to us an entangled vision of a world equally defined by entanglement. Put differently, if official cinema never makes

work clear (in Refn's advert the couple simply has their bottle of Grey Goose; we do not see or know how they came to possess it), then Lou not only brings the work of his characters into visibility, but also the work involved in making his films: he brings lighting to light where most film-makers keep their lights off-screen. If to keep lighting in darkness is the stuff of cinema, then Lou's film must be non-cinema. It is to the relationship between light and darkness that we turn our attention in the next chapter.

Notes

1 Mao Zedong, *Selected Works Volume 1*, 1937, 299–300.
2 Arif Dirlik, 'Postsocialism? Reflections on "Social with Chinese Characteristics"', *Critical Asian Studies*, 21:1 (1989), 33.
3 Dirlik, 'Postsocialism?', 35.
4 Ibid., 36.
5 Ibid., 42.
6 Ibid., 43.
7 Arif Dirlik and Zhang Xudong, 'Introduction', in *Postmodernism and China*, ed. Arif Dirlik and Zhang Xudong (Durham, NC: Duke University Press, 2000), 5. Also quoted in Bérénice Reynaud, 'Dancing with Myself, Drifting with My Camera: The Emotional Vagabonds of China's New Documentary', *Senses of Cinema*, 28 (October 2003).
8 Lu Tonglin, 'Trapped Freedom and Localised Globalism', in *From Underground to Independent: Alternative Film Culture in Contemporary China*, ed. Paul G. Pickowicz and Yingjin Zhang (Lanham: Rowman & Littlefield, 2006), 129.
9 Tonglin, 'Trapped Freedom and Localised Globalism', 138.
10 Yomi Braester, 'From Real Time to Virtual Reality: Chinese Cinema in the Internet Age', *Journal of Contemporary China*, 13:38 (2004), 102.
11 Stephen Teo, '"There Is No Sixth Generation!" Director Li Yang on *Blind Shaft* and His Place in Chinese Cinema', *Senses of Cinema*, 27 (July 2003). See also David H. Fleming 'Deleuze, the "(Si)neo-realist" Break and the Emergence of Chinese Any-now(here)-spaces', *Deleuze Studies*, 8:4 (2014), 519.
12 Lin Xiaoping, *Children of Marx and Coca-Cola: Chinese Avant-Garde and Independent Cinema* (Honolulu: University of Hawai'i Press, 2009), 131.
13 Maurice Meisner, *Mao's China and After: A History of the People's Republic* (New York: Free Press, 1999), 533. Quoted in Lin, *Children of Marx and Coca-Cola*, 283.
14 Lu, 'Trapped Freedom and Localised Globalism', 139.

15 Daniele Rugo, 'Truth After Cinema: The Explosion of Facts in the Documentary Films of Jia Zhangke', *Asian Cinema*, 24:2 (2013), 203.

16 See Fleming, 'Deleuze, the "(Si)neo-realist" Break and the Emergence of Chinese Any-now(here)-spaces'; Wang Qi, *Memory, Subjectivity and Independent Chinese Cinema* (Edinburgh: Edinburgh University Press, 2014); and 2014; and Matthew D. Johnson, Keith B. Wagner, Kiki Tianqi Yu and Luke Vulpiani (eds), *China's iGeneration: Cinema and Moving Image Culture for the Twenty-First Century* (London: Bloomsbury, 2014).

17 See Teo, '"There Is No Sixth Generation!"' For more on 'the coexistence and interpenetration of underground, independent, semi-independent, and official modes of filmmaking', see Zhang Yingjin *Cinema, Space, and Polylocality in a Globalizing China* (Honolulu: University of Hawai'i Press, 2010), 13. See also Cui Shuqin, 'Working from the Margins: Urban Cinema and Independent Directors in Contemporary China', *Post Script*, 2–3 (2000), 77.

18 Paul G. Pickowicz, 'Social and Political Dynamics of Underground Filmmaking in China', in *From Underground to Independent: Alternative Film Culture in Contemporary China*, ed. Paul G. Pickowicz and Yingjin Zhang (Lanham: Rowman & Littlefield, 2006), 7.

19 Zhang Yingjin *Cinema, Space, and Polylocality*, 6.

20 See Pang Laikwan, 'Piracy/Privacy: The Despair of Cinema and Collectivity in China', *boundary 2*, 31:3 (Fall 2004), 101–24; Seio Nakajima, 'Film Clubs in Beijing: The Cultural Consumption of Chinese Independent Films', in *From Underground to Independent*, ed. Pickowicz and Zhang, 161–87; and Chris Berry and Mary Farquhar, *China on Screen: Cinema and Nation* (New York: Columbia University Press, 2006), 204–13.

21 See Sheila Cornelius with Ian Haydn Smith, *New Chinese Cinema: Challenging Representations* (London: Wallflower, 2002), 29.

22 Jia Zhangke, 'The Age of Amateur Cinema Will Return', trans. Yan Yuqian, *DGenerate Films*, 3 March 2010. Zhang Xudong quotes the director as saying that 'I felt I became an essayist with a digital camera and not a film-maker' – with Jia perhaps here signalling to the way in which the essay-film is linked to the digital, and that the film-essayist is not a film-maker, and thus produces not so much cinema as non-cinema. See Zhang Xudong, 'Poetics of Vanishing: The Films of Jia Zhangke', *New Left Review*, 63 (May/June 2010), 71–88.

23 Wu Wenguang, 'DV: Individual Filmmaking', trans. Cathryn Clayton, *Cinema Journal*, 46:1 (Fall 2006), 139–40.

24 Dai Jinhua, 'Celebratory Screens: Chinese Cinema in the New Millennium', in *Futures of Chinese Cinema: Technologies and Temporalities in Chinese Screen Cultures*, ed. Olivia Khoo and Sean Metzger (Bristol: Intellect, 2009), 50.

25 See Wu, 'DV', 137–8. See also Ying Qian, 'Power in the Frame: China's Independent Documentary Movement', *New Left Review*, 74 (March/April 2012), 111; and Cui Shuqin, 'Alternative Visions and Representation: Independent Documentary Filmmaking in Contemporary China', *Studies in Documentary Film*, 4:1 (2010), 5.
26 Zhang Yingjin *Cinema, Space, and Polylocality*, 14.
27 On whether the new documentary movement is a movement, see Zhang Yingjin, 'Styles, Subjects, and Special Points of View: A Study of Contemporary Chinese Independent Documentary', *New Cinemas: Journal of Contemporary Film*, 2:2 (2004), 120.
28 Barad, *Meeting the Universe Halfway*, 67.
29 Ibid., 100.
30 Ibid., 19.
31 Ibid.
32 Ibid., 91.
33 Ibid., 85.
34 Ibid., 333.
35 Lev Manovich, *The Language of New Media* (Cambridge, MA: MIT Press, 2001), 307–8.
36 Lorraine Daston and Peter Galison, 'The Image of Objectivity', *Representations*, 0:40 (Autumn 1992), 81–128.
37 Bazin, *What is Cinema?* 9–16.
38 Deleuze, *Cinema 2*, 171.
39 Ibid., 172.
40 Barad, *Meeting the Universe Halfway*, 393.
41 Luke Robinson, *Independent Chinese Documentary: From the Studio to the Street* (Basingstoke: Palgrave Macmillan, 2013), 68.
42 Bérénice Reynaud, 'Le cinéma de la Chine continentale: les multiples voix du nouveau cinéma numérique chinois', *24 images*, 155 (2011), 13 (my translation).
43 Pang, 'Piracy/Privacy', 115.
44 Ibid., 116.
45 Zhang Yingjin, 'Rebel Without a Cause? China's New Urban Generation and Postsocialist Filmmaking', in *The Urban Generation: Chinese Cinema and Society at the Turn of the Twenty-First Century*, ed. Zhang Zhen (Durham, NC: Duke University Press, 2007), 71.
46 Yingjin, 'Rebel Without a Cause?', 71–2.
47 Zhang, *Cinema, Space, and Polylocality*, 103.
48 For more on *minzhuhua*, see Robinson, *Independent Chinese Documentary*, 19; on activist cinema, see Ying, 'Power in the Frame', 120; and for more on *yeyu yishu*, see Valerie Jaffee, '"Every Man a Star": The Ambivalent Cult of Amateur Art in New

Chinese Documentaries', in *From Underground to Independent*, ed. Pickowicz and Zhang, 79.
49 Chris Berry, 'Independently Chinese: Duan Jinchuan, Jiang Yue, and Chinese Documentary', in *From Underground to Independent*, ed. Pickowicz and Zhang, 116.
50 Wang Qi, 'Performing Documentation: Wu Wenguang and the Performative Turn of New Chinese Documentary', in *A Companion to Chinese Cinema*, ed. Zhang Yingjin (Oxford: Blackwell, 2012), 313.
51 Reynaud, 'Le cinéma de la Chine continentale', 12; Matthew David Johnson, '"A Scene Beyond Our Line of Sight": Wu Wenguang and New Documentary Cinema's Politics of Independence', in *From Underground to Independent*, ed. Pickowicz and Zhang, 65.
52 See Wang, 'Performing Documentation', 304–5. We might note here that *Fuck Cinema* is comparable to Zhu Chuanming's *Qunzhong Yanyuan/Extras* (China, 2001), which similarly sees characters 'waiting outside the Beijing Film Studio for short-term acting work' – much as Wang does with his script in this film. As per *Fuck Cinema*, Valerie Jaffee says that the characters in *Extras* 'encroach upon the glory of a popular culture that is perhaps the most powerful authority in China today' (Jaffee, 'Every Man a Star', 91 and 95).
53 Chris Berry, 'Wu Wenguang: An Introduction', *Cinema Journal*, 46:1 (Fall 2006), 135.
54 Berry, 'Wu Wenguang', 135.
55 Wang, 'Performing Documentation', 311.
56 See Mumbai Boss, 'Ai Weiwei's Documentaries to be Screened at Clark House', *Mumbai Boss*, 12 April 2012.
57 See Zhang Zhen, 'Introduction: Bearing Witness – Chinese Urban Cinema in the Era of "Transformation" (Zhuanxing)', in *The Urban Generation*, ed. Zhang, 19–20; and Robinson, *Independent Chinese Documentary*, 6.
58 See Dai, 'Celebratory Screens', 53.
59 Jason McGrath, 'The Independent Cinema of Jia Zhangke: From Postsocialist Realism to a Transnational Aesthetic', in *The Urban Generation*, ed. Zhang, 103; Ying Xiao, '"Leitmotif": State, Market, and Postsocialist Film Industry under Neoliberal Globalization', in *Neoliberalism and Global Cinema*, ed. Jyotsna Kapur and Keith B. Wagner (London: Routledge, 2011), 157–79.
60 See Zhang, *Cinema, Space, and Polylocality*, 104–5; Wang Qi, 'Navigating on the Ruins: Space, Power, and History in Contemporary Chinese Independent Documentaries', *Asian Cinema*, Spring/Summer 2006, 247; Wang Yiman, 'The Amateur's Lightning Rod: DV Documentary in Postsocialist China', *Film Quarterly*, 58:4 (Summer 2006), 19.
61 See Margherita Viviani, 'Chinese Independent Documentary Films: Alternative Media, Public Spheres and the Emergence of the Citizen Activist', *Asian Studies Review*, 38:1 (2014), 111–16.

62 Ai Xiaoming, 'The Citizen Camera', *New Left Review*, 72 (November/December 2011), 72.
63 Zhang, *Cinema, Space, and Polylocality*, 74.
64 Viviani, 'Chinese Independent Documentary Films', 108.
65 Ibid., 112.
66 Ibid., 117.
67 Quoted in Hans Ulrich Obrist, *Ai Weiwei Speaks with Hans Ulrich Obrist* (London: Penguin, 2011), 69.
68 See Ai, 'The Citizen Camera', 75–6.
69 Shi Liang, 'Contextualising Chinese Lesbian Cinema: Global Queerness and Independent Films', *New Cinemas: Journal of Contemporary Film*, 10:2/3 (2012), 130–2.
70 See Sheldon H. Lu, 'Popular Culture and Body Politics: Beauty Writers in Contemporary China', *Modern Language Quarterly*, 69:1 (2008), 167–85.
71 See Jerome Silbergeld, *Hitchcock with a Chinese Face: Cinematic Doubles, Oedipal Triangles, and China's Moral Voice* (Seattle: University of Washington Press, 2004); Yunda Eddie Feng, 'Revitalizing the Thriller Genre: Lou Ye's *Suzhou River* and *Purple Butterfly*', in *Puzzle Films: Complex Storytelling in Contemporary Cinema*, ed. Warren Buckland (Chichester: Wiley Blackwell, 2009), 187–202; and 2009; Zhang, 'Introduction: Bearing Witness', 20.
72 Barad, *Meeting the Universe Halfway*, 206.
73 Zhang, 'Rebel Without a Cause?', 54.
74 Dai, 'Celebratory Screens', 46.
75 Ibid., 52.
76 Lu Hongwei, 'Shanghai and Globalization through the Lens of Film Noir: Lou Ye's 2000 Film, *Suzhou River*', *ASIANetwork Exchange*, 17:1 (Fall 2010), 123–4.

4

Digital Darkness in the Philippines

As made clear in Khavn de la Cruz's documentary, *Philippine New Wave: This is Not a Film Movement* (Philippines, 2010), a large number of contemporary Philippine film-makers work regularly with digital technology. Among those featured in Khavn's film are Brillante Mendoza, renowned 'slow' film-maker Lav Diaz, Adolfo Alix Jr, Jeffrey Jeturian, Raya Martin, Roxlee, Sherad Anthony Sanchez, Auraeus Solito, John Torres and the 'godfather' of the contemporary Philippine film movement, Kidlat Tahimik. It is Khavn, however, who will be the focus of this chapter. Following the treatment of light in relation to Lou Ye's *Suzhou River* in the last chapter, I shall argue that darkness plays a key role in Khavn's films – and in non-cinema more generally. Before discussing darkness, though, I shall briefly sketch how the nation's wider political context leads Khavn to declare with each of his productions that 'this is not a film'.

The Philippines as non-nation

In *Citizen Kane* (Orson Welles, USA, 1941), the *New York Inquirer*'s business manager Mr Bernstein (Everett Sloane) reads to the newspaper's owner, Charles Foster Kane (Orson Welles), a telegram from one of their reporters in Cuba: 'The food is marvelous in Cuba the señoritas are beautiful stop I could send you prose poems of palm trees and sunrises and tropical colours blending in far off landscapes but don't feel right in spending your money for this stop there's no war in Cuba regards Wheeler.' A brief discussion follows regarding the veracity of a Spanish armada circulating off the coast of New Jersey, about which the *Inquirer* has reported. Dismissing Bernstein's suggestion that there is no armada, and that there will therefore be no war between the United States and Spain, Kane dictates to one of his assistants: 'Dear Wheeler, you provide the prose poems, I'll provide the war.'

Although this moment ostensibly refers to the Spanish-American War of 1898, part of which included American-backed uprisings by Cubans against the colonial Spanish military presence, the war between America and Spain was also to decide the future of the Philippines, equally at the time a Spanish colony. In reality, the war lasted from April to August 1898, and it saw Cuba, Puerto Rico, Guam and the Philippines liberated from Spain and placed under American rule. For the Philippines, however, the transition was neither immediate nor smooth; in February 1899, Philippine revolutionaries began to combat the American forces that had come to replace the Spanish, resulting in a war between the Philippines and the United States that lasted until 1902, at which point the United States gained full colonial control of the country. While this is what happened 'in reality', however, separating reality from fiction is hard to do in the case of the Spanish-American and subsequent Philippine-American wars. For, as *Citizen Kane* suggests, the media played a key role in defining the Spanish-American War, with William Randolph Hearst of the *New York Journal* and Joseph Pulitzer of the *New York World* plying their readers with scare-mongering propaganda in a circulation war that resulted in the birth of sensationalist, or 'yellow', journalism. As media played a key role in the Spanish-American War, so is the contemporary Philippines something of a media creation. Indeed, when on 10 December 1898 American and Spanish delegation members signed the ceding of the Philippines to the United States at the Treaty of Paris, clearly the Philippine public had not been included in negotiations, hence their uprising against the Americans in February of the next year, around the time that the US Senate ratified the treaty.[1] Furthermore, that the Spanish ceded the Philippines to the United States for the sum of US$20 million suggests not only that the Spanish-American War was not at all about the liberation of the Philippines from the Spanish, but also that the Philippines was considered a mere commodity to be bought and sold – confirmation that the concept of the nation is one that goes hand in hand with capitalism.

Of course, the Philippines is named after Felipe II of Spain, as Benedict Anderson reminds us.[2] Named after its colonial master, the selling of the Philippines as a commodity to the United States as the outcome of a media-intensified war is simply the next in a history of indications that the Philippines is not just an imagined, but in some respects also a fabricated, community – even if Anderson also explains how this sense of community was wrested from the colonizing Spanish forces by author José Rizal and used to create an authentic Filipino identity through his novel *Noli Me Tangere* (1887).[3]

The mediatization of the Spanish-American War was not limited to the print press; film also played a crucial role. For example, Thomas Edison made early films that purported to be about the Spanish-American War, but which were really about the Philippine-American War.[4] That Edison eradicates the Philippines in favour of Spain (because his audiences would at least have heard of the latter country?) suggests how the Philippines is somehow a non-cinematic nation or a non-nation. If capital, the nation and cinema are intimately intertwined, then as a non-nation, the Philippines is also perversely non-cinematic.

The claim that the Philippines is 'non-cinematic' is provocative. It is not intended to negate the significant and impressive amount of film production that historically has gone on there. Before the new millennium, the Philippines was

> the fourth largest film industry in the world, next only to India, Hollywood, and the three Chinas (Hong Kong, Taiwan, and Mainland). It produces around 180 films yearly for its bustling domestic mass-market audience. The average budget for a typical mainstream feature is pegged at US$800,000 and the country has about 1,000 screens.[5]

Furthermore, cinema plays a key role in the political sphere of the Philippines in the sense that leading actors become major politicians, including presidents, most notably action hero Joseph Estrada (nicknamed Erap), who governed from 1998 to 2001.[6] Similarly, Alfred W. McCoy explains how Governor Rodolfo Aguinaldo, who had been involved in the 1989 coup d'état attempt against President Corazon Aquino by the Reform the Armed Forces Movement (RAM), was 'the first RAM leader to transform his image through cinema. Through the magic of the movies [in particular the film *Aguinaldo: The True-To-Life Story of Gov. Rodolfo Aguinaldo of Cagayan* (William G. Mayo, Philippines, 1993)], his previous military career of torture, murder, and rebellion became the stuff of heroism.'[7] As McCoy reports, 'Within three years of their surrender, RAM's leaders used mass media, particularly cinema, to effect a remarkable transformation – from far Right to far Left, from coup plotters to congressional candidates, and from torturers to heroes.'[8] In other words, not only is the Philippines a country where cinema has thrived, but it is also a country in which cinema plays a key role in shaping the perception, and by extension the reality, of that country.

However, the number of Philippine films being made has waned in the new millennium, with only 89 films produced in 2001.[9] As a result of this downturn, Lav Diaz argues that 'there is "no film industry anymore"', and Brillante Mendoza,

in spite of winning the Best Director award at the 2009 Cannes Film Festival for *Kinatay* (France/Philippines, 2009), expresses doubt that 'his works will find audiences in the Philippines, due in part to the lack of availability of movies beyond Hollywood'.[10]

To be clear: there continue to be mainstream Philippine films, which no doubt hold some interest, even if only as a result of their aspirational middle-class aesthetics (and the fact that the Philippines has a large number of successful women directors). However, this cinema regularly overlooks the squatters who make up 43 per cent of Manila's households, which in turn amounts to 5.48 million people in a metropolitan area that has a total population of over 10 million people in a country of nearly 73 million.[11] As a result, much – the majority? – of the population of the Philippines remains invisible, or what Jonathan Beller might term relegated 'to a status outside representation and into the unthought of the image'.[12] As these people are invisible, not least as a consequence of American colonialism, so is the Philippines invisible except as a media construct/spectacle. If there is no cinema for these people, then perhaps it is in Philippine non-cinema that they might appear, or in which their invisibility is made apparent.[13]

Philippine precursors and forebears

It is not my intention here to overlook how film-makers like Ishmael Bernal, Lino Brocka, Mike De Leon and Kidlat Tahimik have historically sought (and in Tahimik's case continue to seek) to create an alternative cinema to the Philippine mainstream and Hollywood, giving expression in films like *Maynila: Sa mga kuko ng liwanag/Manila in the Claws of Light* (Lino Brocka, Philippines, 1975) and *Manila by Night* (also known as *City After Dark*, Ishmael Bernal, Philippines, 1980) to the plight of precisely the overlooked, disenfranchised and thus invisible elements of Philippine society – an endeavour that in the 1970s and 1980s went against the image of the nation desired by the ruling Marcos family.[14] Indeed, I have shown elsewhere how Khavn acknowledges his debt to film-makers like Brocka, with the former's *Alaala ng paglimot/Kamias: Memory of Forgetting* (Philippines, 2006) referencing the latter's *Insiang* (Philippines, 1976) by opening with the slaughter of a pig.[15]

Nor do I wish to overlook scholarly precursors. In writing about Tahimik, for example, Fredric Jameson, discusses how we may well regularly see on our

television and cinema screens 'vivid miseries [especially poor people], which offer no problems of figuration', but that we rarely/never see 'its deeper, but non-visual systemic cause', which for Jameson requires 'self-consciousness about the social totality'.[16] For Jameson, capital has become the measure of reality, and its study is therefore now 'our true ontology'.[17] Pertinently, Jameson argues that Tahimik's *Mababangong bangungot/The Perfumed Nightmare* (Philippines, 1979) fits into a genealogy of 'imperfect cinema' along the lines of that proclaimed by Julio García Espinosa – whose work will feature prominently in Chapter Six.[18] In other words, Jameson frames Tahimik's film-making in a fashion not dissimilar to how I wish to frame Khavn's – namely as an attempt to picture the 'social totality' of (life under) capital. However, Jameson is writing about cinema before the digital turn, and so how the digital engages with and challenges the supposedly 'true ontology' of capital is worth readdressing.

Furthermore, Christopher Pavsek argues that Tahimik's later work constitutes an example of the 'utopia of film'. What Pavsek means by this is that 'the promises of cinema will be realised only when the promises of emancipation that slumber uneasily in the history of humankind are also met'.[19] That is, Pavsek sees cinema, especially Tahimik's, as part of a process of liberation, or what we might term an activist cinema that self-consciously and experimentally engages in changing the world, or in the changing that is the ontogenetic nature of the world (Tahimik refuses to make scripted, planned narratives, but instead makes movies as if setting out in a car with only a cup of gasoline).[20] However, where Pavsek discusses the 'utopia of film', this book discusses the topos, or place, of non-film, or non-cinema (or *u*-cinema in the sense that the 'u' in utopia is from the Greek *ou*, meaning 'not'; as utopia is a non-place, so is u-cinema a non-cinema).

Now, E. San Juan Jr criticizes Jameson's 'colonising patronage' and 'self-serving appropriation of elements of [*The Perfumed Nightmare*] ... for his own discursive purposes. Obviously, Jameson is searching for art forms and cultural practices that have succeeded in resisting late-capitalist commodification and reification'.[21] I hope not to commit the same 'colonizing' error. However, I might also take Khavn's lead and suggest that, in producing non-cinema (since what we see is in Khavn's own words 'not a film'), he demonstrates how that which does resist commodification and reification, and how that which thus does resist being 'visible' has a necessary place/topos in cinema. That is, I wish to show how non-cinema props up cinema just as the poor prop up the rich. Or, as Jonathan Beller puts it in relation to *Aliwan Paradise* (Mike De Leon, Philippines, 1992),

a film that is about the production of images of the poor for the purposes of making a consumable spectacle out of them:

> Just as global capital needs the reality of Third World labour in order to valorise itself, the global psyche/aesthetic also needs images of Third World realism to valorise itself. These two registers of production are not essentially separate spheres; indeed, they are codependent.[22]

It is my intention here to demonstrate how this co-dependence, or entanglement, is articulated in more contemporary and digitally enabled Philippine non-cinema. In this way, we might not only demonstrate how 'the origin and present status of Philippine cinema parallels the movement of capital in this century'.[23] We might also show 'the centrality of the Philippines and other Third World formations in launching any counternarrative to "the triumph of global capital" and its oft-unspoken yet "inevitable" and, therefore, officially justifiable damning of the majority to impoverished off-screen oblivion'.[24] That is, rather than being a peripheral nation, the Philippines is central, not only because of the way in which its cinematic history speaks to the contemporary world system (hence fascination with the Philippines by authors as diverse as Anderson, Beller, Jameson and Pavsek), but also because non-cinema is the beating heart of that cinematic, capitalist world system. To make one final comparison: if Rolando B. Tolentino praises the Brocka-Bernal films for 'choosing to remain peripheralised' within the ecology of cinema, contemporary film-makers like Khavn endeavour not even to make cinema, thus attempting not simply to challenge the contemporary hierarchies of that system, but the system of hierarchies (of the visible and the invisible) as a whole.

This is not a film movement

Working outside of Philippine commercial cinema, the Philippine New Wave often comes up against the censorship policies of the Movie and Television Review and Classification Board.[25] Furthermore, Philippine New Wave work regularly shows only to small audiences in private, semi-private and often unconventional spaces – rendering it an 'underground' cinema, which equally exists in conjunction with the 'subcinematic' practice of piracy.[26] Indeed, piracy, DVD culture and the decline of theatrical cinema all feature as themes in *Todo Todo Teros* (John Torres, Philippines, 2006), *Tambolista/Drumbeat* (Adolfo Alix Jr, Philippines, 2007), *Now Showing* (Raya Martin, Philippines/France, 2008),

Ang pagdadalaga ni Maximo Oliveros/The Blossoming of Maximo Oliveros (Auraeus Solito, Philippines, 2005), *Siglo ng pagluluwal/Century of Birthing* (Lav Diaz, Philippines, 2011) and *Serbis/Service* (Brillante Mendoza, Philippines/France/South Korea/Hong Kong, 2008).[27]

If the films of Bernal, Brocka and others sought 'to develop a film language adequate to the complexities of contemporary Philippine existence', so does this happen in contemporary Philippine cinema.[28] Indeed, while a film like *Manila by Night* is characterized by long takes that show the way in which the poor are not separate from but directly abut the rich, Philippine New Wave directors use digital technology to create even longer takes that function in a similarly political way.[29] There is, for example, an impressive long take in *The Blossoming of Maximo Oliveros*, when during a family mealtime we see 12-year-old cross-dresser Maxi (Nathan Lopez) give food to his father, Paco (Soliman Cruz), and his two brothers, Boy and Bogs (Neil Ryan Sese and Ping Medina), all of whom sell telephones and the like on the black market. In some senses, the sequence is a 'nothing' moment, in that it offers an unbroken and documentary-like insight into the Oliveros household over the course of its five-minute duration. However, it is also crucial for helping the audience to understand how close the Oliveros family is in spite of its poverty.

Kubrador/The Bet Collector (Jeffrey Jeturian, Philippines, 2006) also opens with the first of many long takes as we follow bet collector Toti (Niko Milete) down a street, past some children playing, and then into a back alley, where more children dance and/or ask him for money before he approaches an iron gate. Toti passes through the gate to a door, and we only cut when he enters the underground bet collecting office where he works. There follows a second long take in which we see the staff begin to draw numbers for the latest round of *jueteng*, the illegal lottery that is the film's subject – before the police arrive and, in the panic of a raid, the film moves formally into a sequence involving a much more rapid rate of cutting. *Engkwentro/Clash* (Pepe Diokno, Philippines, 2009), meanwhile, is a 60-minute film that is made to look as though it consists of a single take as it follows two brothers (Felix Roco and Daniel Medrana) as they go about their business in rival gangs around southern slums, all the while trying to avoid city death squads. This is not to mention the films of Lav Diaz, which can last for up to 12 hours and which regularly feature takes that are at least five minutes in duration.

Each of these examples – *The Blossoming of Maximo Oliveros*, *Kubrador*, *Engkwentro*, Lav Diaz – shows how Philippine cinema is especially employing the

complexity of the long take in order to convey the complexity of contemporary Philippine existence, exposing various aspects of Philippine life that otherwise are hidden in Philippine cinema, including corruption, criminality and poverty. Furthermore, if one of the perceived strengths of *Manila by Night* is its impoverished 'plastic' and 'sloppy' look, which is employed to create 'something more accessible for a Third World mass audience', then the often low-budget or amateur aesthetic of Philippine New Wave films arguably has a similar effect.[30] Equally, if Beller writes how '8mm ... is the indecent, small-gauge cinema format indexing ... [a] rampant unregulated world of degradation and deviance, a world which the principled, well-funded world of 35mm ... seeks to stamp out', then the 'digital grain' of many New Wave films also fits the degraded and deviant world of Philippine slums and other areas.[31]

Finally, Beller suggests that the 'tacky hallucinations' of a film like *Curacha ang babaeng walang pahinga* (Chito S. Roño, Philippines, 1998), which tells the story of Curacha (Rosanna Roces), a *torero*/live sex performer, who encounters and tries to save from depression her friend Myrna (Jaclyn Jose), 'achieve their gaudiness only because they will not turn a profit. They cannot be validated by "reality" and are left to express the unrealised aspirations of subalterns. Thus, they are the images of Third Cinema, of Third Cinema in a global frame.'[32] This 'tackiness' applies not only to *Curacha...*, but also in particular to the work of Khavn de la Cruz, who embraces his Third World provenance, uses the small gauge of the low-definition digital camera, and accesses spaces, the documentary mise en scène of which places him as a successor to Bernal, Brocka and others. As we shall see, he also embraces darkness as a key component of his films. First, however, let us look at how Khavn's work suggests 'Third Worldness' and, in particular, a place in the lineage of Third Cinema.

Khavn de la Cruz and Third Cinema

A few minutes into Third Cinema's flagship film, *La hora de los hornos/The Hour of the Furnaces* (Fernando E. Solanas and Octavio Getino, Argentina, 1968), the narrator suggests that the English took over from the Spanish as the imperial power in Latin America as a result of some trick loans that local enterprises took out with foreign banks, thereby ensuring dependency for many years to come. 'The country [in this case, Argentina] exported wool and imported textiles', the voice-over continues (in Spanish). 'It exported meat and leather

and imported grand pianos.' There is a piano in *Kamias*, which Khavn's brother at one point plays. More pointedly, however, (grand) pianos play a prominent part in Khavn's two improbably titled films, *Mondomanila, or: How I Fixed My Hair After a Rather Long Journey* (Philippines/Germany, 2010) and *Ang kaisa-isang konsiyerto ng kagila-gilalas na kombo ni Kumander Kulas at ng kanyang kawawang kalabaw sa walang katapusang kalsada ng Kamyas/The One and Only Concert of the Amazing Combo of Kommander Kulas and His Poor Carabao in the Long and Unwinding Road of Kamias* (Philippines, 2011).

Mondomanila ... tells the story of various gang members who spend their time in the squatter slums of Manila getting drunk and high, and carrying out various misdemeanours. The film is a gaudy, frequently shocking film that involves radical editing, obscene language, pornographic elements and murder. Its plot is relatively complex, in that it involves a whole host of characters who vary from disabled rappers (Ogo X, played by Ray Miyano) to gang members who masturbate uncontrollably (Ungay, played by Manuel 'Bonbon' Valerozo) to others whose sexual proclivities include fucking geese (Dugyot, played by Paulo Vicente). Core to the film is the murder of Whiteboy (Tony Hunt), a character who is supposed to be American, but who is played by an Australian actor who makes little to no effort to hide his accent. Whiteboy is killed by Sergeant Pepper (Alex Tiglao) as he has sex in the shower with Naty (Stefan Punongbayan), a young homosexual and Pepper's only son along with nine daughters (the ultra-virile Pepper is disappointed that his only son is gay). The murder has been set up by Tony D (Timothy Mabalot), whose younger brother, Dino Jr (Jim Rocky Tangco), was raped by Whiteboy. Tony and his friend Mutya (Jonathan Reyes) then break into Whiteboy's place and ransack it, spending their findings in a shopping mall, about which more later.

Important for the present discussion is the association between Whiteboy and the piano. For it is at a piano that we first meet Whiteboy, as he plays music and pronounces:

> Compared to the rest of Asia, you Pinoys [Filipinos] are the fucking lowest class. Barely Asian, as the Japs say. Hell, you're barely human. You people fuck each other like there's no tomorrow. What's wrong with this country? They're low-class in the human evolution. No use for the human race except maybe for sexual slavery.

This shocking monologue is Khavn's version of what an American might think of the Philippines. It is clearly imbued with the language of colonialism/Empire, in

that Pinoys are reduced to 'sub-humans' – only fit for being treated like objects. That Whiteboy delivers this line sat at/playing a piano suggests the way in which imperialism claims that it is bringing to the countries that it exploits a sense of culture, while really it is bringing subjection, abjection and objectification in relatively equal measure. If 'civilization' brings the grand piano, it also brings paedophilia (Dino Jr is not even an adolescent) and corruption. No wonder Khavn, while having a piano in his house, rejects 'high culture' in favour of his significantly more punk aesthetic.

Meanwhile, in *Kommander Kulas*, Khavn alternates between three types of sequences, each of which is set to a voice-over describing the plight of the eponymous character, and classic Philippine music from the 1950s – by singers like Carmen Soriano, Ruben Tagalog and Sylvia La Torre. The three sequence-types firstly involve the titular Kommander Kulas (Celino Kaluag) riding his carabao through various settings, both rural and urban, typically heading from the distant background to the foreground, as he goes silently in search of his heart, which has been stolen. This is intermixed with tableaux of relatively grotesque images: children being crucified, rotund women crouched over a bedpan as if to defecate and more that seems straight out of the infernal paintings of Hieronymus Bosch. Finally, the film also features numerous shots of a grand piano in various locations, the vast majority exteriors. At one point, one of the grand pianos sets spontaneously on fire next to a building site. The piano, always square in the centre of the frame, becomes not only a major 'character' in the film as it appears in all manner of Philippine places/spaces, then, but it also is a kind of alien presence – a silent suggestion of the pervasive nature of globalized capital, or what Michael Hardt and Antonio Negri term Empire.[33]

While Kulas searches for his heart, it appears as though it has been replaced inexorably by the often-sexualized images of seeming-suffering Filipinos and the imported grand piano, the burning of which seems like the best, but still futile, form of resistance available to the film.[34] Not as 'punk' as *Mondomanila*, *Kommander Kulas* is nonetheless a film that, through its use of the grand piano alongside the other, rather abstract images (the film does not have a conventional diegesis with characters and a plot, as per mainstream movies), suggests resistance to the advent of the 'high culture' that globalized capital/Empire brings with it, since it also brings a sense of being lost, a sense of corruption (to live like Kulas without a heart is to have had one's core ruptured, i.e. to be cor-rupted), and a sense of degradation, abjection and suffering.

Although the reference to *The Hour of the Furnaces* may not be intentional, in playing with the same iconography, Khavn positions himself not only as a Third World film-maker, then, but also as an inheritor of the political/politicized tradition of Third Cinema 'proper'. It is thus fitting that he renounces the 'high art' and auteur traditions of Second Cinema by partially renouncing his input as the artist behind the film (this is not a film by Khavn), in addition to not making the conventional narratives of First Cinema.

Solanas and Getino write of Third Cinema:

> To an institutionalised cinema, [Third Cinema] ... counterposes a guerrilla cinema; to movies as shows, it opposes a film act or action; to a cinema of destruction, one that is both destructive and constructive; to a cinema made for the old kind of human being, for them, it opposes a *cinema fit for a new kind of human being, for what each one of us has the possibility of becoming*.[35]

Mondomanila in its gleeful criminality and *Kommander Kulas* in its embracing of slowness and abjection both suggest a cinema 'fit for a new kind of human being'. But rather than necessarily humanizing 'those who in the contemporary are made to disappear, rendered otherwise invisible or (dis)figured under various iterations of the inhuman', Khavn foregrounds that inhumanity, suggesting a human that can live on even without a heart.[36] If Third Cinema aims to transform the world of cinema-capital, then it does so through shocking words and imagery, thereby 'creating new ways to apprehend and transform the very conditions of existence. Thus, the paradigm of "representation" gives way to a paradigm of affect', something which is all the more clear as *Mondomanila* and *Kommander Kulas* become films that do not so much have narratives that we follow, as which instil in their viewers troubling sensations of disgust, confusion and boredom.[37]

Minor virtuosity

Kommander Kulas refers not uniquely to Third Cinema, but it also positions itself within a complex web of Philippine cinema and a history of European literature. As *Kamias* makes clear its debt to Lino Brocka via its opening reference to *Insiang*, so does *Kommander Kulas* seemingly make reference to *Ganito Kami Noon, Paano Kaya Ngayon* (Eddie Romero, Philippines, 1976), for both films

share a main character with the same name, and who sets out on a quest to learn what it means to be Philippine. As Caroline S. Hau explains:

> Set in turn-of-the-century Philippines and covering the last years of the Spanish regime that ends with the arrival of the Americans, *Ganito* highlights the changing formulations of Filipinoness by following, in *bildungsroman* fashion, a naïve Tagalog named Nicolas Ocampo, who journeys to the capital in the midst of revolution. The movie is concerned primarily with Kulas's [Nicolas's] growing consciousness of what it means to be 'Filipino'.[38]

If *Ganito* explores the beginning of the American occupation of the Philippines, *Kommander Kulas* seems to explore its ongoing legacy, as the film, like many of Khavn's works, seeks to understand what it means to be 'Filipino' today.

Finally, *Kommander Kulas* opens with a voice-over that recounts four times how the main character dreamt the night before that he was turned into a cockroach, before we are told that Kulas woke up 'from his perfumed nightmare' with stitches in his chest – his heart having been stolen. Not only does this moment reference Tahimik's most famous film (the title of which might itself be understood as a reference to how American culture functions as a seductive fragrance), but it is also a clear reference to Kafka, in particular *Metamorphosis*, which, as I have already explained, recounts how Gregor Samsa wakes up one morning transformed into an *ungeheures Ungeziefer* ('monstrous vermin'). The reference thus situates *Kommander Kulas* once again in the realm of what Deleuze and Guattari might term 'minor cinema' – or which Khavn himself would suggest is non-cinema.

If cinema is the 'language', as it were, of American imperialism, and if the contemporary Philippines was a media construct born almost at the same time as cinema, then non-cinema becomes a means of developing a more specifically Philippine mode of expression. Philippine non-cinema, then, constitutes an attempt to invent a new cinematic language. Khavn's gaudy and wilfully difficult films can thus be read (like those of many others in the Philippine New Wave) as an attempt to create a Philippine identity that is antithetical to cinema, since cinema is equated 'officially' with the all-pervasive (globalized) presence of Empire.

Beller seems to intimate as much when he discusses Khavn's (also improbably titled) *'IDOL': Bida/Kontrabida: D' Bayani S. Makapili Tru Istori: Pasasabugin Ko Ang Ulo Mo Sa Mga Bala Ko Dahil Gawa Na Ang Lapida Mo, Ako Pa Ang Nagbayad, Dahil Gusto Kong Magsayaw Sa Ibabaw Ng Puntod Mo, Hayop*

Ka!!!/'IDOL': Hero/Villain: The Bayani S. Makapili True Story: I'm Gonna Blow Off Your Head With My Bullets Coz Your Tombstone Is Already Made, I Even Paid For It, Coz I Wanna Dance Over Your Grave In The Cemetery, You Animal!!! (Philippines, 2003). *IDOL* is about a young man who loves Philippine action movies and who one day finds himself in an action movie scenario, which turns out far different from how he might have imagined it. Beller suggests that *IDOL* is an 'anti-film', in that it

> refuses various cinematic conventions regarding time, space, and narrative structure Khavn's film about the impossible aspiration to be a hero in a society in which heroism is only possible on TV and in the movies is a film that never could be.[39]

Beller goes on to relate the performance of heroism (or otherwise) in *IDOL* to Paolo Virno's idea of virtuosity.[40]

For Virno, virtuosity is how we validate ourselves in the contemporary era. The virtuoso, formerly a category of person reserved for performing artists (like those who perform on grand pianos), now is in a general sense the condition of work in the contemporary era; as the virtuoso needs an audience, so, too, does a subject need to arouse attention in order to be monetized and validated in the so-called society of the spectacle.[41] Virno says that the virtuoso is thus political and that political work is *virtuosic* – since the requirement of an audience also requires public space, and since we are in the realm of public space, we are also in the realm of politics.[42] The work of the virtuoso is also always in some respects unfinished; the virtuoso being a performer, there is a sense of liveness, and thus of contingency, in that each performance is different, meaning that the virtuoso does not produce a finished product. Finished products, Virno contends, are the result of labour, which is not political and which is not virtuosic. In the era of never-ending work, in which there are perhaps no longer finished products (in the sense that production is never finished), perhaps we are indeed in the era of the virtuoso. However, for Virno most virtuosity is in fact 'servile', in that it plays into the hands of contemporary neoliberal capital (everyone is always working, or performing work, in a never-ending/unfinished fashion). 'Civil disobedience', Virno contends, 'represents, perhaps, the fundamental form of political action of the multitude, provided that the multitude is emancipated from the liberal tradition within which it is encapsulated.'[43] In other words, while virtuosity might be all-pervasive in the contemporary world, it can be subverted by the multitude via civil disobedience, as well as by what Virno calls 'exit', or

'defection'.[44] While fleeing might seem passive in comparison to standing and fighting, Virno's argument is that to exit/defect radically alters the playing field, creating the space for the unrestrained invention of the multitude.

With this in mind, we can understand Khavn's works as virtuosic, in the sense that they are public works made for an audience, and which via their challenging, punk aesthetics constitute a form of 'cinematic disobedience', taking on the qualities of an anti-film. They are political films that 'defect' out of cinema and into non-cinema. As a result, they radically shift the terrain on which we consider film – asking us to look again at the world and to see in it 'what the true *political*, and not servile, virtuosity of the multitude could be'.[45] Khavn does this in particular by taking us into the slums, or squats, of Metro Manila.

'Squatterpunctum'

Jasmine Nadua Trice describes how in 2008 Khavn screened a silent version of *M* (Fritz Lang, Germany, 1931) at Mag:net, an arts venue in Manila, with live musical accompaniment from his band, the Brockas, which also features Lav Diaz. The event also involved a screening of *Ultimo: Distintas maneras a matar un héroe nacional/Ultimo: Different Ways of Killing a National Hero* (Philippines, 2008), a six-minute film based on a poem by Philippine national author José Rizal, and a 30-minute version of *Iskwaterpangk/Squatterpunk* (Philippines, 2007), a film set to the music of the Brockas featuring squatter children playing around in the slums of Manila. An act of cinematic disobedience, Trice explains how

> the exchanges between beer-drinking audience members were as important as those between viewer and screen ... the event performed a reworking of authorship, as the canonical work [*M*] is on put on [*sic*] equal footing with a young, Third World upstart, a persona de la Cruz himself takes pains to cultivate ... de la Cruz mixes the aesthetics of early British punk with images of one of Manila's urban poor communities ... Critics have praised ... [*Squatterpunk*] for its dismantling of stereotypes – rather than displaying the wretched of the earth, the film depicts young boys who might exist in any setting, generally misbehaving against the backdrop of dire poverty ... [The mix of punk and poverty is] more removed from commercial culture (the 'MTV' variation of punk) and thus, more within the realm of what might be labelled subversive.[46]

Beller has also written about *Squatterpunk*, a highly experimental work (there is no narrative, although various of the children are on screen throughout the film, including a central kid who has a Travis Bickle-style Mohawk). He says: '*Squatterpunk* juxtaposes shots of squatter children living on the outskirts of Manila with a punk-rock soundtrack, in order to create the conditions for a new and profoundly complex experience.'[47] He continues:

> The children, although they exercise incredible agency and creativity, also occupy a political position, but this position is not a choice in any sense of the word. Through the solidarity and the disconnect between punk and squatterpunk, Punk is thus construed as an aesthetic symptom, an expression of a deeper reality, a kind of world-historical sickness, that has at its core the subaltern, unrepresentable and indeed unfathomable condition, not just of some humans but of humanity *in toto*.[48]

In other words, by embracing non-cinema, Khavn seems indeed to have shifted the terrain of cinema in such a way that the unrepresentable nature of Manila's squat-slums comes to the fore, via what Beller calls, purloining a term from Roland Barthes, 'squatterpunctum'.[49] That is, the viewer is shocked into the realization of the vast swathes of human society that are outside of representation, and yet which have the political potential for change that is part of the multitude, and which convey the underdevelopment that is not the alternative to globalized neoliberal capitalism, but which is its co-constituted condition. This is the flipside of the mall that we see Tony D and Mutya enter in *Mondomanila* after stealing money from the dead Whiteboy. It is also from a mall, the Araneta Center in Quezon City, from which the principle characters are excluded in Khavn's *Bahag Kings* (Philippines, 2008).

The latter film predominantly depicts various scenes of a bunch of men (including Khavn and various other 'new wave' directors such as Roxlee and Jim Libiran) dancing around to more music by the Brockas, wearing bahags, loincloths commonly worn in the Philippines prior to its existence as such with the arrival of the Spanish (Kidlat Tahimik often wears a bahag, suggesting that it is in part a politicized garment, as well as an historical mode of dress). When the Bahag Kings arrive at a shopping mall, however, they are arrested – and a long sequence of the film plays out, now with direct sound, in a police station as the group awaits their release, much akin to Ai Weiwei's *Disturbing the Peace*. As Trice reminds us, the mall is 'a globalised, First World pocket within a Third World city', and it is from this First World pocket that any

sign of the Third World is banned, suggesting once again that Khavn brings to the attention of his viewers the way in which the Philippines's history has all but been eradicated, or made invisible, in the name of 'progress' (i.e. the homogenization of space that is the erection of shopping malls containing the same shops the world over, at the expense of both difference and the past).[50] The film thus also constitutes a sort of non-cinematic squatterpunctum.

Having addressed Khavn's 'non-cinematic', political aesthetics I wish finally to turn to the nearly all-pervasive motif of darkness, which I shall argue points to the democratic 'whole', in which we can no longer discount the unrepresented, since we are forced to recognize its constitutional role in our reality. Realizing the importance of the unrepresented, of the invisible, of darkness itself, we are nudged towards being more informed, ethical human beings who cannot make the exclusions that under capitalism have until now wrought the injustice of inequality.

Darkness and light

That Khavn is interested in filming darkness is clear from the titles of various of his films. *Maynila Sa Mga Pangil Ng Dilim/Manila in the Fangs of Darkness* (Philippines, 2008) is not only in its title a reference to *Manila in the Claws of Light*, but it is also a deconstruction/corrective/updating of Brocka's film, restaging scenes and reworking footage from the original in order to construct a violent story in which Kontra Madiaga (Bembol Roco) takes revenge on those who, in Brocka's original, compromise the innocence of Ligaya Paraiso (Hilda Koronel). *Day tingnga ti misteryo ti Kristo Negro/The Middle Mystery of Kristo Negro* (Philippines, 2009), meanwhile, starts like *Kamias* with a slaughter, but this time of a water buffalo, before a Christ-like figure appears in the wilderness, dragging the water buffalo's carcass around as if it were a cross. The 'Black Christ' that the film's title evokes similarly suggests an interest in darkness (perhaps to contrast Khavn's version of Christ with Lucifer, whose name means 'bearer of light' or 'morning star' from the Latin *fer* meaning 'bearing' and *lux* meaning light). Finally, *Three Days of Darkness* (Philippines, 2007) depicts three women (Precious Adona, Gwen Garci and Katya Santos) trapped in a house and haunted by their innermost fears as the three days of darkness that signal the end of times seem to descend (three 'days' of darkness is an oxymoron, in that without light one cannot measure days; that said, an inability to measure time would

indeed signal the end of time[s]). Much of *Three Days of Darkness* is also shot in darkness, which is also true of the opening 13 minutes of *Kamias*, which I have analysed elsewhere.[51] In order to account for Khavn's take on darkness, I shall turn to the philosophy of light, especially as expounded by American philosopher David A. Grandy.

In his book, *The Speed of Light: Constancy + Cosmos*, Grandy discusses Albert Einstein's discovery that light speed is constant. That is, humans might move at different velocities, but light remains constant. If I am bombing along a British motorway at 70 miles an hour tops, for example, and a car passes me (illegally) at 80 miles per hour, relative to me, the car moving at 80 miles per hour seems to be doing 10 miles per hour. Not so with light. Regardless of how fast I am going, light speed always remains the same. However, while light remains constant, it is also light that allows us to measure as relative the moving car (when I am stood 'still', it travels at 80 miles per hour; when I am moving at 70 miles per hour, it travels at 10 miles per hour): 'Photons – when they bounce back to our eyes or against scientific instruments of detection – are the means by which we bring the world into focus.'[52] Without light, I would see nothing; with light, I can see things, but I can only see them because they are moving at speeds different to light (if they were moving at a speed the same as light, I would not be able to see them since I would not be able to differentiate them from light itself). In other words, light allows measurement, which itself relies not upon our constancy, but precisely upon our relative movement/motion. The idea that human-conducted measurement is absolute is therefore false; human-conducted measurement is instead based upon relativity (relative speeds).

In the language of this book, this is premised upon entanglement, because I cannot see things without light, and I cannot see things unless they are moving at different speeds – but that difference in speed, together with my perception of it, results not from my separation from those things but from my relation/relativity to those things. For this reason, Grandy suggests that 'Einstein's innovation [the discovery of light speed constancy] nudged physics toward a more experience-based view of light; that is, one from which we cannot abstract our own presence'.[53] In a fashion that echoes Niels Bohr's theory of complementarity and entanglement, as furthered by Karen Barad, Grandy argues that 'modern physics reminds us that we are threaded into nature, that nature and human knowing are mutually constitutive at the level of local experience'.[54] Furthermore, while light is what allows us to see, itself a necessary condition for measurement to take place, we cannot in fact see light itself (we cannot see light, but we can see

because of light). In other words, our entangled presence in (as opposed to our detachment from) the universe is also a condition for measurement, and thus by extension for science more generally – even if there is a history and in some quarters an ongoing assumption that humans are able 'objectively' to measure reality.

Grandy continues: 'The agency of revelation – light – is subtle, but not so subtle that it does not disturb and thereby obscure the world it illuminates.'[55] Put differently, 'Light signals its arrival only when it arrives, not a moment sooner. Put [yet] another way, we never see light in intermediate space. It dawns only in the moment of immediate experience – when photons strike the eye. Indeed, the very idea of seeing light off in the distance is incoherent.'[56] The eye is not 'waiting for' light; the eye is constituted only with light. In this sense, the eye is historical (an oft-forgotten fact, in that we know that humans have evolved from eyeless creatures, and thus know that it is at best a probabilistic tool for gauging reality, rather than an entirely, if more often than not, reliable window on to the world). Light as a result again suggests entanglement, in that reality constitutes us as we constitute reality, and both reality and humans could be very different from how they presently are: 'When light strikes the eye, our own visual experience occurs, and we are at the very centre of it.'[57]

The invisible (light itself) allows us to see, and thus the invisible is the condition of the visible. Furthermore, Grandy posits that

> seeing of course is a matter of *vision*, but it is also a kind of light-based *division* whereby objects show up in places they have no material existence – namely, in our minds. Light, in other words, gives us the here-there split: the perceiving mind is not co-located with the perceived object. But that split is not intrinsic to light, which, if it is to do its work of vision clearly and cleanly, must lack the ability to cast off images of itself. So, light remains invisible or imageless and at the same time fully intact or indivisible.[58]

Grandy then draws on the work of physicist David Bohm to suggest that 'ultimately, the entire universe (with all its "particles", including those constituting human beings, their laboratories, observing instruments, etc.) has to be understood as a single undivided whole, in which analysis into separately and independently existent parts has no fundamental status'.[59] In other words, Grandy's reading of light speed constancy also suggests a 'whole' that is invisible to us.

I have argued elsewhere that the indivisibility of the universe is suggested in mainstream cinema by impossible tracking shots that pass into and out of

solid objects and/or which zoom from the earth and into the cosmos.[60] While non-cinema, as I am defining it here, does not have the means to create such expensive, if impressive, shots, nonetheless the presence of darkness does, I wish to argue, suggest something similar – with both types of shot being redolent of the digital age. I described in the last chapter how the distinction between a wave and a particle is in fact, after Barad/Bohr, a consequence of human measurement. 'These boundaries', says Grandy, 'have been erased, and the Cartesian mind-matter divide is under assault [in that the mind is not abstracted from the universe, but itself thoroughly enworlded/entangled]. Not only that, but the once clean demarcation between being and non-being no longer commends assent', he continues.[61] If in darkness we cannot see anything, such that that which is (being) does not exist, then the presence of darkness in all films (but a presence that is brought to the fore in Khavn's work) also suggests the indistinction between cinema and non-cinema, the indistinction between being and non-being.

And yet, we must hasten to add, humans do draw a distinction between cinema and non-cinema, as well as between being and non-being. This distinction, though, is not ontological (or if it is 'ontological' it is only so inasmuch as that which is, the ontic, is conditioned by that which is not, the non-ontic). Rather, the distinction is political. It is a political distinction in the sense that, much as the eye itself is historical, so is the very reality with which we reside: reality is defined by becoming, and so it has no fixity, and can always be different. Since reality can always be different, and since humans are not separate from, but a co-constitutional component of, reality, then so might we make a choice ethically – whether or not we succeed in bringing it about – to try to create a reality in which the contribution of that which seems not to exist is in fact recognized, at the very least by acknowledging its existence.

This act of recognition applies to the 'invisible' squatters of the Third World (the recognition of whom is defined by what Beller terms the 'squatterpunctum') as much as it applies to the invisible light that is the condition of vision itself. To try to see that which we cannot yet see, be it 'politically' (those excluded from, but necessary to, cinema-capital) or 'ontologically' (seeing darkness), might sound impossible, vain or just plain stupid. And yet, in a universe of becoming in which all is contingent and thus susceptible to (or inevitably in the process of) change, the division between the political and the ontological itself breaks down (since what is can be otherwise, then striving to make real something that is not yet, and of including within our conception of reality

that which is currently excluded – politics – are two variations on the same theme). Of course it sounds stupid to ask humans to transcend their current physical abilities and to 'see darkness', or to 'see a whole' that presently is invisible to them. (Grandy: light speed constancy 'has nothing to do with any particular thing *in* the cosmos; it is *of* the cosmos and therefore expressive of its fundamental nature'.)[62] And yet, becoming – evolution itself – is always only a journey into that which does not yet exist. As we bootstrap ourselves up to greater levels of consciousness regarding our reality – such that we at first become aware of the whole, perhaps by feeling it, before we eventually see it (just as eyes presumably developed from light-sensitive skin that initially only 'felt' light, before seeing it reflected off objects), so might we begin to ask of ourselves precisely the impossible. For, in an entangled universe of becoming, to ask the impossible is the most realistic task that we can set for ourselves. Seeing darkness, or seeing what mathematician Robert Kaplan, in reference to the concept of zero, calls the 'nothing that is', is what Khavn's films seem to ask us to do: to see the non-beings that are the squatter kids, and to see the darkness that invades his mise en scène.[63]

True to entanglement, Khavn is self-conscious about this process ('this is not a film'). Furthermore, in his use of darkness he asks us to consider how objects, including the cinematic image itself, are framed. This is brought forcibly to the fore in his documentary, *Philippine New Wave: This is Not a Film Movement*. Although somewhat unremarkable visually (certainly in comparison to the rest of his work), the film nonetheless features its interviewees in a frame within the frame of the screen, the image of the talking head surrounded, of course, by black. Introducing the phenomenological thought of Edmund Husserl to his consideration of light as experience, Grandy suggests that the German philosopher's concept of the *Lebenswelt*, or backdrop, might be a constant, or

> a kind of permanence that recedes from view so that impermanence or change may show up, and perhaps the obvious instance of such is a movie screen. The white homogeneity of the screen – its relative blankness – affords the play of shapes and colours that attract human interest, and those ever-shifting images may seem the very picture of visual autonomy: the presentation apparently begins and ends with their showing. But, of course, this attitude stares past the screen, whose featureless constancy functions as a kind of visual and mental absence – a kind of forgetfulness – against which images show up and appear to assume a reality all their own.[64]

In other words, Grandy draws precisely upon cinema in order to suggest how we understand light, while cinema itself, Khavn's (non-)cinema in particular, always suggests the 'invisible' screen that allows us to see.

Back to 'reality'

It might seem contradictory that I have been discussing darkness, and yet have turned my attention latterly to light. And yet while light exposes, light itself remains concealed, that is, it is in darkness: 'It remains in the erasures or clearings, but not in a self-showing way.'[65] Light, in other words, incessantly exceeds/excessively 'inceeds' into the world; it is, to use a metaphor, the 'black (w)hole'. Since we cannot 'see' it, we can perhaps only feel it (just as humans cannot see black holes, since light cannot escape from them; humans can only detect black holes by their effects on other things).

There is perhaps also a contradiction to be resolved in the fact that to suggest a 'whole' also suggests that ultimately there is a 'fixed' universe defined not by change, but by constancy (as light itself travels for Einstein at a constant speed). And yet, much as light itself is invisible to us, so is time, or change itself. Perhaps, then, the 'black whole' is not a thing so much as a process; the black whole is change itself, that which is invisible to us, and not the things changed that we see in our everyday lives. To encourage ourselves to 'see' change, this is perhaps the greatest service that cinema can pay to humans, and the greatest use to which humans can put cinema – an argument that of course chimes with that of Gilles Deleuze in *Cinema 2*.

Further, more mundane contradictions loom. Khavn, whom Beller describes as 'the father of digital cinema in the Philippines', may make profound films – but who ultimately watches them?[66] As Trice reminds us: 'This new cinema sits largely outside the domains of a "film industry," which is no longer a relevant means of categorising cinema production.'[67] However, these films' very lack of success, together with accusations that they are not very 'Philippine' might be a further reason why the Philippine New Wave in general, and Khavn's work in particular, constitutes a form of non-cinema.[68] One does not need commercial success in order to demonstrate what it is that cinema is or can do. One simply needs a film, and these films have been made, meaning that they are as valid as any other. Indeed, given the lack of support for these films, their existence is all the more remarkable. Beller concludes that

> the work of art functions as a network, a kind of connective tissue that enables experiences, links, and alliances that take viewers beyond themselves and toward an outside. It is a cybernetic engagement with the viewer, a kind of social reprogramming. The scale of the interventions in the contemporary is thus far, at least, that of the microperceptual, the momentary, the affective, and the spiritual rather than that of the macrostructures of class and nation. The capitalist world-media system, otherwise known as globalisation, finds its antithesis in subjective and affective links and practices that instantiate new orders of solidarity.[69]

In other words, being new, being non-cinematic, changing the rules of the game, making us rethink the nature of our reality: this is a process that inevitably starts small, without commercial success, and 'minor'. But it comes to affect the whole – because it is of the multitude.

Beller further suggests that 'the emergent digital does not simply represent a kind of aesthetic sea-change; rather, in some deeper way that we will have to make manifest, it is that change'.[70] The digital marks, then, the transition from cinema to non-cinema. Nonetheless, Beller asks, 'With the understanding that "the digital" may be among the most pernicious reifications of all time (right up there with "the human"), today we must pursue the following thought: what would it take to stage the confrontation between the fully capitalised world of representation and the horizon of the impossible such that the results were not merely convivial but transformational?'[71] For Beller, the human has become reified in the sense that we believe that humanity is fixed, rather than contingent, historical and thus able to change, including to change through our own conscious (ethical) involvement in changing ourselves as best as we can (i.e. imperfectly). The same is true of the digital: many believe that the digital is not indexical as a result of its 'ontological' divorce from reality (1s and 0s, not light imprinted on polyester). And yet, the digital is capable of achieving the squatterpunctum. We should not seek simply to accommodate digital films into a pre-existing worldview. Instead, we should unlock the potential in the digital to change our worldview, and to change our understanding of vision itself. This is what a digitally enabled non-cinema helps us, hopefully, to achieve.

The Philippines is an invented country, which reveals to us that all countries are invented, or what Anderson terms imagined communities. And yet, politically, countries are often presented to us as natural and unchanging. Khavn's non-films, however, help us to understand that everything (the black whole) is historical. As such, everything can change. Non-cinema may not be cinema, but it is cinematic; better, it expands what cinema is or can do, taking

cinema beyond itself, just as films also take viewers beyond themselves. Even with its most humble beginnings (small budgets, small audiences), non-cinema points to a 'black whole' beyond the partial world of cinema-capital. We have not yet quite reached the so-called end of history. There is still, therefore, hope. Or, in Beller's words, six billion flowers can bloom.[72]

Notes

1. Camilla Benolirao Griggers, 'Goodbye America (The Bride Is Walking…)', in *Geopolitics of the Visible: Essays on Philippine Film Cultures*, ed. Rolando B. Tolentino (Manila: Ateneo de Manila University Press, 2000), 297.
2. Anderson, *Imagined Communities*, 166.
3. Ibid., 26–32.
4. See Griggers, 'Goodbye America (The Bride Is Walking…)', 296–7.
5. Patrick D. Flores, 'The Dissemination of Nora Aunor', in *Geopolitics of the Visible*, ed. Tolentino, 87.
6. See Robert Silberman, '*Aliwan Paradise* and the Work of Satire in the Age of Geopolitical Entertainment', in *Geopolitics of the Visible*, ed. Tolentino, 277–89.
7. Alfred W. McCoy, 'RAM and the Filipino Action Film', in *Geopolitics of the Visible*, ed. Tolentino, 209.
8. Ibid., 216.
9. José B. Capino, 'Philippines: Cinema and Its Hybridity (or "You're Nothing but a Second-rate Trying Hard Copycat!")', in *Contemporary Asian Cinema*, ed. Anne Tereska Ciecko (Oxford: Berg, 2006), 43.
10. Jasmine Nadua Trice, *Transnational Cinema, Transcultural Capital: Cinema Distribution and Exhibition in Metro-Manila, Philippines, 2006-2009*, PhD thesis, submitted to the Department of Communication and Culture, Indiana University, August 2009, 266 and 287.
11. Rolando B. Tolentino, 'Cityscape: The Capital Infrastructuring and Technologisation of Manila', in *Cinema and the City: Film and Urban Societies in a Global Context*, ed. Mark Shiel and Tony Fitzmaurice (Oxford: Blackwell, 2001), 159.
12. Beller, *The Cinematic Mode of Production*, 64.
13. See Jean Vengua Gier, 'The Filipino Presence in Hollywood's Bataan Films', in *Geopolitics of the Visible*, ed. Tolentino, 35.
14. See Rolando B. Tolentino, 'Marcos, Brocka, Bernal, City Films, and the Contestation for Imagery of Nation', *Kritika Kultura*, 19 (2012), 115–38.

15. See William Brown, 'Non-cinema: Digital, Ethics, Multitude', *Film-Philosophy*, 20 (2016), 111.
16. Fredric Jameson, *The Geopolitical Aesthetic: Cinema and Space in the World System* (London: British Film Institute, 1992), 2.
17. Jameson, *The Geopolitical Aesthetic*, 82.
18. Ibid., 187. See also García Espinosa 'For an Imperfect Cinema', 24–6.
19. Christopher Pavsek, *The Utopia of Film: Cinema and Its Futures in Godard, Kluge, and Tahimik* (New York: Columbia University Press, 2013), 2.
20. Pavsek, *The Utopia of Film*, 82.
21. E. San Juan Jr, 'Cinema of the "Naïve" Subaltern in Search of an Audience', *Geopolitics of the Visible*, ed. Tolentino, 268.
22. Jonathan Beller, *Acquiring Eyes: Philippine Visuality, Nationalist Struggle, and the World Media System* (Manila: Ateneo de Manila University Press, 2006), 170.
23. Rolando B. Tolentino, 'Introduction', *Geopolitics of the Visible*, ed. Tolentino, xiii.
24. Beller, *Acquiring Eyes*, 4.
25. See Clotualdo del Mundo Jr, 'Philippine Movies in 2001: The Film Industry is Dead! Long Live Philippine Cinema!' *Asian Cinema* (Spring/Summer 2003), 173.
26. See Trice, *Transnational Cinema, Transcultural Capital*, 196 and 226.
27. Ibid., 84.
28. Beller, *Acquiring Eyes*, 195.
29. See Patrick D. Flores, 'The Long Take: Passage as Form in the Philippine Film', *Kritika Kultura*, 19 (2012), 74.
30. Joel David, 'Film Plastics in *Manila by Night*', *Kritika Kultura*, 19 (2012), 41–59.
31. Beller, *Acquiring Eyes*, 164.
32. Ibid., 179.
33. See Hardt and Negri, *Empire*.
34. Of coincidental note, a burning piano also figures prominently in Alejandro Jodorowsky's *Fandy y Lis/Fando and Lis* (Mexico, 1968), which David H. Fleming has considered as an example of 'unbecoming cinema', a concept that is related to non-cinema. See David H. Fleming, *Unbecoming Cinema: Unsettling Encounters with Ethical Event Films* (Bristol: Intellect, 2017). Fleming and I have also written jointly about unbecoming cinema in relation to Gaspar Noé's *Enter The Void* (France/Germany/Italy/ Canada, 2009). See William Brown and David H. Fleming, 'Cinema Beside Itself, or Unbecoming Cinema: *Enter the Void*', *Film-Philosophy*, 19 (2015), 124–45.
35. Fernando E. Solanas and Octavio Getino, 'Towards a Third Cinema', in *Movies and Methods Volume 1*, ed. Bill Nichols (Berkeley: University of California Press, 1976), 63.
36. Beller, *Acquiring Eyes*, 24.

37 Ibid., 25–6.
38 Caroline S. Hau, 'The Criminal State and the Chinese in Post-1986 Philippines', in *Geopolitics of the Visible*, ed. Tolentino, 233.
39 Jonathan Beller, 'Iterations of the Impossible: Questions of a Digital Revolution in the Philippines', *Postcolonial Studies*, 11:4 (2008), 439.
40 Beller, 'Iterations of the Impossible', 445.
41 Virno, *Grammar for the Multitude*, 52.
42 Ibid., 53.
43 Ibid., 69.
44 Ibid., 70.
45 Ibid., 71.
46 Trice, *Transnational Cinema, Transcultural Capital*, 203–5.
47 Beller, 'Iterations of the Impossible', 447.
48 Ibid., 448.
49 Ibid.
50 Trice, *Transnational Cinema, Transcultural Capital*, 128.
51 See Brown, 'Non-Cinema'.
52 Grandy, *The Speed of Light*, 45.
53 Ibid., 26.
54 Ibid., 41.
55 Ibid., 45.
56 Ibid., 51.
57 Ibid.
58 Ibid., 56.
59 Ibid., 73.
60 Brown, *Supercinema*, 44.
61 Grandy, *The Speed of Light*, 88.
62 Ibid., 134.
63 Robert Kaplan, *The Nothing that Is: A Natural History of Zero* (Oxford: Oxford University Press, 2000).
64 Grandy, *The Speed of Light*, 121–2.
65 Ibid., 164.
66 Beller, 'Iterations of the Impossible', 438.
67 Trice, *Transnational Cinema, Transcultural Capital*, 269–70.
68 See Capino, 'Philippines', 40, and Trice, *Transnational Cinema, Transcultural Capital*, 257.
69 Beller, *Acquiring Eyes*, 267.
70 Beller, 'Iterations of the Impossible', 436.
71 Ibid., 249.
72 Beller, *Acquiring Eyes*, 267.

5

Digital Acinema from Afrance

I did not remember much of the plot of Alain Gomis's *L'Afrance* (France/Senegal, 2001) after seeing it for the first time at the Ritzy cinema in Brixton, London, in November 2013. I knew that the film is about a Senegalese man, El Hadj Diop (Djolof Mbengue), who has been studying in France for several years, and who faces deportation for not renewing his visa in time. However, my memory of the screening was – and continues to be – dominated by the fact that we must have been watching a DVD projection of the film rather than a good-quality print. I suspected this because throughout the film, especially during scenes set at night or in darker interiors (of which there are many), I could not make out El Hadj from the background that surrounded him. That is, he and other dark-skinned characters in the film (of whom there are several) regularly appeared to be simply monochromatic, literally black (as opposed to, precisely, dark-skinned) figures – without detail, without nuance, and without skin tone. In effect, El Hadj and various other characters became invisible. Given that Olivier Barlet has written of *L'Afrance* that 'the film embraces the black skin: a sensuality devoid of eroticism that demonstrates, that unambiguously incarnates the belonging to a social body, to society', then the fact that in this screening El Hadj and others seemed precisely not to belong to society as a result of their invisibility would suggest an exclusion as a result of the technological conditions of the screening.[1] What is more, exactly the same thing happened the second time that I saw *L'Afrance* via Box of Broadcasts (a national online archive run by the British Universities Film and Video Council).

L'Afrance was not shot digitally, although Gomis used digital cameras for his subsequent *Tey/Aujourd'hui* (France/Senegal, 2013). Nonetheless, the digital conditions of the two screenings described above (first on DVD, and then online) hopefully allows me to suggest that the digital crystallizes the racial limitations of cinema, and how black skin belongs not to cinema, but to non-cinema. As a continuation of the last chapter, this chapter therefore aims to look at darkness

in relation to the human body; that is, as an issue of race, especially as it relates to issues of the nation within the context of European, here French, colonialism and francophone African post-colonialism. I shall do this by looking at Gomis's work, before then considering the digitally shot films *Wesh wesh, qu'est-ce qui se passe?* (Rabah Ameur-Zaïmeche, France, 2001) and *Baise-moi/Rape Me* (Virginie Despentes and Coralie Trinh Thi, France, 2000). The latter film is notorious as an example of European 'extreme' cinema, where I shall argue that cinema meets its extremities and pushes into non-cinema. From *Baise-moi*, I shall pass on to the equally 'extreme' cinema of Philippe Grandrieux, whose digitally shot *Sombre* (France, 1998) has, after Jean-François Lyotard, been considered 'acinema'.[2] Since 'acinema' is a theoretical precursor to non-cinema, I shall explain the similarities and differences between Lyotard's concept and my own, with the chapter thus progressing from afrance to acinema via a series of challenging films shot with digital cameras.

Becoming cinematic

Richard Dyer suggests in *White* that in cinema race is 'never not a factor, never not in play'.[3] Whiteness, he demonstrates, is constructed, especially in photographic media, as part of a system of 'imperialism and domestic control' that has, for example, used biological race research as a means 'to know, fix and place the non-white rather than ... to establish the characteristics of whiteness'.[4] In other words, we continue to live in what Dyer refers to as 'the white era'.[5]

Jonathan Beller, meanwhile, has similarly suggested that photography might inherently be racist, in the sense that photography, racism, colonialism and slavery are all part of a history of objectification – the making-object of a human such that they are deprived of humanity and can instead be considered simply as the means to the end of profit, or surplus value – with slavery being as close as humanity has got to the rendering into pure surplus value of some human beings by others.[6] The 'white era', therefore, is also the era of racism, colonialism, slavery, photography and, by extension, cinema.

With regard to the latter, Dyer demonstrates how cinematography, with photography and other aesthetic uses of light before it, has historically been devised in order to light white, as opposed to black, skin: 'The apparatus was developed with white people in mind and habitual use and instruction continue

in the same vein, so much so that photographing non-white people is typically construed as a problem.[7] More than this, though, is the fact that

> movie lighting valorises the notion of the unique and special character of the individual, of the individuality of the individual ... Further, movie lighting hierarchises. It indicates who is important and who is not. It is not just that in white racist society, those who are not white will be lit to be at the bottom of the hierarchy, but that the very process of hierarchisation is an exercise in power.[8]

In other words, film lighting, a technique that we might normally consider to be completely 'innocent', is in fact caught up in the creation of hierarchies and thus the exercising of power. That is, traditional film lighting not only privileges certain individuals over others, but also privileges the very notion of the individual over other ways of thinking about being in the world (such as a sense of collective, communitarian identity). Finally, traditional film lighting also has a racial dimension because the apparatus favours white over black skin. This racial dimension is rendered especially problematic (if not downright dangerous) when a moral dimension is given to film images, in that light/white stand for goodness and dark/black for evil/badness. The validation of whiteness – to the point of its goodness being normalized – is in other words the validation and the rendering natural of a system of exploitation and the separation of different humans into individuals such that those individuals can in turn be placed in a hierarchy that in general functions along the lines of the human being more powerful, more 'real' even, if they have more money – and if they are, in Beller's terms, more visible as a result of having more attention paid to them.

It is not that cinema simply reflects a society that favours whiteness. Furthermore, it is not simply that the technology used to make films 'neutrally' records what is before it, even if this has been one of the founding myths of film theory (a myth linked to that of indexicality). Rather, as Dyer puts it, 'The aesthetic technology of the photographic media, the apparatus and practice *par excellence* of a light culture, not only assumes and privileges whiteness but also constructs it.'[9] That is, traditional lighting methods and the tools traditionally used to make films more generally not only reflect but also feed back into ('construct') a world in which whiteness is linked to power and goodness, and in which becoming white, cinematic and/or light is a way of succeeding under capitalism.

To become cinematic or to 'become light' is thus a process undertaken for the purposes of (self-)empowerment; in making one's life cinematic, in

becoming light, one becomes validated both as 'real' and one gains money via the reception of attention. However, becoming cinematic also involves a loss of corporeality; one becomes an image, or an ideal, as opposed to a flesh and blood person. Within cinema, this is made clear by Dyer's distinction between shine and glow. For Dyer, women are made in cinema to glow, or to seem via up- and back-lighting as though light emanates from them (they have become light), as opposed to shining, or reflecting light – with the reflection of light thus confirming that they have a body. As Dyer makes clear, non-white skin tends to shine as opposed to glow under traditional film lighting, meaning that the black human is defined more by their body (shine suggests a body) than by their 'ethereal' qualities (glowing suggests 'something heavenly').[10] As a result, it is perhaps 'logical' that cinema historically has depicted black humans as 'mere' bodies, or objects, which (as opposed to who) simply perform work, rather than as possessing intellectual or spiritual qualities. In effect, a history of slavery is inscribed into cinema's traditional lighting system.

Now, all humans need a body. However, cinema-capital constructs whiteness, cinema and/or becoming light as the bodiless goals towards which as many bodies as possible must be encouraged or coerced to strive, as well as by the pervasion of cinematic/light/white culture via ubiquitous screens. And if cinema-capital is constructed as whiteness or light, then blackness is non-cinematic, as my first two viewings of *L'Afrance* made clear: the quasi-invisible black characters did not quite shine, and certainly did not glow, but instead seemed to absorb light, like a black hole.

In becoming invisible, El Hadj and his companions are non-cinematic, which is fitting for a film that highlights how they also are non-French ('a-french'), with the nation being an important component of the system of cinema-capital. And yet, as black skin (most clearly in the form of slavery) has made a crucial historical contribution to the global dominance of white/light society, so does *L'Afrance* suggest, via the illegal construction work that El Hadj is forced to undertake once his visa has not been renewed, that the very fabric of France would not exist without (black) people like him. In other words, blackness and whiteness are entangled, and Africa and France are intertwined such that we have not only not-France (a-France), but also Africa and France in one (Afr-ance).

At the height of the independence movements of African countries, Frantz Fanon argued that 'Europe is literally the creation of the Third World' and not vice versa – in the sense that

Europe has stuffed herself inordinately with the gold and raw materials of the colonial countries: Latin America, China, and Africa. From all these continents, under whose eyes Europe today raises up her tower of opulence, there has flowed out for centuries toward that same Europe diamonds and oil, silk and cotton, wood and exotic products The wealth which smothers her is that which was stolen from the under-developed peoples.[11]

However, if cinema constructs whiteness as separate from other colours and if cinema constructs the nation as separate from other nations, then this entanglement, or the recognition of this exploitative history in which we see that the wealth of the West is dependent on theft from the rest of the world, is perhaps better found in non-cinema.

Black film, white cinema

El Hadj is writing a thesis on Ahmed Sékou Touré, who was the first president of Guinea and who played a key role in gaining that country's independence from France in the period in which Fanon was writing. Having forgotten to renew his student visa, El Hadj faces deportation. As the courts decide his fate, El Hadj starts a relationship with a white Frenchwoman, Myriam (Delphine Zingg), who works in art restoration, while also starting to work illegally – although El Hadj is not really cut out for manual labour. Myriam suggests that they could marry, but El Hadj rejects this option, instead briefly contemplating getting a fake identity through his Algerian friend Khalid (Samir Guesmi), before finally returning after six years away to Dakar in Senegal, where his family lives and where he also left behind a woman, Awa (Joséphine Mboub), whom he was promised to marry, but who may no longer be waiting for El Hadj.

The film opens with a close-up of El Hadj against a yellow/orange background as he listens to an audiocassette sent to him from Dakar by his father. We cut to shots of his father narrating, before we see a brief sequence of El Hadj in the shower (which will become a repeated motif in the film), and then a flashback to a young El Hadj at school, and high-angle shots of the streets of both Paris and Dakar. Soon after, El Hadj attends the wedding reception of a friend who has married a white woman, during which we hear discussions about life in Paris, intermixed with brief sequences from El Hadj's past and present, including his participation in a non-white football team as well as images of Patrice Lumumba, the Congolese independence leader and that country's first democratically

elected prime minister – who like Sékou Touré becomes a recurring figure in the film.

The effect of the film's opening moments, which cut rapidly between the past and the present, between Paris and Dakar, is somewhat dislocating, embodying formally the sense of dislocation that El Hadj himself feels. He is tired of being a foreigner, he says, before affirming that he is also tired of being regarded as black and considers himself to be Senegalese. Nearer the end of the film, El Hadj also says that he considers himself to be both French and African, while at one point proclaiming (drunkenly) that he is no one's son, which suggests dislocation from his cultural heritage. Indeed, when El Hadj returns to Senegal at the end of the film, he explains to his father (Thierno Ndiaye Doss) that he will return to France once again.

Carrie Tarr describes *L'Afrance* as French, while Melissa Thackway sees it as belonging to 'contemporary sub-Saharan francophone African filmmaking'.[12] Formally, thematically and in terms of its reception, then, *L'Afrance* moves between France and Africa/Senegal in a somewhat schizophrenic fashion, suggesting both a-france and afr-ance, or what Carrie Tarr calls 'an impossible, negative hybrid space'.[13] However, in El Hadj's final expressed desire to return to France, do we not see an affirmation of France's centrality – thereby also affirming Senegal's 'inferiority'?

As much also is suggested by El Hadj's friend Demba (Théophile Sowié), who bemoans how when he is back in Senegal he gets treated like a foreigner, or as if sick, and that he is 'eaten alive' by his family and friends, who rapidly take all of his money. It feels just like a film, Demba pointedly argues, in that it feels as though he is not really there. Demba feeling like an outsider in what he claims is his homeland bespeaks not just the fact that France and Senegal are so vastly different that he cannot assimilate when he returns to Senegal. Equally, it bespeaks the fact that Senegal has, via colonialism, taken to heart some of capital's most important lessons – namely the erection of boundaries and the treatment of other human beings not as human, but as a source of money to be exploited. The exploitation is petty, perhaps, and an expression of disempowerment. Nonetheless, it also expresses the desire to buy into the system of power that is cinema-capital – hence Demba feeling that going home is like being in a film, with cinema itself historically a tool for abstracting humans from each other and from their environment (cinema as providing 'objective observation' instead of entanglement).

This final centrality of France might find succour in Fanon, who suggests that

every colonised people – in other words, every people in whose soul an inferiority complex has been created by the death and burial of its local cultural originality – finds itself face to face with the language of the civilising nation; that is, the culture of the mother country. The colonised is elevated above his jungle status in proportion to his adoption of the mother country's cultural standards.[14]

Not only might Demba and El Hadj both want to stay in or return to France, thus feeling less inferior, but cinema itself is a technology as well as a cultural form that comes from the 'mother country' (France, where the name of the inventors of cinema, Auguste and Louis Lumière, coincidentally/appropriately enough means 'light'), meaning that it is precisely via cinema – as opposed to non-cinema – that the colonized people (and Gomis) can rise above their 'jungle status'. Fanon continues:

There is a fact: White men consider themselves superior to black men.

There is another fact: Black men want to prove to white men, at all costs, the richness of their thought, the equal value of their intellect.

...

However painful it may be for me to accept this conclusion, I am obliged to state it: For the black man there is only one destiny. And it is white.[15]

In other words, in returning to/staying in France, the destiny of Demba and El Hadj is white. Furthermore, as a film, *L'Afrance* itself pursues a white, cinematic destiny, with France/the nation reaffirmed as centre.

However, I shall presently show that *L'Afrance* does not quite reaffirm France as centre, thereby rendering it an example not of cinema but of non-cinema. El Hadj shouts while taking a shower that he will remember his promise to resist assimilation to the French way of life. Furthermore, he also asks himself about how many people lie about France when they go home to Senegal, having worked hard and saved up in order to lord it over the people whom they have left behind, proclaiming France to be some sort of El Dorado, where riches await and are easily accessible. In other words, El Hadj is caught between two worlds that are both defined by capital. Now, while there clearly is an imbalance of wealth and power between France and Senegal, ironically it is by being between these two cultures that El Hadj, whether he likes it or not, finds himself excluded more fundamentally by capital. This is rendered in a telling shot of El Hadj reflected in the window of a gymnasium in which white people use exercise machines. El Hadj is a disembodied spectral presence, a reflection, invisible.

El Hadj quotes Sékou Touré at one point, saying that 'we have proven our desire for liberation, and our incapacity to exist outside the French context'. France cannot simply be ignored or forgotten, even if one wants liberation from the colonial centre. In part this is because, while 'inferior', Senegal is itself (perhaps simply as a result of being a nation) complicit with capital. El Hadj therefore is not at home back in Dakar, but must continue to exist in his interstitial, nomadic, exilic state in Paris, since it is only 'between' Paris and Dakar, in 'l'afrance' that he can exist in the state of resistance against the centre that is his stated aim – even if this has been the source of much unhappiness during the film. In this sense, we can read *L'Afrance* as an example of intercultural cinema as defined by Laura U. Marks.

Towards the end of *The Skin of the Film: Intercultural Cinema, Embodiment, and the Senses*, Marks writes that

> popular cinema and television attempt unproblematically to deliver a world of senses to the viewer; travelogues, conventional ethnographic films, art-house imports, and other films present a foreign culture with seeming transparency. Occasionally intercultural films and videos do this as well, in a sort of neocolonialist gaze at their own (or former) culture. Such works, directed to a viewer perfectly comfortable in the dominant culture, represent sense knowledges as commodities, *supplements* to the wealth of the viewer's other resources. Intercultural cinema, in contrast, represents sense knowledges from a position not of wealth but of scarcity, as the precious vessels of memory. These knowledges, difficult to recall and to represent cinematically, will not be available to every viewer. Thus intercultural cinema troubles the ease with which we approach culture not our own.[16]

In other words, for Marks the power of intercultural cinema comes with its emphasis not on the visual – the sense of disembodied, detached and objective observation – but instead on the haptic, especially the sense of touch as it can be evoked/induced by film. Here, then, comes the importance of El Hadj's repeated showers and other interactions with water: it is as if Gomis wants to evoke, especially through images of flowing water, the *feeling* of El Hadj's nomadic, unstable and fluid identity/status. And in producing a film that emphasizes feeling rather than looking, Gomis also produces something non-cinematic (if cinema is defined by 'objective' looking rather than entangled feeling).

In this way, Gomis potentially also dodges the issue of 'adopting the mother country's cultural standards', as Fanon would put it. He surely makes a film, but it is a black film in the midst of an otherwise white cinema. *L'Afrance* may not

have been shot on DV, but the digital screenings that I saw draw out the non-cinematic qualities that are manifested in Gomis's film.[17] As we shall see, these non-cinematic qualities are also present in digital films about post-colonial immigrant populations in France, including *Wesh wesh, qu'est-ce qui se passe?* and *Baise-moi*.

The long, slow process of low-budget digital film-making

Dyer considers lighting techniques for analogue cameras. In the digital era, there is some debate regarding whether the same issues arise in terms of lighting. Lorna Roth, for example, outlines like Dyer the way in which 'non-"Caucasian" communities identified shortcomings and became more critical and questioning of their [photo technologies'] visual quality'.[18] Roth goes on to argue that

> evidence has been accumulating that the reason for these deficiencies [facial images without details, lighting challenges, and ashen-looking facial skin colours contrasted strikingly with the whites of eyes and teeth] is that film chemistry, photo lab procedures, video screen colour balancing practices, and digital cameras in general were originally developed with a global assumption of 'Whiteness' embedded within their architectures and expected ensembles of practice.[19]

In other words, for Roth the same issues persist in the digital era, as the digitized images of *L'Afrance* and the loss of El Hadj's features would suggest.

Nonetheless, the digital era has also involved the development of cameras that can capture a much greater range of skin tones and without having to resort to techniques like using different lighting systems or, as historically might have happened, smearing the black actor's skin with Vaseline in order to reflect light (i.e. to shine but not to glow).[20] Not only does the digital challenge this racial history of cinema, then, but its ready availability also means that many more people can make a film. Barlet suggests, for example, that 'thanks to digital technology young amateur filmmakers no longer require outside intervention to create the images that they are trying to distribute beyond their close circle of friends'.[21] However, Barlet then slams this amateur film-making, validating instead a more traditional auteur cinema. In other words, perhaps this amateur film-making does not qualify for Barlet as cinema. Perversely to agree with Barlet, though, maybe we can productively think about this work as non-cinema.

Wesh wesh, qu'est-ce qui se passe? tells the story of Kamel (Ameur-Zaïmeche himself), who arrives illegally in France after having spent two years in Algeria after deportation following a five-year prison sentence. In facing deportation at the end of his prison sentence, Kamel is a victim of the *double peine* (being punished for the same crime twice), a punishment felt to be particularly unjust in France towards those who were born in, say, Algeria, but who, like Ameur-Zaïmeche himself, moved to France as a young child and thus have in many respects lost contact with (what French law deems to be) their 'home' nation.[22]

Wesh wesh, qu'est-ce qui se passe? took several years to make, with Ameur-Zaïmeche working closely with friends and family outside of the French film industry, and on location in and around the Parisian suburb/*banlieue* of Les Bosquets.[23] Shot on DV, the film also features acting of a distinctly amateur and heavily improvised quality. This is evident in scenes that repeatedly last longer than their narrative purpose, with the camera lingering on characters who banter with each other about various goings on. For example, a group of locals hanging on the steps into one of the *cité*/housing estate's graffiti-strewn apartment blocks joke about how teacher Irène (Serpentine Textier) is in a relationship with Kamel after the former has gone inside to find the latter's family home (their apartment is on the fourth floor by the lift). Often the actors repeat their lines, lending to the film not only a sense of realism (in reality people regularly repeat themselves), but also a sense of the amateur, only quasi-scripted nature of the film. What is more, the actors, including Ameur-Zaïmeche, not only speak in a mixture of Arabic and French, but their French is also heavily vernacular, using especially terms from *verlan*, a 'back slang' in which the syllables of words are reversed (with *verlan* itself being *verlan* for *l'envers*, meaning 'the other way round'). In addition, rather than enunciate like trained actors, the characters regularly mumble, while the overall sound design is in some of the locations not clear at all (e.g. Kamel briefly discusses the *double peine* with a friend in a café near the film's beginning; although we can hear what the characters are saying, their words do not stand out clearly against the ambient noise that surrounds them). Finally, we also see the shadow of the camera on the backs of one of the characters when police officers pull over and search a car in which ride Kamel's brother, Mousse (Ahmed Hammoudi), and some friends.

In addition to these technical imperfections, *Wesh wesh, qu'est-ce qui se passe?* has a structure that we might at best describe as episodic, in that the film consists of fragments of life from the *cité* rather than of a coherent cause-and-

effect-driven narrative. Indeed, the only 'plot point' that gets put into motion in the film is when Mousse and friends beat up a drug addict, Kader (Christian Milia-Darmezin), from whom they earlier buy some golf clubs, which prompts a relatively surreal sequence in which they attempt to play golf around the *cité*. Sore from being beaten, Kader explains to a cop that Mousse is the local drug kingpin – something barely apparent if we are to expect guns and bling from drug dealers, even though Kader describes Mousse's place as like 'Ali Baba's cave'. Cue a police raid on Kamel and Mousse's family home, during which Kamel's mother is hurt and Mousse is arrested (as he is led away, Mousse delivers the line from which the film takes its title: *Wesh wesh, qu'est-ce qui se passe?* – which might translate as something like 'wassup, y'all?'). Kamel tracks down the cop that put his mother in hospital, beats him with a motorcycle helmet and then rides off on a motorbike that he has taken for a test drive. We see numerous cops in and around the *cité* (they are more or less a constant background presence), before Kamel gets into a car. Some police officers drive after him. We see Kamel and the police officers running through a wood. A long shot of a lake where Kamel earlier went fishing, and where he met up with Irène. Two gunshots ring out – and the film ends after a brief montage of people in the *cité* and a tracking shot along one of its streets, which ends with a pan up into an overcast sky, the screen thus turning white.

Will Higbee argues that the episodic narrative is a 'well-trodden path' for second-generation Maghrebi French, or *beur*, and *banlieue* film-makers.[24] Carrie Tarr, meanwhile, finds the film more unusual for its use of green spaces and the relationship between Kamel and Irène.[25] Finally, Alison J. Murray Levine defines the film through its 'defiantly proud' soundtrack, which features music by local rap groups like Assassin and N.A.P.[26] While the film might be 'well trodden' for Higbee, I might however side more with Tarr and Murray Levine, especially by evoking the long gestation of the film. As explained by co-screenwriter Madj(id) Benaroudj, whom Martin O'Shaughnessy identifies as a major figure in French hip hop,

> You have to remember that, when we started writing the film, *La Haine* [Mathieu Kassovitz, France, 1995], *Ma 6-T va crack-er* [Jean-François Richet, France, 1997] and *Raï* [Thomas Gilou, France, 1995] hadn't been released. There was only *Hexagone* [France, 1994] by Malik Chibane, and *Le Thé au harem d'Archimède* [France, 1985] by Mehdi Charef.[27]

That is, *Wesh wesh, qu'est-ce qui se passe?* does not follow a 'well trodden' path at all.

However, while Higbee, Tarr and Murray Levine all situate the film (for better or worse) within a tradition of *beur* and *banlieue* cinema, I wish to suggest that the imperfect or 'unpolished' nature of the film, combined with its digital grain and its episodic, non-narrative structure, might exemplify a more general non-cinema.[28] The film's status as 'non-cinema' is affirmed by the non-industrial (and lengthy) production of the film, which 'take[s] place in the interstices of the French film industry'.[29] The film thus succeeds in 'evading systemic pressures'.[30] Furthermore, it is in the words of another ethnic minority film-maker, Zaïda Ghorab-Volta, a film 'outside the system'.[31] But where Ghorab-Volta's first film, *Jeunesse dorée* (France, 2001), was shot on 35 mm, Ameur-Zaïmeche works digitally (i.e. even further outside the system). Furthermore, where *Jeunesse dorée* opens with an extended (cinematic) crane shot around a *cité* tower block, Ameur-Zaïmeche must work at a far more pedestrian, (non-cinematic) street-level and pace.

What is true formally of *Wesh wesh, qu'est-ce qui se passe?* is also true thematically, in that the film's status as non-cinema reflects the relative 'non-being' of Kamel, Mousse and others as they struggle to find legitimate work and/or feel at home in France. 'It is evident', argues Tarr, 'that ... [this film has] difficulty in finding a place for ... [its] *beur* (and other *banlieue*) protagonists to settle.'[32] Indeed, during a brief sequence from the point of view of some of the police officers who patrol Les Bosquets, we hear them describe some of the local youths as *racaille*, which translates most commonly as 'scum'. This term has come to be associated with a statement made on 25 October 2005 by Nicolas Sarkozy, who at the time was interior minister and who described as *racaille* young troublemakers in Argenteuil, another Parisian *banlieue*.[33] Now, *Wesh wesh, qu'est-ce qui se passe?* was released before Sarkozy made this statement, and so it cannot be a direct reference. Nonetheless, Ameur-Zaïmeche seems clearly to demarcate what the police, as representatives of the state, think about inhabitants of *cités* like Les Bosquets. That is, as 'scum' they seem to be less than human – and thus are excluded from society, as made clear by the film's ending in which Kamel not only is killed, but his death itself takes place off-screen (i.e. he is, in an echo of his *double peine*, doubly excluded). Neither French nor Algerian, Kamel is, like El Hadj, non- or a-French. Uprooted, outside of the nation and thus outside of cinema, perhaps only non-cinema can express Kamel's plight.

If non-cinema is a useful framework through which to think about *Wesh wesh, qu'est-ce qui se passe?* and France's minority ethnic population, then it is also a useful framework through which to think about digitally shot films like

Baise-moi, which is about the role of women, including minority ethnic women, in France.

The monstrosity of *Baise-moi*

Baise-moi tells the story of two young women, Nadine (Karen Bach) and Manu (Raffaëla Anderson), who go on a road trip around France. To this extent, *Baise-moi* bears some resemblance to the aforementioned *Jeunesse dorée*, which also tells the story of two young women, Gwénaëlle (Alexandra Jeudon) and Angela (Alexandra Lafrandre), who similarly go on a road trip around France. However, as *Wesh wesh qu'est-ce qui se passe?* is non-cinema in relation to *Jeunesse dorée*'s cinema, so is *Baise-moi* – as a brief comparison might help to clarify. For, if Gwénaëlle and Angela go around France shooting people with cameras as they complete a photography project for school, in *Baise-moi* Nadine and Manu go around France shooting people with guns as revenge for the violence that they endure before and at the film's outset. Both films have a *banlieue* aspect, since sequences of *Baise-moi* are shot in Juvisy-sur-Orge, from which the main characters, a white and a *beur* woman, attempt to escape. And yet, *Jeunesse dorée* is a sweet and charming tale that may well go against most films from/about the Parisian *banlieues* by featuring white lead characters and no violence whatsoever, but it is precisely 'cinematic' for its sweetness and its whiteness.[34] *Baise-moi*, meanwhile, is a graphically violent film that is hard to like, even if it also seeks to avoid cliché through its unusual depiction of friendship across racial boundaries. Indeed, the white Nadine and the *beur* Manu come together through suffering in a patriarchal and objectifying society – which in turn seems incapable of tolerating their friendship, even though it has helped to create it. Intolerable to society, the mixed race female solidarity enjoyed by Nadine and Manu is thus in some senses intolerable to cinema. If *Jeunesse dorée*, despite being 'outside the system', is cinema as a result of its highly cinematic crane shots and its story of two white girls empowered through their use of cameras, then *Baise-moi* is like *Wesh wesh, qu'est-ce qui se passe?* even further outside the system, such that it becomes non-cinema as a result of its monstrous violence and grainy digital images, as we shall explore below.

Nadine kills her relationship-obsessed flatmate (Delphine McCarty), steals her rent money, and travels to Juvisy, where she has a meeting with a dealer friend, Francis (Patrick Eudeline). Meanwhile, Manu (Raffaëla Anderson)

hangs out with a junky friend (Lisa Marshall), before three men kidnap and rape them in a warehouse. When Manu's brother (Hacène Beddrouh) surmises that she has been sexually assaulted (not for the first time), he begins to accuse her of enjoying it, which prompts Manu to shoot him with a gun that he has left lying around. Crossing paths late at night at Juvisy station, Manu asks Nadine to drive her out of the *banlieue* and into Paris in a stolen car, before changing her mind and demanding at gunpoint that Nadine drives her to the coast. Nadine recognizes Manu from a porn film, and, arriving early the next morning on the coast, they begin to bond. The pair dance in their underwear in a hotel room, before holding up a shop and killing a woman at a cashpoint. There follow the murders of various policemen, an architect (Marc Rioufol), and the patrons of a swingers club, including a racist man whom they anally penetrate with a gun. Since the murder spree is attracting media attention, the two women gain some notoriety, and Manu is shot when recognized by the owner of a tyre shop. This prompts Nadine, having killed the shop owner, to take Manu's body to the coast again – where she attempts suicide, but is arrested before being able to succeed.

Various aspects of *Baise-moi* are harrowing to watch, including many of the murder scenes, the generally depraved atmosphere of the film (one gets the impression that Manu's fellow rape victim and Francis, for example, could be genuine junkies given their haggard look combined with the non-professional quality of their acting), and the pervasive violence of the language adopted by nearly all of the people whom Nadine and Manu encounter. However, nothing is more harrowing, at least for this viewer, than the prolonged rape scene that lasts an excruciating three minutes near the start of the film. In particular hard to watch is the combination of visibly erect penises penetrating vaginas, combined with the pleas and physical struggle of Manu's friend for this to stop and the abusive language of the rapists. It is hard to fathom how anyone would be able willingly to take part in the creation of such a scene, and yet this is what we have before us. The grimy interior of the warehouse, together with the non-professional acting (or rather, acting carried out – 'badly' according to Linda Williams – by a range of porn actors, 'decidedly not ready for crossover') and the aforementioned grain of the DV images all add to the unpleasant nature of the scene.[35]

The film might in some respects blur the line between fiction and documentary (these are genuine penises that are genuinely erect during the filming of a scene in which the actors are all 'simulating' rape), but it also specifically exploits the

'dirty/impure/imperfect' DV aesthetic in order to give to viewers a deliberately constructed sequence. That is, this is a scene that takes place in a fiction film. Nonetheless, the film shows to us something harrowing, a rape, and in (almost) unflinching detail, such that the film becomes cruel as the viewer is forced to confront (should he remain in the auditorium) the fact that rape exists and that it is our fellow conspecifics, people equally as human as anyone else, including ourselves, who both perpetrate and endure such acts. In effect this monstrous moment suggests that the distinction between humans and monsters is potentially false.

I use the terms monstrous and monster deliberately. For there is a link to be made between the act of showing, often referred to in film scholarship as *monstration*, and the act of telling, which arguably falls under monstration's 'opposite' term, narration.[36] I have written at length about the 'monstrous' nature of digital cinema, and so might here simply recap how, in the same way that André Bazin sees cruelty as being linked to the absence of cuts, so, too, does Deleuze see the rise of *montrage* (from the French, *montrer*, to show, a word that is linked etymologically to monstration) as being in opposition to *montage/editing*.[37] In monstrating monstrous acts, *Baise-moi* moves away from narrative cinema (cinema 'proper') and towards an improper cinema, perhaps even a non-cinema.

Sombre acinema

As an 'extreme' film, *Baise-moi* is invested in exploring the limits of cinema. Digital technology allows film-makers to explore difficult themes for less money, and thus with less risk of losing money not by alienating, but rather by overly affecting their audience. Furthermore, lightweight and portable digital cameras allow access to intimate spaces and 'monstrous' experiences. Typically, we do not see such 'monstrosity' in mainstream cinema. That is, mainstream cinema might feature much violence and sexual violence, but it typically is not shown to us in the 'monstrous', unflinching style that the digital seems to encourage. Different from mainstream cinema, digitally enabled 'extreme' films like *Baise-moi* might be better understood not as cinema, then, but as non-cinema. What is more, that a film like *Baise-moi* explores issues of race and class in its story of two women escaping from the *banlieues* also allows us to consider how France's ethnic minority population, and perhaps even its

lower classes more generally, are often excluded from mainstream cinema. They can instead be found more clearly in non-cinema.

I shall end this chapter with a consideration of another 'extreme' French film-maker, Philippe Grandrieux, who also works outside of conventional, narrative cinema, and whose films, including *Sombre*, have been considered an example of what Jean-François Lyotard has defined as 'acinema'.[38] Comparing and contrasting acinema (and Akira Mizuta Lippit's off-shoot term 'ex-cinema') with non-cinema, this section nonetheless allows us to complete the journey from afrance through to acinema, a journey that highlights how the nation is tied to cinema (afrance is to acinema as France is to cinema).

For Lyotard, learning how to make films involves eliminating many of the possibilities of what cinema is or could be. That is, a film-maker might discard shots that are 'dirty, confused, unsteady, unclear, poorly framed, overexposed'.[39] The purpose for discarding these takes is because they have no obvious value. They have no obvious value because they do not feature easily recognizable objects; and if cinema is (like capital) the movement of objects so that they are 'exchangeable against other objects', then cinema is a succession of (images of) objects one after the other.[40] The (images of) objects are produced, consumed and then replaced in order to satisfy the new demand created by the space left after consumption. In this respect, cinema is defined by the concept of return on various levels, with return meaning repetition of the same: box office returns, the return to the norms of film-making, and thus the repetition of certain types of film.[41]

Lyotard suggests that he is 'hardly about to form a club dedicated to the saving of rushes and the rehabilitation of clipped footage', a task that instead has fallen to film-makers like Bill Morrison, whose *Decasia* (USA, 2002) is made up precisely of otherwise discarded rushes.[42] Instead, Lyotard proposes a cinema made not for money, but for no purpose, or for 'fun'.[43] A 'fun' film might also be a film made to see what happens (an 'experimental', an 'errant', or an 'essay' film), rather than one made for the purposes of the continued circulation of money. With regard to specific techniques, Lyotard suggests that both excessive mobility and the freeze frame can take us in this direction, since they both subvert the norms of representation, which features the regular return of images at the same rhythm, images that themselves return, in the sense that they are of recognizable objects, which themselves might repeat, in this sense that we see the same types of objects within and across films.

Lyotard proposes that such moments of excess mobility and immobilization not only disrupt the regular rhythm of a film, but also bring to mind the 'nothing' that supports capital. Lyotard's point is somewhat obscure, but he suggests that when a film's 'transparency' (by which he means the ease with which we can recognize the objects that we see) is clouded, then something interesting is revealed:

> Thus the memory to which films address themselves is *nothing* in itself, just as capital is nothing but an instance of capitalisation; it is an instance, a set of empty instances which in no way operate through their content; *good* form, *good* editing, *good* sound mixing are not good because they conform to perceptual or social reality, but because they are a priori scenographic *operators* which on the contrary determine the objects to be recorded on the screen and in 'reality'.[44]

Films are not good because they are realistic. Films are deemed good because they include those things that were going, or which have been made, to look good for a film (which in the era of cinema-capital is increasingly the world itself). And yet, just as not everyone is photogenic, so is there a surplus of humans and world that is not made for cinema. To demonstrate that this is so, to demonstrate that cinema is not the measure of reality (only that which is ready for and reproduced on film is real), is to point to the nothing from which sprang reality as a whole (nothing is the necessary condition of something).

How *Sombre* can be construed as an example of acinema would quickly be clear to its viewers. The film opens with seemingly darkened images of a car driving along mountain roads before we see a sequence of shots of the faces of young children, generally looking towards the left of the screen, and who shout and scream at some sort of spectacle that lies beyond the borders of the picture's frame. We then see more mountain scenery through a car window, the images often blurring as a result of the jitter of the camera (they recall the sensitivity to movement that takes place when one films on full zoom), while also often being blurred as a result of a lack of focus. We hear what sounds like a woman's breathing over what seems to be a black screen, before seeing a blindfolded child standing in penumbra outside a barn on the side of a mountain. The barn then takes on the quality of a Kubrick monolith – as per *2001: A Space Odyssey* (Stanley Kubrick, USA/UK, 1968) – as it dominates the next shot, before we see white light shining through black clouds. Shots then follow of a female body, a man in bed with white sheets, an insect circling a lamp, and more darkness, with the movement of a man walking about barely visible. The film then cuts to images of the road again, and we see that the Tour de France is taking place.

Akin to Lyotard's acinema, *Sombre* thus does seem to be comprised of 'dirty, confused, unsteady, unclear, poorly framed, [and] overexposed' images, while it is also hard to tell what is happening as a puppeteer called Jean (Marc Barbé) drives around the Haute-Loire killing women. Jean encounters Claire (Elina Lowensöhn), who is travelling with her sister, Christine (Géraldine Voillat). The three of them begin to tour together. Jean tries to kill Christine next to a lake one day, but Claire prevents him. Jean gets Claire drunk, and they attend a dance, where a man (Tony Baillargeat) tries to hit on her. Claire then sees Christine on to a train to Paris, before we see Claire talking to a woman (Martine Vandeville), seemingly about Jean (although claiming that they are married), before the woman tells her own life story. Jean murders another woman and the film ends with images of crowds lining the road to see the Tour de France.

The above synopsis demonstrates the elliptical and potentially acinematic nature of the film: Christine leaves, never to return, and Claire and Jean seemingly separate, with Jean going on killing women and Claire talking to a single mother in an HLM (*habitation à loyer modéré*), a rent-controlled home, typically found in tower blocks of the sort that characterizes *cités* like Les Bosquets and Juvisy-sur-Orge. That is, the film does not have a neat storyline that ties up all loose ends. On the contrary, all ends remain loose at the film's close, while the murders themselves are shot in an opaque fashion: we see blurred images, or images in extreme close-up, and which thus are deprived of context. Much of the film is in near darkness, meaning that we must also often rely on the soundtrack to have a sense of what is happening, although this regularly consists of mere grunts, gasps and other noises, with very little in the way of expository dialogue to guide us. We are given no explanation for Jean's murders, or why Claire and Christine stay with him. This seems to be a film that serves no purpose, which will struggle to make money, and which depicts objects and people that are hard to recognize. In this way, it can be considered acinema. However, while acinema is clearly useful as a concept for understanding *Sombre*, to ascribe it to the film also involves a slight misunderstanding of the term, while not taking into account how Grandrieux's film was shot digitally, which may mean that non-cinema is a more apt framework yet.

Acinema, ex-cinema, non-cinema

Sombre can be understood to 'alienate' viewers in that it is very difficult to understand. However, while the film may 'alienate' viewers, it also directly

affects them as the film becomes something not so much to understand as to experience. For, *Sombre* is a beautiful composition of sound and image that is haunting and memorable precisely because perplexing and vexing.

It should come as no surprise that Grandrieux's work has been interpreted as part of a French *cinéma du corps* (cinema of the body), which indeed offers 'sensory experiences' that can induce 'bewilderment' in the spectator.[45] Martine Beugnet suggests that the best way to engage with *Sombre* is via a 'sensual apprehension', which in turn '"moves" the spectator into thinking'.[46] The way in which *Sombre* cues such a haptic/physical engagement suggests what I am terming the entanglement of film and viewer, or the diegetic spectator. Furthermore, in a fashion that is redolent of my discussion of Khavn de la Cruz, we can understand how *Sombre* is 'an exposure of the darkness of humanity, or indeed the inhumanity within and without humanity'.[47] That is, the film's 'dark' aesthetic is linked to a philosophy of showing what Giorgio Agamben calls 'bare life' – which for Agamben refers to the lives of those excluded from society (and who may therefore be treated at times like animals), and which Jenny Chamarette interprets in relation to Grandrieux as being the human animal, or humanity's propensity for animalistic behaviour.[48] Writing on Grandrieux, Greg Hainge says that 'the majority of cinematic texts produced today ... have come to condition our common sense perception of what the cinema *is*'.[49] If *Sombre* goes against this 'common sense perception of what the cinema is', then it may well qualify as acinema. But by entangling its viewers, by exploring the darkness both within and without humanity, and by using digital cameras to achieve this, non-cinema emerges as a more coherent framework through which to understand the film.

For, Lyotard does not really discuss spectatorship or darkness in his elaboration of the concept. What is more, Lyotard's sole example of acinema is not a movie from outside of the mainstream, but precisely a Hollywood film, namely *Joe* (John G. Avildsen, USA, 1970), starring Peter Boyle and Susan Sarandon. Indeed, Simone Knox has persuasively identified how acinema can be seen in much contemporary mainstream film-making, not least through the great speed of Hollywood blockbusters.[50] If acinema is in fact quite mainstream, then, non-cinema allows us to think more 'holistically' about cinema, in that non-cinema is most clearly found at the margins, the 'extremes', and perhaps even outside of cinema – with digital technology playing a key role in its existence.

Akira Mizuta Lippit has recently used Lyotard's essay as a frame through which to understand the experimental cinema of Martin Arnold. Lippit

cites Lyotard in saying that commercial cinema purges itself of 'impulsional movement', which is to say movement that is spontaneous and which does not serve a purpose.[51] Lippit's attention is also drawn to how 'blackness overtakes' the final moments of Arnold's *Deanimated* (Austria, 2002), itself a reworking of the classical Hollywood horror film, *The Invisible Ghost* (Joseph H. Lewis, USA, 1941). Arnold has, says Lippit, 'marked the break from cinema to ambient space, televisuality, digital video', thus implying that the digital also has a role to play in acinema.[52] Since *Deanimated* makes central a black character, Evans (Clarence Muse), who was merely a secondary part in *The Invisible Ghost*, the film is also concerned with making race and racial difference visible.[53] Furthermore, the dark screen 'signals the end of cinema, this and every cinema, but also a point of departure for the cinema that comes after cinema, after this and every cinema, from this and every cinema, ex-cinema. No longer cinema … at the end of cinema, the outside begins.'[54]

Lippit suggests beyond Lyotard not acinema, but ex-cinema, a moving away from cinema – and a framework that also could be applied to Grandrieux's films, as well as to the work of Gomis, Ameur-Zaïmeche and Despentes and Trinh Thi as they use the digital to explore blackness. However, while Lippit's work is exciting (it moves away from citing others to become ex-citing, or original), when cinema is the measure of the real under capital then stepping outside of cinema is not such an easy task. In attempting to identify non-cinema, the idea is not simply to mark off territory as Lippit does (in-cinema and ex-cinema). It is, rather, to bring to consciousness the fact that marking off territory (e.g. in the creation of a nation-state and/or in the colonial project) is a cinematic, capitalistic process. Non-cinema is the path not towards a short-lived utopia beyond the purview of capital, but a tool for exposing how capital works and how it excludes that which is in fact of vital constitutive importance to it (colonialism as engendering France).

Conclusion

Is it problematic that this chapter has shifted from the dark skin tones of El Hadj to the lighter skin of Kamel and Manu and to the white skin of Jean, who exists in a film alongside a white woman deliberately referred to as Claire/light? Arguably it is. The point, though, has been to show that cinema-capital's others, those who are not cinematic, or who are invisible on film, are not only those

who have black skin. For Jean, too, embodies something that remains regularly invisible, namely 'dark' desires and 'dark' thoughts.

It is perhaps fitting that *Sombre* is set during the Tour de France, the most viewed annual sporting event in the world. Not only does the Tour suggest the demarcation of the boundaries of the nation, but it also does this within the spectacular logic of the competitive sporting event. The Tour thus represents capital and power – just as tour-ism is the empowered version of the economic migration that El Hadj and Kamel attempt. The Tour represents the society of the spectacle, and while it might seem that the events of *Sombre* unfold in stark contrast to this sanitized sporting event, Grandrieux's film would seem to suggest that Jean's murderous desires are what is repressed by the nation, just as France's post-colonial subjects have also been suppressed historically for the purposes of constructing a spectacular image of the nation, or constructing the nation as an image, with a concomitant emphasis on light and whiteness as opposed to darkness and blackness as a result.[55]

In *La Vie nouvelle*, Grandrieux depicts an American tourist who falls in love with and tries to rescue an Eastern European woman who has been trafficked into prostitution. The film is shot in a style similar to *Sombre*, that is, in Grandrieux's signature non-cinematic style, with blurred shots, uncertain action and so on. Michael Goddard sees the film as deconstructing the way in which Eastern Europe is presented to westerners as a 'monstrous' and 'dark' other, the very monstrosity of which is as a result of its perceived nature as 'surplus' to western Europe.[56] What Goddard says of Eastern Europe could equally apply to France's colonies: either invisible, or perceived as a threatening excess/surplus, these are not cinematic spaces. More particularly, the humans from these spaces and places are not cinematic either. Through their digital materiality (be that shot or screened digitally – or both), and through the way in which they explore 'darkness' both without (skin tones) and within ('extreme' cinema), *L'Afrance*, *Wesh wesh, qu'est-ce qui se passe?*, *Baise-moi* and *Sombre* positively embrace the non-cinematic, becoming non-cinema in the process.

Notes

1 Olivier Barlet, 'Africultures Dossier', *Black Camera: An International Film Journal*, 1:2 (Summer 2010), 67.
2 Lyotard, 'Acinema', 52–9.

3. Richard Dyer, *White* (London: Routledge, 1997), 1.
4. Dyer, *White*, 23.
5. Ibid., 140.
6. Jonathan Beller, 'Camera Obscura After All: The Racist Writing With Light', *Scholar & Feminist Online*, 10:3 (Summer 2012), http://sfonline.barnard.edu/feminist-media-theory/camera-obscura-after-all-the-racist-writing-with-light/.
7. Dyer, *White*, 89.
8. Ibid., 102.
9. Ibid., 122.
10. Ibid., 122–40, especially 127.
11. Frantz Fanon, *The Wretched of the Earth*, trans. Constance Farrington (New York: Grove Press, 1963), 102.
12. Carrie Tarr, 'Transnational Identities, Transnational Spaces: West Africans in Paris in Contemporary French Cinema', *Modern & Contemporary France*, 15:1 (February 2007), 65–76; and Melissa Thackway, 'Exile and the "Burden of Representation": Trends in Contemporary Sub-Saharan Francophone African Filmmaking', *Black Camera: An International Film Journal*, 5:2 (Spring 2014), 5–20.
13. Carrie Tarr, 'The Porosity of the Hexagon: Border Crossings in Contemporary French Cinema', *Studies in European Cinema*, 4:1 (2007), 15.
14. Frantz Fanon, *Black Skin, White Masks*, trans. Charles Lam Markmann (London: Pluto Press, 1993), 18.
15. Fanon, *Black Skin, White Masks*, 12.
16. Marks, *The Skin of the Film*, 239.
17. It is perhaps fitting that, like Wu Wenguang and Kidlat Tahimik, Alain Gomis has also organized video production workshops for youths in Nanterre (see Tarr, 'Transnational Identities, Transnational Spaces', 67). To teach and/or to hand the camera to others seems the logical extension of entanglement in relation to film-making.
18. Lorna Roth, 'Looking at Shirley, the Ultimate Norm: Colour Balance, Image Technologies, and Cognitive Equity', *Canadian Journal of Communication*, 34 (2009), 117.
19. Roth, 'Looking at Shirley', 117.
20. See Ann Hornaday, '*12 Years a Slave, Mother of George* and the aesthetic politics of filming black skin', *The Washington Post*, 17 October 2013, http://www.washingtonpost.com/entertainment/movies/12-years-a-slave-mother-of-george-and-the-aesthetic-politics-of-filming-black-skin/2013/10/17/282af868-35cd-11e3-80c6-7e6dd8d22d8f_story.html.
21. Barlet. 'Africultures Dossier', 77.
22. See William Brown, Dina Iordanova and Leshu Torchin, *Moving People, Moving Images: Cinema and Trafficking in the New Europe* (St Andrews: St Andrews Film Studies, 2010), 142–7.

23 Vincent Ostria, 'Rabah Ameur-Zaïmeche: Belle Saga Cité', *Les Inrockuptibles*, 30 April 2002, http://www.lesinrocks.com/2002/04/30/cinema/actualite-cinema/rabah-ameur-zaimeche-belle-saga-cite-11115203/.
24 Will Higbee, *Post-Beur Cinema: North African Émigré and Maghrebi-French Filmmaking in France since 2000* (Edinburgh: Edinburgh University Press, 2013), 172.
25 Carrie Tarr, *Reframing Difference: Beur and Banlieue Filmmaking in France* (Manchester: Manchester University Press, 2005), 180.
26 See Alison J. Murray Levine, 'Mapping Beur Cinema in the New Millennium', *Journal of Film and Video*, 60:3–4 (Fall/Winter 2008), 49.
27 Quoted in Cristina Johnston, *French Minority Cinema* (Amsterdam: Rodopi, 2010), 43. See also Martin O'Shaughnessy, *The New Face of Political Cinema: Commitment in French Film Since 1995* (Oxford: Berghahn, 2007), 79.
28 Ibid., 75. O'Shaughnessy, *The New Face of Political Cinema*
29 Tarr, *Reframing Difference*, 213.
30 O'Shaughnessy, *The New Face of Political Cinema*, 15.
31 Quoted in Higbee, *Post-Beur Cinema*, 183.
32 Tarr, *Reframing Difference*, 189.
33 See Alec G. Hargreaves, 'Translator's Introduction', in Azouz Begag, *Ethnicity & Equality: France in Balance*, trans. Alec G. Hargreaves (London: University of Nebraska Press, 2007), xvi.
34 See Zaïda Ghorab-Volta, 'The Experience of a Maghrebi-French Filmmaker: The Case of Zaïda Ghorab-Volta', trans. Martin O'Shaughnessy, *Cineaste*, 3:1 (Winter 2007), 52–3.
35 Linda Williams, 'Cinema and the Sex Act', *Cineaste*, 27:1 (Winter 2001), 21.
36 For more on this distinction, see André Gaudreault, 'Showing and Telling: Image and World in Early Cinema', trans. John Howe, in *Early Cinema: Space, Frame, Narrative*, ed. Thomas Elsaesser and Adam Barker (London: BFI, 1990), 274–81.
37 See André Bazin, *The Cinema of Cruelty: From Buñuel to Hitchcock*, trans Sabine d'Estrée (New York: Seaver Books, 1982); and Deleuze, *Cinema 2*, 40. See also William Brown 'The Pre-Narrative Monstrosity of Images: How Images Demand Narrative', *Image [&] Narrative*, 12:4 (2011), 43–55; and William Brown, 'A Monstrous Cinema', *New Review of Film and Television Studies*, 10:4 (2012), 409–24.
38 See Rodney Ramdas, 'The Acinema of Grandrieux: On *Un Lac*', *Lumen*, 2014, http://lumenjournal.org/i-forests/ramdas-grandrieux/.
39 Lyotard, 'Acinema', 53.
40 Ibid.
41 Ibid., 55.
42 Ibid., 53. It might be worth adding that the 'blooper' reel, which consists of 'discarded' takes in which actors fluff their lines, might constitute in this respect an iteration of 'acinema' that regularly exists in commercial films.

43 Ibid., 53.
44 Ibid., 56.
45 Tim Palmer, *Brutal Intimacy: Analyzing Contemporary French Cinema* (Middletown: Wesleyan University Press, 2011), 58–9.
46 Martine Beugnet, *Cinema and Sensation: French Film and the Art of Transgression* (Edinburgh: Edinburgh University Press, 2007), 5 and 60. See also Deleuze, *Cinema 2*, 182.
47 Jenny Chamarette, 'Shadows of Being in Sombre: Archetypes, Wolf-men and Bare Life', in *The New Extremism in Cinema: From France to Europe*, ed. Tanya Horeck and Tina Kendall (Edinburgh: Edinburgh University Press, 2011), 79.
48 Chamarette, 'Shadows of Being in Sombre', 75. See also both Agamben, *Homo Sacer*, and Giorgio Agamben, *The Open: Man and Animal*, trans. Kevin Attell (Stanford: Stanford University Press, 2004), 37.
49 Greg Hainge, 'Le corps concret: Of Bodily and Filmic Material Excess in Philippe Grandrieux's Cinema', *Australian Journal of French Studies*, 44:2 (May 2007), 156.
50 See Simone Knox, 'Eye Candy for the Blind: Re-introducing Lyotard's Acinema into Discourses on Excess, Motion, and Spectacle in Contemporary Hollywood', *New Review of Film and Television Studies*, 11:3 (2013), 374–89.
51 Akira Mizuta Lippit, *Ex-Cinema: From a Theory of Experimental Film and Video* (Berkeley: University of California Press, 2012), 173.
52 Lippit, *Ex-Cinema*, 176.
53 Ibid., 177.
54 Ibid., 178–80.
55 Another film about dark, murderous desires, about the limits of the nation within Europe, and which is set during the Tour, is *Voorloos/The Vanishing* (George Sluizer, Netherlands/France/West Germany, 1988), which tells the story of a Dutchman looking for his missing partner in France.
56 Michael Goddard, 'Eastern Extreme: The Presentation of Eastern Europe as a Site of Monstrosity in *La Vie nouvelle* and *Import/Export*', in *The New Extremism in Cinema*, ed. Horeck and Kendall, 82–92.

6

A Certain Compatibility: The British Digital Wave

In the last chapter, we explored how non-cinema provides a useful framework through which to understand the suppression of issues of race and sexual violence in the context of French cinema and society more generally, ending with an exploration of 'extreme' films like *Baise-moi* and *Sombre*. In this chapter, I shall be considering British non-cinema by looking at the work of Michael Winterbottom, a film-maker who on occasion has also been associated with 'extreme' cinema, especially as a result of his film *9 Songs* (UK, 2004), as well as at essay-films by Mark Cousins and Mania Akbari, and by Andrea Luka Zimmerman. I shall be arguing how Winterbottom's work productively engages with Britain's famously grey weather, while also blurring the distinction between cinema and television. I shall also consider how Winterbottom continues a tradition of 'imperfect cinema', a concept devised in Cuba by Julio García Espinosa in the 1960s, and which relates to non-cinema in several ways. The chapter will then look at the essayistic aspects of Winterbottom's work before exploring in more detail how the essay-film might also constitute an iteration of non-cinema, looking in particular at Cousins and Akbari's *Life May Be* (UK/Iran, 2014) and Zimmerman's *Taşkafa, Stories of the Street* (Turkey/UK, 2013). The latter film in particular provides an opportunity to look at another 'suppressed' component of cinema and a key ingredient of non-cinema, namely animals.

First, though, let us playfully work with – rather than against – a comment made by François Truffaut about British cinema, not least because Truffaut is a constant point of reference in Winterbottom's films.[1] For, while the UK crops up relatively consistently in Truffaut's œuvre, including in *Fahrenheit 451* (UK, 1966) and *Les Deux Anglaises et le continent/Anne and Muriel* (France, 1971), the French director famously stated to Alfred Hitchcock that there is a certain incompatibility between the terms Britain and cinema.[2] He continues:

There are national characteristics – among them the English countryside, the subdued way of life, the stolid routine – that are anti-dramatic in a sense. The weather itself is anticinematic. Even British humour – that very understatement on which so many of the good crime comedies are hinged – is somehow a deterrent to strong emotion.[3]

If Britain and cinema are incompatible, then in this chapter, I wish to show how Britain and non-cinema are paradoxically very compatible, especially as a result of digital cameras and their increasing use in British film-making. I shall do this by looking first at the work of Michael Winterbottom, who deliberately embraces in his work many of the things listed above by Truffaut as both British and anti-cinematic.

Grey skies and small screens

The perception that grey skies and regular rain are not 'cinematic' is tied to the perception that certain qualities of light are (more) cinematic (than others). This itself is tied both to technology (how much light is required 'successfully' to expose film such that everything within the frame is 'clearly visible', especially when on location), and to distribution (the normalization of the light intensities and qualities associated with the cinemas that circulate most widely).

It is not a coincidence that the mainstream film industry should find its centre in a place that enjoys such constant sunshine as California. Much like the history of cinema in relation to skin colour, the role that climate, and in particular sunshine, has played in the history of cinema is not to be overlooked: with greater intensity of light and less cloud cover, it is easier to make films using the traditional, analogue tools of cinema, meaning that film-making technology has, as Jean-Louis Comolli might argue, an ideological component (the technology favours certain conditions, consigning those places that do not share those conditions to the outside of cinema).[4]

In the digital age, however, cameras can film in all manner of lighting conditions, and from as early as *Butterfly Kiss* (UK, 1995), the plot of which is strikingly similar to that of *Baise-moi*, Winterbottom captures grey weather and the British countryside and motorways – with even the urban spaces of films like *Wonderland* (UK, 1999) and *The Look of Love* (UK/USA, 2013) being grey, slightly under-exposed and thus not 'cinematic'. More than this, Winterbottom consciously explores the incompatibility of Britain and cinema by looking at the

relationship between film and the supposedly inferior medium of television, in particular through his collaborations with Steve Coogan and Rob Brydon.

Repeatedly in *A Cock and Bull Story* and the two *Trip* series, namely *The Trip* (UK, 2010) and *The Trip to Italy* (UK, 2014), we see Coogan and Brydon, both perhaps best known as television personalities, doing impressions of various film stars from Al Pacino to Michael Caine to Christian Bale to Marlon Brando. What is more, all three works play repeatedly with the perception that Steve Coogan is a 'failed' Hollywood leading man; that is, he is not 'cinematic' as a result of being both British and associated with television – even though he has, of course, acted in an increasingly large body of theatrical films. In other words, these three works deliberately explore the relationship between cinema and other, 'smaller' media – with Coogan and Brydon aspiring overtly to become cinematic.

However, the Coogan–Winterbottom collaborations also subvert the perceived superiority of cinema over television, especially through Brydon, who more affirmedly than Coogan is a television as opposed to a film star, and yet who in all three productions manages repeatedly to upstage Coogan, thereby suggesting that television, the non-cinematic medium, is every bit as powerful as cinema. In the first series of *The Trip*, for example, the pair are admitted entrance to William Wordsworth's Dove Cottage residence in Grasmere, Cumbria, only because the museum attendant recognizes not Coogan (supposedly the more famous of the two), but Brydon. Meanwhile, in the second series, it is Rob who ends up being offered a part in a (fictional) Michael Mann film, a source of resentment for Steve. In the era of so-called 'quality television' – and perhaps also in relation to a nation with such a strong history of television as the UK – it is perhaps redundant to suggest that television can rival cinema; nonetheless, in their own way, the Coogan-Brydon-Winterbottom collaborations celebrate the non-cinematic as much as the cinematic through the consistent presence of the televisual, the characters' aspirations towards the cinematic – and of course the weather.[5]

Documentaries of their own making

The Trip series mixes high and low culture, a mix that is equally redolent of the tension between cinema and non-cinema.[6] Here, though, I shall explore how Winterbottom's mix of fiction and documentary also undermines the status of his work as cinema, paying particular attention to *A Cock and Bull Story*.

A Cock and Bull Story is an adaptation of Laurence Sterne's 'unfilmable' 1759 novel, *Tristram Shandy*. Rather than being a 'straight' adaptation, however, the film is also (shades of *Day for Night*) about the very process of adapting Sterne's text as we see Steve Coogan and Rob Brydon play themselves as they prepare for and respectively act the parts of Tristram and his Uncle Toby, with Coogan also playing Tristram's father, Walter. The film within the film is being directed by Mark (Jeremy Northam) based on a script by Joe (Ian Hart), with various actors, including Shirley Henderson and Keeley Hawes, playing themselves and playing characters within the film. The production, however, runs into problems when the shooting of a key battle scene goes wrong: underwhelming and lacking in spectacle, the film-makers decide that it must be excised, but manage hopefully to raise the commercial appeal of the film by enticing Gillian Anderson to step in to play Widow Wadman, a small but notable character who has a comical 'love affair' with Uncle Toby (who cannot make love since damaging his groin at the Siege of Namur in 1695, a battle that has left Toby so traumatized that he obsessively works on a miniature recreation of it).

The promotion of Toby/Brydon from a supporting role to co-lead predictably irks Coogan, since Brydon has claimed from the film's beginning that he is Coogan's 'co-lead', something that Coogan vehemently denies. In this way, Coogan's inability to be the star of his own film – the persona that also comes to the fore in *The Trip* shows, and which draws upon both Coogan's 'loser' television characters like Alan Partridge and his own 'real world' persona as a 'failed' Hollywood star – mirrors the way in which Tristram, as the leading character and the narrator of Sterne's novel, can barely get the story of his own life started even after several hundred pages. Indeed, when mulling over the need for Anderson to step into the movie, Mark remarks, with reference to Anderson, that 'it would make it a real movie if it had a real star', before remembering that Coogan is listening and adding, sheepishly, 'two stars'. The suggestion is, then, that *A Cock and Bull Story* embraces the non-cinematic, with Coogan in particular being a non-cinematic film star.

At one point in the film, Tony Wilson, playing himself, interviews Coogan, who, ironically enough, played Wilson in Winterbottom's earlier *24 Hour Party People* (UK, 2002). He asks Coogan why anyone would make a film of a novel that is 'unfilmable'. Not only is the moment self-reflexive, as it refers to Winterbottom's earlier collaboration with both Wilson and Coogan, but it also points to how an adaptation of *Tristram Shandy* goes against cinema, even if, as Coogan replies to Wilson, the novel was 'a postmodern classic written before

there was any modernism to be post about' (Coogan: 'In fact, for those who haven't heard of it, it was actually listed as number eight on *The Observer*'s top 100 books of all time.' Wilson: 'That was a chronological list'). In other words, Winterbottom consciously engages with the non-cinematic nature of his film.

This is so from the opening scene, in which we see Coogan and Brydon in the make-up department discussing the colour of Brydon's teeth. Hint of yellow, barley meadow, Tuscan sunset: these are the metaphors that Brydon uses to describe the colour of his pearly off-whites, before Coogan, having himself suggested 'pub ceiling' as a suitable metaphor, responds: 'You're getting laughs [from the make-up artists], but it's not making your teeth look any better.' Straight away, then, *A Cock and Bull Story* presents us with an analysis of what is deemed to be cinematic – perfect white teeth, which indeed are like pearls and thus have monetary value – and it juxtaposes this with the non-cinematic yellow of Brydon's teeth (with the cliché of bad British teeth also being made to tie in here with the idea of Britain being uncinematic, including via its supposedly uncinematic sense of humour).

Deliberately and self-reflexively non-cinematic, *A Cock and Bull Story* nonetheless engages consciously with the history of cinema. For example, the soundtrack features music by Nino Rota taken from Federico Fellini's classic movie-about-making-movies, *8½* (Federico Fellini, Italy/France, 1963), as well as pieces from Michael Nyman's score to Peter Greenaway's *The Draughtsman's Contract* (UK, 1982), itself like *A Cock and Bull Story* a sort of anti-heritage film. Like the mix of high and low culture in *The Trip* shows, this is not to betray the film's ultimately 'cinematic' aspirations. Rather it is to trouble our understanding of what cinema is, such that we are forced to ask why certain things are considered cinematic (certain novels, certain stars, certain colours of teeth) and others not. What is more, this engagement with what is cinematic or otherwise, via the film's exploration of the non-cinematic, is deeply indebted to the digital nature of the film.

During the shoot, two or three operators with lightweight digital cameras would roam around the set, which might consist simultaneously of multiple spaces. For example, I personally took part in the shooting of a scene towards the end of the film, where various collaborators on the adaptation gather to see an initial cut of their movie. What happens (concern about whether the adaptation of *Tristram Shandy* is good enough for release) is not as important as the shooting methods. For, at London's CFC Framestore (since 2008 known simply as Framestore), the camera operators simultaneously filmed performers

both in a screening room and at a food and drinks reception next door. Rarely were the words 'cut' or 'action' spoken; instead there was almost continuous filming, with little to no opportunity to work out whether any of the assembled actors (including Anderson, Brydon and Coogan) were 'in character' or 'being themselves'.

Winterbottom himself was on set, but his presence was muted, with the shoot involving less planning and more a sense of 'Let's just see what happens'.[7] Indeed, this 'open' shooting method seemed similar to that of *24 Hour Party People*, for which Winterbottom would place radio microphones on his actors and record numerous aspects of the same scene, as well as different scenes, simultaneously – 'with two people talking in one corner and two in the other. We'd shoot the entire scene in one go.'[8] In other words, improvisation plays a key role in these films, together with a rejection of the traditional shooting methods, like giving a scene both a specific focus (all cameras pointing in the same direction and not shooting two aspects of a scene in two different parts of the same location at the same time) and a specific time (cameras running between 'cut' and 'action', rather than continuously until batteries die, DV tapes run out, or memory cards are full).

As Adam Ganz and Lina Khatib put it: 'Space in digital drama is vague. There is a zone rather than one angle. This is because first, there are often multiple cameras, and second, because there is feedback and crossover between the area behind and in front of the camera.'[9] In other words, the boundary between where and when a scene begins and ends is not just invisible, but non-existent. The digital cameras used to shoot these and many of Winterbottom's other films are always on, and thus in some respects the viewers are also 'observing and participating in how the drama is made'.[10] The blurring of the boundaries between fiction and documentary is thus tied to and intensified by the digital technologies used to create these films. In this way, we can begin to understand *A Cock and Bull Story* and other of Winterbottom's films as documentaries of their own fiction-making.

Just after Tony Wilson explains that *The Observer* books list is chronological, we hear Coogan in a voice-over telling us that 'if you want to see the EPK [electronic press kit] interview, it'll be part of the DVD package along with extended versions of many of the scenes, which should act as footnotes to the main film'. Coogan nominally suggests here that the DVD is a separate entity to the main film. However, that this very comment is included in the 'main film' subverts the distinction between the film and the making-of, as well as

the distinction between the film and the director's/star's commentary – with the making-of and the director's commentary being regular features on DVD versions of mainstream movies. Not only does Winterbottom's work engage with the relationship between cinema and television, but it also actively reflects upon its digital shooting methods and its digital distribution (on digital versatile disc, or DVD).

Furthermore, Bruce Bennett analyses how the film's website is a sort of 'metasite' designed to look like a computer desktop within a computer desktop, and which includes email messages about the making of the film-within-the film.[11] Henry Jenkins might well refer to such practices as transmedia storytelling, but this is not just about the extension of a diegetic fictional world across different media.[12] Rather, what we have here is an explosion of the differences between media, such that the cinematic and the non-cinematic are granted an equal status. This production of non-cinema in turn raises issues about why we erect standards, expectations and norms regarding what is 'cinematic' in the first place.

Imperfect cinema

Even if his films challenge the medium specificity of cinema, we might nonetheless contend that Winterbottom uses the audiovisual techniques that are central to what Jonathan Beller terms the attention economy.[13] That is, by using images, sound, editing, stars and other techniques that help to maintain attention on screens (the society of the spectacle), Winterbottom cannot be as subversive as all that. And yet, aspects of Winterbottom's work challenge normal modes of representation and perhaps even representation itself. As various characters discuss what to do with Sterne's insertion into *Tristram Shandy* of a black page – after the death of Yorick, a character understood to be based on Sterne himself – so, too, does Winterbottom's film cut to a black screen. The black screen suggests the limits of representation, with the unrepresentable being linked via *Tristram Shandy* to death. In showing us darkness, or an absence of light, we also move outside of cinema and into non-cinema. We also see this challenge to, or testing the limits of, representation in Winterbottom's more overtly 'political' films, especially *In This World* (UK, 2002).

The film tells the story of two Afghan refugees, Jamal and Enayat (Jamal and Enayatullah Udin Torabi), who travel from a refugee camp in Peshawar, Pakistan, and across Asia and Europe to London, where they hope to join relatives and

have a 'better' life. The film has a loose script, written by Tony Grisoni, but it also involves many non-actors playing versions of themselves as Jamal and Enayat carry out their journey. Like *A Cock and Bull Story*, *In This World* was shot digitally, with the continuous running of the cameras making it difficult to tell which scenes are staged and which are 'genuine' – much to the frustration of some viewers, as Grisoni has reported.[14] Both Yosefa Loshitzky and Bruce Bennett see this blurring of the boundary between fiction and documentary as 'Brechtian', in that it directly involves *In This World*'s viewers by inviting them to consider what is or might be real.[15] However, rather than simply explain how this involvement of the spectator suggests entanglement, or what I have termed the diegetic spectator, I would like here to examine how this entanglement takes on a political dimension, which in turn is tied to the 'imperfection' of the digital image.

Steve Rubio sees *In This World* as a punk film.[16] I should like to add that this 'punk' aesthetic is characterized by imperfection. Cuban film-maker and theorist Julio García Espinosa famously embraced imperfection as a political tool for film-making in the late 1960s. Perhaps it is no surprise, then, that studies of Winterbottom's films, especially *In This World*, have also evoked García Espinosa.[17] The latter suggests that

> imperfect cinema is no longer interested in quality or technique. It can be created equally well with a Mitchell or with an 8mm camera, in a studio or in a guerrilla camp in the middle of the jungle. Imperfect cinema is no longer interested in predetermined taste, and much less in 'good taste'. It is not quality which it seeks in an artist's work. The only thing it is interested in is how an artist responds to the following question: What are you doing in order to overcome the barrier of the 'cultured' elite audience which up to now has conditioned the form of your work?[18]

Through its 'raw', digital aesthetic, *In This World* challenges not just the aesthetic norms of the 'cultured' elite audience, but also that of mainstream audiences (who are deeply cultured in the mainstream, 'cinematic' aesthetic – a rich, big-budget and 'elite' image, even if popular). We see sequences that are shot in torchlight – for example, when Enayat suffocates along with many other migrants when hiding in an unlit container on a boat from Istanbul to Trieste. Almost totally in darkness, this sequence highlights the unrepresentable nature of the issue of human migration, asking us to engage with it using other (non-cinematic) sensory modalities.

Imperfect cinema should, García Espinosa suggests, 'above all show the process which generates the problems. It is thus the opposite of a cinema principally dedicated to celebrating results, the opposite of a self-sufficient and contemplative cinema, the opposite of a cinema which "beautifully illustrates" ideas or concepts which we already possess.'[19] This we can also see in *In This World*, which is dedicated to showing us the process of Enayat and Jamal's journey, as well as the reasons behind it. The film does not offer us a traditional happy ending as Enayat dies before reaching London and as Jamal, initially refused asylum, is granted 'exceptional leave' to stay in the country until his eighteenth birthday. This open ending suggests that no issues have been resolved ('a cinema principally dedicated to celebrating results'), and it is matched by the blur between fiction and documentary, which García Espinosa also sees as a core aspect of imperfect cinema:

> Imperfect cinema can make use of the documentary or the fictional mode, or both. It can use whatever genre, or all genres. It can use cinema as a pluralistic art form or as a specialized form of expression. These questions are indifferent to it, since they do not represent its real alternatives or problems, and much less its real goals. These are not the battles or polemics it is interested in sparking.[20]

García Espinosa ends his essay by suggesting – like Jia Zhangke in relation to amateur cinema – that cinema's future is a folk cinema: 'A thousand different flowers [will] bloom. ... Art will not disappear into nothingness ... it will disappear into everything.'[21]

Given that Winterbottom does still work within commercial cinema, his relationship to García Espinosa might end here: Winterbottom's visibility as a film-maker signals not the success of digital technology as heralding an era in which everyone makes films, but rather the continuation of cinematic business as usual. Nonetheless, Winterbottom arguably does point the way from within the film industry towards a politicized use of (digital) form – imperfect, grainy images, shot in near darkness and featuring amateurish performances – in order not simply to entertain (although García Espinosa does accept that imperfect cinema can be 'enjoyable, both for its maker and for its audience'), but also to provoke thought.

In one remarkable sequence, we see Enayat and Jamal up in the mountains of Iran – shot through the night vision lens of a digital camera. As per a similar sequence in Philippe Grandrieux's *La Vie nouvelle*, the sequence uses thermal as opposed to photochemical imaging processes. If, as discussed, light is the

essence of cinema, then here we have a sequence that shows not light, but heat. Since all living humans emit heat, and since when we see humans as emitters of heat rather than bearers of particular traits such as skin (or teeth) colour, all humans are depicted as radically equal. By embracing a technique that is in certain respects non-cinematic (the thermal images are not created with light as per conventional image-making processes), Winterbottom draws out the hierarchical processes of conventional cinema and destabilizes them. What is more, these images also lend to the sequence an undeniable corporeality: rather than seeing Enayat and Jamal as representatives of a particular race, ethnicity, class, sex, sexuality, nationality or religion, we see them as living bodies, as alive. The objectifying processes of the visual are thus denied here. Instead we feel entangled with Jamal and Enayat, unable to deny their existence.

The film-essay: He(u)retical (non-)cinema

García Espinosa states that 'today we read a good essay with much greater pleasure than a novel'.[22] Acknowledging the power of the essay over narrative, García Espinosa's imperfect cinema is in some respects akin to the essay-film, which also eschews story and instead presents to us ideas, thoughts and sensations.[23] If Winterbottom is the maker of 'imperfect' films, then perhaps he also is something of a film-essayist, even when making films that are relatively 'narrative'.

Indeed, there are various similarities between Winterbottom's work and that of some of the canonical essay film-makers who have been discussed by scholars of the form. *The Trip to Italy*, for example, echoes various sequences from Roberto Rossellini's *Viaggio in Italia/Journey to Italy* (Italy/France, 1954), especially the ruins of Pompeii, where Rob does his 'Small Man Trapped in a Box' voice before the victims of the AD 79 volcanic eruption and who are now preserved in a glass box ('Oh my God, I can see the volcano erupting, and I am petrified'). The latter film was believed by *Cahiers du Cinéma* critic and later (essay-?)film-maker Jacques Rivette to be the 'first film that offers the cinema the possibility of the essay'.[24] For Rivette, *Viaggio in Italia* goes against a cinema 'hitherto condemned to narrative', and instead becomes a hybrid 'metaphysical essay, confession, log-book, intimate journal' as we see Alexander (George Sanders) and Katherine Joyce (Ingrid Bergman) travel around Italy by car, argue,

visit various monuments, especially the ruins of Pompeii, remember past loves and consider the possibilities of both infidelity and divorce.[25] As both Brydon and Coogan travel around Italy by car, struggle with the meaning of their lives, and flirt with women and each other, *The Trip to Italy* also takes on essayistic dimensions *à la* Rossellini/Rivette.

What is more, 'classic' essay-films like *Filming Othello* (Orson Welles, West Germany, 1978) and *Scénario du Film 'Passion'* (Jean-Luc Godard, France/Switzerland, 1982) are in some respects documentaries about the making of other films and/or director's DVD commentaries *avant la lettre*. Their self-consciousness and self-reflexivity do not help, but rather complicate our understanding of the films upon which they comment – respectively *Othello* (Orson Welles, USA/Italy/Morocco/France, 1952) and *Passion* (Jean-Luc Godard, France/Switzerland, 1982). For, the commentaries expand the films upon which they are based beyond simply the movies that we can see at the cinema (or on DVD/online), and they ask us to question where each (any) film begins and ends. In other words, both *Filming Othello* and *Scénario du Film 'Passion'* playfully explode the distinction between text and commentary – much as *A Cock and Bull Story* does via its self-conscious references to its existence as a DVD, replete with commentary already added.

In Godard's *Scénario du Film 'Passion'*, the director (who for much of the film remains a black silhouette against a white screen inside an editing suite – i.e. invisible) speaks of how he does not want to read or write a script ('scénario'), but to film one. In other words, industrial cinema is defined by making films a priori. That is, via scripts and storyboards, set-making and rehearsals, a film is designed in advance and in a controlled fashion in order to minimize the amount of money spent on film stock and processing costs; the economics of film-making determine the way in which the film is made, and to some extent also the kinds of films that get made, with the script, together with the storyboard, determining what the film will do. Godard, meanwhile, wants to retain the freedom to escape the script and to see, or search for, what he terms the invisible – that which is not possible for the industrial cinema to show, including most especially the mechanics of its own making, with the script itself being something that is invisible in a film (we never see the physical script that the cast and crew follow), hence Godard's desire not to read or write the script, but to film it.

In a similar vein, Orson Welles, towards the end of *Filming Othello*, declares to an audience during a question-and-answer session in Boston that

if you have a masterplan for what you're going to do, if you know exactly where the camera's going to be, exactly what the scene is supposed to state, if you are locked into that, [then] you are depriving yourself of the divine accidents of movie-making, because everywhere there are beautiful accidents. And then there are the true accidents, and my definition of a filmmaker is the man who presides over accidents ... but who doesn't make them.

We can link this move away from the script in Godard and this management of accidents in Welles to the role of improvisation in Winterbottom: *In This World* was only semi-scripted by Tony Grisoni, with the film containing much scope for 'accidents', while Frank Cottrell Boyce felt that *A Cock and Bull Story* moved so far away from his original script that he (willingly and playfully) changed his name in the credits to Martin Hardy. In other words, as we can see traces of the essay-film in Winterbottom's work, so can we see links between the essay-film and non-cinema, especially thanks to the 'heretical' dimensions of the essay-film, as I shall discuss presently.

Timothy Corrigan draws on Theodor W. Adorno to argue that the essay (and by extension the essay-film) has heresy as its 'innermost formal logic'.[26] Laura Rascaroli, meanwhile, describes the essay-film as a 'diverse, paradoxical, heretical body of work'.[27] The essay-film is heretical because it is not driven by narrative, while also being structured in a rambling, maybe even random-seeming fashion, as per the discussion of improvisation above. Furthermore, the essay-film is driven less by commercial concerns and more by a desire to explore the world, to try out new things (*essayer* is the French verb for 'to try'), and thus to undergo openly a process of trial and error (or what is also termed heuretics). A heuretical and heretical form, the essay-film is thus not unlike (it forms an important branch of) non-cinema. Indeed, Philip Lopate suggests that the essay-film 'barely exists', arguing that it lies somewhere outside of cinema as we conventionally understand it.[28] Furthermore, Rascaroli makes clear the essay-film's non-cinematic status when she quotes Godard, who suggests that his *Deux ou trois choses que je sais d'elle/Two or Three Things I Know About Her* (France, 1967) 'isn't really a film, it's an attempt [in French, an *essai*] at film and is presented as such'.[29] If it isn't really a film, then perhaps the film-essay is better understood as non-cinema.

However, rather than using this proclamation as a basis for trying to abstract or essentialize the essay-film (in Adorno's language, to put up a boundary around it), perhaps the essay-film is better understood not as a thing, but as a process – and one that, like non-cinema, is at work in many films, perhaps even in every

film, even if more clearly in some films than in others. In this way, we need not speak specifically of heretical essay-films, but about he(u)retical film theory – with he(u)retical here signalling a combination of heresy and heuretics, or the process of trial and error described above (see Brown Forthcoming a).[30] He(u)retical film theory suggests cinema as an entanglement of film and spectator, and in which both parties are engaged not in the reaffirmation of what we already know (clichés on the part of the film-maker, easily read on the part of the viewer), but on a heuristic drive (or an attempt – again *essai* in French) to discover what cinema can do, and what a spectator can think or feel while watching a film (what our bodies and minds can do).

Furthermore, if considerations of the essay-film have up until now tended to focus on trying to explain what the essay-film is (with 'is' itself being redolent not of entangled becoming, but of stasis and abstraction; that is, at odds with the essay-film itself), then perhaps we can improve upon these by relating the notion, sketched above, of the essay-film as a process as much as a 'thing', to earlier discussions, linked to entanglement, regarding complementarity and the issue of whether a phenomenon is a particle or a wave (or whether it has momentum or a position).

In an early text on Chris Marker, André Bazin wrote that *Lettre de Sibérie/ Letter from Siberia* (France, 1957) offers us an example of the essay-film, and that this is characterized by a new type of montage that Bazin calls 'horizontal': 'Here a given image doesn't refer to the one that preceded it or the one that will follow, but rather it refers laterally, in some way, to what is said.'[31] Rascaroli argues that this comment brings to mind Adorno's suggestion that 'thought does not advance in a single direction' since, as per a carpet, 'the aspects of the argument interweave'.[32] In other words, it seems that in moving in more than one direction at once, the essay-film shares something of the wave/particle duality of, say, the electron. Furthermore, the film-essay suggests entanglement or a 'diegetic spectator' because of its emphasis on what Rascaroli and David Montero both define as the creation of dialogue/dialogism with the spectator for the purposes not of closing down meaning (a film that offers solutions), but of liberating it (a film that moves us to thought).[33]

Academic interest in the essay-film ties into the growth of cinema's tendency towards the essayistic in the digital era. Indeed, Rascaroli contends that the outbreak of essay-films 'may in part be explained by the spread of new technology, and in particular the wide availability of digital video and the internet', before also suggesting that 'essay films, which historically rarely

enjoyed proper theatrical distribution, have now become more easily accessible through DVD'.[34] In other words, it would seem as though the digital has played a role in intensifying the presence of the essay-film in contemporary cinematic culture, and that this might also link to the rise of non-cinema. Let us look at how this is so, then, in relation to *Life May Be* and *Taşkafa, Stories of the Street*.

Life May Be ... Everywhere

Life May Be is a series of five film-letters that Mark Cousins exchanges with Mania Akbari, the star of Abbas Kiarostami's *Ten* and *Shirin*, the director of *20 Fingers* (Iran, 2004) and *Yek. Do. Yek/One. Two. One* (Iran, 2011), and who herself moves from Iran to the UK during the film. The film clearly stages dialogue between the film-makers, as the film progresses from a fan piece from Cousins to Akbari (a letter commissioned for the DVD sleeve notes of *One. Two. One*) to being increasingly intimate: Cousins strips naked as he sits and types on his laptop and eats Pringles on his hotel sofa in Kaunas, Lithuania; Akbari briefly stands naked in a still image by Virginia Woolf's house in Bloomsbury, London (this after the removal of one of her breasts following an operation to cure her of cancer), while from a high angle we also see her at length wash herself under a thin layer of foam in a bath.

Life May Be takes its title from 'Tavalodi Digar/Another Birth', a 1964 poem by Forugh Farrokhzad, whose *Khaneh siah ast/The House is Black* (Iran, 1963) is perhaps one of the great essay-films. The poem tells the story of a woman whose lot is to remain indoors, invisible and behind the wall of an enclosed garden. The following forms a central section of the poem, whose title is translated as 'Perhaps life' in the 2010 translation from the Farsi by Hasan Javadi and Susan Sallée:

Perhaps life
is a long street on which a woman with a basket passes every day.
Perhaps life
is a rope with which a man hangs himself from a branch.
Perhaps life is a child returning from school.
Perhaps life is lighting a cigarette in the languid repose
 between two embraces
or the mindless transit of a passer-by
who tips his hat

and with a meaningless smile says 'good morning' to another passer-by.
Perhaps life is that thwarted moment
when my gaze destroys itself in the pupil of your eyes.
And in this lies a sensation
which I will mingle with the perception of the moon and the discovery
 of darkness.[35]

The poem brings together several ideas that have resonance with the themes of this book, and which we can nuance in relation to Cousins and Akbari's film. First, the notion of the exchanged gaze brings to mind the issue of dialogue, which involves not just a loss of subjectivity ('my gaze destroys itself') but also a sense (or sensation) of shared experience. Secondly, in discovering darkness, the voice in the poem also shares in the showing of darkness that is core to non-cinema, and which perhaps finds poetic expression in Akbari's occlusions. That is, we see Akbari thinly veiled by foam and milky water in the bath, suggesting that she exists as an image (not least for Cousins, who seems romantically to fall in love with her), and that she is occulted in a (capitalist) world in which a woman is forced to be an image/to attract attention in order to be considered real. Finally, in positing that life may be any of the things listed – from a street to a rope to a child to a cigarette – we get a sense of the radical equality of all things. That is, even the most insignificant details count, in the sense of being part of the universe and thus contributing to reality. In this sense, life may not just be everywhere, but actually it *is* everywhere.

The suggestion that life is everywhere can help us to understand the contents of *Life May Be*, which regularly features landscapes and objects selected as if at random from the world, appearing in the film as thoughts crop up in our heads. Frost-covered thistles and snow globes all come to have an equal role to play in the world of the film, meaning that the boundary between life and non-life itself seems to fade: landscapes and objects are themselves as alive as the film-makers whose exchanges we experience. This heretical suggestion – that everything is alive – matches the heuretical style of the film as Cousins and Akbari attempt to communicate with each other, essaying, playing and having fun as they go along.

If life may be or is everywhere, then to exclude from life is not simply a question of ontology (this is, that is not), but also a question of politics: exclusions reveal to us the ideological underpinnings of the person or society making those exclusions, determining certain things as having life and not others, with the non-life of those other things potentially enabling us to treat them differently to how

we treat that which we do consider to be alive. I shall leave for later an exploration of how matter itself may be alive (or at the very least 'vibrant'). For the time being, though, I should like to make an initial expansion beyond the human in our consideration of life by looking at animals. There are numerous animals in *Life May Be*, including dogs, goldfish and birds, but a more focused consideration of animals in a (digital, non-cinematic) essay-film is Andrea Luka Zimmerman's *Taşkafa, Stories of the Street*. In telling the story of street dogs in Istanbul, *Taşkafa* invites us to consider how societies often exclude animals as having a right to life (even though we cannot deny that animals live and breathe for the duration of their existence). This exclusion of animals is linked to the objectification and use of animals, an exclusion, objectification and use that is also inscribed into cinema, as we shall see. If cinema reflects and embodies the exclusion, objectification and use of animals, then it is with non-cinema that their lives may be included.

Animals and cinema

There has been much scholarship recently on animals, including the role that animals play in film. This includes work by Akira Mizuta Lippit, Nicole Shukin and Anat Pick – as well as dossiers on animals and film in issues of both *Screen*, and *NECSUS European Journal of Media Studies*.[36] Furthermore, dogs specifically form the focus of work by scholars like Susan McHugh and Donna J. Haraway, with the latter considering dogs to be a 'companion species', or a species with whom we share things ('companion' is derived from the Latin 'cum', meaning with, and 'panis', meaning bread, with the term thus having a sense of 'sharing bread').[37] Finally, John Berger, who in *Taşkafa*, reads from *King: A Street Story*, which is a 1999 novel about dogs, has also written an essay called 'Why Look at Animals?' – and in response to which Anat Pick has asked why not look at animals.[38]

I do not have space to go into all of these texts in detail. However, a few key points will be necessary to set up my analysis of Zimmerman's film. First, it is important to make clear that humans have always had companion species, with McHugh specifically calling dogs the 'midwives of human civilisation'.[39] Indeed, a thought experiment: Prior to the domestication of animals, we can imagine that there were two wild species – humans and canines – that began to work together for protection, warmth and food. This would have been a relationship based on cooperation, not exploitation (it is almost unthinkable that a species would willingly offer itself up to another species for domestication). This would also have

been a relationship based simply on survival, and not necessarily on profit. When the relationship between humans and animals shifted from one based on survival to one based on profit, however, then we have the instantiation of a primitive or prototypical form of capital as humans do not live with but farm animals, having more meat than is necessary simply for survival, and/or using animal energy/biopower for specifically human rather than mutually beneficial purposes. If a human is to profit from animals, then what must take place is a radical shift from a symbiotic, or mutually beneficial relationship, to one in which the human considers its existence not to be inextricably intertwined with/dependent on that of the other species, but separate/independent from it, and with a concomitant shift to getting from the animal use- and/or surplus value. This separation, or what Berger calls the marginalization and disappearance of animals, is in keeping with the tendency for humans to see themselves as separate from the world, rather than entangled with it, which, as I have argued, is a key aspect of the logic of exploitation that is integral to capital (and by extension to cinema).[40]

This separation of humans from other animals leads us to a second important point regarding animals, which is that humans have all-too-often forgotten about the contribution that animals have made to human society. Without the energy and input of animals, the construction of human civilization would not and could not have taken place. This input is not just in the form of meat (or eggs or milk) that humans consume in order to wrest energy from the animal for themselves; it is animals transporting raw materials, protecting humans from yet further species, and, indeed, animals being broken down in order to provide various of the raw materials that humans use to build their societies. When it comes to cinema, for example, Nicole Shukin explains clearly that gelatin, or 'animal glue', is a necessary ingredient for the creation of film stock.[41] That is, while animals might have featured in films since the birth of cinema (there are at least two dogs in Auguste and Louis Lumière's *Workers Leaving the Factory/La sortie de l'usine Lumière à Lyon*, France, 1895), thereby meaning that cinema can and does in some senses preserve animals that otherwise might be disappearing from view (Lippit suggests that cinema is 'haunted by the animal figure'), in another sense cinema has always hidden and failed to recognize the role that animals have played in its material base.[42] In a kind of synthesis of Shukin and Lippit's work, Laura McMahon picks up this thread: 'As cinema moves into the digital age it distances itself from this literal link to the materiality of animal bodies, but traces of this deathly relation inevitably remain, haunting the history of film.'[43] That is, digital cinema does not use gelatin as analogue film did. For McMahon, though, animals continue to be

marginal, especially in mainstream cinema (where animals can often feature, even as leading characters, but where they are offered up as spectacles, rather than considered as animals).

From the anthropocentric perspective, then, humans are agential beings that have brought about the technological wonders of civilization, having forgotten, precisely through the centring of self that is the process of anthropocentrism, the contribution that animals have made to human society. However, so integral to humans are animals that Haraway even suggests, with a tip of the hat to Bruno Latour, that 'we have never been human'. That is, if to be human is to be separate from the world and from other animals such that we are self-sufficient, then humans have never achieved this, and thus have never existed – even if they believe that they have. Instead, 'we are in a knot of species coshaping one another in layers of reciprocating complexity all the way down'.[44] Indeed, going 'all the way down', we might even argue that humans are dependent upon other species on a cellular level. Mitochondria, for example, are organelles (specialized parts of a cell) that are believed to have their origins as bacteria that came to be part of what we now call the human through the process of endosymbiosis, or symbiogenesis (mitochondria, which exist in many different types of cell in the human, have their own DNA, with their own separate genome).[45] Humans are inextricable from, or entangled with, other species. While mainstream cinema exploits animals (we are separate from them), non-cinema, especially via its film-essay form, attempts to expose our relationship with animals more clearly (we are with them).

Indeed, the essay has long been associated with animals. Michel de Montaigne, the first great essayist, famously asks in the twelfth chapter of his second book of essays whether, when he plays with his cat, she is equally playing with him.[46] Animals form the focus of key essay-films like Georges Franju's *Le Sang des bêtes* (France, 1949), which exposes the inner workings of abattoirs, while cats also feature prominently in the work of film-essayists like Chris Marker and Agnès Varda.[47] Indeed, the prominence of animals, especially cats and dogs, on YouTube would also point to a contemporary fascination with animals that is not cinematic, but rather digitally non-cinematic.

Philosopher or Dog?

Taşkafa, Stories of the Street bears some similarity to Varda's *Les Glaneurs et la glaneuse/The Gleaners and I* (France, 2000), in that both films draw our attention

to members of society who otherwise are overlooked. Rather than introducing us to France's 'forgotten' human beings via gleaning, however, *Taşkafa* focuses on Istanbul's street dog population and those humans and other animals that interact with them. It is important that *Taşkafa* focuses on street dogs, as opposed to dogs as pets (the distinction is made at various points in the film). For, in looking at street dogs, we look at animals that are not domesticated, but which are, for want of a better term, wild. And yet, these dogs are not shown within the film to be dangerous. Kerem, an interviewee, does explain that he was once bitten by a dog, meaning that today he does not go near them (his daughter calls him a coward after confessing this). And Bill McAlister (one of the film's producers) recounts how dogs crowded around and growled at him when he first walked across Galata Square alone at night. But beyond this, the dogs are not dangerous, and soon allowed Bill to pass once he had introduced himself to Taşkafa, at the time the leader of the Galata Square pack. Indeed, contrary to the street dogs being dangerous, it seems that mainly it is humans and domestic animals that are the most violent. Aziz, for example, explains to us that people bring their (domestic) pit bulls out to attack the street dogs, including Paşa, an old dog that lies in his square. We also hear about campaigns to poison the dogs, dogs that have been beaten and abandoned by their owners, and so on. Ismail, a local shop owner, recounts how in the 1800s there was a genocide against the dogs, before explaining that it is only humans who destroy nature and who are wild. It is at this point that a local explains how Taşkafa himself was removed from the streets and destroyed.

The genocide to which Ismail refers is explained on two other occasions in the film. First, one speaker, Gülen, explains to Bill how in Ottoman times a British diplomat was harassed by the street dogs and, in fleeing from them, fell from a wall and died. In response, the dogs were rounded up and massacred by the Sultan – although the people of Istanbul supposedly smuggled the dogs back into the city. Secondly, we read a sign on an island just off the coast of Istanbul, explaining the Hayırsızada Dog Massacre, in which numerous street dogs were rounded up in 1910 and sent to the nearby island of Sivriada, where an estimated 80,000 died, mainly from starvation. When an earthquake struck Istanbul soon after this massacre/genocide, the locals felt that this was a punishment from God for what had happened to the dogs, with Sivriada thus being renamed Hayırsızada, which means 'the wicked island'. The idea of divine retribution is also mentioned in the film as one of the interviewees, Hacı, says: 'There is a verse in the Quran [in the Elham Surah]. Even including the plants …. It says: "If any

of these die of hunger, dogs and cats, they all have souls, I hold you responsible."' This echoes a comment made earlier in the film, suggesting that 'those who fear God wouldn't harm them'.

It is not that *Taşkafa* invites a specifically religious reading. However, far from the dogs being dangerous, we instead see them living in symbiosis with humans, many of whom feed the animals. This symbiosis is most clear when we are told by Gülru that the dogs take children to their school buses and accompany old people, while Varol explains how Taşkafa served people by accompanying and protecting them. This is not a dog serving humans out of coercion, but out of choice. However, Taşkafa and his like are under threat, mainly as a result of the processes of gentrification, or the westernization that is affecting Istanbul via globalization. As we see Louis Vuitton shops and Rolex adverts come to prominence in the film's mise en scène, we also hear from Erdoğan, a Turk who speaks German, about how stray dogs destroy the illusion of chic in aspirational neighbourhoods, while Gül speaks of how formerly she would put the dogs up if they wanted to stay, but that this has stopped and the dogs have been forced into the streets because more and more people close off their houses, live in protected areas, and wish to have nothing to do with the dogs as money flows into the area. In other words, the street dogs are treated as an underclass, even though they do volunteer work – with their marginalization and destruction being linked to the British diplomat, that is to Turkey's aspirations as a European country, even as it sits on the border between Europe and the Middle East. Even putting the dogs in a shelter is unfair, explains Serdar, a former criminal who looks after numerous dogs, each of which to him has a different story and character. Freedom is for animals, too, he explains, before telling us how dogs were living in Istanbul before humans.

Taşkafa suggests, then, that those who serve no financial purpose, or who are not own-able as commodities, should be disappeared. To be without capital is thus to ask for non-existence, or at the very least invisibility. And the plight of the dogs is clearly linked to the plight of the humans whom we see, since many of those who look after and interact with the dogs are homeless, dispossessed, substance abusers, poor, or, like Serdar, ex-convicts. The more wealthy citizens have their own, domesticated animals, with children today being raised to fear not just dogs, but also cats and birds, as if they were a threat to humans, as Andaç contends towards the film's end. The link between dogs and humans is made clearer still when we cut from Sivriada/Hayırsızada to a shot of Yassıada Island, where, text on the screen informs us, political prisoners were held between 1960

and 1981. Humans do to other, undesirable humans what they do to undesirable animals: confine them, make them invisible, deprive them of life.

This vivid, vital film is surely also an example of imperfect cinema, as we are confronted with memories, with all of their imperfections and contradictions, as opposed to an official history (different interviewees remember the dog massacre as happening in different periods). The 'imperfection' of *Taşkafa* is made clear by its final shot. *Taşkafa* opens with a shot of a dog (Taşkafa himself?) lying with his legs in the air, as if in a heliotropic trance. We return to this shot at the end of the film. The camera, handheld, approaches the dog before coming to a rest at ground level a few metres away. A few seconds elapse before the camera is picked up again and approaches the dog, this time coming to a rest a couple of metres from it, the sun shining towards the camera, the dog somewhat in silhouette. Finally, the camera is raised and moved again, before finding its final resting place alongside the dog, which now lies across the image, its head frame left, its hind legs and tail stretching out to the right. That we see how this image was composed, including the first two, less aesthetically pleasing placements of the camera, clearly conveys that the film is concerned with documenting its own making, and that it wishes to record its 'failures' (two not-so-good attempts at framing the sun-worshipping dog) as much as its successes (the film's striking opening image).

What is more, this imperfection seems to be tied to the digital. This is not simply a matter of Zimmerman gaining the confidence of and filming intimate moments with locals. During the sequences that involve Berger reading from *King*, the film shows us shots of trees or water, but which have been enlarged and slowed, such that they are pixelated and blurry. This pixilation brings to mind the digital perspective that we are being offered. A digital essay-film, *Taşkafa* is thus an example of non-cinema.

If the British sense of humour, weather and teeth are not cinematic, then in this chapter I have attempted playfully and positively to work with François Truffaut's claim that the word Britain and the word cinema are not compatible in order to establish how there is conversely a strong compatibility between Britain and non-cinema. We find this in Michael Winterbottom's cinema in several ways: his exploration of the British weather and landscape, as well as in his playful analysis of the relationship between film and television, especially in his collaborations with Steve Coogan and Rob Brydon. Winterbottom can also be understood as an essay film-maker: someone who makes heretical films that also are heuretical, in the sense of trying out new ideas and running the risk

of failure. Moving on from Winterbottom, I have analysed how the essay-film more generally points to the ways in which life may be everywhere, as per Mark Cousins and Mania Akbari's *Life May Be*, before looking specifically at the role of animals in Andrea Luka Zimmerman's *Taşkafa, Stories of the Street*. As aspects of British life are supposedly not cinematic, so has cinema typically excluded, as well as objectified and exploited, non-human forms of life. If cinema is a tool for exclusion, objectification and exploitation, as the principle tenets of capitalism, then it is in digitally enabled non-cinema that we can think beyond cinema and thus also beyond the human and into the animal realm itself.

Notes

1 In being a film about film-making, *A Cock and Bull Story* (UK, 2005) recalls *La Nuit américaine/Day for Night* (France/Italy, 1973), while *Everyday* (UK, 2012), in being a film made over the course of five years and about children growing up, recalls Truffaut's Antoine Doinel films starring Jean-Pierre Léaud. Indeed, *Les Quatre Cents Coups/The 400 Blows* (France, 1959) ends with Doinel running along a beach having just escaped a borstal (a prison for children), while *Everyday* similarly ends with the Kirk family reunited on a beach after the release from prison of father Ian (John Simm).
2 See Truffaut, *Hitchcock*, 124.
3 Ibid., 124. See also Bruce Bennett, 'Very Un-British Films: Michael Winterbottom and the Cinema of Incompatibility', in *Rereading Britain Today: Essays in British Literary and Cultural Studies*, ed. Yan Liu (Shanghai: Shanghai Foreign Language Education Press, 2007), 285.
4 See Jean-Louis Comolli, *Cinema Against Spectacle: Technique and Ideology Revisited*, trans. Daniel Fairfax (Amsterdam: Amsterdam University Press, 2015).
5 *The Trip to Italy* makes various references to Jim Jarmusch's *Coffee and Cigarettes* (USA, 2003). In the final episode of that film, opera singer Janet Baker sings 'Ich bin der Welt abhanden gekommen' from Gustav Mahler's *Rückert-Lieder* (1901) as painter Bill Rice and writer Taylor Mead discuss their past as part of the New York art scene. The Mahler features regularly in Winterbottom's show, while the Rice/Mead conversation is not wholly dissimilar to the way in which Coogan and Brydon impersonate Roger Moore and Michael Caine reminiscing at the memorial service of British film director Michael Winner. They discuss *Bullseye!* (Michael Winner, UK/USA, 1990), a film starring Moore and Caine, but confuse it with British darts-based television gameshow, *Bullseye* (UK, 1981–), hosted by

Jim Bowen ('there's only one word for that, Master Bruce: magic darts'). More pertinently, though, *Coffee and Cigarettes* also features Coogan playing 'himself' as he shakes off Alfred Molina, also playing 'himself', who wants to work with Coogan, and who explains that they are distant cousins. Coogan regrets ditching Molina, however, when the latter receives a phone call from Spike Jonze, who offers him a part. Much like the Coogan persona from *A Cock and Bull Story* and *The Trip*, Coogan in the Jarmusch film wants to work with the fashionable Jonze, but now is rebuffed by Molina for his mercenary attitude towards achieving fame.

6 See Adam Underwood, '*The Trip* as Mourning Comedy', *Senses of Cinema*, 74 (March 2015), http://sensesofcinema.com/2015/feature-articles/the-trip-as-mourning-comedy/.
7 Richard Porton, 'In Praise of Folly: An Interview with Michael Winterbottom', in *Michael Winterbottom: Interviews*, ed. Damon Smith (Jackson: University Press of Mississippi, 2010), 101.
8 Jeremiah Kipp, 'Anarchy in the UK: An Interview with *24 Hour Party People* Director Michael Winterbottom', in *Michael Winterbottom*, ed. Smith, 57.
9 Adam Ganz and Lina Khatib, 'Digital Cinema: The Transformation of Film Practice and Aesthetics', *New Cinemas: Journal of Contemporary Film*, 4:1 (2006), 22.
10 Ganz and Khatib, 'Digital Cinema', 26.
11 Bruce Bennett, *The Cinema of Michael Winterbottom: Borders, Intimacy, Terror* (London: Wallflower, 2014), 7.
12 Henry Jenkins, *Convergence Culture: Where Old and New Media Collide* (New York: New York University Press, 2008), 93–130.
13 Beller, *The Cinematic Mode of Production*.
14 See Jessica Winter, 'World in Motion', in *Michael Winterbottom*, ed. Smith, 61.
15 See Yosefa Loshitzky, *Screening Strangers: Migration and Diaspora in Contemporary European Cinema* (Bloomington: Indiana University Press, 2010), 120–3. See also Bennett, *The Cinema of Michael Winterbottom*, 184–5.
16 Steve Rubio, 'Making it Real', in *New Punk Cinema*, ed. Nicholas Rombes (Edinburgh: Edinburgh University Press, 2005), 138–49.
17 See Andrew Dix, '"Do you want this world left on?": Global Imaginaries in the Films of Michael Winterbottom', *Style*, 43:1 (Spring 2009), 3–25; and Vicente Rodríguez Ortega, 'Digital Technology, Aesthetic Imperfection and Political Film-making: Illegal Bodies in Motion', *Transnational Cinemas*, 2:1 (2011), 3–19.
18 García Espinosa, 'For an imperfect cinema', 24–6.
19 Ibid.
20 Ibid.
21 Ibid.
22 Ibid.

23 For recent considerations of the essay-film, see Laura Rascaroli, *The Personal Camera: Subjective Cinema and the Essay Film* (London: Wallflower, 2009); Timothy Corrigan, *The Essay Film: From Montaigne, After Marker* (Oxford: Oxford University Press, 2011); and David Montero, *Thinking Images: The Essay Film as a Dialogic Form in European Cinema* (Oxford: Peter Lang, 2012).

24 Rascaroli, *The Personal Camera*, 26.

25 Jacques Rivette, 'Letter on Rossellini/Lettre sur Rossellini (*Cahiers du Cinéma*, 46, April 1955)', trans. Tom Milne, in *Cahiers du Cinéma: The 1950s – Neo-Realism, Hollywood, New Wave*, ed. Jim Hiller (London: British Film Institute, 1985), 199.

26 Theodo W. Adorno, *Notes to Literature Volume One*, trans. Shierry Weber Nicholsen (New York: Columbia University Press, 1991), 23; quoted in Corrigan, *The Essay Film*, 23.

27 Rascaroli, *The Personal Camera*, 2.

28 Philip Lopate, 'In Search of the Centaur: The Essay-Film', *The Threepenny Review*, 48 (Winter 1992), 19. See also Montero, *Thinking Images*, 22.

29 Jean-Luc Godard, *Godard on Godard: Critical Writings*, ed. Tom Milne and Jean Narboni (London: Secker & Warburg, 1972), 239; quoted in Rascaroli, *The Personal Camera*, 89.

30 William Brown (Forthcoming a), He(u)retical Film Theory: When Cognitivism Meets Theory', in *The Film Theory Handbook*, ed. Tom Conley and Hunter Vaughan, London: Anthem Books.

31 André Bazin, 'Bazin on Marker', trans. Dave Kehr, *Film Comment*, 39:4 (2003), 44.

32 Adorno, *Notes to Literature*, 160; quoted in Rascaroli, *The Personal Camera*, 27.

33 See Rascaroli, *The Personal Camera*, 34; Montero, *Thinking Images*, 12.

34 Rascaroli, *The Personal Camera*, 4 and 65.

35 Forough Farrokhzad, *Another Birth and Other Poems*, trans. Hasan Javadi and Susan Sallée (New York: Mage, 2010), 111.

36 See Akira Mizuta Lippit, *Electric Animal: Toward a Rhetoric of Wildlife* (Minneapolis: University of Minnesota Press, 2000); Nicole Shukin, *Animal Capital: Rendering Life in Biopolitical Times* (Minneapolis: University of Minnesota Press, 2009) and Anat Pick, *Creaturely Poetics: Animality and Vulnerability in Literature and Film* (New York: Columbia University Press, 2011). See also Laura McMahon, 'Screen Animals Dossier: Introduction', *Screen*, 56:1 (Spring 2015), 81–7; and Barbara Creed and Maarten Reesink, 'Animals, Images, Anthropocentrism', *NECSUS European Journal of Media Studies* (Spring 2015), http://www.necsus-ejms.org/animals-images-anthropocentrism/. Animals also loom large in John Ó Maoilearca's *All Thoughts Are Equal*, a consideration of the work of François Laruelle that also is in part about cinema, especially Lars von Trier and Jørgen Leth's *De fem benspænd/The Five Obstructions* (Denmark/Switzerland/ Belgium/France, 2003).

37 See Donna J. Haraway, *When Species Meet* (Minneapolis: University of Minnesota Press, 2008), 17. See also Susan McHugh, *Dog* (London: Reaktion, 2004).
38 John Berger, *About Looking* (London: Penguin, 1980), 3–28. See also Anat Pick, 'Why not Look at Animals?' *NECSUS European Journal of Media Studies* (Spring 2015), http://www.necsus-ejms.org/why-not-look-at-animals/.
39 McHugh, *Dog*, 23.
40 Berger, *About Looking*.
41 Shukin, *Animal Capital*, 104–14.
42 See Lippit, *Electric Animal*, 197.
43 McMahon, 'Screen Animals Dossier', 83.
44 Haraway, *When Species Meet*, 42.
45 See Siv G. E. Andersson, Olof Karlberg, Björn Canbäck and Charles G. Kurland, 'On the Origin of Mitochondria: A Genomics Perspective', *Philosophical Transactions of the Royal Society of London B: Biological Sciences*, 358:1429 (January 2003), 165–79.
46 Michel de Montaigne, *Essais II* (Paris: Gallimard, 1965), 156.
47 See Corrigan, *The Essay Film*, 69.

7

Non-Cinema in the Heart of Cinema

In this chapter, I shall focus on the work of Giuseppe Andrews, who in the late 1990s and the 2000s made a string of ultra-low-budget films on and around the trailer park where he then lived in Ventura, near Los Angeles in California. The reason for looking at Andrews's work is two-fold: to demonstrate that non-cinema is a global phenomenon and not just a trend relegated to so-called peripheral nations, and to consider the role of scatology and comedy in non-cinema.

To limit discussion to Andrews is not to overlook the long history of unofficial and 'peripheral' cinema that has long since emerged from the United States. Among experimental film-makers, Robert Florey, Maya Deren, Kenneth Anger, Stan Brakhage, Jonas Mekas and Michael Snow might all merit mention as an avant-garde of contemporary non-cinema. As might 'trash' film-makers from Edward D. Wood Jr, whose movies David E. James sees as constituting a form of minor cinema, to the likes of Larry Clark, Lloyd Kaufman, Harmony Korine, George and Mike Kuchar, Russ Meyer, Andy Warhol and John Waters.[1] The latter's *Pink Flamingos* (USA, 1972) in particular presents viewers with an assault on conventional cinematic tastes. While the film is perhaps most remembered for its final images of Divine eating dogshit, it earlier features, in its tale of rivals locked in a contest to become the world's most disgusting family, Divine and Crackers (Danny Mills) breaking into the house of the Marble family and licking everything that they can find in a bid to spread their filth. The Greek for tongue is γλῶσσα/glossa, with glossiness being related, therefore, to the shine that appears on an object when one licks it. That is, while we think of glossy, cinematic images as being beautiful and somehow detached from the world of spit and filth, Waters makes clear that the glossy is intimately linked to spit, filth and the human body as his characters literally make the Marble house glossy with their tongues. Waters's anti-cinematic aesthetic of degradation and abjection is equally as cinematic as the glossy images that are created in

mainstream cinema. In other words, Waters embraces many of the qualities of non-cinema long before the widespread use of digital technology in films.

While Waters (with others) is thus an important precursor to Giuseppe Andrews, it is also worth pointing to a more contemporary film-making context in the United States, where there has been a surge in low- to zero-budget film-making, especially as a result of affordable digital cameras. Most attention surrounding contemporary low-budget cinema has focused on the so-called mumblecore movement, a contested term for a group of film-makers who started making films digitally and using other formats in the early 2000s, and upon whom I shall briefly focus now.[2]

Mumblecore: An unsustainable aesthetics of failure

The central figures in the movement include Joe Swanberg, Andrew Bujalski, Mark and Jay Duplass, Aaron Katz and Lynn Shelton, who between them have directed numerous films (as well as regularly acting in each other's productions). Amy Taubin in part understands this work as 'an update of the "New Talkie," the strand (not quite a genre) of no-budget indies that emerged in the early nineties with such landmark films as Richard Linklater's *Slacker* [USA, 1991], Kevin Smith's *Clerks* [USA, 1994], and Rose Troche and Guinevere Turner's *Go Fish* [USA, 1994]'.[3] Furthermore, Anna Backman Rogers sees mumblecore as something of an inheritor to the indy films of Sofia Coppola, Jim Jarmusch and Gus Van Sant.[4] However, while mumblecore shares with these films and film-makers a lack of emphasis on narrative, what distinguishes mumblecore is that its budgets often have been even lower than those with which the aforementioned film-makers worked in the early parts of their careers. Before various of the mumblecore directors (and actors) went on to bigger, more recognizably 'indy' film projects, their early work was characterized by tiny budgets, with some films costing only US$3,000 to make. What is more, their work typically circulated outside of theatres and in 'ancillary markets and alternative distribution outlets'.[5] Nessa Johnston has identified how the films are characterized by 'poor' sound, while Yannis Tzioumakis suggests that the 'subject matter [of mumblecore films] … in some instances has flirted with pornography', and that they have a 'harsh aesthetic created by the use of digital video' – meaning that mumblecore is 'far away not only from Hollywood, but also from the studios' specialty labels that have focused primarily on indiewood titles'.[6]

With this description in mind, it should be clear that (early) mumblecore can be understood as 'non-cinema' – with Amy Taubin singling out Swanberg's work as being so artless that he is a director 'merely as a description of function', rather than because he makes films worth viewing.[7] That is, Swanberg's films do not merit the name cinema.

Aymar Jean Christian suggests that Swanberg's LOL (USA, 2006) is almost a YouTube film *avant la lettre*, especially through its use of vlog-style direct address, its emphasis on close-ups, and its digital intimacy.[8] In accordance with Taubin, but also in defiance of her criticism, LOL is thus expressly non-cinema. What is more, there is a sense of deliberate poverty in this and other mumblecore films, such that Maria San Filippo sees mumblecore as exemplifying a 'cinema of recession'.[9] That is, the aesthetic poverty of the films (such that for Taubin they seem not to qualify as cinema?) is linked to the digital (the YouTube aesthetic of LOL is deliberately not cinematic), which in turn is linked to socio-economics in two ways. First, these films speak of life under economic recession in terms of their budgets and concomitant 'poor' aesthetic values. Secondly, the introspective and drifting nature of many of the protagonists of mumblecore films is linked to the fact that they either do not have and cannot find a job, or feel deeply alienated from life as a result of the seemingly pointless nature of their work. In other words, and contrary to the 'upward' career trajectories of several of their makers, the films feature downwardly mobile characters.

Taubin has correctly criticized mumblecore for being focused almost exclusively on white, middle-class American males. Being downwardly mobile, it is possible, then, that mumblecore as a whole bespeaks a kind of 'gentrification of poverty' in the contemporary United States; that is, the films are fantasies of being poor when in fact its protagonists have the cultural capital and the intellectual capacity to escape poverty at any given moment.[10] While this critique is worth bearing strongly in mind – especially when one compares mumblecore films to those of Giuseppe Andrews – mumblecore nonetheless does, or did, demonstrate how under neoliberal capitalism downward mobility is in part thrust upon (and in part also chosen by) American citizens who otherwise belong to (but who wish to leave?) the mainstream racial, sexual and social majority – and this applies to white, middle-class males before we even get to those groups and classes traditionally excluded from the mainstream.

The films thus feature images of what Maurizio Lazzarato might term 'indebted man', or humans who permanently are beholden to capital as a result, or in spite, of their efforts to avoid debt (being in greater levels of debt is the

equivalent of getting poorer[11]). What is more, Backman Rogers suggests that the films of Coppola, Jarmusch and Van Sant constitute a 'crisis image', which for her connotes lives in transition from youth to adulthood, from life to death and from repetition to becoming. Aesthetically, the crisis image is signified by things like darkness, sections of black leader, a refusal of narrative, an emphasis on the overlooked and trash, and the invisible. In other words, not only does Backman Rogers's definition of the crisis image overlap on an aesthetic level with my understanding of non-cinema (black leader, invisibility), but we might also use the term to define mumblecore's images of the economic crisis that leads characters into poverty and/or debt.

In this way, mumblecore is a cinema of failure – but it is also unsustainable.[12] This unsustainability can be seen in the growing success of its various filmmakers – and the appropriation of its tropes and stars by established 'indy' figures like Noah Baumbach.[13] This success constitutes an end to the 'movement', both in the sense that it contradicts the movement's emphasis on failure, and in the sense that the failure of the movement is perhaps the logical destiny of such a movement about failure (as per Khavn de la Cruz's understanding of contemporary Philippine digital film production, we might understand mumblecore as positively 'not a film movement').

We could quite possibly put the idea of failure here into dialogue with, say, Samuel Beckett, who in *Worstward Ho* called for people to try and to fail, to try again and to fail again, and in short to 'fail better'.[14] This we could link to Gilles Deleuze's consideration of Beckett as expressing how exhaustion is ultimately an inclusive act, since to have exhausted all possibilities (and still to have failed – as Beckett attempted to do with literature) is to have included everything possible, something that Julie Allan also relates to Deleuze's concept of the stutter.[15] However, mumblecore ultimately did not 'fail better' but rather 'failed to fail' – and what 'stuttering' it did, it also forgot as it became more successful (and less inclusive, if ever mumblecore really was inclusive from the start).

We can perhaps illustrate this further by looking not at Swanberg, the Duplasses and Shelton, who have gone on to increasing levels of success via their entry into 'cinema', or the film industry 'proper', but at Arin Crumley and Susan Buice, who directed one of the founding mumblecore films, *Four Eyed Monsters* (USA, 2005). Crumley and Buice went heavily into debt as a direct result of making their film, and a decade after its first screenings still seem to have made no money from it – perhaps tellingly as a result of Crumley and Buice's 'naïve' and 'unprofessional' refusal to take part in the capitalist aspects

of the film industry. *Four Eyed Monsters* continues to exist on YouTube, but as Buice summarizes, 'Being on YouTube is not legit.'[16] That is, YouTube is not cinema, and since it exists on YouTube, *Four Eyed Monsters* is not cinema either.

The film is a self-reflexive tale that in effect charts the downward mobility and doomed relationships of its chief protagonists (Crumley and Buice themselves, who in aspiring to make a film tellingly aspire themselves to become, but cannot quite make it as, cinematic). Cinema-capital creates debt: the literal debt of making *Four Eyed Monsters*, which itself was built upon the need to become cinematic in order to become 'real' (a kind of cultural debt); the film is thus a failure in many respects, as well as being about failure. However, rather than embrace this, Crumley and Buice seem resentful of their lack of success. In other words, both the failure of Crumley and Buice and the success of Swanberg, the Duplasses et al. reinforce the ideology of success-cinema as more valid than failure-non-cinema.

Ewa Mazierska reminds us that the reason why there are no second acts in American lives is because failure is not tolerated.[17] If cinema is the American art form, then cinema cannot tolerate the willed failure that is – or was – mumblecore. Those mumblecore directors who failed (Crumley and Buice) cannot make cinema; those mumblecore directors who succeeded (Swanberg, the Duplasses, Shelton) now do make cinema. Both reaffirm success and cinema as the only tolerable reality, and failure as a concept that is antithetical to the American ideology. In this way, we might think that while something like mumblecore provides a temporary iteration of non-cinema in the United States, ultimately non-cinema can only have a precarious and unsustainable existence there. However, a film-maker like Giuseppe Andrews offers a much more subversive non-cinema, one that does not fail to fail, but which seeks always to 'fail better'. His is a digital non-cinema that does not seek success at all, but which revels in its own poverty.

Thinking outside the box office

Andrews is prolific, having made fifty or so shorts and features since his debut, *Touch Me in the Morning* (USA, 1999). Sticking to his features, synopses of three should suffice to convey their strangeness. *Garbanzo Gas* (USA, 2005) tells the story of a cow (Vietnam Ron), who wins a paid weekend at a motel before it is sent to the abattoir. Hearing that there is a cow at the motel, two drunken gamblers (Miles Dougal and Walt Dongo), who have lost all their money on

a kangaroo boxing match, plot to kill it for a slab of prime beef, before two different serial killers – one of whom (Walter Patterson) is told to kill by towels and the other (Tyree) who is told to kill by his shoe – also arrive at the hotel. The cow continues to order room service steaks for all-comers.

In *It's All Not So Tragic* (USA, 2008), film historian Greg Gonner (Miles Dougal) has a nervous breakdown after beginning uncontrollably to masturbate during the recording of a DVD commentary for a classic *film noir*. Sent on vacation by his psychiatrist (Ed), Greg encounters various weirdoes, including a harmonica-playing disabled artist (Wally Lavern), a poet with a suitcase full of cockroaches (Sir Bigfoot George), a member of the Walanco cult called Distosia (Marybeth Spychalski), a soap star (Walter Patterson), and a man he once photographed in the nude (Giuseppe Andrews, credited here as Giapetto Woftmuller), whom at regular intervals we find seated on a toilet and who later develops rabies. Greg also encounters various incarnations of himself, for example dressed as a clown copulating with a vacuum cleaner. Greg disappears into a state of psychosis, still unable to control his auto-erotic urges, before the film ends with a musical number sung by Andrews dressed only in stuffed underwear, with Greg/Dougal doing backing dancing with his penis out, followed by a harmonica number from Wally Lavern, and a testimony from the psychiatrist/Ed about staying in a hotel that refuses animals – while dogs lick his legs. The psychiatrist takes out of a fridge a sheep's head that he considers to be a pet; one of the dogs chews on it, before Ed sings to it a good night lullaby.

Finally, *Orzo* (USA, 2008) has even less of a narrative than the other films as it tells the story of Toggle Switch (Karen Bo Baron), a dwarf woman who is obsessed with an emaciated television fitness guru (Andrews, again credited as Woftmuller) and who has a series of stuffed animals, including a crow that shits pearls and which attacks her after escaping from a microwave. Toggle Switch's daughter Alison (Marybeth Spychalski) is married to Rehelio (Walter Patterson), who has just got out of prison for stealing dildos and burying them in his backyard. Inside, he was friends with Colin (Vietnam Ron), who escapes prison via a portal in a fridge and comes to find Rehelio. Rehelio sends Colin to Toggle Switch to get laid, but the latter instead electrocutes Colin, temporarily forcing him to behave like an ostrich. Colin then joins his Viking son (Sir Bigfoot George) for a drink, while Toggle Switch hangs herself after losing a bet with a neighbour (Ed) that there is no evidence for a mythical part of the ear called a quagie. Alison, after killing a rapist meth addict, performs a song and dance routine with Rehelio entitled 'Give me a twat like that'.

As all of the films descend in many respects into a series of surreal episodes, Andrews deliberately eschews narrative and seeks instead to instigate a different form of cinema, a non-cinema. Indeed, so challenging to conventional tastes are Andrews's films that Robert Koehler, in the telegram style of *Variety*, sums up *Garbanzo Gas* as follows: 'Pic is the sort most fest[ival]s will be too scared to touch, allowing aud[ience]s to discover it on their own, including as a DVD on Andrews' own website.'[18] In other words, Andrews's films, with *Garbanzo Gas* serving for Koehler as the template, are not even suitable for the film festival circuit; their life on DVD available from Andrews's website affirms their life beyond cinema as a theatrical venue, and the way in which Andrews thinks outside the box office with regard to what he is creating.

The films also formally constitute a non-cinema through what by now are familiar tropes: bad acting, obvious make-up (Greg Gonner sports an overtly fake beard in *It's All Not So Tragic*), silly costumes (in *Garbanzo Gas*, the cow is simply Vietnam Ron dressed in a cow onesie; he speaks English, but no one questions that the cow is not a cow), shaky camerawork, deliberately lo fi special effects (when the crow attacks Toggle Switch in *Orzo*, we see an inset still image of a crow moving across the screen towards the dwarf woman, a rectangle of a flame inserted into the square image of the crow to signify that it is threatening her), tacky music (generally performed by Andrews himself) and poor editing (cuts when performers forget their next line). Bill Gibron, an enthusiastic supporter of Andrews, suggests that the film-maker is 'tied to a true outsider idea of cinema, a desire to rewrite the language of the medium to fit his own idea of expression', with Andrews often reading lines to actors one at a time and thus creating a rhythmic edit that involves cutting on dialogue.[19] Furthermore, the gradual disappearance of narrative from all of the films suggests not only a piecemeal tactic that results in non-cinema, but an articulated strategy that, in Deleuze's language breaks the sensory-motor links of the action-image, in that we cannot readily predict what will happen, where the action is heading, or even at what pace, as instead random (or illogical) edits take place, juxtaposing incongruous ideas alongside each other (a naked old man hugging a dead pig, for example) thereby producing new thoughts as a result of their shocking nature and pushing Andrews's cinema in the direction of the time-image. The division between fiction and documentary also breaks down as we see not actors performing but non-professionals incapable of concealing the fact that they are performing, the films making little to no attempt to hide their artifice.

The fact that Andrews makes his films just outside Los Angeles with genuine trailer park residents, whom he has known since childhood and who carry in/on their figures the blemishes and scars characteristic of poverty, makes his work a political cinema. For, Andrews is not just making bad movies, but making movies that show us, even in films that tell a (clearly) fictional story, the faces of people – so-called 'trailer park trash' – who normally do not feature in cinema (there are plenty of films about trailer parks, but they typically do not cast inhabitants of trailer parks). If for Deleuze the people are missing from cinema after the crisis of the action-image towards the end of the Second World War, as explained in the chapter on Iranian cinema, then the people seem resolutely here to return. Or rather, as he works repeatedly with the same community of performers, Andrews's becomes a cinema of the multitude, not least through the repeated images of the gnarled and harrowed faces of various of his leads, as well as through Andrews's entangled presence in the films, both in terms – Grandrieux-style – of how he generally acts as his own cameraman, but also literally sometimes as Andrews captures himself in the mirror, and cares not to retake the shot (as happens in the motel room of *Garbanzo Gas*).[20] Unlike mumblecore, Andrews creates a cinema not of the gentrification of poverty, then, but of the poverty of poverty, a cinema of total failure – failure even to tell a coherent story. Since to be cinematic is a sign of success, with success equally being a sign of cinema, then in *Garbanzo Gas*, *It's All Not So Tragic* and *Orzo* we have various examples of non-cinema.

It's actually all quite comic

While his films can be disturbing, in poor taste, and an affront to many viewers' aesthetic/cinematic sensibilities, I would like to suggest that Andrews's is ultimately a comic (non-)cinema, and that comedy has a key role to play in non-cinema more generally (which is not to say that all non-cinema is funny). I shall do this by looking in particular at *Orzo*, arguing that comedy suggests withness and entanglement.

Lisa Trahair attempts to recuperate slapstick comedy from its reputation as 'low' or 'base'. She suggests both that the earliest slapstick films were antithetical at least in part to narrative cinema, and that slapstick, the gag and various other elements of comedy remain in (and often at odds with the demands of) narrative as it comes to dominate – and thus in some senses to become – cinema itself.

Drawing on Georges Bataille, Trahair makes a distinction between restricted and general economy: 'Restricted economy is geared toward production and expenditure for the return of profit' while general economy 'envisages meaning exposed to its comic underside, wasted, destroyed without reserve'.[21] That is, with regard to cinema, narrative is aligned with restricted economy – as we might surmise from the way in which we regularly talk about getting rid of, or restricting, the 'excessive' components of films (so-called 'boring' bits that are not driving the story). Meanwhile, comedy – especially slapstick comedy and the gag, which often have little or nothing to do with the narrative – belongs to, or at the very least implies, the general economy. The argument is redolent of Jean-François Lyotard's acinema essay, which Trahair mentions, in that for Lyotard acinema is, as discussed, like striking a match for fun; it is 'comic' (if not necessarily funny) because it involves no intended return other than pure pleasure.

Furthermore, Trahair also draws upon Bataille to suggest that the comic suggests sovereignty. Sovereignty for Bataille is 'much more complicated than is conveyed in its everyday usage'.[22] Indeed, in the first two chapters of this book, I used the term sovereignty in this 'everyday' sense when discussing the concept of the nation and when drawing on the term as used by Giorgio Agamben and Michael Hardt and Antonio Negri. In this 'everyday' sense, sovereignty is akin to control (with multitude being somewhat antithetical to state sovereignty, or the control of the people). For Trahair/Bataille, however, sovereignty is quite different, being a moment almost of a lack of control, or the revelation of the uncontrollable nature of reality. Citing Jacques Derrida, who himself is commenting on Bataille, 'sovereignty puts an end to determinate meaning', with sovereignty being the 'comic operation' as such.[23]

In order to understand the distinction between these two types of sovereignty – control and a lack thereof – I should like to mention an anecdote recounted by Bérénice Reynaud in her work on Wu Wenguang. Reynaud discusses how the Indian film-maker Mani Kaul, when studying traditional Indian singing techniques, was told by his instructor that when he sings out of tune or otherwise makes mistakes, then it is at this moment that he hears the sound of his own voice.[24] Reynaud relates this to Wu's cinema in that the 'dirty' sound in his films is also the sound of reality, rather than the sound of cinema (this might also apply to the bad sound of mumblecore).

I mention this anecdote in relation to sovereignty, because the comic moment, or operation as Trahair/Bataille/Derrida terms it, is a bit like the

moment of singing out of tune: we are perhaps most ourselves at this moment, when we elude control of ourselves and the world, and when we fall outside its codes of meaning. It is, in effect, the fart that escapes during a committee meeting; it almost involuntarily produces laughter, with the communal aspect of the laughter also providing immense reassurance to both the perpetrator of the fart and its victims, since the laughter signifies that this could happen to anyone. The comic operation is sovereign because, in being a moment when we are, like Kaul, confronted with ourselves, a self that we cannot control but which perhaps is more fundamentally 'us' for this very reason, then in being ourselves we also attain sovereignty. This sovereignty is somewhat paradoxical not just because 'selfhood' is here being measured by a lack of control, but also because it is a marker of difference (in being myself, I am separate from the rest of the world, I am sovereign), while at the same time being a marker of withness (laughter conveys how we all recognize our susceptibility to these 'weaknesses' or 'mistakes', while the shame that I feel for having farted in public, for having been incapable of controlling myself, is also communal in nature, and an index of entanglement). We might sum up this paradox by using the metaphor of being 'beside oneself' with laughter: one sees one's difference, one sees one's self as different, which has as its necessary condition a sense of withness.

For Trahair, then, 'what constitutes the comic is the disruption of discourse, or, to put it another way, the subjection of meaning to a certain nonmeaning. In this sense, the comic is essentially transgressive The comic is not nonsense as such, but the relation of meaning to nonsense.'[25] Discourse here is a term used to signify meaning, or the codes that involve the pinning down (or restriction) of meaning, with discourse thus being linked to the restricted economy, while the general economy is the world beyond this, the world that typically is kept invisible (not least because outside of discourse, which in cinematic terms is the codes and conventions, malleable as they are, of narrative cinema). The general economy equates to a world that lies beyond sense (if not beyond sensibility, in that we can feel that world as it affects us and as we affect it in an entangled fashion), and 'narrative comedy (or perhaps more appropriately comic narrative) diminishes the agency of the individual to show that the world continues to work according to a logic that is unknowable and ungraspable'.[26] Akin to Deleuze's time-image, then, where agency is reduced, perhaps even to the point of non-existence, in comic cinema the agent also struggles to make sense of anything, with chance, fate, luck and coincidence playing greater parts in comic films.[27]

As Trahair reminds us, 'One economy [restricted and general] does not dominate the other. Both operate at the same time.'[28] In Trahair's analysis of the works of Buster Keaton and various other stars of the silent comedy era, it is not that sense completely disappears; but the comedy is derived from exposing 'the nonsense that lies at the heart of all (cinematic) narrative' – much as this book is trying to demonstrate that non-cinema lies at the heart of cinema.[29] Indeed, Trahair argues how, 'for Bataille, the "beauty" of the poetic is still subordinate to the logic of reason and meaning, whereas he perceives laughter to exceed this logic to the extent that it occupies a position outside the system of philosophy'.[30] There is no need for a detailed discussion of the phrase 'the "beauty" of the poetic'; rather, I wish to draw attention to how laughter might lie outside of philosophy – or in what François Laruelle might term the realm of non-philosophy. As non-philosophy is for Laruelle the reality that upholds the possibility for philosophy to exist in the first place, so is non-cinema the reality that lies beyond cinema, in the sense of cinema as the manifestation of capitalism in the contemporary world.[31] All of the world's wealthy people would not exist without the world's poorest, with whom they are entangled, but who seem to lie outside of reality (they exceed visibility, with this excess being incessant). It is these poor people whom Andrews brings to the fore – in comic movies that both formally and in terms of content suggest a comic (non-)philosophy of (non-)cinema.

The scatologic of *Orzo*

Orzo opens with Toggle Switch trying – at uncomfortable length – to get a toy spider, called something like Heap Fart Rupert or Deep Fried Looper (Karen Bo Baron's pronunciation is unclear, perhaps because she is drunk), to jump through a metal chain – a skill that she hopes will land her a spot on a talent show. The spider does not acquiesce to her demand, and so she ends up 'killing' it by strangling it with the chain. After a brief phone call about cabbage with someone called Stafford (Toggle Switch keeps putting the phone down mid-conversation, before magically appearing via a cut to have the phone still in hand and continuing the conversation), she then falls over. In close-up Toggle Switch explains to the camera that she is a 'flumpsest', supposedly a medical term that describes her clumsy condition. As she explains that no one knows where flumpsest comes from or how to eradicate or control it, we see Toggle Switch falling over again on a repeated loop.

In these opening moments, we can already see Andrews setting up the opposition between sense and nonsense that is key to comedy as Trahair identifies it. Toggle Switch tries to control the toy spider – and later a lizard and the pearl-shitting crow – but ultimately cannot. Not only is reality/nature beyond our control, but the fact that we clearly see a stuffed doll spider also makes ridiculous Toggle Switch's attempts to do so. Indeed, Toggle Switch cannot even control her own body, as the visualization and the muttered, unclear verbal explanation of 'flumpsest' makes clear, with the neologism itself signifying how Toggle Switch's body evades language, representation and thus in some senses control. That Karen Bo Baron finds it hard to pronounce the words that she delivers only adds to this moment a comic pathos; Andrews is creating a fictional world, surely, but it also feeds into reflections on the real world as he documents the people and the space of his Ventura trailer park.

Orzo means barley in Italian, as well as being a kind of pasta, although the relevance of the film's title is oblique at best, suggesting a further aspect of nonsense in the film. Furthermore, the film is primarily concerned with the body and its desires/perceived shortcomings. Toggle Switch regularly farts, especially on Colin's head after she has electrocuted him/turned him into an ostrich. There is an extended 'sex' scene between Rehelio and Alison, in which, after Rehelio has told Alison that 'when I look at your crotch, I see a waffle maker', they make love using a waffle maker as an intermediary/stand-in for her genitals. When we first meet Colin, during a flashback as Rehelio reminisces about his time in jail, he is humping a golf bag using a club as an ersatz penis. And of course a central conceit of the film is about the existence of the so-called quagie, a (fictional) part of the ear that Toggle Switch claims to be the only person to know about – a claim that her neighbour proves wrong by finding a website dedicated to it. In other words, the body and its desires consistently elude control in this film.

Meanwhile, all controlled bodies are in part lampooned. Take for example Colin's Viking son, Wes. When we first meet him, he is trying to impress his father by doing wheelies on a BMX. However, what is normally a feat involving great skill and control (think, for example, of the YouTube videos of stunt bike performers like Danny MacAskill) is here anything but that. For, rather than actually performing wheelies, Wes is simply standing next to the bike and raising its front wheel from the ground. At a later point – in a brief sequence that is randomly interpolated into the film – we see a pile of sand. From screen right, an obvious cut-out rectangle that features different lighting, a different background

and Wes perched on a stationary bike, moves across the screen, edges up the pile of sand, and does a flip (or rather, Andrews rotates the image so that it looks like it does a flip) before exiting screen left. Again, a stunt that should involve great skill and control is reduced to a clearly faked 'special' effect. None of the bodies that we see is disciplined, somehow eluding control and thus mainstream society itself. In Trahair's terms, none of these characters is an agent, being instead beholden to clumsiness, uncontrollable urges and desires, and thus both sovereign and indicative not of a restricted economy, but of the general economy that is senseless reality.

What is true of the bodies in the film is also true of the film's form. The bike stunt helps to illustrate this. For, Andrews has no concern with actually making a convincing special effect, but rather lays bare the artifice of the cut-out image, creating a comic moment in which the 'control' of not just the stunt but also of the visual special effect is lampooned. Here the idea of making mistakes visible, of hearing one's own voice when out of tune, comes to the fore, as Andrews ceaselessly includes in his films fluffed lines, unconvincing costumes and more – including, of course, the grainy images of the digital camera, as if cheap filmmaking equipment were the bastard 'mistake' child of cinema, illegitimate but in Andrews's hands obstinately demonstrating that it is alive and entitled to live. If, to trade briefly in clichés, there are no rehearsals in life, then there certainly are none in Andrews's films, which thus capture the uniqueness of each moment, rather than creating a cinema that is based upon rehearsing, or what in French is called *répétition*, and which thus is about repeating and returning, a central tenet of cinema with its capitalist logic of box office returns. When one can repeat something time and again, for example, as an actor or as a stuntman, then surely this does involve great and admirable skill and control; but it also eludes, or takes us away from, the unrepeatability of a becoming universe, with which we are only ever entangled.

As per Trahair's conception of comedy, Andrews's cinema is also full of chance events, random interruptions and coincidences that suggest a lack of agency in the world. Indeed, were it not for the final song and dance sequence, the film comes close to tragedy as Alison is attacked by a rapist meth addict and as Toggle Switch hangs herself just before the film's end. The world truly is beyond the control of these people, as violent forces interrupt from elsewhere (perhaps it is significant that the meth addict is younger, middle class and not seemingly a trailer park resident; meanwhile, that the quagie exists on the internet suggests that the trailer park residents cannot keep up with a highly

technologized society, which nonetheless takes from them a part of the body that they thought was secret and their own). Were it not for the regenerative force of sex (the 'twat like that' about which Rehelio and Alison sing), death might be the only option for these characters, who in some respects are 'dead' to the world anyway as a result of their trailer park (non-)existence. Nonetheless, while *Orzo* flirts with tragedy, the film is ultimately comic as suggested by its incessant excess and its desire to express all of the perversity of humanity, such that we have before us what Honoré de Balzac might, in his own quest to depict the whole of society, from top to bottom, term the human comedy.

Orzo is full of scatological dialogue and deeds. When Rehelio remembers his time in prison, Colin recounts how 'I once lost my wallet in a wino's womb tunnel, and cancelled all the credit cards because I thought she was going to shit it out and charge up a storm' (Rehelio: 'Yeah, that Colin was delightful'). In describing his family to Toggle Switch, Rehelio explains how his overweight father died aged thirty-six in a gay dance club. 'Oh, he swung both ways?' asks Toggle Switch. 'Oh yeah', replies Rehelio. 'When you got that much ass I suppose you got to do something with it beside shit.' Toggle Switch: 'Amen.' Rehelio then describes his mother as a black bulimic, and recounts an incident involving the discovery of the piles of vomit that she used to leave under the trailer, as well as her seemingly magical ability to fart out his bedroom light when he was a kid. Meanwhile, Rehelio's brother, Rinkydink the Fajita King, is a 'classical music fanatic with toilet paper theories to boot'. As Rehelio explains: 'Well, he said if you huff scented toilet paper while listening to any of the three Bs, it will add six inches to your dick.' Furthermore, there is a sequence in which we see Toggle Switch and Alison fixing a trailer park toilet. In other words, *Orzo* seems to be influenced by effluence, while also documenting the 'effluence' of society in a self-conscious manner (we also see Toggle Switch cleaning her home, suggesting that there is dignity involved in looking after 'even' a trailer). In this way, *Orzo* seems to involve an articulated scato-logic that deliberately explores nonsense, non-sequiturs, random and surreal events, and a world that forever eludes control, together with the bodies that inhabit it. This is a sovereign cinema that is truly independent from Hollywood's mainstream, despite being made right on its doorstep. Put another way, this is a cinema that shows aspects of the world and the body that many might consider unbecoming, in the sense of being unfit for polite society. In creating an unbecoming cinema, Andrews's films unbecome cinema, or become non-cinema.[32]

The digital carnival

The digital image can be manipulated in any way whatsoever. In other words, it is perfectly controllable. It is paradoxical, therefore, that Andrews uses digital technology in order to make a cinema that is about loss of control. That a film is at least partly scripted (it might be unexpected for the meth addict rapist to turn up towards the end of *Orzo*, but Andrews clearly has planned for this to happen) means that cinema is in some ways antithetical to a loss of control. Furthermore, those are not real farts that Toggle Switch does; as (overtly) fake farts, they are controlled, unlike the embarrassing guffs one might expel in a busy lift. In the same way that both the restricted and the general economy operate at the same time, as Trahair points out, so, too, is there control operating at the same time as a loss thereof. Nonetheless, Andrews uses the very digital tools of control to create a cinema of an intensified lack of control, a cinema of nonsense, or, if cinema be about control, then a non-cinema that expresses the paradoxical non-cinematic potential of the digital.

In discussing literature from Latin America – a continent to which we shall turn in the next chapter – Djelal Kedir writes that '*scatology*, in its ambiguous Spanish version – "*escatología*" – is an equivocal term that means both scatology and eschatology at once'.[33] Citing Peruvian author Mario Vargas Llosa writing on Colombian Nobel laureate Gabriel García Márquez, Kedir explains how the link between scatology and eschatology is manifest in the process of self-cannibalization. For, to eat oneself is both clearly reliant on bodily processes, while also involving, eventually, one's own death. *Orzo* seems in part to see cinema eating itself, as made clear by the interpolation within the film of scenes from a rom-com that Alison watches, and which features Karen Bo Baron and Walter Patterson in costumes (and in the latter's case a wig) different from the ones they wear to perform Toggle Switch and Rehelio. We also see this in the film-within-a-film sequences of *It's All Not So Tragic*. In effect, Andrews finds anything and everything and uses it for his 'trash' films, a scatological eschatology that carries with it some of the 'end times' logic that occasionally surrounds discourses in the digital era (apocalyptic strands of post-humanism, the idea of the end of history and so on). In effect, everything is equal for Andrews, which lends to his work also a touch of what Mikhail Bakhtin would call the carnivalesque, with carnival being a concept that the latter established in relation to the work of François Rabelais, whose sixteenth-century novel, *Gargantua and Pantagruel*, also features, in Pantagruel, the notion of self-cannibalization, as Kedir points out.[34]

As Robert Stam puts it in his consideration of Bakhtin and cinema:

> The carnivalesque principle abolishes hierarchies, levels of social classes, and creates another life free from conventional rules and restrictions. In carnival, all that is marginalised and excluded – the mad, the scandalous, the aleatory – takes over the centre in a liberating explosion of otherness. The principle of the material – hunger, thirst, defecation, copulation – becomes a positively corrosive force, and festive laughter enjoys a symbolic victory over death, over all that is held sacred, over all that oppresses and restricts.[35]

In other words, with the overwhelming emphasis on defecation and copulation in his work, Andrews's cinema also takes on a political quality, a sort of latter day 'aesthetic of hunger' as Glauber Rocha might term it, an imperfect, digital non-cinema that does indeed abolish hierarchies, including the social hierarchy that places trailer park residents in the/as 'trash'.[36]

However, one of the potential shortcomings of carnival as a radical, equalizing or revolutionary force is the fact that the carnival – traditionally the day of the year where the rich dress as the poor and the poor as the rich, such that they swap places and traditional hierarchies are temporarily reversed – is itself a controlled exercise in reversing hierarchies, but not in eradicating them. Indeed, the trailer park itself is a delineated space in which the 'trash' can play with/for Andrews as much as they wish. But how does this go about helping to abolish both social and cinematic hierarchies? As we have established via Koehler's review of *Garbanzo Gas*, festivals won't touch Andrews's work, let alone mainstream film distributors. Andrews can and indeed does make whatever films he wants to, and he is enabled by affordable digital technology that previously might not have been available. However, what does this really change?

This is where Andrews's cinema must indeed be understood as non-cinema, for in some respects it does not change cinema; it is a kind of controlled carnival, joyous but brief. Nonetheless, Andrews is also empowered by producing precisely not cinema, but non-cinema. What is more, while most audiences might not watch or find out about his work, it is digital technology, via Andrews's website, that allows him to bust Karen Bo Baron, Walter Patterson, Vietnam Ron, Ed, Tyree, Miles Dougal, Marybeth Spychalski, Bill Nowlin, Walt Dongo and the others in his comic community of collaborators, off the trailer park and out into the real world.

Trahair writes that

> film analysis itself contributes to the subordination of the comic to narrative because the attribution of comic surprises to any kind of motivating forces, even

'noncausal' ones, rationalises away the very force of the comic that had emerged from the fabula-syuzhet relationship. The process of exchange (of syuzhet for fabula or comedy for meaning) results in the subordination of general economy to restricted economy.[37]

In other words, to explain in language that comedy defies language is in some senses to deflate its subversive potential. It is, as they say, to ruin the joke. Nonetheless, it is also important to celebrate and to write about people like Andrews to aid precisely in the effort for his work to get off the trailer park and out into the wider world where it can challenge preconceptions and help to bring about a different kind of thinking. Taking part in this process is in some respects to take part in the comedy. What is more, if scatology and eschatology meet in the comic and carnivalesque/grotesque process of self-cannibalization, then one must take 'the subordination of the comic to narrative' and level that, too. In short, non-cinema might seem to reaffirm the centrality of cinema; but the point to make is that cinema is contained within and owes its existence to a far more vast non-cinema, such that cinema's self-proclaimed centrality, such that the perception that a capitalist world is our only seeming option, is such a small-world view that its absurdity melts into comic insignificance. Put another way, and in reference to Jeffrey Sconce, to write about Andrews in an academic context might bourgeoisify his work somewhat, but it also helps to trash the academy.[38]

A world of comedy

Andrews's final film from Ventura adopts a specifically home movie aesthetic. That is, *Diary* (USA, 2011) is shot through a camera that the characters themselves manipulate within the story-world of the film, as opposed to through a camera that the characters ignore because it is supposed not to be real. Numerous films, including *The Blair Witch Project* (Daniel Myrick and Eduardo Sanchez, USA, 1999), *My Little Eye* (Marc Evans, UK/USA/France/Canada, 2002), *Paranormal Activity* (Oren Peli, USA, 2007), *[REC.]* (Jaume Balagueró and Paco Plaza, Spain, 2007), *Cloverfield* (Matt Reeves, USA, 2008), *Chronicle* (Josh Trank, USA, 2012) and *Project X* (Nima Nourizadeh, USA, 2012) adopt the 'home movie' or 'found footage' aesthetic that Andrews uses in *Diary*. However, where Andrews thinks outside the box office, these films place the techniques that might otherwise characterize non-cinema in the service of capital. That is, these films restrict

their economy (they are guided primarily by economy) and as a result they lose their comic potential.

In the final chapter of the fourth book of *Gargantua and Pantagruel*, Rabelais discusses how Panurge, the friend and travelling companion of Pantagruel, is so scared by the sound of canon fire that, as the latter shoots at the Island of the Muses in order to salute them, he fouls himself. Rabelais tells us how Frère Jean, another of their companions, 'smelt an odour which was not that of gun-powder. So he tugged out Panurge and saw his shirt all covered with thin excrement and freshly beshitten.'[39] The sight of Panurge covered in poo, together with scratch marks from Rodilardus, a cat whom Panurge mistakes for a demon, causes Pantagruel to laugh. As M. A. Screech explains in his notes on this chapter, this is the first time that Pantagruel has laughed in a long time: 'He cannot help it. Pantagruel has been an agelast, a non-laugher, throughout the last two books: that too makes him like Socrates, who had a great sense of fun and laughed with his friends.'[40] Indeed, in his prologue to the first book, Rabelais mentions on several occasions the importance of laughter, and specifically praises Socrates for his ability to laugh, despite being profoundly ugly.[41] Bakhtin then takes up this motif when he argues that Tappecoue, a Franciscan sacristan who refuses to lend François Villon some clothes in Chapter 13 of the fourth book is 'the worst of all enemies: he was the very incarnation of that which the author most detested. He was what Rabelais called an agelast, a man who does not know how to laugh and who is hostile to laughter.'[42]

Meanwhile, Umberto Eco's 1980 novel, *Il nome della rosa/The Name of the Rose*, hinges upon the discovery of an otherwise suppressed book on comedy by Aristotle. The book has been suppressed, it would seem, because comedy is antithetical to control; were comedy to be more widely understood, or at the very least enjoyed, then the humourless, or agelastic, control of society – which achieves control by dividing rather than by entangling (or co-mediating) people – would be subverted. Comedy, and the sense of entangled witness that comes through laughing about making mistakes, is a means by which, then, we can achieve a better sense of our enworldedness and of the fact that we are with, and not separate from, the so-called 'trash' of the trailer park. Scatological, it is eschatological in embracing change, randomness and becoming – as opposed to gesturing towards eschatology in the form of movies about the end of the world for the purposes of returning to the same old rule of box office returns. Although little known, and in some senses 'lost' like the Aristotle book in Eco's novel, the digitally enabled non-cinema of Giuseppe Andrews is a comic non-

cinema that is out of control and thus which becomes perhaps some of the most important work in the United States today. Even at the very heart of cinema, perhaps precisely at the very heart of cinema, non-cinema blooms.

Notes

1. David E. James, *The Most Typical Avant-Garde: History and Geography of Minor Cinemas in Los Angeles* (Berkeley: University of California Press, 2005).
2. Ryan Gilbey, 'Mumblecore: "It was Never a Unified Movement. There was No Manifesto"', *The Guardian*, 7 November 2013, http://www.theguardian.com/film/2013/nov/07/mumblecore-andrew-bujalski-computer-chess.
3. Amy Taubin, 'Mumblecore: All Talk?' *Film Comment*, November/December 2007, http://www.filmcomment.com/article/all-talk-mumblecore.
4. Anna Backman Rogers, *American Independent Cinema: Rites of Passage and the Crisis Image* (Edinburgh: Edinburgh University Press, 2015), 149–59.
5. Yannis Tzioumakis, *Hollywood's Indies: Classics Divisions, Specialty Labels and the American Film Market* (Edinburgh: Edinburgh University Press, 2013), 194. For a similar argument, see also Chuck Tryon, *Reinventing Cinema: Movies in the Age of Media Convergence* (New Brunswick: Rutgers University Press, 2009), 116–19.
6. Tzioumakis, *Hollywood's Indies*, 194. On 'bad' sound in mumblecore, see Nessa Johnston, 'Theorizing "Bad" Sound: What Puts the "Mumble" into Mumblecore?' *The Velvet Light Trap*, 74 (Fall 2014), 67–79.
7. See Taubin, 'Mumblecore.'
8. Aymar Jean Christian, 'Joe Swanberg, Intimacy, and the Digital Aesthetic', *Cinema Journal*, 50:4 (Summer 2011), 117–35.
9. Maria San Filippo, 'A Cinema of Recession: Micro-Budgeting, Micro-Drama, and the "Mumblecore" Movement', *Cineaction*, 85 (2011), http://www.cineaction.ca/wp-content/uploads/2014/04/issue85sample1.pdf.
10. The term 'gentrification of poverty' came up during an informal discussion, with Mathew Abbott, Matthew A. Holtmeier and Eva Sancho Rodríguez, about *Wendy and Lucy* (Kelly Reichardt, USA, 2008) and *Frances Ha* (Noah Baumbach, USA/Brazil, 2012) at the Film-Philosophy Conference in 2015. I am grateful to all three, especially because I am not certain who actually coined the phrase (I think it was me, but perhaps we all think as much).
11. Lazzarato, Maurizio (2012), *The Making of the Indebted Man: Essay on the Neoliberal Condition* (trans. Joshua David Jordan), Los Angeles: Semiotext(e).
12. Failure is a constant motif in the work of various non-mumblecore contemporary American film-makers including Ramin Bahrani, Larry Clark, Harmony Korine,

Mike Ott, Kelly Reichardt, and perhaps even the more recent digital work of David Lynch. Meanwhile, Paul Schrader's crowd-funded controversy *The Canyons* (USA, 2013), cult director Monte Hellman's exploration of the DVD, *Road to Nowhere* (USA, 2010), and Steven Soderbergh's 'smaller' digital films, especially *Bubble* (USA, 2005), point to other possible iterations of American non-cinema. Indeed, Soderbergh's exodus from cinema and into television in particular connotes some sort of non-cinematic evolution, in that while television is clearly driven by a need for profit, it seems in the 2010s to be a medium more suited to experimentation than cinema (the rise of 'quality television' – even if a growing amount of it in fact is funded and distributed by online platforms and providers like Amazon).

13 See Tzioumakis, *Hollywood's Indies*, 194–5.
14 See Beckett, *Nohow On*, 89.
15 Julie Allan, 'Staged Interventions: Deleuze, Arts and Education', in *Deleuze and Education*, ed. Inna Semetsky and Diana Masny (Edinburgh: Edinburgh University Press, 2013), 51. For more on exhaustion, see Gilles Deleuze, 'The Exhausted', trans. Anthony Uhlmann, *Substance*, 24:3 (1995), 3–28.
16 See Jason Guerrasio, 'Forgotten Mavericks: Ten Years Later, What Happened to *Four Eyed Monsters*?' *Indiewire*, 21 January 2015, http://www.indiewire.com/article/forgotten-mavericks-ten-years-later-what-happened-to-four-eyed-monsters-20150121.
17 Ewa Mazierska, *From Self-Fulfilment to Survival of the Fittest: Work in European Cinema from the 1960s to the Present* (Oxford: Berghahn, 2015), 236.
18 Robert Koehler, 'Review: *Garbanzo Gas*', *Variety*, 10 July 2007, http://variety.com/2007/film/reviews/garbanzo-gas-1200557911/.
19 Bill Gibron, 'Giuseppe Andrews' *Orzo*', *Pop Matters*, 2 February 2008, http://www.popmatters.com/post/giuseppe-andrews-orzo/.
20 The shot in *Garbanzo Gas* is reminiscent of a similar moment in Lars von Trier's Dogme 95 film, *Idioterne/The Idiots*, Denmark/Spain/Sweden/France/ Netherlands/Italy, 1998, in which a first cameraman captures a second as the movie's protagonists run naked around a garden while 'spassing'/behaving as if mentally impaired.
21 Lisa Trahair, *The Comedy of Philosophy: Sense and Nonsense in Early Cinematic Slapstick* (Ithaca: State University of New York Press, 2007), 24.
22 Trahair, *The Comedy of Philosophy*, 26.
23 Ibid.
24 Bérénice Reynaud, 'Translating the Unspeakable: On-Screen and Off-Screen Voices in Wu Wenguang's Documentary Work', in *The New Chinese Documentary Film Movement: For the Public Record*, ed. Chris Berry, Lu Xinyu and Lisa Rofel (Hong Kong: University of Hong Kong Press, 2010), 159.
25 Trahair, *The Comedy of Philosophy*, 32–3.

26 Ibid., 44.
27 Ibid., 67.
28 Ibid., 101.
29 Ibid., 86.
30 Ibid., 16.
31 See, for example, Laruelle, *Principles of Non-Philosophy*.
32 Andrews's films could quite happily feature in Fleming's *Unbecoming Cinema*, mentioned in the last chapter. Although not focused on the digital per se, Fleming argues that various 'extreme' cinemas, including the 'vomit gore' films of Lucifer Valentine, suggest cinema pushing beyond its old boundaries and into new territory. When cinema digitally unbecomes, it becomes non-cinema.
33 Djelal Kedir, *The Other Writing: Postcolonial Essays in Latin America's Writing Culture* (West Lafayette: Purdue University Press, 1993), 139.
34 Kedir, *The Other Writing*, 139. See also Mikhail Bakhtin, *Rabelais and His World*, trans. Hélène Iswolksy (Bloomington: Indiana University Press, 1984).
35 Robert Stam, *Subversive Pleasures: Bakhtin, Cultural Criticism and Film* (Baltimore: Johns Hopkins University Press, 1989), 86. The passage is also quoted in Stephanie Dennison and Lisa Shaw, *Popular Cinema in Brazil* (Manchester: Manchester University Press, 2004), 17.
36 Glauber Rocha, 'An Esthetic of Hunger', trans. Randal Johnson and Burnes Hollyman, in *New Latin American Cinema*, ed. Michael Martin (Detroit: Wayne State University Press, 1997), 59–61.
37 Trahair, *The Comedy of Philosophy*, 43.
38 See Sconce, 'Trashing' the academy.
39 François Rabelais, *Gargantua and Pantagruel*, trans. M. A. Screech (London: Penguin, 2006), 868.
40 Rabelais, *Gargantua and Pantagruel*, 867.
41 Ibid., 11–14.
42 Bakhtin, *Rabelais and His World*, 267.

8

Globalization and Erasure: Digital Non-Cinema in Uruguay

Since shortly before the turn of the millennium, Uruguayan cinema has undergone a renaissance – or what some characterize as simply a *naissance*, or birth rather than rebirth.[1] Indeed, it is common that whenever Uruguayan films receive international attention, they are repeatedly and paradoxically fêted as the first Uruguayan films to do so.[2] For each new wave to be new, then, previous waves and moments in the history of Uruguayan cinema are erased.

However, rather than provide a 'true' history of Uruguayan cinema (identifying which films really did come first, etc.), this chapter will explore not only how Uruguayan cinema disappears, but how it also in some senses is a cinema about disappearance, or erasure. Since it is erased, perhaps Uruguayan cinema can be understood best as non-cinema.[3] I shall do this first by looking at *La casa muda/The Silent House* (Gustavo Hernández, Uruguay, 2010) and its American remake, *Silent House* (Chris Kentis and Laura Lau, France/USA, 2011), suggesting both that the remake represents the impossibility of Uruguayan cinema (but the possibility of Uruguayan non-cinema) and, drawing upon the work of Argentine philosopher Enrique Dussel, that this exemplifies wider relationships between the so-called global north and south in the era of globalization. The chapter then looks at Federico Veiroj's *La vida útil/A Useful Life*, arguing that the film, which is about the closing of the Cinemateca Uruguaya, a renowned independent cinema in Montevideo, charts the decline of cinema in the digital era, concomitantly suggesting that non-cinema functions as a relevant framework through which to think about cinema in the contemporary age. Before analysing *La casa muda* and *La vida útil*, however, I should briefly introduce the ways in which Uruguayan cinema is a cinema of erasure.

The erasures of Uruguayan cinema

As Tamara L. Falicov has noted, Uruguay has a population of only three million people, which means that it does not have a market large enough to sustain a dedicated feature film industry. Although there has been state support for Uruguayan film-makers since at least 1995 via FONA (the *Fondo para el Fomento y Desarrollo de la Producción Audiovisual Nacional*), it is often necessary for film-makers to apply for and to use funding from international and transnational sources, such as Spain's IBERMEDIA, various European and North American festival development funds, and production companies from other MERCOSUR countries.[4] For this reason, Uruguayan cinema struggles to exist, with David Martin-Jones and María Soledad Montañez pointing out how certain types of Uruguayan cinema by necessity erase the local, namely Uruguay itself, in order to create a transnational appeal that befits the transnational system of funding, and which might enable the films to reach a larger, international audience, thereby recouping the costs of making cinema/increasing the chances of making a profit.[5] In other words, in addition to the erasure of Uruguay's cinematographic history as each new film is supposedly the country's first, a geographical erasure also seems inscribed into Uruguayan film-making. A film like *Gigante/Giant* (Adrián Biniez, Uruguay/Argentina/Germany/Spain/Netherlands, 2009), for example, anonymizes its Uruguayan setting in order to maximize international appeal, while a film like *Blindness* (Fernando Meirelles, Canada/Brazil/Japan, 2008) was shot in Uruguay, but erases the country as the film's story takes place in an anonymous location. Finally, a film like *The City of Your Final Destination* (James Ivory, USA, 2009) is partially set in Uruguay, but not shot there. In all cases, then, Uruguay is erased, suggesting that Uruguay and cinema are not compatible, or that Uruguay is non-cinematic.[6]

In the short film *¡Ataque de pánico!/Panic Attack!* (Fede Alvarez, Uruguay, 2009), computer-generated alien spacecraft destroy Montevideo, suggesting precisely the erasure of the local (the landmarks of Montevideo) at the hands of a global computing industry (CGI aliens) that allows for the creation of such digital special effects.[7] Being a short film that achieved great success on YouTube – such that Fede Alvarez was invited to Hollywood to direct *Evil Dead* (USA, 2013), a remake of Sam Raimi's *The Evil Dead* (USA, 1981) – it would seem that not only is Uruguay erased in Uruguayan cinema, but that its most watched film circulates outside of cinemas, and that its director cannot work in Uruguay, instead leaving for Hollywood. Again, as cinema struggles to exist in Uruguay,

perhaps non-cinema becomes a more fitting framework through which to consider Uruguayan films.

With these erasures in mind, then, we can now turn our attention to *La casa muda*, a film that has the appearance of having been made in a single take and which tells the story of Laura (Florencia Colucci), her father Wilson (Gustavo Alonso) and Wilson's boss, Néstor (Abel Tripaldi), who go to a cabin in the woods, and where Laura murders the two men in revenge for what seem to be past abuses. As we shall see, *La casa muda* is also a film about erasure, with its digitally enabled single-take aesthetic cementing our understanding of the film not as cinema but as non-cinema.

La casa muda: Unedited, inedible

If the digital special effects of *Panic Attack!* are instrumental in conveying the erasure of Uruguay in the era of globalization, then the digital form of *La casa muda* plays a similar role. For, as mentioned, *La casa muda* is a single-take movie. I have argued elsewhere that the extremely long takes and mobile cameras of digital cinema suggest the connected, or what I might term entangled, nature of those spaces. That is, single-take films encourage an understanding of space whereby space and all that fills it (including humans) are on a single continuum. This marks a shift from analogue cinema, which for reasons of technological limitations features cuts that fragment space and time (with the frame also fragmenting space, a matter to which I shall return in the final chapter).[8]

More than simply showing the continuity of space, though, *La casa muda* also sees the camera passing, without a cut, from 'objective' to 'subjective' points of view, with characters looking directly at and addressing the camera as if it were now one of the other characters in the film. More than an entanglement of different spaces (and times, as the film veers without a cut between past and present, between memories and perhaps fantasies), *La casa muda* suggests an entanglement between characters, such that we cannot truly separate them from each other, and who equally are entangled with the space with which they find themselves. In this way, *La casa muda* follows a digital logic of continuity as opposed to an analogue logic of fragmentation, while also being a film about erased histories, in particular Laura's past. As we shall see, *La casa muda* furthermore suggests a wider continuity as opposed to fragmentation between the global north and the global south (or what in old money might be referred

to as the First and Third Worlds), while also suggesting that globalization in the digital age involves the erasure of a history of abuse and/or exploitation.[9]

Martin-Jones and Montañez argue that Laura is in fact two people in the film: one who is the victim of abuse at the hands of Wilson and Néstor, and one who is also exacting revenge on both of them for that abuse and for taking away her unborn child.[10] Their reading is not incorrect, not least because it helpfully suggests that there is both a 'present' Laura (with Wilson and Néstor now) and a 'past' Laura (come to exact revenge). However, I might argue for a less conventional interpretation and suggest that the way in which the film combines different perspectives from supposedly different characters and without a seeming cut suggests that the 'two Lauras' are equally inseparable from Wilson and Néstor, and that all of them form a continuum, including with the space of the film – a space highlighted, of course, by the film's title. In other words, *La casa muda* suggests entanglement, and one that does not just have a spatial dimension (Laura is Wilson is Néstor is the house is Laura, as the camera moves between all of these perspectives in a single, unbroken movement) but also a temporal dimension (the past coexists with the present, as seen by what Martin-Jones and Montañez describe as the 'return' of the second Laura).

It might be tempting to read *La casa muda* as an allegory of one or more specific but erased pasts coming back to affect the present (e.g. civil unrest in the 1960s, especially by the Tupamaros group to which recent president José Mujica belonged; the civic-military dictatorship that ran between 1973 and 1985, and during which numerous human rights abuses took place). However, such a reading would be tenuous at best. What more productively we might suggest is that the very openness/ambiguity of the film, in encouraging interpretation from the viewer, suggests that the viewer herself is also entangled with the film (the spectator is 'diegetic'), a process that has at its core the film's digitally enabled single-take appearance (the absence of cuts creates ambiguity).

While *La casa muda* is a tale of madness, then, the various entanglements of characters, space and viewer that it involves would also suggest a 'schizophrenic' conception of reality. After Gilles Deleuze and Félix Guattari, we can read this 'schizophrenia' as emblematic of life under capitalism.[11] Furthermore, we might read the single-take nature of *La casa muda* as being related to Deleuze and Guattari's concept of the 'minor', in that if editing gives to cinema a 'grammar' or a 'language', then the absence of an edit makes for an ungrammatical film (or a non-film) that disrupts the major language of mainstream cinema. This is especially true for the horror genre – to which *La casa muda* otherwise belongs,

since horror relies heavily on various different types of cut, from the cuts caused by the slasher's knife to the cuts made by the editor of the film. However, I would also like to propose that being a single-take film makes *La casa muda* 'hard to consume' – in that it demands a single, uninterrupted viewing (it must be viewed whole) at a time of increased fragmentation. While by no means the only single-take movie, the form nonetheless runs the risk of alienating viewers (even if it can also function as a sales gimmick), who simply will not put up with having to look at the same image for such a prolonged period of time, especially in an era when fragmentation via the cut is a chief tool used to attract and to maintain viewers' attention, with attention, after Jonathan Beller, being at the core of the contemporary economy of neoliberal globalization.[12] Being a single-take film, *La casa muda* goes against the logic of the attention economy; if the attention economy is based upon a cinematic mode of production, then to go against that mode of production is to go against cinema, or to become non-cinema.

The reason why I call *La casa muda* 'hard to consume' is based upon a pun. The word 'edit' typically is thought to derive from the verb *ēdere*, which in Latin means to dispatch and, by extension, to give out, to eject, to produce, to publish and to relate (in the sense of relating a story). However, in Latin *edere* also means to eat, with 'edit' meaning 'he, she or it eats'. Playfully I would like to suggest, therefore, that in some senses cinema is eating, or consumption: viewers consume films while, more importantly, films consume our attention. In an era of films featuring increasing numbers of cuts, or what David Bordwell calls intensified continuity, the more edits there are in a film, the more it consumes our attention.[13] The more it consumes our attention, the more monetizable that film therefore is or becomes, as per Beller's attention economy and my own research regarding how films capture and maintain our attention, especially through cutting.[14] A film with no edits, meanwhile, might not be so easy for viewers to consume – perhaps to the point of being inedible, not least because ambiguous/hard to understand. Rather than consuming our attention, rather than being easy to consume, the film instead invites its viewers much more carefully to chew on and to spend time digesting it, or considering it.

I may willingly enter into a cinema to watch a highly edited film, but once there my attention is grabbed – such that I can concentrate on nothing else. This grabbing or consumption of my attention increasingly happens in places where I do not expressly choose it to happen: screens featuring edits in pubs, on train platforms, in supermarkets, in taxis, other people's screens on public transport and in public space, etc. More than this, I increasingly do choose to have my

attention consumed as I take out my smartphone and let its screen give me a small dose of attention-grabbing cinema at times when the situation with which I find myself is otherwise too boring. This exploitation of my attention, which becomes so naturalized that I regularly seek it out, is capitalist consumption and not what in the chapter on British non-cinema we defined as companionship (literally, 'sharing bread'). In contrast to the rapid edits that exploit my attention to reinforce the attention economy (and to seek to make profit), the single-take film becomes a more respectful gesture of companionship, perhaps even of love.

If cinema is overcome by the logic of capital, or rather if life under capitalism is overcome by the logic of cinema and its attention-grabbing cuts, then a single-take film like *La casa muda* is arguably an example of non-cinema. Being non-cinema, it runs the risk of poor box office returns, a risk that can be more clearly understood through a comparison between the original film and its remake. For, while the latter film also uses the single-take format, its non-cinematic credentials are mitigated by various other more mainstream/commercial techniques, such as frontality and stars, which allowed it to take greater part in the attention economy and by extension to make considerably more money. A comparison between the two will enable us better to understand how non-cinema works against the capitalist demand for profit, while cinema is always working with and for capital's question to make money.

La casa muda versus *Silent House*: Aesthetics and exploitation

According to IMDb, *La casa muda* is the ninth highest-grossing Uruguayan film in the United States. In the top spot is *Miami Vice* (Michael Mann, USA/Germany/Paraguay/Uruguay, 2006), a film that was partially shot there, despite not being set there (Uruguay is erased!). However, while the table says that *Miami Vice* made US$63.4 million at the US box office, the box office revenue for *La casa muda* is marked simply by a dash.[15] This is not to say that the film has not made money in North America, particularly via DVD and streaming sales, as well as sales to television networks and the like. However, *La casa muda* basically made no box office revenue in the United States.

Meanwhile, *La casa muda* did make US$1.15 million at the box office worldwide, with BoxOfficeMojo reporting that the majority of that money came from Latin America (specifically Argentina, Bolivia, Mexico, Peru and

Uruguay), with the film also enjoying a healthy box office performance in France (US$180,893) and a more modest one in the UK (US$13,997).[16] Within Uruguay, *La casa muda* made US$112,616, making it the 44[th] highest-grossing film of 2011, with only two other Uruguayan films outperforming it (the football documentaries *Manyas La Película*, Andrés Benvenuto, Uruguay, 2011, and *3 Millones*, Jaime and Yamandú Roos, Uruguay, 2011).[17] To make it clear, this means that 41 of the 44 highest-grossing films in Uruguay in 2011 were not Uruguayan.

The point of this foray into statistics is to suggest that the neglect shown towards *La casa muda* in all regions outside of Latin America, and especially in the United States (where Uruguayan cinema seems to be ignored wholesale), demonstrates that Uruguayan cinema is in effect a non-cinema. And yet as mentioned *La casa muda* was within a year remade, with *Silent House* grossing US$16.5 million worldwide – nearly 15 times more than the original film. The vast majority of that money was made in the United States (US$12,754,783), with the remake enjoying a release in over twice the number of territories as the original, making US$3.8 million outside of the United States (oddly without a release in France, even though the film is listed as a French co-production).[18] Tellingly, in the four territories in which both versions of the film were released (Argentina, Mexico, Peru, the UK), the remake made more money than the original in all but one (Peru, where the figures were basically equivalent; see Table 1).

In other words, audiences preferred to watch the American remake over the Uruguayan original, even though in Argentina and Mexico the original is in the major language of the domestic population. There are several conclusions to draw here.

First, that the remake makes more money (even if the original made a greater profit in relation to budget size, in that *La casa muda* was allegedly shot for US$8,000) suggests the power of North American companies with regard to securing distribution deals (more territories) and with regard to promoting the film (more people know about *Silent House* and thus see it). Secondly, that as many or significantly more people watch the remake in Spanish-speaking territories like Argentina, Mexico and Peru suggests that cultural imperialism is strong in these places, as audiences prefer the English- to the Spanish-language film. Thirdly, that the remake happened at all suggests the continuing 'brain drain' from Uruguay (and other 'peripheral' countries) to the centre (the United States), here in the form of the film itself, although elsewhere in the form of Fede Alvarez heading to

Table 1 Comparative box office returns of *La casa muda* and *Silent House*

Territory	La casa muda	Silent House
Argentina	US$252,927	US$354,713
Mexico	US$305,829	US$980,483
Peru	US$256,006	US$246,968
United Kingdom	US$13,997	US$680,524

Source: BoxOfficeMojo.

Hollywood after the success of *Panic Attack!* Using the work of Enrique Dussel, I shall argue shortly that this 'brain drain' is a form of exploitation. However, for the time being we might look at the different aesthetics of the two films to further the distinction between cinema and non-cinema.

For, while the remake employs the same (seeming) single-take aesthetic as the original, it nonetheless has a very different approach to its subject matter, as Catherine Grant has outlined. For example, the original starts off at shoulder level as Laura approaches the house, while the remake sees Sarah (Elizabeth Olsen) from above, or from what Grant calls 'god's eye view'.[19] As Laura approaches the house, the camera follows her, whereas when Sarah approaches the house, the camera is in front of her, allowing us to see her face. What the original hides, therefore, the remake in some senses shows – namely the face of the main protagonist. In part, the remake 'must' do this, since the film's star, Elizabeth Olsen, must be visible in order to help make the film visible (which is not to mention potential legal contracts that require a performer to have their face appear in a certain percentage of any given film). In other words, *Silent House* is cinema in the sense that it is driven by an economic imperative, while *La casa muda* is non-cinema because, even though the film made a healthy profit, its aesthetic is not determined by commerce.

If more people in Argentina and Mexico watched the remake than the original, then we can propose that the remake adopts various strategies (a star, frontality) that are more familiar to audiences and thus 'easier' to understand and follow (or what we might term 'read'). Why is this? Because the citizens of those countries have seen similar types of image in the numerous North American audiovisual products that swamp their media screens. We might say that Mexico, being its neighbour, is in fact closer culturally to the United States than it is to Uruguay, thus justifying on some levels the preference in Mexico for the remake. However, when it comes to Argentina, the neighbour of Uruguay, we cannot make the same case; Argentina is closer culturally to Uruguay – or so we might believe –

than it is to the United States. The reason why the North American version is preferred, however, is because of the cultural imperialism of the north, meaning that the culture of the United States dominates in places like Argentina, such that its aesthetics are preferred to those of even Argentina's closest neighbour. As the economies of Latin America are forced into dependence on the north, so, too, are the cultures. This leads us, therefore, to the issue of exploitation.

In *Ethics and Community*, Dussel suggests that 'the "poor" constitute the majority of the population of the nations of the world, especially in the "peripheral" world', and that 'the "poor" in the economic sense are the wretched, those left lying by the side of the road, those living outside the system'.[20] The poor are exploited thus:

> The person having money proposes to the poor person (the individual who has already been *violently* coerced, with the violence of the injustice that has destroyed his or her community of origin) a contract, an exchange. Thus a *relationship* is struck between the two: I give you money and you give me your work, which, purchased as a commodity, now becomes my property, for I am the one who had the money. Correlatively, the one who had work to offer exchanges it for money – receives wages.
>
> But there is a subtle *inequality* in this exchange, invisible both to the one who has the money and the one who offers the work. This is a *social* relationship because it is a relationship of domination, of injustice. Invisibly, imperceptibly, it is sin. Why? Because the person having the money uses the *person* of the worker while paying only for that person's *work capacity*. The employer makes use of the whole worker, makes use of the 'creative source of value', though paying only for his or her 'upkeep'. It is as if someone wished to purchase an automobile by paying only for fuel and servicing. I receive the 'creative subject' gratis, and pay only for what is needed to keep that subject from dying, to keep it working. As creators in the image of God, inventors by nature, obviously human beings will produce a value equivalent to the value of their needs (which is the value of the money they are to be paid in wages!) in a certain time, and then will go on to produce beyond this limit. Thus the value of the product produced by the worker will acquire a 'more-value', *more life* and more reality than the value of the wages received. In order words, the worker will give more life than he or she receives. This is an injustice, a *social* relationship of domination, a sin.[21]

Now, some readers may feel unhappy with Dussel's use of Christian terminology, for example sin, which for him equates to domination and/or exploitation. However, Dussel asserts that 'liberation is possible only when one has the courage to be atheistic vis-à-vis an empire of the centre', and that 'in order to *be able to*

believe, one must first be an "atheist", an anti-fetishist, with respect to the idol constituted by the prevailing system'.[22] Since capitalism is the prevailing system, which presents itself to us as if it were the only possible reality (as the saying goes, it is easier to imagine the end of the world than it is to imagine the end of capitalism), then atheism towards capitalism is perhaps the more important point to take home here than a specifically Christian conception of the universe.

To return to *La casa muda*, we can read the remake of the film as an example of exploitation (even if there are unlicensed remakes and appropriations in all directions within the world of cinema).[23] Furthermore, we can see the 'brain drain' from Uruguay to the United States as in particular the continuation of 500 years of pillaging, or the opening up and bleeding dry of the veins of Latin America, as the late Uruguayan writer Eduardo Galeano might put it.[24] This exploitation of Latin America historically was the birth of modernity, in that it allowed the colonial powers to enrich themselves, while creating the poor and excluded, who remain incapable of achieving equality (for David Martin-Jones, it was also the birth of the Anthropocene).[25] Indeed, the drain of *La casa muda* (and Fede Alvarez) from Uruguay to the United States demonstrates how what was true in 1971, when Galeano wrote *The Open Veins of Latin America*, remains true today, but now also for film-makers: ongoing dependency means that 'we [Latin Americans] give ourselves the luxury of providing the United States with our best technicians and ablest scientists [and films and film-makers], who are lured to emigrate by the high salaries and broad research possibilities available in the north'.[26] This exploitative, capitalist relationship is in particular predicated upon a rejection of entanglement and the ability to treat the world and other people like objects. As we shall see, if capitalism is cinematic, then the fight against exploitation involves adopting the logic of non-cinema. We can demonstrate this by exploring the aspects of Dussel's work that overlap with non-cinema as it is defined here.

The heroic heresy of immanentizing the eschaton

It is not that simplistically there are 'good' poor people and 'bad' rich people who dominate them. Indeed, domination is impersonal, another reason for its being invisible. It is impersonal on two levels. First, it is impersonal because it is as much systemic, or institutional, as it is carried out on a one-with-one basis. Dussel explains: 'If a person (or group of persons) dominates another person

(or group of persons) *stably* or *historically* (as the encomendero dominated the Amerindian, the capitalist dominates the wage-earner, the man the woman, and so on), we may say that this praxis of domination, this defect or sin is *institutional* or social.'[27] Secondly, it is impersonal because capitalist exploitation involves the reification of people such that they cease to be persons and become instead things: 'It is not the *person-person* relationship that prevails, but the *I-thing* relationship, the relationship of subject to object.'[28] The exploited is not considered a person, rendering the exploiter's relationship with her impersonal.

Nonetheless, domination, exploitation and reification – which in turn lead to impoverishment – are all prevalent in the contemporary capitalist world; indeed, the historical context of Latin America, the discovery and then exploitation of which equates after 1492 to the dawn of the modern world, suggests that domination, exploitation and reification are at the core of capitalism. And in Dussel's language, domination destroys community; it moves people away from the person–person relationship defined above, and into the subject–object relationship that is key to the prevalence of notions like impartial observation, objective scientific measurement and a general denial of one's ontological entanglement. Ethics, meanwhile, denotes 'the future order of liberation, the demands of justice with respect to the poor, the oppressed, and their project ... of salvation'.[29]

Dussel distinguishes ethics from morality, with morality meaning the prevailing beliefs in a given place and/or at a given moment in time. That is, morality can change, meaning that morality is thus better understood in the plural (moralities), while ethics – which has as its unique goal simply the liberation of the poor – remains constant. For example, Dussel summarizes how the morality/prevailing belief in ancient Greece was that 'the "poor" are poor by natural inclination, by reason of the evil disposition of their body or their soul, by reason of their vagrancy, or want of virtue, or simply their ill luck'.[30] That is, in ancient Greece and as seems to be the case for many people in contemporary times, the poor are lazy, unlucky or just plain bad people. Not only is such a morality therefore one that might change (there could be times during which people believe that the poor are exploited), but it also shows the radical disassociation of morality from ethics; for, the ancient Greek (and strands of contemporary) morality is antithetical to ethics, while a morality that is about helping the impoverished and bringing about the end of impoverishment might coincide with ethics. To be clear, then: who is poor can change, as can attitudes towards the poor; but the liberation of those who are poor, the ethics of

liberation/ethics as liberation, does not change.[31] If it did change, then humans would have achieved what currently is utopian thought: the radical equality of all humans.

For Dussel, those who attempt to bring about this radical equality are prophets and heroes, who run the risk of being considered heretics for going against the morality of their times, and who are paradoxical in a strict sense, since the term paradox derives from the Greek παράδοξος/parádoxos, meaning 'unexpected' or 'strange', a term that itself is derived from παρα/para-, meaning 'contrary to' and δοξα/doxa, meaning 'opinion'. That is, to go against prevailing opinion is always paradoxical.[32] If a hero is to succeed, or if a prophet's words are to be heeded, then change is what takes place, an apocalypse (deriving from ἀπό/apo and καλύπτω/calypso, meaning 'unveiling'). That is, the work of the hero is eschatological; Dussel says that the 'church of the poor' is an 'eschatological community', meaning that an ethics of liberation is also eschatological, even if never-ending (and thus a process that involves a series of attempts and failures, or an essayistic endeavour).[33]

Now, for Dussel moralities are immanent in the sense that they are 'intrasystemic'.[34] An ethics of liberation, meanwhile, is transcendent, in that it comes from outside of the system of capital (it is antithetical to capital). Meanwhile, Dussel explores the way in which

> diatheke – the word for 'covenant' in the Greek of the New Testament ... denotes a pact ratified in blood (Luke 20:22; Amos 1:9). It is also a 'pact of peace' (Ezek. 34:25), a pact for the good of the community. The covenant is *Immanuel*, 'God with us', God among us, God our equal, God as the one who has kept the promise. The right, the law that God has now established, will abide unshakable, for the 'covenanted' are now God's 'adopted children' (Rom. 9:4).[35]

In other words, even though the terms Immanuel and immanence supposedly have no common root (the former is from the Hebrew 'immanu'/with us and 'El'/God; the latter is from the late Latin, in- and maneō, meaning 'stay' or 'remain'), there is nonetheless a sense in which Immanuel is immanent ('among us/our equal') as opposed to transcendent. If an ethics of liberation (of the poor) is eschatological and transcendent (ethics supposedly is not intrasystemic), then to realize that ethics, to bring about the liberation of the poor, would be in some senses to immanentize the eschaton, to make immanent that which is transcendent, or to make God earthly.[36] Put otherwise, it would be to refuse the hegemony of capitalism (to be atheistic) and to admit to the radical equality of

all beings, if not all matter (and antimatter) in the universe. What is presented to us as a fixed and incontrovertible order – capitalism – is therefore revealed to be a false god, contingent, changeable, questionable, whether or not there is another 'God' beyond that towards which we might be reverent or otherwise.

Entanglement instead of objectification, heretical ethics, essaying, eschatology: Dussel's philosophy clearly relates to concepts that we have been drawing upon to understand non-cinema. Furthermore Dussel can help us to understand how to embrace non-cinema is to be atheistic towards capital-as-cinema. Non-cinema involves the liberation of the poor in the aesthetic realm, a process that takes place not via the production of homogeneous special effects blockbusters (arguably a shortcoming of *Panic Attack!*), but via the liberation of the poor of cinema, or what Hito Steyerl terms, with a tip of the hat to Frantz Fanon, the 'wretched of the screen'[37]. 'Bad', or 'poor' films are equal to 'good' (read: rich) films. Regardless of box office figures and its non-commercial aesthetics, *La casa muda* is the equal of *Silent House*, just as non-cinema is the equal of cinema; indeed, the two have an entangled relationship, in that the remake would not exist without the original, even if the remake in some senses 'erases' the original (cinema tries to relegate non-cinema into non-existence), just as capital erases the traces of exploitation by relegating the poor into a condition of non-being, which, by virtue of not being, does not have to be accounted for.

To recognize the 'wretched of the screen' is to recognize the equality of non-cinema and cinema. To recognize this equality is thus to love all of cinema (cinema and non-cinema), and not just to love the cinema that one wants to love. In other words, non-cinema as the ethical project of the liberation of what Steyerl also calls the poor image is an act of cinephilia, just as the liberation of the poor is an act of community and love.[38] In order to explore further, then, the role that cinephilia can play in non-cinema's liberation of the poor image, let us turn to *La vida útil*, a film that is precisely about cinephilia in the contemporary era.

Use value versus cinephilia: *La vida útil*

To consume cinema and/or to have one's attention consumed by cinema involves a capitalist relationship therewith; it is a relationship defined by use value. To love films, on the other hand, is to have *cinephilia*, in which the usual is fine, but in which we also value the unusual, the strange, the 'paradoxical', the different, the useless, the other (to love the other is wisdom, or to be otherwise).

Dussel defines use value as follows:

> The 'use value' of the object produced is ... human life objectified – and nothing less. The use value of an object is 'blood' ... it is life. It is the circulation of human life from the subject of the work to the object of the worked, by way of the activity of working. The value of the object produced is ultimately the worker's lifeblood, coagulated.
>
> Thus the 'use value' of an object, as objectified human life, is a *sacred* 'wealth' or good.[39]

In his *Grundrisse*, Karl Marx similarly defines a commodity as 'objectified labour'.[40] That is, I carry out some work, and the object that I produce is my work in object form. The amount of labour objectified in the commodity determines its exchange value (how much I sell the thing for; if it has taken me a long time, it is worth more than something that has taken me a short period of time). However, the sum of money exchanged might also be affected by use value, which is how much I need in order to be able to continue working (I need food, warmth and shelter in order to retain enough energy to work, with a family perhaps also being necessary to perpetuate the possibility for work to carry on after my death). In other words, the use value of an object involves the objectification of human life, in that the reason why I produce the object (the way in which it is useful) is in order for me to continue living. However, use value also becomes 'a reality only by use or consumption'; that is, not only must the thing be useful to me, in that in making and selling it I can go on living, but, if I am to sell it, then other people must also find it useful such that they want or need to buy it off me in the first place.[41] As Marx says: 'Nothing can have value, without being an object of utility. If the thing is useless, so is the labour contained in it; the labour does not count as labour, and therefore creates no value.'[42]

The reason for this foray into use value is because *La vida útil* tells the story of Jorge (Jorge Jellinek), a man who works at the Cinemateca Uruguaya, which is on the verge of collapse as membership dwindles and as the foundation that traditionally supports it removes its funding as a result of the Cinemateca's failure to make profit. 'Vida útil' might be translated as 'shelf life', but it literally means 'useful life'. In this way, it recalls Marx and Dussel's words, and as the Cinemateca fails, we understand how it (and non-mainstream cinema more generally) is of diminishing use value to Jorge and his colleagues (it will fail to keep them alive) as it also becomes of diminishing value, or interest, to the people of Montevideo.

La vida útil is a paean to cinema, both in terms of the spaces that are theatrical cinema venues – and specifically the Cinemateca Uruguaya – and in terms of being a celebration of cinema in all of its history and global reach. At the beginning of the film, we see the opening moments of Erich von Stroheim's *Greed* (USA, 1924) being narrated live by projectionist and Jorge's fellow Cinemateca worker, Martínez (Manuel Martínez Carril); the Cinemateca is due to hold a season of films by Portuguese centurion Manoel de Oliveira (a man who at the time of *La vida útil*'s making had lived more or less the entirety of cinema's own lifespan) as well as recent Uruguayan films; Jorge and Martínez split a pile of DVDs from Iceland in order to put together a season; we see Jorge sit in his office next to a poster of *Ran* (Akira Kurosawa, Japan/France, 1985); he keeps his keys in a VHS box for *Ikiru* (Akira Kurosawa, Japan, 1952); we see both him and Martínez at the Cinemateca alongside reproductions of photographs taken by cinema pioneer Eadweard Muybridge. The cinephilia extends beyond simply references to other movies, though. There is also a(n understated) sense in which the cinema inspires Jorge in his actions.

Having been sacked from the Cinemateca, we see Jorge crying on a bus. However, he then rallies and goes to a café, where an old man is watching a film on television. We do not see the film, but we hear that it is a western or some such as a result of what sounds like cowboys defending a wagon trail from 'Indians' (the rumble of horseback, gunshots, the 'yahs' and 'hahs' of men urging on their steeds). Jorge takes the phonebook and calls up Paola (Paola Venditto), a law professor at the Universidad de la República who occasionally comes to see films at the Cinemateca. Jorge is sweet on Paola and asks when she will finish teaching (nine o'clock). Jorge then decides to go to the Universidad and to ask her out in person – calling his father in the meantime to tell him that he won't be home for dinner (Jorge is well into middle age, and so that he still lives at home suggests at the very least an introverted lifestyle). As he walks across town, the sound of the western continues on the soundtrack, suggesting that in Jorge's head, he now sees himself as the heroic cowboy going to find his love.

Jorge's connection to westerns does not end there. At one point we hear Macunaíma singing Leo Masliah's 'Caballos perdidos/Lost Horses', a song that references Tom Mix, the star of many silent era westerns, and which at its end explores a feeling of uselessness: 'Estoy vacío de patas / tan inútil y quieto / como un viento mutilado/Like mutilated wind, I am empty on my feet, useless and still'. Metaphorically speaking, Jorge has lost the horse that is the Cinemateca, but he gets back up again to go find Paola. Indeed, as he walks to

the university, the rousing trumpet call of a cavalry rescue sounds, suggesting thus an impending happy ending. There follows a relatively extended sequence (Jorge arrives at the university 17 minutes from the end of the film – which only has a running time of 63 minutes) in which Jorge waits for Paola. And just before he finds her (the end of the film sees Paola accept Jorge's invitation to go not for a drink, but to the cinema), we see Jorge performing a kind of dance routine on some steps in the university's grand interior. In other words, it seems as though Jorge's life is itself inspired by films – with the phone call from the café also being a major trope in classical Hollywood cinema (e.g. Thompson (William Alland) calls his boss from El Rancho in *Citizen Kane*; Jorge seems not to have a mobile phone, even though we see him pass a poster for the latest iPhone as he walks towards the university). For Jorge – and for *La vida útil* itself – cinema is not just a commodity, but something that, perhaps even with which, one shares, something that one loves; Jorge – and Veiroj – are cinephiles.

And yet, what good is cinephilia in an age dominated by capital? As is perhaps clear from the title, von Stroheim's *Greed* is a critique of how the pursuit of money over humanity leads to tragedy. Kurosawa's *Ikiru* is likewise about a man who must find meaning in his life when he is diagnosed with cancer after a career of meaningless bureaucracy. Jorge and Martínez might well love old and 'obscure' cinema, but in a world that cares not for the old or the obscure (precisely because obscure, i.e. not visible) their love is not one that many people share. Under contemporary capitalism, it would seem that cinephilia (a love of all cinema) is under threat, even as the world's societies are increasingly dominated by a set of techniques and values developed precisely in cinema: glossiness, speed, the desire to have one's attention consumed, the display of wealth. *La vida útil* does not show us any rival kinos that are thriving on showing blockbusters; but we definitely see that people are not watching de Oliveira, von Stroheim, or work by Icelandic and Uruguayan auteurs. If the cinematic mode of production is about the homogenization of the world using specific techniques and values (those of the mainstream), then cinephilia stands in contrast to this by celebrating not homogenization but difference. In a globalized/homogenized world, the 'useful' life that Jorge and others lead in their desire to promote and to understand difference (their desire to be otherwise) is rapidly becoming useless.

And yet, even if useless, the cinephilic engagement with difference is also a labour of love. We see Jorge and Martínez at work, projecting films. We see a meeting in which they discuss how a projector is broken and how a replacement Russian projector will not work because there is insufficient voltage for its lamp

to shine powerfully enough. We see Jorge recording promotional messages that he then plays in the Cinemateca. We see Jorge and Martínez working on their film show for Radio Capital. And we regularly hear the whirring of film projectors. In other words, the film endeavours to make visible the labour that goes into running the Cinemateca, such that we understand how in Dussel's language it is 'blood', it is Jorge's life, and it is a *'sacred* "wealth" or good'. Jorge loves his work, even if this is little understood, or desired, by others.

In going on a date with Paola, Jorge seems pretty upbeat at the end of the film. While there is a vaguely happy ending, though, we nonetheless do seem to be witnessing the end of cinephilia as a celebration of difference. The advent of an era of homogenized blockbusters as the sole recognized iterations of cinema suggests an era not of love (cinephilia as being other-wise) but of capital (the need for profit; cinema dominated not by difference but by returns). If cinema excludes difference, then let us understand those different films, including *La vida útil* itself, positively to be non-cinema as they reject film-making strictly for profit, as well as the capitalist ethos more generally, in favour of film-making as a labour of love.

A musical abolition of narrative

La vida útil is an episodic film, full of what we might call 'dead' time. For example, Marga (Marga Koritniky) allows spectators into Sala 2 (room two) of the Cinemateca before a film. After everyone has entered, she then exits screen left to find Martínez (we hear her telling him that it is 5.30 pm – presumably time to start the film). The camera, meanwhile, remains on the entrance to Sala 2, where 'nothing' is happening. Likewise, we see both Martínez and Jorge standing by the Muybridge reproductions for extended durations during screenings. At one point, when Jorge goes to the basement loo in the Cinemateca, we also see an extended shot of an air vent-cum-window that looks out on to the street above – seemingly for no reason, except perhaps to convey that there is a world outside of the Cinemateca. In other words, *La vida útil* seems less preoccupied by narrative (there is no 'rescue' of the Cinemateca as people come to learn the value of old and foreign films), and more interested in the space that is the Cinemateca and the work that goes into running it.

The absence of narrative is also reflected in the soundtrack. Aside from the Macunaíma/Maslíah song, the film predominantly features music by Uruguayan

composer Eduardo Fabini. Associated with a nationalist musical movement from the early twentieth century, Fabini represents how *La vida útil* offers a specifically Uruguayan vision of the modern world. His compositions have been compared with those of Claude Debussy, including *La isla de los ceibos* and *Mburucuyá*, both of which feature in the film, and which, like the work of Debussy, have a 'stop-start' quality, full of pauses and a sense of 'breathing in and breathing out'.[43] Meanwhile, of Debussy, Deleuze and Guattari write that his music 'retains just enough form to shatter it, affect it, modify it through speeds and slownesses'.[44] That is, if what Deleuze and Guattari say of Debussy can be applied to Fabini, his music has structure (what in relation to cinema, we might call narrative), but barely; there is in his music 'the danger of veering toward destruction, toward abolition'.[45] What is more, 'Debussy['s] ... [m]usic molecularises sound matter and in so doing becomes capable of harnessing nonsonorous forces such as Duration and Intensity.'[46] If Fabini's music also captures duration (time/change/becoming), and if it also captures intensity (a sense of being with the world rather than using it), then so, too, might Veiroj's film, which similarly moves towards the 'abolition' of narrative cinema (narrative as cinema), and into non-cinema.

While waiting for Paola at the university, Jorge is mistaken for a substitute teacher and ends up giving a talk to law students about the art of lying, suggesting that lying is inevitable, especially among lawyers, and that liars might as well be more conscientious of their lies and lie for a good reason, that is to help and not to harm others. The speech is taken from Mark Twain's 'On the Decay of the Art of Lying', written in 1880, and its presence in the film is unexpected; Jorge has not been portrayed up until this point as a risk-taking man who would act as an impostor, even if in its bid for humans to be thoughtful and humane the speech fits in with Jorge's seeming philosophy of love, as per his cinephilia that includes old and foreign films. In other words, *La vida útil* is organized more around duration and intensity rather than it is around narrative, and the film suddenly shows us hidden depths (a subversive Jorge who pretends to be a substitute teacher) that had previously remained hidden from view. In its quasi-formlessness, in the way that it nearly has no narrative at all, *La vida útil* instead lives in the moment, in the present, and in this way it becomes pure cinema, or what to cinema-capital, a cinema of narrative, is not cinema at all: non-cinema.

As Fabini was a nationalist composer, so might *La vida útil* also reflect upon national themes. Maslíah's 'Caballos perdidos' was written during the Uruguayan dictatorship, while Fabini's *Mburucuyá* is named after the Guaraní

term for certain passion flowers. Both therefore evoke history, bringing a hidden past (the dictatorship and Uruguay's indigenous population) into the present. Meanwhile Jorge also hears – but we do not see – what seem to be student protests when he gets off the bus after losing his job. Unseen, we nonetheless get a sense of Jorge/the Cinemateca not just being the backdrop for a love story (love of cinema, Jorge and Paola's potential love affair), but of being part of a political world, in which political struggle has happened (dictatorship, extermination of the indigenous population) and is ongoing (student protests today).

Perhaps it is no mistake that Jorge delivers his Twain-inspired sermon to future lawyers; the rule of the law is what Dussel might term a morality – bound up with the mores of its time, and not necessarily taking part in the timeless and ethical task of the liberation of the poor. Jorge in this way becomes a paradoxical prophet who preaches to the students that which they do not necessarily want to hear, since it goes against the morality of the time/of the law, but which is ethically sound. Furthermore, if the film is in this way 'Uruguayan' in that it evokes a specifically Uruguayan history, then it is only so inasmuch as Uruguay is part of a wider world, which includes Iceland, the United States and Japan. That is, Uruguay may be a small nation that can produce not cinema but non-cinema, but it is also an important nation entangled with the (rest of the) world.

Bourgeois film literacy

As happens when watching other cinema-based films like Abbas Kiarostami's *Shirin*, Brillante Mendoza's *Serbis*, Tsai Ming-liang's *Goodbye, Dragon Inn* (Taiwan, 2003) and Lisandro Alonso's *Fantasma* (Argentina/France/Netherlands, 2006), it becomes hard not consciously to be aware when watching *La vida útil* that one is watching a film, meaning that the spectator's entangled relationship with the film is made visible as she sees the labour that goes into the exhibition and indeed the viewing of movies. Nonetheless, *La vida útil* also engages self-consciously with the idea that there is an educated film viewer, an idea with which I should like to engage briefly now in order to tease out the question of non-cinema's audiences. That is, can only 'educated' or 'literate' audiences enjoy non-cinema, thus meaning that its role in the liberation of the poor is always already undermined by virtue of its exclusivity? We shall answer this question by looking at *La vida útil*'s treatment of literacy before looking at the difficulty of escaping the values of mainstream cinema. Access to literacy

and the stranglehold of cinema-capital would seem to make non-cinema the preserve of the privileged bourgeoisie. Nonetheless, using the work of Latin American literary theorist Ángel Rama, I shall go against *La vida útil*'s approach to film literacy and propose that non-cinema can indeed be 'read' by anyone and that it radically democratizes cinema.

When listening to a tape recording that he has made for the Cinemateca's answerphone service, we hear Jorge explain how at the Cinemateca you learn to watch films (before also suggesting that you might find your soulmate there, with the message being somewhat ambiguous as to whether that soulmate is a person or cinema itself). Later, during one of his radio shows, Jorge invites Martínez to explain film literacy; the latter says that knowing about cinema is not memorizing lists of great films, but about the enrichment of the spectator via accessing creative works. Martínez at one point corrects himself, suggesting that the viewer need not be educated per se, but that the viewer must learn to be sensitive to cinema, rather than seeing cinema as merely data to be processed. In other words, while cinema is about intensity and feeling and not about 'use value', to learn as much requires literacy. That is, if capital-cinema is a cinema of use, and if that which is useless is thus perhaps better understood as non-cinema, then non-cinema might, if we were to accept Jorge and Martínez's views, be solely the remit of educated (and thus likely privileged, bourgeois) film viewers.

Louis Althusser might help to clarify this point when he argues that workers under capitalism are never (or only rarely) paid enough such that they do not have to work anymore.[47] Indeed, if they were paid enough such that they did not have to work, then they would not work – and the capitalist who runs the business would fail to turn a profit. It is important, therefore, from the perspective of capital, always to pay people slightly less than they need – in order to keep them working. A lack of job security, the need to work multiple jobs and the encouragement to take on debt (as per Lazzarato's 'indebted man') are all further guarantees that the worker will continue to work. It is paradoxical, then, that it is only with enough money to survive that one can keep oneself healthy; if one does not have quite enough money to survive, then one must continue working, which in turn means to damage one's health. The condition of the worker, then, is to work oneself to death. If one cannot even stay healthy, then how can one become strong enough to resist the capitalist and to overthrow him? That is, one is paid enough to have a sufficient but diminishing amount of strength in order to continue working, but not paid sufficiently to become strong enough not to work, or to resist the structural necessity of work as a whole.

As it is for the body, so is it for the mind: it is important to educate humans so that they can work. However, it is not in the capitalist's interest to educate the proletariat such that they can come up with their own business ideas, or have radical and revolutionary thoughts that might bring about the kind of structural change in which the capitalist class's position of dominance is threatened and/or brought to an end. In effect, humans receive a moral education in which they are taught the predominant values of their time – and learn to accept them as incontrovertible truths. Ethical education, meanwhile, remains sorely lacking – in part because to go against the standards of the time, or to be heretical, paradoxical and untimely, is not of any ostensible use.

By this rationale, it is all well and good to suggest that non-cinema involves the liberation of the poor (in the aesthetic if not in the political realm), but what good is this if only a privileged few can, as per *La vida útil*, 'understand' as much? Going to the cinema is not necessarily cheap, nor always is buying a film on DVD or streaming it. Similarly, in order to be educated or to educate oneself, one must commit time to it, since it takes time to learn. Liberating time (such that one has free time) is often a costly endeavour (free time is not 'free'); most people cannot afford that much free time since they need to work. Even while at school, children have enough time to gain a moral education, but not necessarily an ethical one. Furthermore, during the working person's time away from work and the child's time away from school, humans fill their free time increasingly with (moral) media that reinforce the prevailing values of the day, rather than encouraging ethical liberation. Indeed, with their attention increasingly consumed by the ubiquitous screens, children and adults alike are constantly doing what Lazzarato terms 'immaterial labour', giving their attention to advertisements that make money for the advertisers and the advertising companies alike, and to products (television shows, computer games, films) that themselves are in the business of making money via gaining and maintaining attention.[48] That is, with everyone's attention consumed by cinema-capital, how to make time for non-cinema, especially when cinema-capital directly or indirectly reinforces the idea that non-cinema (which in *La vida útil* extends to cinema's history and global diversity) is not legitimate? Escaping this is difficult.

Now, Ángel Rama has powerfully argued that literacy played a strong role in the institution of colonial and subsequently post-colonial Latin America.[49] In effect, text – writing and sign production – became a means for the privileged few to assert control over the illiterate masses by consolidating power within the system of literacy itself (without literacy via education you have no access

to power, since power is and has been consolidated in writing). Rama's political manoeuvre was to try to break the canon of Latin American literature by introducing into it supposedly unorthodox, perhaps even 'illegitimate', texts such as oral literary traditions, graffiti, experimental texts and readings of classical texts against the grain. With Rama's work in mind, then, we might theorize how cinema also plays a role in the maintenance of power in the hands of a privileged few – although it manifests itself in a different way.

For, mainstream cinema is 'easy to read' – that is more or less everyone is 'literate' in cinema, as cognitive film theorists like David Bordwell have demonstrated.[50] However, mainstream cinema is also a moral cinema that reinforces the values of the day, not least by being a capitalist product that has the reproduction of capital as its bottom line. What is more, unlike graffiti, which will by definition be local, many/most mainstream films are not local, but come from abroad, predominantly North America (only three of the 44 highest-grossing films in Uruguay in 2011 were from Uruguay). As Dussel writes:

> The culture that dominates in the present order ... is the refined culture of European and North American elites. This is the culture that all other cultures are measured against And this culture has the collective means of communication in its hands (the United States originates and transmits 80 percent of the material that is used in Latin America by daily newspapers, magazines, radio, movies and television).[51]

Access to films that might have a different, more ethical dimension is expensive and the films are 'harder to read' – with even local films failing to receive as much attention as the more familiar North American films (*La casa muda* was only 44th at the box office in Uruguay in 2011; *La vida útil* does not even feature on BoxOfficeMojo). While there is probably much to learn from mainstream cinema, its fast food, easy-to-consume essence gives people the illusion of film literacy, such that other, even local, films are rejected (North American films are more familiar to Uruguayans than Uruguayan films!).[52]

Even though there is a reversal, then, in that mainstream cinema is, unlike literature, highly accessible – to the point of people preferring that mainstream to the equivalent of graffiti and other 'illegitimate' or non-cinematic texts – we can still take Rama's lead to suggest that non-cinema can radically democratize cinema. Contrary to the policy of the Cinemateca Uruguaya in *La vida útil*, which attempts to introduce audiences to 'high' rather than to 'low' artworks (von Stroheim, de Oliveira), non-cinema aims to include 'low' films, which includes both *La casa muda* and *Panic Attack!* (even if the story of one and the

director of the other have been poached by Hollywood). This is not a rejection of either education or 'high' films, but it is to understand the value of non-cinema in addition to these, as well as to appreciate the small, the low and the poor in terms not just of budget, duration, aesthetic and audience. As Dussel might put it:

> With ... their 'underground economy' (their own consumption or production, invisible to the capitalist economy), their communal solidarity, their system of feeding themselves, and so on, they [the people] continue to do today what they have done for hundreds of years – bypass the oppressor's 'universal culture'.[53]

In other words, non-cinema does not have to 'rival' cinema on its own terms. Indeed, non-cinema is perhaps not so much the rival of cinema as the ground upon which cinema is built, and traces of which can therefore be found in all cinema. To expect non-cinema to be directly oppositional to cinema, then, is to ask of it the wrong question. It may be exploited by mainstream cinema, and it may also expose that exploitation (it exposes mainstream cinema as exploitation), but non-cinema also does not suffer from the economic imperative of cinema and thus can risk failure with much greater ease. In this way, perhaps no single film that could be defined as non-cinema could 'overthrow' cinema. Rather, we can understand non-cinema more clearly as being defined by the small (during the season of Uruguayan films screened at the Cinemateca in *La vida útil*, Jorge introduces director Gonzalo De Galiana, played by one of the film's co-writers, Gonzalo Delgado, who in turn introduces his work to an audience of about five people). However, when we put together all of the different small, poor and low films, together with their tiny audiences, then we realize that there is a multitude of 'minor' cinemas. And it is in this sense that as the power of cinema-capital seems to intensify under neoliberal globalization, there nonetheless also seems to be a multitudinous proliferation of small films, or non-cinema, which combined threaten the hegemony of cinema-capital.

A small conclusion

I would like to end, then, by suggesting that Uruguay seems a fitting starting point for the development of an ethical liberation of cinema. For Uruguay is the country of José Mujica, a former Tupamaro who served as the nation's president between 2010 and 2015, and who has been described as the world's 'poorest' president.[54] Hailed for his modesty and compassion and thus a practitioner of commiseration, or the sharing of poverty, Mujica is what Dussel might term a

hero, heretically rejecting all of the perks that come with the job of president in order to live on a ramshackle farm with an old VW Beetle for transport and no security guards.[55] If, as has been suggested, Mujica failed to achieve much during his tenure, perhaps this is because he was antithetical to the spectacular (spectacle-driven) world of contemporary politics, functioning instead as something like a non-politician who simply does not play by the capitalist values of his era.[56]

Noam Chomsky says of Cuba that it is a threat to the United States not because it is big, but precisely because it is small: if even a small country can put into practice the democratization of wealth and/or the liberation of the poor, then this might inspire larger countries to try to do the same.[57] For this reason, Cuba must be shown always to fail. And so it may be with Uruguay. That is, Mujica could not succeed because we live in an age in which the neoliberal logic (morality) of contemporary capital is deeply ingrained. An ethical human being in Dussel's sense of the word, Mujica is a paradox, a heretic, untimely.

With regard to the films considered in this chapter, we might also suggest that while Uruguay is too small a country single-handedly to produce cinema, while at the same time dependent on North America in a very cinema-capitalist way (Uruguayans watch mainly North American films), that the country can produce such examples of non-cinema demonstrates a potential not just for becoming cinematic (a capitulation to cinema-capital), but for other ways of thinking. If not everyone can make cinema, it would seem that anyone can indeed make non-cinema. That Alvarez gets poached by Hollywood and *La casa muda* remade only makes this more clear: these films are appropriated in part because they otherwise pose a threat to the dominant system of cinema-capital. Uruguay might seem an unlikely place in which to find a powerful iteration of non-cinema – but that is what makes it all the more exciting to behold.

Having established the value (if not the use – precisely because useless) of the small, the poor and the low, then, we shall look in the next chapter at films made on even smaller screens, including films shot partially on smartphones. For these films constitute a non-cinema that eludes the control of cinema-capital, thereby giving to them an important role in subverting capital itself.

Notes

1 See, for example, Keith Richards, 'Born at Last? Cinema and Social Imaginary in 21st-Century Uruguay', in *Latin American Cinema: Essays on Modernity,*

Gender and National Identity, ed. Lisa Shaw and Stephanie Dennison (Jefferson: MacFarland & Company, 2005), 137–59.
2. See Tamara L. Falicov, 'Film Policy under MERCOSUR: The Case of Uruguay', *Canadian Journal of Communication*, 27:1 (2002), http://www.cjc-online.ca/index.php/journal/article/view/1270/1282.
3. For more on the 'new' Uruguayan cinemas, see, *inter alia*, Falicov, 'Film Policy under MERCOSUR'; Christine Ehrick, 'Beneficient Cinema: State Formation, Elite Reproduction, and Silent Film in Uruguay, 1910s-1920s', *The Americas*, 63:2 (October 2006), 205–24; David Martin-Jones and María Soledad Montañez, 'Cinema in Progress: New Uruguayan Cinema', *Screen*, 50:3 (2009), 334–44; and Jorge Ruffinelli, 'Uruguay 2008: The Year of the Political Documentary', *Latin American Perspectives*, 40:1 (January 2013), 60–72.
4. Falicov, 'Film Policy under MERCOSUR'.
5. See Martin-Jones and Montañez, 'Cinema in Progress', and 'Uruguay Disappears: Small Cinemas, Control Z Films, and the Aesthetics and Politics of Auto-Erasure', *Cinema Journal*, 53:1 (Fall 2013), 26–51.
6. See Martin-Jones and Montañez, 'Uruguay Disappears'.
7. See William Brown, '¡*Ataque de pánico!* and the Impossibility of Uruguayan Cinema', *Studies in Latin American Cinema*, under consideration.
8. See Brown, *Supercinema*.
9. For more on the camera passing between different perspectives without a cut, see Brown and Fleming, 'Cinema Beside Itself, or Unbecoming Cinema'.
10. David Martin-Jones and María Soledad Montañez, 'What is the "Silent House"? Interpreting the International Appeal of Tokio Films' Uruguayan horror *La casa muda/The Silent House* (2010)', *Studies in Latin American Cinema*, under consideration.
11. See Gilles Deleuze and Félix Guattari, *Anti-Oedipus: Capitalism and Schizophrenia*, trans. Robert Hurley, Mark Seem and Helen R. Lane (London: Athlone, 1983), and *A Thousand Plateaux*, trans. Brian Massumi (London: Continuum, 2004).
12. Beller, *The Cinematic Mode of Production*.
13. See David Bordwell, *The Way Hollywood Tells It: Story and Style in Modern Movies* (Berkeley: University of California Press, 2006), 117–89.
14. See Brown, 'Resisting the Psycho-Logic of Intensified Continuity'.
15. See IMDb, 'Top-US-Grossing Titles With Country of Origin Uruguay', *Internet Movie Database* (not dated), http://www.imdb.com/search/title?countries=uy&sort=boxoffice_gross_us,desc.
16. BoxOfficeMojo reports that *La casa muda* made $US517,365 worldwide, although if one adds up the actual numbers from the individual territories in which the film was released, then the box office gross is US$1.15 million. I am not sure why the

discrepancy. See BoxOfficeMojo, '*La Casa Muda (The Silent House)*', *BoxOfficeMojo* (not dated), http://www.boxofficemojo.com/movies/intl/?page=&id=_fLACASAMUDATHESI01.
17 BoxOfficeMojo, '2011 Uruguay Yearly Box Office Results', *BoxOfficeMojo* (not dated), http://www.boxofficemojo.com/intl/uruguay/yearly/?yr=2011&p=.htm.
18 See BoxOfficeMojo, '*Silent House*', *BoxOfficeMojo* (not dated), http://www.boxofficemojo.com/movies/?page=main&id=silenthouse.htm.
19 Catherine Grant, 'Single Take Horror Film Mutations', *Vimeo* (2014), https://vimeo.com/89730868.
20 Dussel, *Ethics and Community*, 125 and 128.
21 Ibid., 126–7.
22 Ibid., 8 and 223.
23 For more on unlicensed remakes, see Iain Robert Smith, *The Hollywood Meme: Transnational Adaptations in World Cinema* (Edinburgh: Edinburgh University Press, 2016). For a similar consideration of Asian remakes, see Gary G. Xu, 'Remaking East Asia, Outsourcing Hollywood', in *East Asian Cinemas: Exploring Transnational Connections on Film*, ed. Leon Hunt and Leung Wing-Fai (New York: IB Tauris, 2008), 191–202.
24 Eduardo Galeano, *The Open Veins of Latin America: Five Centuries of the Pillage of a Continent*, trans. Cedric Belfrage (London: Serpent's Tail, 2009). See also Dussel, *Ethics and Community*, 148–57.
25 See David Martin-Jones, '"Trolls, Tigers and Transmodern Ecological Encounters" Enrique Dussel and a Cine-ethics for the Anthropocene', *Film-Philosophy*, 20:1 (2016), 63–103.
26 Galeano, *The Open Veins of Latin America*, 245.
27 Dussel, *Ethics and Community*, 21.
28 Ibid., 18.
29 Ibid., 28.
30 Ibid., 34.
31 Ibid., 76.
32 Ibid., 49.
33 Ibid., 84.
34 Ibid., 107.
35 Ibid., 40.
36 The term 'immanentising the eschaton' is borrowed from Robert Anton Wilson and Robert Shea's cult novel, *The Illuminatus! Trilogy* (London: Raven Books, 1998).
37 Steyerl, *The Wretched of the Screen*.
38 Ibid., 31–45.
39 Dussel, *Ethics and Community*, 115.

40 Karl Marx, *Grundrisse*, trans. Martin Nicolaus (London: Penguin, 1993), 272.
41 Karl Marx, *Capital: A New Abridgement* (Oxford: Oxford University Press, 2008), 33.
42 Marx, *Capital*, 37.
43 Graciela Paraskevaídis, *Eduardo Fabini* (Montevideo: Trilce, 1992), 38 (my translation).
44 Deleuze and Guattari, *A Thousand Plateaus*, 270–71.
45 Ibid., 299.
46 Ibid., 343.
47 Louis Althusser, *Lenin and Philosophy and other Essays*, trans. Ben Brewster (New York: Monthly Review Press, 1971), 121–76.
48 Lazzarato, 'Immaterial Labour.'
49 Ángel Rama, *The Lettered City*, trans. John Charles Chasteen (Durham, NC: Duke University Press, 1996).
50 David Bordwell, 'Convention, Construction, and Cinematic Vision', in *Post-Theory: Reconstructing Film Studies*, ed. David Bordwell and Noël Carroll (Madison: University of Wisconsin Press, 1996), 87–108.
51 Enrique Dussel, *Philosophy of Liberation*, trans. Aquilina Martinez and Christine Morkovsky (Eugene: Wipf & Stock, 1985), 91.
52 See Brown, *Supercinema*.
53 See Dussel, *Ethics and Community*, 63.
54 Ibid., 202.
55 Vladimir Hernandez, 'Jose Mujica: The world's "poorest" president', *BBC News Magazine*, 15 November 2012, http://www.bbc.co.uk/news/magazine-20243493.
56 See Eve Fairbanks, 'José Mujica Was Every Liberal's Dream President. He Was Too Good to Be True', *New Republic*, 5 February 2015, http://www.newrepublic.com/article/120912/uruguays-jose-mujica-was-liberals-dream-too-good-be-true.
57 Noam Chomsky with Heinz Dieterich, *Latin America: From Colonisation to Globalisation* (Melbourne: Ocean Press, 1999).

9

Cinema out of Control: These are Not Films

I ended the last chapter by proposing that the small, the poor and the low have equal value to the big, the rich and the high, perhaps even calling into question the perceived need for value as a concept and its concomitant creation of hierarchies. This trend of looking at 'small' films continues in this chapter, where I focus on two films, *This is Not a Film* and *Film Socialisme* – both of which were shot in part using low-definition smartphone cameras. I shall argue that in addition to embodying various of the ideas discussed in previous chapters, the former film allows us to think about the role that control plays in cinema, with non-cinema being a cinema 'out of control', and in which random elements are allowed to and do appear, thus blurring the line between fiction and documentary while also suggesting a radically democratic vision of cinema and an absence of prejudice regarding not just that which is fit to be included in cinema, but also how those things are included. This 'democratic' vision perhaps naturally leads us to Jean-Luc Godard's *Film Socialisme*, which also seems to propose a radical equality of all things, including matter itself. I should perhaps point out that where up until now I have in each chapter given examples of non-cinema that have in common a specific national (or non-national) context, here my examples are united by the digital technology (specifically smartphones) used to make the films – with digital technology after all being the unifying focus of this book. This chapter then sets up the next, final chapter, in which we consider how 3-D technology also has a role to play in non-cinema via Godard's *Adieu au langage*, before ending with a geopolitical consideration of non-cinema as produced in Nollywood. For the time being, however, let us turn our attention to one of the signal films of non-cinema, namely Jafar Panahi's *This is Not a Film*.

The treachery of cinema

Panahi has since 2010 been serving a twenty-year ban on film-making, with a suspended six-year prison sentence also hanging over him for 'allegedly making anti-government propaganda'.[1] Nonetheless, Panahi has, in defiance of his ban, made not only *This is Not a Film*, but also *Pardé/Closed Curtain* (Iran, 2013) and *Taxi Tehran* (Iran, 2015), a film that bears some resemblance to Abbas Kiarostami's *Ten*, in that it takes place entirely in a taxi travelling around Tehran, here driven by Panahi himself. My intention is not to add to the clamour of those who call for Panahi's ban to be lifted. Nor is it simply to recount the curious episode that saw *This is Not a Film* leave Iran on a pen drive hidden within a cake before being delivered to the Cannes Film Festival. Rather, I should like to take Panahi at his word and suggest that he is making not cinema, but non-cinema.

This is Not a Film takes its name from René Magritte's 1928–9 painting, *La Trahison des images/The Treachery of Images*, which famously features an image of a pipe, underneath which is written 'ceci n'est pas une pipe' (this is not a pipe). However, there is a crucial difference between Panahi's film and Magritte's painting. For, Magritte does not call, or even write on, his painting *This is Not a Painting*; the words that he uses refer instead to the supposed content of the painting, the pipe. Panahi, meanwhile, does not deny the contents of his film. Rather, he says that the film as a whole is not a film. Where Magritte refers to content (pipe), Panahi contrastingly refers to form (film). Where Magritte positively affirms that his work is a painting (we do not see a pipe, but a representation of a pipe), Panahi denies that his film is even a film. What, then, can be Panahi's motivation for doing this?

If Panahi announces that *This is Not a Film* is in fact a film, then he contradicts his ban. Therefore, to pronounce that 'this is not a film' is a way of simultaneously defying and working within the confines of his ban. But on what grounds could *This is Not a Film* not be considered a film? For, as an audiovisual document that has been exhibited at various festivals and cinemas all over the world, as well as being widely available on DVD and other formats, *This is Not a Film* surely is a disingenuous title; it is absolutely a film.

In the sense that *This is Not a Film* is a digital film, it truly is not a film made using film stock; indeed, its 'original' copy is not a strip of negative film but, if anything, an invisible file 'hidden' on a pen drive inside a cake. More tellingly, Panahi spends several minutes during the film reading from and trying within his apartment to 'produce' a script for a film that he now cannot make as a result

of his ban. Fed up, Panahi at one point explains that the process is pointless; he cannot make the film in his apartment and using tape to map out the perimeters of his would-be film's setting; without actors, without a set, without lighting, and without all of the other paraphernalia that goes into making a film, this cannot be a film. Panahi thus cocks a snook to Iran's MCIG by reaffirming the idea that a film can only be made if a script has been submitted and approved prior to production. Hoisting them by the petard that is their own definition of cinema (cinema consists of films based upon approved scripts), Panahi must produce a non-film because his is a movie shot without a script (and his script is 'shot' without actors, lights and so on).

Cinema, from the state's perspective, is thus defined as control: it is the control of all elements included in the film by the film-makers and following a script 'blueprint' that exists in advance of the film itself – and the control of the film industry more generally by institutions like the MCIG, or, beyond Iran, simply capital, which attempts to eliminate risk via the vetting of scripts prior to production. From Panahi's perspective, however, cinema cannot be controlled. Indeed, while he is frustrated at not being able to shoot his script, Panahi seems to advocate a lack of control in his film-making – and in defiance of the state, he calls his out-of-control cinema 'non-cinema' – as we shall see presently.

Film-making out of control

Hamid Dabashi believes that *This is Not a Film* is a poor piece of work in comparison to Panahi's 'masterpieces', *Dayereh/The Circle* (Iran/Italy/Switzerland, 2000), *Talaye sorkh/Crimson Gold* (Iran, 2003) and *Offside* (Iran, 2006). For Dabashi, Panahi

> should have heeded the vicious sentence and stayed away from his camera for a while and not indulge, for precisely the selfsame social punch that ... made his best films knife-sharp precise has now dulled the wit of the filmmaker that was once able to put it to such magnificent use.[2]

Dabashi finds *This is Not a Film* to be introspective and self-indulgent. He also feels it to be the result of Panahi's anger towards the Iranian system and thus too political – as opposed to artistic – a film. However, a close look at *This is Not a Film* demonstrates that it is as intelligently constructed as his 'masterpieces' – perhaps all the more remarkably so because it does not appear to be.

This is Not a Film demonstrates careful construction at various points, but most of all it is coherent in terms of its thematic construction. Panahi shows a scene to his cinematographer and co-director Mojtaba Mirtahmasb from the DVD of his own film, *Ayneh/The Mirror* (Iran, 1997). The scene in *The Mirror* features a little girl, Mina (Mina Mohammad Khani), breaking character and refusing to act. As Mirtahmasb pans over to Panahi, we see a shelf housing a variety of DVDs. Most of the DVD sleeves are illegible – at least to this viewer – but prominent among those that are legible is the DVD of *Buried* (Rodrigo Cortés, Spain/USA/France, 2010). *Buried* is about an American truck driver in Iraq, Paul (Ryan Reynolds), who wakes up in a coffin. Practically the whole of *Buried* is set within the confines of the coffin as Paul uses a smartphone in order to work out how he got there and how to escape. To have the DVD of *Buried* so prominent in the frame, then, suggests a parallel between that film and this non-film: Panahi's house arrest is akin to some sort of artistic death, as if he, too, were buried alive and as he, like Paul, continues his connection with the outside world more or less uniquely via his smartphone (we regularly see Panahi on the phone to, inter alia, his lawyer and fellow film director Rakhshan Bani-Etemad). While the DVD of *Buried* could randomly be placed within the mise en scène of *This is Not a Film* (i.e. Panahi just happens to own a DVD copy of *Buried* and Mirtahmasb just happens to film it), in another sense it suggests – or at the very least offers the possibility for – a coherent and constructed mise en scène. That is, *This is Not a Film* might well be partially scripted and thus pre-planned.

As much is also suggested by the film's strange chronology. By this, I do not mean to say that *This is Not a Film* tells a nonlinear story. In fact, the 'story' of the film (if rightly it has one) takes place over a single day as Panahi wanders about his apartment making phone calls, having tea and talking to neighbours. Indeed, *This is Not a Film* supposedly takes place on *Chaharshanbe Suri*, or Fireworks Wednesday. Fireworks Wednesday takes place in Iran on the Tuesday night before 'Red Wednesday', which itself takes place on the last Wednesday before *Nouruz*, or the Persian New Year. This means that, if *This is Not a Film* were filmed in one day, then it was filmed on 15 March 2011.

However, at one point Panahi reacts to television news coverage of the Tōhoku earthquake as if it were a new event. Since the earthquake took place on 11 March 2011, that is four days before the day on which the film is supposedly set, then this would suggest that *This is Not a Film* was in fact not shot over the course of a single day. Naturally, it is possible that Panahi only discovers

the earthquake four days later, but given that watching the news seems to be a major pastime for him, it equally seems plausible that the film was shot non-chronologically (potentially we move between at least 11 and 15 March 2011). *This is Not a Film* might therefore not be a random assemblage of footage from a day in the life of Jafar Panahi under house arrest, but footage that has been edited in a particular way in order to give that impression.

If these details suggest that *This is Not a Film* is planned, and thus in some senses controlled, it nonetheless is hard to read the film purely as staged, or as fiction, not least because of the insistent intrusion of what seems to be chance into the film – particularly through the presence of animals. Panahi's pet iguana, Igi, seemingly is not stage- or screen-trained (we see no wrangler other than Panahi himself), as is made clear when Igi climbs a bookshelf behind Panahi, as well as when he climbs over Panahi and scratches him with his sharp claws. Meanwhile, one of Panahi's neighbours, Shima, tries to deposit her dog Mickey with Panahi while she goes out to celebrate Fireworks Wednesday. Mickey enters and off-screen starts barking uncontrollably; apparently Mickey is scared of Igi. (We also hear Mickey barking later on when Panahi leaves his apartment with a concierge, Hassan.) These uncontrolled moments featuring animals not only suggest an unscripted, documentary film, but they are also comic both in terms of being funny and in terms of suggesting witness and entanglement: Igi scratches Panahi, Mickey's barks are piercing, and so to be with another species is to be confronted with an uncontrollable difference that exposes as amusing our pretensions to control. Given that the film is made under a regime that endeavours to be all-controlling, *This is Not a Film* takes on a political meaning that resonates far beyond the self-indulgence of which Dabashi accuses it.

This absence of control takes on a self-conscious quality on a number of occasions. First, Panahi discusses his unfilmed script with Mirtahmasb before supping on his tea and saying 'cut'. The camera keeps on rolling. 'Go on. Cut', Panahi insists, before Mirtahmasb answers that Panahi cannot direct him since to do so would be an offence (it would contradict his ban). In calling cut and in Mirtahmasb not cutting, we have a sense here of an unscripted film, of which Panahi is not the director. Panahi tries to control his film, but ultimately he cannot, or at the very least performs a failure to do so. As far as a cinema of control is concerned, then, this is not a film.

Furthermore, when Panahi discusses the scene in *The Mirror* when Mina breaks character, we see a clip from that film in which the young actress refuses to act and throws off the cast that had been placed on her arm as part of her

performance. Panahi talks about how he, too, must 'throw off the cast' and thus elude the control of those who seek to restrain and contain him. What is more, the unfilmed script that Panahi reads and tries to create in his apartment is also about a girl who is imprisoned in her own home and who is forbidden from attending the university arts course for which she has won a place, because her family does not think it appropriate. The film, therefore, is thematically consistent in that it addresses issues of confinement and control. And yet, while semi-scripted and while being structured in such a way that the same themes repeatedly come up, *This is Not a Film* is also about how the world – and the animals and people that inhabit it – cannot be controlled.

If Panahi's film is in this way about defying control, then it is also about how cinema involves an absence of control, or what we might term 'filmmaking out of control'. This is not the 'objective' capturing of events that are 'real', but the participatory entanglement of the film-maker with a world in which the camera is acknowledged – as Panahi turns to the camera here and as Mina turns to the camera in *The Mirror*. Contra Dabashi, then, *This is Not a Film* is a coherent and intelligently constructed treatise on control in relation to cinema and society. Cinema lies for Panahi in the places where for Dabashi it apparently is not. Or rather, both seemingly agree that 'this is not a film', but where Dabashi slams Panahi for this, Panahi positively embraces non-cinema.

Ethics and control

It is hard, if not impossible, to tell to what extent *This is Not a Film* is scripted. As Godfrey Cheshire puts it: 'Panahi is not acting as a film-maker, he's a film-maker-as-actor in a documentary-like fiction (or fiction-like documentary?) about his own life.'[3] By being ambiguous, the film asks the viewer to choose what to believe, thereby involving/entangling the viewer, in that participation is required in the ethical process of choosing what to believe.

As Mirtahmasb leaves Panahi's apartment to go home, they open the door to find Hassan, a concierge supposedly come to collect the rubbish. Panahi is at this moment filming Mirtahmasb with his smartphone, while the main camera that the latter has been using is on Panahi's kitchen table – still recording (Mirtahmasb declares that the cameras should be left on, although he does not explain why). We switch between footage taken by the two cameras: in the frame of Panahi's phone there is Mirtahmasb next to the entrance to the elevator, which

is crowded with a garbage trolley, while the frame of the main camera features Panahi in long shot, stood in the doorway to his apartment, smartphone in hand. Hassan passes across Panahi's smartphone frame and enters his apartment; we cut to the perspective of the camera on the table as Hassan walks across frame with some rubbish; we then cut back to the smartphone as Hassan comes back out of Panahi's apartment and joins Panahi and Mirtahmasb in the doorway. Mirtahmasb then takes the lift down, leaving Hassan with Panahi, who continues to film with his phone.

Hassan knows who Panahi is, referring to him by name throughout the sequence. However, Panahi does not know who Hassan is – and so he asks. Hassan explains that Nasrin is his pregnant sister and that she has gone to Isfahan to give birth with Akbar, whom we presume to be the regular concierge and Nasrin's husband. There follows a conversation in which Hassan explains that he does various different things, including being a student at Arts University. However, Hassan is evasive and vague in answering Panahi's questions, and while he may be nervous because Panahi is a well-known film director, he also begins to arouse suspicion – especially when he asks for the identity of Mirtahmasb (Hassan claims that the latter looks like Iraj Tahmasb, the star and co-creator of satirical television puppet show, *Kolah Ghermezi/Red Hat*, Iraj Tahmasb and Hamid Jebelli, Iran, 1990–). Is Hassan a government agent sent to keep tabs on Panahi and the people who visit him – hence his being outside the door just as Mirtahmasb leaves?

The paranoia concerning Hassan's identity only increases as Panahi accompanies him down to collect garbage from the other apartments. While the sequence involves a comic second encounter with Mickey, it also includes more seeming evasiveness from Hassan (he vaguely explains that he has various jobs, including distributing flyers, working in an advertising agency, etc, while remaining unclear about his studies). As they stop to collect trash at each floor, Hassan notes that no one is leaving their rubbish out for him, before also saying that he was in the building when Panahi got arrested. One wonders whether the reason why no one is leaving out their trash is because it is not really trash collection day, and that Hassan really works for the police – hence his presence at Panahi's arrest.

However, as some viewers might suspect Hassan of being a spy, we cannot be certain. 'Mr Panahi, please don't come outside', he continues. 'They'll see you with the camera'. If Hassan really were a spy, then why would he warn Panahi in this way – even if the warning also makes clear that Hassan knows

about Panahi's sentence? It is not that Hassan is a spy. However, *This is Not a Film* invites us to contemplate that he could be – i.e. to experience paranoia. In a country seeking to control its people, such paranoia is useful because while no country truly can control its people, spreading the belief that it can and does means that the people begin to control themselves – wary always that they are under surveillance and that the mysterious 'they' that Hassan mentions are always observing.

If the spectator must choose for herself whether Hassan is a spy, so must Panahi in some respects also choose. And, regardless of Hassan's warning, Panahi follows Hassan outside, where the film ends with a shot of a fire surrounded by darkness beyond a metal gate that Hassan opens and through which he passes with the garbage trolley. In other words, while the viewer might suspect that Hassan is a spy and/or that Panahi will be spotted with his camera, Panahi himself does not succumb to paranoia and goes outside to film the final moments of his (non-)film – significantly of a traditional fire of the sort that accompanies Fireworks Wednesday.

The shot is significant for several reasons. Not only does it demonstrate Panahi's courage in refusing to succumb to paranoia – an ethical act as he chooses to believe in the goodness rather than the badness of his fellow humans, but it also pictures for us an act of defiance by the Iranian people. Earlier in the film, we hear from a television news report that Fireworks Wednesday has been denounced by the authorities as irreligious, and that the festival has thus been banned. And yet, the festival goes ahead, with fireworks going off outside Panahi's apartment and fires also being lit in the street. As a festival, not only does Fireworks Wednesday contain aspects of what Mikhail Bakhtin calls *carnival*, in that it reverses traditional hierarchies, but its going ahead in spite of the government's calls for it not to suggests the courage of a people who will not be controlled. What is more, Fireworks Wednesday is itself a festival that celebrates the advent of spring, and as such is associated with regeneration and change. The reason why fires are lit is in part in order for there to be light throughout the night, thus staving off darkness. While I argued earlier that non-cinema involves making darkness visible (and the final shot of *This is Not a Film* arguably does this by showing a screen that is mostly black), here the light of the fire is also a symbol of hope and defiance against a regime that seeks to, but which will not, control its people. The moment is ethical because it involves Panahi and the Iranian people choosing to hope by going ahead with the festival in spite of attempts to shut it down.

The aesthetics of ethics and politics

In an interview, Panahi says that

> today, as soon as an Iranian child opens their eyes, they will be watching moving images; before they can talk or read and write, these children will have accumulated a vast knowledge of film and deep emotion towards those images: they'll laugh, become sad, angry or happy with every image they see. Films educate them and show them how to perceive problems or how to deal with them. They have a much stronger relationship to images than to words. The historical heritage of poetry or cinema is meaningless for them.[4]

What Panahi seems to be describing is the pervasive nature of moving images in the contemporary world – a world in which cinema-capital dominates. Films that offer alternative perspectives on the world (what Panahi calls the 'historical heritage of poetry or cinema') lose favour in relation to those films that conform to the contemporary morality (films as adverts both for specific products and for a lifestyle that involves the consumption of products, the pursuit of wealth, and the impoverishment of other humans). *This is Not a Film* wilfully goes against the aesthetics of the pervasive images that Panahi describes in an ethical gesture that hopefully will encourage viewers equally to strive towards ethical behaviour (the liberation of the poor as opposed to the material enrichment of the self). How does it do this?

In part the film does this through its relatively languorous pace, its lack of a clear narrative, and via the ambiguity that forces the viewer also to engage with the film in such a way that she must choose what to believe. The film's aesthetic is also overtly digital: only a digital camera can be left to run on a table by Mirtahmasb until Panahi again picks it up to film Hassan in the elevator and beyond. Mirtahmasb says that the cameras should be kept on, and the reason for doing this is perhaps now easy to clarify. Since the digital camera can run for longer, and since the mobile phone can film at any time, digital technology thus allows for the capturing of moments that are so unlikely as to be almost unbelievable, or moments in which viewers are encouraged to see that the world is full of magic, that the world is full of beauty, and moments so strange that paradoxically they seem almost unreal (what in Chapter 3 was referred to as *xianchang*). Rather than finding, say, the digitally-constructed world of Pandora in *Avatar* (James Cameron, USA, 2009) more beautiful than Earth, humans are encouraged to see that nothing can be more beautiful than our world (which by

definition is greater than the fictional world of Pandora since it is only because of our real world that Pandora can be created in the first place).[5] In short, the digital allows film-makers more easily to show that the real world is, as it were, stranger and thus more compelling than fiction.

Seeing Panahi recording him with his phone, Hassan whips out his own phone and asks: 'Do you think I can make a film with this?' Panahi's response: 'You certainly can make a film with it.' In other words, where some people (including Hassan?) believe that a film cannot be made with a phone, Panahi is of the view that it can. Or, if the film made with the phone is not a film, then Panahi embraces this, but in such a way that his film is indeed not a film, since he is engaged in the production not of cinema, but of non-cinema.

Now, the smartphone is arguably a technology that plays into the hands of surveillance culture. Given that all mobile phones operate via satellite technology, each involves the emission of a signal that in principle allows one easily to be located at any moment in time (provided the phone is on one's person and contains a battery). Furthermore, the placing of images on Facebook, Instagram, Twitter and various other social networking websites and/or apps can be interpreted not only as an acceptance of surveillance culture, or what Gilles Deleuze might term a society of control, but also a wilful volunteering to take part therein.[6] However, for Panahi the inclusion in his (non-)film of 'low-quality' images recorded on a mobile phone also involves a democratization of cinema, such that even 'poor' images are 'liberated' from the tyranny of the homogeneous aesthetics that is mainstream cinema. This might mean that Panahi is experimenting, or producing a heretical and heuretical essay-film, since he does not and cannot know *a priori* how things will turn out. But he shoots and eventually a (non-)film is made. In other words, aesthetics are tied to (or entangled with) ethics and vice versa. What is more, and contrary to Dabashi's seeming edict that they should not be, aesthetics are also tied to (or entangled with) politics, as we shall now see in relation to the work of Jacques Rancière.

In his consideration of *This is Not a Film*, James Harvey-Davitt draws on Rancière to explain how

> the politics of art ... is determined by this founding paradox: art is art insofar as it is also non-art, or is something other than art There is a contradiction that is originary and unceasingly at work. The work's solitude carries a promise of emancipation. But the fulfilment of that promise amounts to the elimination of art as a separate reality, its transformation into a form of life.[7]

Similarly, Rey Chow and Julian Rohrhuber cite Rancière to suggest that 'genuine art is what indistinguishes art and non-art; in such capacity for indistinction lies art's transformative power and potential to bring about a new humanity'.[8] That is, if art encourages us to question rather than giving us answers or imposing solutions so as to finalize the world (imposing a 'final solution'?) then in questioning we change and we bring about change, and we consciously and conscientiously take part in (realize our entanglement with) the process of change that is reality itself. A (final) solution might suggest the eschaton – it would be the end of the world. However, the immanentization of the eschaton would be an immanentization across space (the liberation of the poor everywhere) as well as across time (the eschaton not as a one-off event, but as a process that is spread across all time). In other words, the eschaton is not a one-off event or a 'final solution'; it is change, or time itself.

Here, then, we can map Rancière on to Deleuze's understanding of time in relation to cinema, which in turn we can link to the digital's capacity to record in an unbroken fashion. For, in Deleuze's estimation the time-image is an art cinema. It is in part an art cinema because it makes us question the reality of what we see (is it dreamed or real?). If we can record for long enough, then eventually we will record events that are 'stranger than fiction' in the sense that we do not believe them to be real, even though they look real (the confusion of fiction and documentary). This in turn leads us to question the reality of what we see rather than simply accepting it as an immutable, unquestionable given (we could be lucky and record such events straight off; but being able to record for longer considerably increases the chances of filming such strange events). Furthermore, once we begin to see 'events stranger than fiction' in one place, we might begin to see them everywhere. That is, we might begin to see that (much of) reality itself is almost unbelievable. And yet this is our reality and we must choose to believe (in) it. Believing in this world, I realize that I am a part of it (entanglement), which in turn encourages me to be an ethical human being, believing in the reality of other humans, other species, and perhaps of matter more generally. Believing in the reality of other humans, other species and more, it is only in extreme situations that I will bring myself to do harm to or exploit them (because they are real, and I know that my actions have consequences, I must choose carefully what I do). If the prevailing morality of our time is capitalist and involves 'scientific' quantification and objective access to an independently observed world, in which others are treated not as real but as abstract data or objects, and if the expression of such abstraction

is cinema, which foregrounds only certain things as real over others, then perhaps non-cinema is cinema's only hope. Non-cinema is what might, in Rancière's language, emancipate spectators from watching films and the world itself in a detached fashion, and from accepting this status quo precisely because seemingly detached from the world and thus imbued with a sense of disempowerment. Indeed, non-cinema might emancipate not only spectators, but also humans from spectatorship – the condition of merely watching the world as opposed to participating with it.[9] Contrary to Dabashi, then, *This is Not a Film* uses the smartphone to suggest that non-cinema is art is politics. Furthermore, Panahi is spot on: this – that which we experience and with which we are entangled – really is not a film, since this that we experience and with which we are entangled is life, or reality itself. Cinema is part of reality and not the measure thereof. Making a film in part with a smartphone suggests a deference towards rather than a desire to dominate reality. This democratization of cinema, whereby cinema is part of but no longer dominates reality, is in some senses a socialist manoeuvre. With socialism in mind, therefore, it seems apt that we should move on to Jean-Luc Godard's *Film Socialisme*, which equally features images captured on smartphones.

Whither socialism?

Film Socialisme is a dense film containing numerous images and a plethora of quotations and references to current affairs, other films, literature, music, painting, philosophy, photography and more. I shall not offer a definitive reading of the film. Instead, I wish simply to establish how with *Film Socialisme* (and in the next chapter with *Adieu au langage*) Godard embraces new film-making technologies, while also bringing together – and developing upon – many of the aspects of non-cinema that I have outlined in this book.

Film Socialisme does not have a story per se. Instead, it is split into three sections, each of which at times mentions various places around the Mediterranean: Egypt, Odessa, Palestine, Greece/Hellas, Naples/Napoli and Barcelona. The first section, *Des choses comme ça* ('Things Like That'), takes place on the *Costa Concordia*, a cruise ship that two years after filming was wrecked off the coast of Italy, killing thirty-two people. It features random-seeming scenes of life on the ship, including low-grade digital images of people in the ship's nightclubs and numerous shots of people dining. There is some semblance

of a narrative in that Otto Goldberg (Jean-Marc Stehlé) is on board, and there are various questions – typically raised in voice-over by journalist Constance (Nadège Beausson-Diagne) and photographer Mathias (Mathias Domahidy) – regarding how his family became wealthy, the implication being that this is linked to the disappearance of Spanish and other gold in the 1930s and 1940s. There is also a historian (Maurice Sarfati) who seems to be investigating Goldberg's links to Richard Christmann, a double agent who used to work for the Abwehr (a German intelligence agency) before and during the Second World War, before working for the American Gehlen intelligence force after the war. But while loosely the section has a narrative, it also features fragments of discussions about economics, the history of Haifa, and even a lecture on geometry delivered by French philosopher Alain Badiou. What is more, Patti Smith wanders the ship singing with her guitarist Lenny Kaye (although we later also see Smith looking out to sea on her own).

The second section, *Quo Vadis Europa* ('Whither Europe'), takes place in and around a garage, owned by Jean-Jacques Martin (Christian Sinniger), somewhere in France. Two television journalists (Élisabeth Vitali and Eye Haidara) arrive, requesting an interview with Martin, who apparently is running in the elections of the local canton. Meanwhile, we also see random-seeming discussions, readings and other conversations that involve various combinations of the journalists, Martin's wife Catherine (Catherine Tanvier), and his children Florine/Flo (Marine Battaggia) and Lucien/Lulu (Gulliver Hecq). The section is structured as a succession of scenes/moments rather than as a cause and effect-driven narrative, although we do discover at the end of the section – via a series of intertitles – that Jean-Jacques does not win the election since it was cancelled but that he (or perhaps his children) are favourites for a landslide victory next time. Then we are told that the Martin family had been involved during the Second World War in the production and distribution of a clandestine newspaper, *Combat*, which promoted freedom and federation in France.

(Here we potentially have a link between the first and second parts of the film, since the historian in the first part seems to be tracking down Goldberg because of his connection in the betrayal and deportation of Alice Simmonet, a real historical figure who was involved in the production of another clandestine wartime journal, *Résistance*.)

Finally, the last minutes of the film, *Nos Humanités* ('Our Humanities'), involve a montage structured around the six places mentioned above, including footage from and a recreation of the Odessa steps sequence from Sergei M. Eisenstein's

Bronenosets Potyomkin/Battleship Potemkin (USSR, 1925). The film as a whole also features unusual sequences involving animals (the opening image is of two parrots; we see footage of cats miaowing; the Martins inexplicably own a donkey and a llama), archive footage of various twentieth-century events and scenes from other films, insertions of text, freeze frames, still images and slow motion shots. What is more, the dialogue is sometimes inaudible, with wind ruffle often featuring on the soundtrack together with aggressive sound distortion during the disco scenes.

The lack of a coherent narrative, the presence of animals, the low-grade digital images, and the occasional poor sound should suggest preliminary links between *Film Socialisme* and non-cinema. Furthermore, as David Sterritt has identified, Godard seeks to show us the invisible, or that which is antithetical in many respects to cinema.[10] In *Film Socialisme* (and not for the first time in Godard's œuvre), this 'invisible' is primarily the workings of capital.

We do occasionally see tourists emerging from the *Costa Concordia*, for example, when they arrive at Odessa. However, on the whole the cruise ship tourists remain on, or inside, the ship; even the decks are generally empty. While the film features numerous (mesmerizing) shots of the sea, the tourists never seem to look out to sea and at the world that surrounds them. Instead, they go to the disco, shop, gamble at the casino and, in numerous shots, they eat. At one point, we see Badiou giving his lecture in an empty room (apparently no one on the ship turned up to Badiou's talk, even though it was advertised and genuinely took place).[11] We then cut to a crowd of people in a more brightly illuminated part of the ship, over which we hear information about shopping, before the film cuts again to a screen featuring an animation of the ship – seemingly part of an infomercial that the gathered tourists are watching. Additionally, when Goldberg and the girl who accompanies him, Alissa (Agathe Couture), visit a gallery/shop selling paintings, seemingly also on the ship, it is equally empty.

In other words, Godard seems to be suggesting that humans in the contemporary world are not interested either in the 'natural' world, or in anything like culture, philosophy or art. Instead, humans seem only to be interested in screen-based entertainment, hedonism and consumption. As much might possibly be affirmed when we see a man (Bernard Maris) at a gambling machine in the ship's casino. 'Money was invented so people wouldn't have to look each other in the eye', he says. That is, capital means humans no longer look at the world or at each other, but instead have their eyes always elsewhere – on money. As Christopher Pavsek puts it,

Little to no experience exists any longer that is not explicitly or implicitly articulated in the language of profit and exchange: the value of art is clearly expressed in financial terms; education has become the mere training in skills necessary for employment; in academia, research secures jobs, further research gains salary increases; children's play is thought of in terms of future financial reward, the fantasy of scholarships animating the mind of many a sideline parent; and a young child's pleasure in drawing a line is an indication of her future fitness for university.[12]

If cinema and capital go hand in hand, then cinema also is an invention that discourages humans from looking at each other – especially in the sense of sharing a gaze, since figures on the film screen rarely stare back at us (they rarely break the so-called fourth wall), and even when they do it is not as if they can actually see us looking at them, since all they could have seen at the time of the image's being taken is the camera that was filming them. Their attention grabbed, humans (prefer to) look at screens instead of other people.

From Plato's Cave to vibrant matter (taking it lying down)

The earliest machines for viewing films were the kinetoscope, developed by Thomas Edison and W. K. L. Dickson between 1888 and 1893, at which one stood in order to watch a film. These quickly were replaced by the film projectors developed by Auguste and Louis Lumière and famously unveiled at the Salon Indien du Grand Café in Paris in late 1895; here, people either stood or sat. There followed a history of cinema going that involved viewers slowly reclining further and further in their seats (which themselves reclined) until today, when many (most?) people watch films on their computers lying down – as Alissa does in *Film Socialisme*, stretched out on her cabin bed while watching a screen featuring cats miaowing at each other.

The progression from the vertical to the horizontal film viewer reflects how cinema (as capital) has come to dominate the world. That is, humans have over time prostrated themselves before cinema-capital as if it were a god, offering up to it their attention, their labour and their money. What has allowed cinema-capital to become quasi-divine is the fact that its workings are invisible. Indeed, studies show that viewers watching mainstream cinema often experience 'edit blindness', whereby they cannot see the cuts, or how the film is put together.[13] With viewers thus unaware of how cinema works, cinema – and the cinematic

mode of production under capitalism more generally – becomes unquestionable, manifesting itself as a seemingly immutable status quo. Cinematic time, the fast-paced and attention-grabbing rhythm of cinema, becomes the only time accepted as real as humans surround themselves and even carry about on their person screens that provide them with shots of cinema in order to live, much as we get shots to protect us from disease and drink shots in order to avoid contact with reality.

In his *Republic*, Plato has Socrates explain the simile of the cave: it is possible that the reality that humans see is in fact just shadows being projected on to a wall inside a cave – and that beyond the cave there is a completely different and more profound reality.[14] The retreat of humans to interior spaces (including the *Costa Concordia*), where they do not have to look either at the world or at each other, but where they only need look at screens (the equivalent of shadows projected on to walls) suggests not so much that humans have learnt to emerge from Plato's Cave, but that under capitalism humans are forced and even volunteer willingly to retreat into it. That is, humans willingly retreat and lie down before the shadows on the wall of Plato's Cave and which are cinema and other screens. It is against this tendency, or it is as non-cinema, then, that Godard makes *Socialisme*, with its 'poor' smartphone images and sounds and its deliberately aggressive editing and refusal of narrative rejecting the glossy, 'clean' images of cinema-capital and its spectacular displays of wealth and power.

This rejection of the values of cinema, or this production of non-cinema, spreads further than just a democratization of images, though, as smartphone images feature alongside those shot on high-end cameras. For *Film Socialisme* also shows us the vibrant life not just of people and animals, such that we might understand equality between them. It also shows us the vibrant life of matter itself – suggesting that life is not simply reserved for humans and animals, however it is we may distinguish them, but that life is immanent in the world more generally. We can begin to see how this is so by looking at Godard's insistent images of waves in the film. For, waves play no small part in *Film Socialisme* even if they do not contribute to the film's 'story'. By featuring so prominently, with various shots showing us just the sea and its never-ending waves, the sea becomes less the backdrop for whatever action is taking place, but it almost becomes a character in the film.

Daniel Morgan has argued that images of nature play a crucial role in Godard's films, with *Nouvelle vague* (Switzerland/France, 1990) in particular showing 'the natural goodness of the countryside … [while] the urban, industrial scene of

capitalism is depicted as rife with corruption, greed and moral failings'.[15] It is not that Godard shows us a totally 'wild' nature in which there is no trace of human presence, but Godard nonetheless presents to us *cultivated* nature'.[16] With regard to this chapter, the concept of 'cultivated nature' provides an expression of entanglement: the natural is not opposed to the human; humans and nature are entangled. That is, humans are not detached from a nature that they can thus treat as they wish, including by destroying it – even if capital originates in 'the forceful taking of land from its original owners', or more clearly in the application of the concept of ownership to the land.[17] Ownership of the land, or the development of the concept of property (which then leads to the concept of property development), leads to the invention of nations and states as that ownership becomes static (this is mine and that is yours).[18] With this notion of property-as-capital in mind, no wonder Godard ends his film with a defiant insertion of the FBI warning regarding copyright protection and intellectual property; cinema is not the property of one person, one corporation or one nation, even if cinema is used to reinforce and to naturalize the concept of property. But if humans are not detached from but in fact entangled with nature, then life itself is not simply the property of the human, with nature a 'dead' space or thing that we must protect; if properly we are entangled, then life itself is in nature as much as it is in humans. To show nature, then, and especially the sea that never stops moving, and which, unlike the land, is so much harder to divide and to define, defies the stasis and immutability of capitalism-as-property by harnessing the disruptive power of, to make a Godardian pun, the 'vague' (or wave). That is, the ship is not a means to rule the waves (something that the *Costa Concordia* signally – fatally as far as the lives of thirty-two people are concerned – failed to do). Rather, the ship exists only because of the waves.

The subtitle of Sterritt's monograph on Godard is *Seeing the Invisible*, which is also the name of a study of Wassily Kandinsky by French philosopher Michel Henry (to whom Sterritt does not refer). Henry explains that 'by listening to the inner resonance dwelling in each particular object ... Kandinsky was able to discover abstraction. This was the discovery of the invisible life that spreads out everywhere under the shell of things and supports their being.'[19] Quoting Kandinsky himself, Henry continues: 'The world sounds. It is a cosmos of spiritually affective beings. Thus, dead matter is living spirit ... [and] the whole cosmos is alive: an immense subjective composition. As such, there can be no world without an affection and without the sensations that are the Whole of our sensibility and that continually make it vibrate like the flesh of the universe.'[20]

Henry/Kandinsky's argument chimes with Barad's theory of entanglement, as well as with work by scholars like Jane Bennett, with her concept of 'vibrant matter', and Manuel De Landa, with his concept of 'nonorganic life'.[21] That is, the distinction between the living and the non-living as they have traditionally been separated is perhaps not as certain as we tend to believe. Indeed, an understanding of quanta as ultimately being differentiated not by what they are, but by their temporality (or what physicists call their 'spin') would suggest that if what distinguishes a living being from a 'dead' being is the rhythm at which it moves (both are, after all, made up of quanta), then in some senses all matter is alive since moving.[22] In other words, Godard helps us with his insistent shots of nature to 'see the invisible' life of the natural world, as well as our entanglement with it. This is a technologically enabled 'democratic' vision that perhaps does bring us close to socialism in film form. Since this is achieved not through analogue film stock, but through the digital, we might nonetheless understand how cinema involves a capitalist logic of separation and property, as capital involves a cinematic logic of the same. It is only through the creation of non-cinema, then, that this socialist vision of the world can be realized.

'We don't talk to people who use the verb "to be"', say both Lulu and Flo to the television journalists when asked if the garage is the Martin residence. This echoes Deleuze's belief that Godard 'does away with all the cinema of Being = is'.[23] For perhaps to be is itself a concept associated with stasis and property; to be is really to be this and not that, to have an identity rather than to flow (or Flo), rather than to be a flower. In this way, to be or not to be is not the question. Rather, to be and not to be are simultaneous, co-dependent, indistinguishable as life becomes recognized as immanent, and not limited to certain things, including people. Similarly, to suggest that cinema is one thing and not another, to apply 'to be' to cinema, is not the question. That is, André Bazin asked the wrong question when he asked 'what is cinema?'[24] As art blurs the distinction between art and non-art, non-cinema also blurs the distinction between cinema and non-cinema.

From anger to love

It is not uncommon for students to register annoyance at films that lecturers impose upon them. However, no film has angered some of my students more than *Film Socialisme*, with one continuing to register on social media a year after

having seen it how much he hated the film and that it should never have been made (I should make clear that plenty of students find the film fascinating; but it would seem that those who dislike the film absolutely loathe it).

There is in fact much to learn from such a vehement reaction, not least the fact that Godard's film can strongly affect people, thus involving the audience in a direct way. As Jean-Jacques says in the film: 'Everyone is busy. You need courage in order to think.' If thought, as we are defining it here, is becoming and change via a confrontation with difference, or a sense of entanglement, then perhaps one does need courage in order to think. That is, *Film Socialisme* tries to encourage its viewers to think. And with courage comes thinking not uniquely with the head (reason/capital), but with the heart (core/*cœur*). That is, thought is an act of love.

In trying to encourage thought via his radical, perhaps incomprehensible, montage, Godard also runs the risk of failure – as per the vehement response of my student, who considers *Film Socialisme* unworthy of cinema (meaning that it is non-cinema). André Habib sees failure as being a key component of Godard's work, while Christopher Pavsek reminds us in terms that recall the philosophy of Enrique Dussel, that 'not only is every document of culture also a document of barbarism, but every document of barbarism is also a document of culture'.[25] In other words, Godard willingly embraces a 'barbarian' aesthetic, adopting various non-cinematic techniques like the insertion of black leader into the film, in an attempt, or *essai*, to get us to think such that we might change.

Pavsek goes on to ask, partly in relation to Godard: 'What is the experience of anaesthesia, if not the suspension of time itself?'[26] If to feel nothing (anaesthesia) is not to feel time, then to feel is to feel change and thus to feel time. This feeling of time happens not via anaesthesia, but via its opposite, namely aesthetic experience, or art – including via the seemingly negative experience of a film that one hates, since in hating that film at least one is feeling something. Even this negative experience, then, involves the change that is thought that comes about via aesthetic experience, which involves an act of love.

'The state dreams of being alone. Individuals dream of pairing up', says Flo in voice-over as we see her thinking in close-up. If the state does indeed dream of being alone, then it is because the state separates itself off from other states (as nations do from nations), and because it separates itself off from the flow of time (the state is defined by stasis). In this sense, as cinema-capital is involved in the process of separating man from world, so is the state involved in the process not of demonstrating entanglement, but of enforcing and maintaining isolation.

Individuals, meanwhile, wish to conjoin with other humans – what Flo refers to as pairing up, or which we might define here also as love.

As Alain Badiou, *Film Socialisme*'s philosopher-in-residence, puts it: 'You learn that you can experience the world [and thus you learn love] on the basis of difference and not only in terms of identity'.[27] As a result, 'love comes to be the idea that something exists in this void'.[28] In other words, we are not alone/in a vacuum/void; there is instead difference. Badiou even relates love to time in suggesting that it is 'the desire for an unknown duration. Because, as we all know, love is a re-invention of life'.[29] In this way, love for Badiou is a confrontation and an embrace with difference, it is the courage to change, to become, to experience time. This conception of love might also be called socialism. Socialism, or a world of love, is thus not the utopian promise (or the non-place) of cinema, as Pavsek sees it.[30] Rather, socialism is the reality of non-cinema.

Kino-brush aesthetics

If in this chapter we have seen how non-cinema is in some senses out of control, and that it is an ethical cinema that not only offers but also tries to realize a democratic or socialist conception of the world, including a loving vision of life in all matter, then I should like to end by returning specifically to the digital imagery that we see in *Film Socialisme*, suggesting that the 'poor', pixelated smartphone images that we see are themselves entangled with the socialistic and loving sense of vibrant matter that the film offers.

Daniel Morgan explains how for Godard 'photography has to pass through painting in order to become cinema' – and that much of Godard's late work draws upon painting as much as, if not more than, photography in order to demonstrate that cinema is not just an art of moving photographic images, but that it is part of a much greater pictorial history.[31] Furthermore, 'Godard [specifically] uses digital technology to explore the pictorial capacities of cinema'.[32] Shot with smartphones, the pixelated images in *Film Socialisme* of *Costa Concordia* tourists in the ship's nightclub and of Goldberg walking down a corridor similarly suggest not graphic realism, but distortion and manipulation.

This manipulation of the image becomes overt when, for example, the camerawoman who is trying to interview the Martins sits down next to Lulu to show him her watch outside the garage. We see Lulu from behind in a blue and white flowery shirt as he tries to paint a picture that bears a striking resemblance

to the work of Pierre-Auguste Renoir. Beyond him is the camerawoman, shrouded in bright yellow and unnatural light, as to the right of frame we see the donkey beyond a metal bannister, now bright green instead of black. In other words, the image clearly is not interested in realism, in the sense of conforming to our 'normal' colour perception of the world, but instead seeks deliberately to foreground its pictorial qualities. This is a manipulated image, meaning that the presence of the film-maker is felt, again suggesting entanglement. As mentioned with reference to Lev Manovich in the chapter on Chinese non-cinema, we are no longer in the age of the detached kino-eye, but the age of the kino-brush.[33]

Paradoxically, manipulating the image does not suggest isolation from the world, or what we might call a lack of indexicality. Even though the digital image is supposedly not indexical, it nonetheless suggests entanglement. According to Pavsek, Godard wanted cinema to show us that 'the world is there', before adding that cinema might also 'show us the world will *still be there* in the future'.[34] In some senses, Pavsek is correct. But we might adjust his words slightly to say that non-cinema does not show us that the world is there, but it makes us feel that the world is here, with us, and that we and the world are both changing. If we are changing, then by definition we know that there is a future, since for there not to be a future means the cessation of change.

Louis Lumière famously wrote that cinema is an invention without a future.[35] Although Lumière was patently wrong in the mundane sense that cinema went on to become the most influential medium of the twentieth century (its fate this century lies in the balance), Lumière was also perhaps correct in a more obscure, but challenging way. Morgan explains how Hollis Frampton draws upon T. S. Eliot's idea of tradition to explain that if cinema is to have a future, then it must also invent a past, or tradition.[36] If for many people their primary experience of the world is via cinema – that is if they are, like the children in Iran, exposed to media from the get-go – then as the past determines the future, so will a cinematic infancy lead towards a future that will be cinema, or cinematic. Cinema is an invention without a future, then, because cinema as capital is about precisely the control of the world – and of time itself – such that there is no future, no unforeseen change, and the imposition of a regular, cinematic rhythm. Raised on the capitalist values of cinema, those capitalist values of cinema become our future – a future characterized not by change, but by repetition (the stasis of returns without difference). Breaking the diet of the easy, fast food that cinema feeds to us is no easy task, and it is perhaps not cinema's future to do this, for cinema has no future/it does not allow for the

concept of futurity. It is non-cinema that has a future, and which enables the concept of futurity to emerge, since it embraces change.

Film Socialisme democratically finds the time and space to include images shot on smartphones and various other devices. Such a smartphone aesthetic might eventually become yoked into the service of capital, as is suggested by the emergence of high-profile films shot entirely on smartphones like *Tangerine* (Sean Baker, USA, 2015). Nonetheless, for the time being *This is Not a Film* embraces the smartphone in order specifically not to be cinema, while the 'poor' quality of Godard's films leads people like my student to discount it as cinema at all. If these technologies are to become normalized (and as even smartphones begin to capture images at ever-higher levels of resolution), perhaps we must adopt lines of flight to ever-smaller, non-cinematic forms, in order to ensure that none is excluded from cinema as none should be excluded from society, not even (perhaps especially) the 'poorest'. This means working with obsolete technologies like PixelVision, as exemplified by films like *Another Girl, Another Planet* (Michael Almereyda, USA, 1992) and *Girl Power* (Sadie Benning, USA, 1993). But in addition to working with obsolete technologies, these lines of flight might also be made using the 'newest' technologies, such as stereoscopic cameras, as per Godard's next film, *Adieu au langage*, which in taking cinema beyond the frame also takes cinema into the realm of non-cinema, as we shall discuss in the first part of the next chapter.

Notes

1 Anonymous, 'Iranian Film Wins Best Screenplay Award At Berlin Film Festival', *Radio Free Europe/Radio Liberty*, 17 February 2013, http://www.rferl.org/content/iran-film-berlinale-screenplay-award-panahi/24904546.html.
2 Hamid Dabashi, 'The Tragic Endings of Iranian Cinema', *Al Jazeera*, 21 March 2013, http://www.aljazeera.com/indepth/opinion/2013/03/20133201757391003572.html.
3 Godfrey Cheshire, 'Iran's Cinematic Spring', *Dissent*, 59:2 (Spring 2012), 80.
4 Shiva Rahbaran, 'An Interview with Jafar Panahi', *Wasafiri*, 27:3 (2012), 9.
5 See Matthew A. Holtmeier, 'Post-Pandoran Depression or Na'vi Sympathy: Avatar, Affect, and Audience Reception', *Journal of the Study of Religion, Nature and Culture*, 4:4 (2010), 414–24.
6 Deleuze, 'Postscript on the Societies of Control', 3–7.
7 Jacques Rancière, *Aesthetics and Its Discontents*, trans. Steven Corcoran (Cambridge: Polity Press, 2009), 36. This quotation also appears in James Harvey-Davitt,

"'Non-Film": A Dialogue between Rancière and Panahi on Asceticism as a Political Aesthetic', *Evental Aesthetics*, 2:4 (2014), 95.
8 Rey Chow and Julian Rohrhuber, 'On Captivation: A Remainder from the "Indistinction of Art and Nonart"', in *Reading Rancière: Critical Dissensus*, ed. Paul Bowman and Richard Stamp (London: Continuum, 2011), 45.
9 Jacques Rancière, *The Emancipated Spectator*, trans. Gregory Elliott (London: Verso, 2009).
10 David Sterritt, *The Films of Jean-Luc Godard: Seeing the Invisible* (Cambridge: Cambridge University Press, 1999).
11 See Jean-Marc Lalanne, '«Le droit d'auteur? Un auteur n'a que des devoirs» Jean-Luc Godard', *Les Inrockuptibles*, 18 May 2010, http://blogs.lesinrocks.com/cannes2010/2010/05/18/le-droit-dauteur-un-auteur-na-que-des-devoirs-jean-luc-godard/.
12 Pavsek, *The Utopia of Film*, 231.
13 See Smith and Henderson, 'Edit Blindness'.
14 See Plato, *The Republic*, trans. Desmond Lee (London: Penguin, 1987), 255–64.
15 Daniel Morgan, *Late Godard and the Possibilities of Cinema* (Berkeley: University of California Press, 2012), 104.
16 Morgan, *Late Godard and the Possibilities of Cinema*, 108.
17 Ibid., 109.
18 Ibid., 152.
19 Michel Henry, *Seeing the Invisible: On Kandinsky*, trans. Scott Davidson (London: Continuum, 2005) 134.
20 Henry, *Seeing the Invisible*, 138–9.
21 See Barad, *Meeting the Universe Halfway*; Jane Bennett, *Vibrant Matter: A Political Ecology of Things* (Durham, NC: Duke University Press, 2010); and Manuel De Landa, 'Nonorganic Life', in *Zone 6: Incorporations*, ed. Jonathan Crary and Sanford Kwinter (New York: Urzone, 1992), 129–67.
22 For more on how quanta are distinguished not by being made up of different substances, but by the speed at which they spin (meaning that the difference between quanta is not a question of matter but a question of time), see Brian Greene, *The Elegant Universe: Superstrings, Hidden Dimensions, and the Quest for the Ultimate Theory* (London: Vintage, 2000), 9 and 172.
23 Deleuze, *Cinema 2*, 174. See also David Sterritt, 'Godard, Schizoanalysis, and the Immaculate Conception of the Frame', in *The Legacies of Jean-Luc Godard*, ed. Douglas Morrey, Christina Stojanova and Nicole Côté (Waterloo: Wilfred Laurier University Press, 2014), 146.
24 Bazin, *What is Cinema?*

25 Pavsek, *The Utopia of Film*, 186. See also André Habib, 'Godard's Utopia(s) or the Performance of Failure', *The Legacies of Jean-Luc Godard*, ed. Morrey, Stojanova and Côté, 217–34.
26 Pavsek, *The Utopia of Film*, 115.
27 Alain Badiou with Nicolas Truong, *In Praise of Love*, trans. Peter Bush (London: Serpents Tail, 2009), 16.
28 Badiou with Truong, *In Praise of Love*, 20.
29 Ibid., 33.
30 Pavsek, *The Utopia of Film*, 235.
31 Morgan, *Late Godard and the Possibilities of Cinema*, 155.
32 Ibid., 160.
33 Manovich, *The Language of New Media*, 307–8.
34 Pavsek, *The Utopia of Film*, 23.
35 See Morgan, *Late Godard and the Possibilities of Cinema*, 196–7.
36 Ibid., 197.

10

Farewell to Cinema; Hello to Africa

If in the last chapter we considered how 'smaller' films like those featuring images captured by smartphones constitute non-cinema in various respects, in this chapter I shall argue that the very latest digital imaging technologies can achieve similar results. For, using Jean-Luc Godard's *Adieu au langage* as a template, I shall argue digital 3D cinema 'unframes' cinema, thereby also taking us into the realm of non-cinema. Continuing on from the last chapter's analysis of Godard's *Film Socialisme*, I shall also propose that *Adieu au langage* knowingly engages with the limits of cinema, and that it is thus exemplary of non-cinema, especially through its treatment of hair, language (including the 'language' of film) and Africa. Godard's 'turn' to Africa in both *Adieu au langage* and *Film Socialisme* will help us to progress smoothly to my final example of non-cinema, namely *Osuofia in London* (Kingsley Ogoro, Nigeria, 2003), a popular comedy from the Nigerian film industry known as Nollywood. Through my analysis of *Osuofia in London*, I shall propose that Nollywood is the most vibrant and prolific producer of non-cinema in the contemporary world, and that the 'cheap' Nollywood aesthetic exemplifies not just 'bad' film-making but an oppositional approach to film-making that speaks to a wider African contemporaneity. Africa, long neglected by cinema, is a hub for non-cinema, which given its size can give us hope not only for the future of film-making, but also the world more generally. But first let us consider *Adieu au langage*.

God-awful Godard

Like *Film Socialisme*, *Adieu au langage* does not so much tell a story as present a series of fragments. There is a woman, Josette (Héloïse Godet), who stands outside a building labelled *Usine à Gaz*, a concert hall built on the site of a genuine gas factory in Nyon, Switzerland. Josette is having an affair with Gédéon

(Kamel Abdeli), whom she met in Kinshasa and around whose apartment she walks naked as old movies play on his television (including *Les Enfants terribles*, Jean-Pierre Melville, France, 1950; *Dr Jekyll and Mr Hyde*, Rouben Mamoulian, USA, 1931; *U samogo sinego moray/By the Bluest of Seas*, Boris Barnet and S. Mardanin, USSR, 1936). At one point Josette's German banker husband (Daniel Ludwig) threatens her with a gun, while the early parts of the film also feature a man, Davidson (Christian Gregori), who discusses with various people topics ranging from Aleksandr Solzhenitsyn's *Gulag Archipelago* (1973) to the invention of television by Vladimir Zworykin in Russia in 1933, and the paintings of Nicolas de Staël.

The film then sees a second couple, Ivitch (Zoé Bruneau, whom we have already seen talking to Davidson) and Marcus (Richard Chevallier), who look strikingly like Josette and Gédéon (such that it is hard at times to tell them apart), and who enact many similar scenes to the first couple, including a moment when Ivitch's husband appears with a gun. At the end of the film, there is a strange 'costume drama' section in which Lord Byron (Alexandre Païta), Percy Bysshe Shelley (Dimitri Basil) and Mary Wollstonecraft Shelley (Jessica Erickson) come to the shores of Lake Geneva, where the latter devises *Frankenstein* (1818), a novel mentioned at several points in the film.

More than these 'narrative' elements, though, the film is punctuated by shots of leaves and trees, the sky, cars driving in the snow and rain, traffic lights, a ferry carrying passengers across/around Lake Geneva, flowers and water. Above all, however, the film, especially its second half, features repeated images of Roxy (Miéville). Roxy is a dog that we see predominantly in wooded areas, by Lake Geneva, splashing in a brook, and swimming in a river. In true Godardian fashion, the image track is accompanied by music and fragmented voice-overs, which are sometimes inaudible, sometimes repetitive. Furthermore, the film is punctuated by sections of black leader and intertitles, especially those featuring the words Nature and Metaphor, supposedly the two structuring topics of the film. That said, *Adieu au langage* is not split easily into two parts, one on nature and the other on metaphor; rather, the two intertitles recur several times and not necessarily in order.

Adieu au langage features images that are upside down, canted, on their side, and which involve seemingly unnecessary camera movements. Some images are solarized, some clearly have had their colours modified. Some images are in black and white, some in colour (one shot of Roxy alternates between the two). Some are at 'normal' speed, many are in slow motion. There are also several freeze frames. Various sequences are 'poorly lit', such that characters appear in

silhouette or are barely visible. Godard furthermore makes use of extended fart and shit noises during conversations about otherwise serious topics (philosophy and democracy).

In other words, *Adieu au langage* bears many of the hallmarks of what I am terming non-cinema as it makes little easy sense in its rejection of narrative, as it experiments/essays with form and content, as it verges on being an amateur/ home movie of a pet dog, as it features 'bad' lighting/a black screen, and as it emphasizes both animals and scatology. The latter is made clear by a canted shot in which we see Gédéon astride the lavatorial throne in a posture not unlike Auguste Rodin's famous *Penseur/Thinker* (1882). Like Alain Badiou in *Film Socialisme*, Gédéon discusses geometry, but here accompanied by the squelching sound of a wet dump, concluding that 'thought regains its place in poop [*le caca*]'. In a second sequence, Marcus also clears his bowels as Ivitch walks naked around him, waiting to get in the shower. 'I talk about equality and each time you talk about poop', she complains. 'Because', replies Marcus, now over black leader, 'that's where we're all equal'. In other words, effluence, associated through the black screen with the unrepresentable, influences and is a key component of Godard's vision of, or feeling for, democracy; as poop is equal to thought, so might 'shit' films be equal to 'good' ones.

Marcus and Ivitch go on to discuss how she has 'no more forest', likely a reference to her having shaved off her pubic hair, especially because it echoes a moment when Gédéon says that members of the Apache Chikawas (Chickasaw?) tribe refer to the world as a forest as we see a yonic shot of Josette, her pubic hair prominent in the frame. The shot is reminiscent of *L'Origine du monde/Origin of the World* (1866), a painting by Gustave Courbet and which itself features a vagina more or less centre frame. To have a 'forest' of pubic hair is clearly considered here to be natural, an equal part of our world. And yet, this is a part of our world that we also try to hide, as signalled by Ivitch shaving her pubic hair. As we shall see below, humans go to great lengths to remove (unwanted) hair from images and from their bodies, a process perhaps designed to help humans to feel different from animals like Roxy – with the hair of the dog also featuring prominently in the film.

Floccinaucinihilipilification

The Latin for hair is *capillum*, from which we take various words, including capillary (a small blood vessel, which is 'hair-like') and to depilate, meaning to

remove hair. It is the stem -pil/-pilo/-pili that is important here in conveying hair, since it is linked also to the Latin term, *pellis*, meaning skin. In other words, hair and skin are basically inseparable, as is made clear by the English word 'pelt', which is both a skin and the fur/hair of an animal. The skin and its hairs constitute our largest organ, and the skin possesses sensory neurons, which themselves perform 'advanced' calculations about touch and even shape.[1] That is, our skin is at the very least a peripheral neural mechanism, or part of our brain. In this way, neither our skin nor our hair 'cover' us; they *are* us. If Photoshopping and the cosmetics industry more generally, including mainstream cinema, involve the removal of (especially female) body hair because it is deemed excessive, then *Adieu au langage* would seem to suggest that the removal of pubic hair for the purposes of patriarchy and the commodification of the female body (to be desirable to a man, the female body must resemble a little girl?) is a move away from nature, a destruction of the world as forest (as vagina?).[2]

Now, *pil* is also the root for various terms for film, including the French word *pellicule*, the Spanish word *película* and so on. In other words, film is itself like a skin, which in turn arguably has a similar relationship to hair as the human, in that cinema wants to be 'invisible', while at the same time specifically making hair invisible, not just in terms of 'Photoshopping' the bodies on camera to remove unwanted hair, but also in terms of the supposedly unwanted hair caught in the gate of a traditional film camera, and which looms large on the projected images when shown on a big screen. The hair in the gate is something that most film-makers want to make invisible. However, in some senses it is an important and contributing aspect of the film (I feel great fondness for hairs flickering in the corner of film images), and certainly a sign of the film's imperfect enworldedness, or entanglement, an 'excessive' detail that supposedly subverts film's capitalist prerogatives (film as capitalism) since it threatens the impression of disembodied detachment and objective observation.

Cinema has thus traditionally made hair invisible, with hair no doubt connoting some sort of 'animality' that humans under cinema-capital at best exteriorize and at worst deny, but which is in fact an inescapable part of our nature (Richard Dyer compares hairless white muscle men to the hairy beasts that they fight).[3] And yet, certain films make their and our skin felt (note that felt is also a term that connotes fur/hairiness), as scholars like Laura U. Marks and Tarja Laine have made clear.[4] If these films run counter to the cinema of detached observation (the cinema that wants to remove the hair in the gate), then in some senses they are not a cinema of capital (the removal of excess),

but non-cinema (a celebration of excess). In being non-cinema, 'felt' films are useless to capital – even if *Adieu au langage* is still a professional production.

In being 'useless' to capital (which is not the same as being useless to humans), non-cinema might constitute an example of floccinaucinihilipilification. For the term refers to that which is completely useless (except perhaps as a piece of playground 'trivia' as one of the longest words in the English language, along with antidisestablishmentarianism). Floccinaucinihilipilification's Latin root is from *floccus*, meaning a wisp, *naucum*, meaning a trifle, *nihil*, meaning nothing, and *pilus*, meaning a hair, and *facere*, meaning to make. In other words, floccinaucinihilipilification means the making trivial, nothing and hair-like of things. Non-cinema not only makes things hair-like, but more than this it validates the wispy, the trivial, it shows the nothing that is, and it reveals the importance of the useless and of hair. That is, the hair in the gate is not something that should be removed from cinema, but is a fundamental part thereof.

With regard to *Adieu au langage*, then, this seemingly God-awful, 'shit' and 'useless' film undermines the ever-present demands for usefulness in cinema-capital. What is more, by being a 3D film, *Adieu au langage* potentially undermines cinema as a whole, reinforcing its credentials as non-cinema – as we shall see in the next section.

Cinema unframed

There are numerous uses of off-screen sound in *Adieu au langage* (and in *Film Socialisme*). The 'acousmatic presence' that off-screen sound creates signals that there are limits to the frame.[5] A history of film stock, screen sizes (both large and small), exhibition sites (e.g. multi-screen video installations), and even editing techniques (split screen, superimposition, irises) clearly also signal the limitations of the traditional, singular frame. Indeed, there is (at present) no camera big enough to 'capture' the whole of reality (as Josette says, in Russian *kamera* means prison). For such a camera would have to be bigger than the universe and able to show us all possible perspectives at once. To use the language of someone like François Laruelle, then, an image must as a result of the frame always be an 'image of' something. The existence of the frame means that every image involves an act of separation, or what Laruelle might call a 'decision' – from the Latin '*de-* "off" + *caedere* "cut"'.[6] Images therefore cut things off from reality, rendering them objects, rather than showing them as entangled

with that reality. As a result, cinema typically involves the production of 'images of', in contrast to which the production of what Godard might call 'just images' is very difficult, if not impossible. Indeed, as thinking beyond the 'decision' is for Laruelle not philosophy but non-philosophy, then so might film-making beyond images of things and in the realm of 'just images' be not cinema, but non-cinema.

It is in thinking beyond the delimiting frame that the use of 3D in Godard becomes important, then, for our understanding of non-cinema here. For, while the screen is a two-dimensional surface on which we typically see framed images, to bring the image off the screen and into the auditorium (when using negative parallax) and to have the images extend beyond the screen (through positive parallax) is in some senses to 'break' the frame, for cinema to be unframed as in the last chapter it was out of control.

It might be possible to argue that all 3D films possess aspects of non-cinema as a result of 'transgressing' the frame, even if spectacular 3D effects films like *Avatar* are created as much as anything for the purposes of making profit by embracing a logic and the techniques of consuming our attention. Nonetheless, Godard 'unframes' cinema in a radical way, especially when he 'splits' the two lenses that typically are needed to record a stereoscopic image, such that instead of two slightly different views of the same thing we are instead offered a simultaneous view of two quite different things. This happens twice in *Adieu au langage*, and I shall describe both moments in some detail before analysing them in terms of non-cinema.

'W-w-w-what', Ivitch stutters, 'is the difference between an idea and a metaphor?' 'To metaphor', Davidson answers, 'ask the Athenians on the tram. We start at the beginning'. There is a medium two-shot of Ivitch (left) and Davidson (right) on a bench looking at a book of Nicolas de Staël reproductions. 'Interior experience is now forbidden by society in general and by spectacle in particular', says Davidson. 'You mentioned murder...' Davidson turns pages of the de Staël book as Ivitch rubs her face with her hands. 'What they call images are becoming the murder of the present.' Ivitch leans forward to look at what appears to be a reproduction of de Staël's *Marathon* (1948), an oil painting of mainly grey, black, white, red and occasionally light green lines that loosely form the shape of a head. 'The present is a strange beast [*un étrange animal*]', she says, before a hand and torso dressed in a grey suit suddenly intrude into the frame from the right, grab her, and pull her from the bench and out of frame. The camera tilts up as Davidson gets to his feet before impassively leafing through the de Staël book as Ivitch says off-screen, 'I don't care [*ça m'est égal*]'. Something extraordinary

then happens. The right lens of the stereoscopic camera pans right as the left lens holds on Davidson. We simultaneously see Davidson looking at the de Staël book as Ivitch's husband circles her and shoves a pistol in her face. 'I'll finish you off, you shit-mother', he exclaims, before Ivitch pushes the gun away and shouts again: *Ça m'est égal!* She then walks back to Davidson and stands next to him, frame left. It is at this point that the images reconverge, and Davidson continues as if nothing had happened: 'Take truth.' The husband walks off in the background. 'Plato declares that beauty is the splendour of truth. Now there's an idea.'

Meanwhile, Marcus sits beyond Ivitch, his face in shadow as we see only her torso, vagina and thighs. Both are naked as he rubs the back of her legs, explaining that there is 'something awkward about our relation to the world'. He stands as Ivitch runs her hands down her front and leans forward, her face still out of frame. The image splits in two as one of the stereoscope's lenses stays on Ivitch's midriff and the other follows Marcus across his apartment, where he picks up Ivitch's trench coat. 'It [our relation to the world] acts against pure freedom.' Ivitch lights a cigarette and sits down and, as the two images reunite into a single stereoscopic image, Marcus hands her the coat, which covers her breast. The lenses separate again as Marcus steps away: 'I speak', he says. 'Subject', Ivitch puts the coat over her shoulders as Marcus, at the other end of the room, also puts on a jacket. 'I mustn't stay', says Ivitch. 'I listen. Object', replies Marcus, as he rejoins Ivitch and the images reunite again, Ivitch's left breast sticking out from the trench coat and prominent in centre frame. Shadows cover and reveal Ivitch as Marcus steps away again, but this time with both lenses remaining fixed on Ivitch, who covers her breast with her arm as she raises her cigarette to her mouth. 'You've given up everything', Marcus continues in a flat tone. 'Take it one step further. Give up freedom itself and everything will be returned to you', he continues, before offering her two red roses. Ivitch laughs and takes the roses as Marcus steps away again. 'We need to get an interpreter', she says. 'Why?' asks Marcus as Ivitch's face drops into shot for the first time as she smells the flowers. 'Soon everyone will need an interpreter to understand the words coming from their own mouths.'

What is remarkable about these moments is that, as one of the stereoscope's lenses pans right while the other remains stationary, we see two images superimposed the one over the other. As mentioned, superimposition is not new, but what is remarkable here is that we see the transition from what appears to be a 'unified' 3D image to two shots that are taking place simultaneously.

Pablo Picasso's paintings, for example *Dora Maar au Chat/Dora Maar with Cat* (1941), are considered important in part because they simultaneously present two perspectives of the same person – hence why Picasso's paintings seem so 'unrealistic' (because it must indeed look strange to see the same thing from two different angles at once). Cinema has regularly been able to show us the same thing from more than one angle, but generally in shot after shot rather than at the same time, or through split screen and superimposition techniques. However, stereoscopic cinema always shows us two perspectives – and not one after the other, but at the same time. Conventionally, these are unified into a single, coherent image (*Avatar*). However, Godard defies this convention and shows the lenses diverging. Because we go from a unified to a seemingly not unified image without a cut, unlike with a superimposition it becomes hard to tell where the lack of unity starts and where the divergence ends. Put another way: If the stereoscopic image supposedly offers us a perspective of depth, then Godard asks in these moments whether we are seeing width or depth, such that the two become impossible to tell apart. As a result, not only do we understand that there are multiple perspectives on events (what Picasso admirably achieves), but we also understand that depth and width are in effect indistinguishable. What cinema typically treats as separate dimensions are in fact utterly entangled. Godard thus not only explodes the frame, but he also explodes singular perspective and the dimensionality of the cinematic image, producing a kind of non-cinema as a result.

In addition, Godard stages these effects at thematically relevant and/or self-conscious moments. For, if Davidson says that images are the murder of the present, what he means perhaps is that conventional cinematic images (as opposed to the de Staël reproductions that he browses?) divorce us from the real world, putting us in a position of seemingly objective authority (with objectivity really here being a mask for empowerment and superiority, with superiority itself being shorthand for exploitation, in the sense of superiority over someone else, i.e. the creation of hierarchies). In divorcing us from the real world, images typically do not convey a sense of entanglement and presence. When Godard splits his lenses, however, we are confronted by a perplexing image that is made powerfully present to us as we try to make sense of it (it is, as Jean-Luc Nancy might say, pre-sense).[7]

Furthermore, if humans are limited rather than liberated by their awkward relation to the world, it is because, as Marcus suggests, it is split into a strange subject–object binarism (I am a subject when I speak and an object when I

listen). An entangled, present/pre-sent relation to the world, on the other hand, dissolves that binarism, with the transition from the unified to the 'double' image of Ivitch and Marcus powerfully conveying this as we go from seeing not a subjective perspective, but rather two perspectives at once. What is more, if love is the acceptance of difference, as we discussed in relation to Badiou in the last chapter, then these two simultaneous perspectives also convey love. This might seem a strange assertion to make, in that in the first instance Ivitch and her husband are fighting. However, that Ivitch says to her husband *ça m'est égal*, literally translated as 'that is equal to me', suggests that for her love is equality, even if for him it seems not to be about the acceptance of difference but about possession. Given that Marcus and Ivitch discuss subjectivity and objectivity, the divergence in the second meeting seems self-consciously to be about the acceptance of difference that is love. As Badiou says: 'Love involves two.'[8] Godard's image, then, is an image of love in that there are two images; or perhaps better, it is an image as love in its duality. Godard points to the limits of the frame and provides not images of, but just images.

That Ivitch stutters her question about the difference between an idea and a metaphor recalls the discussion of 'stuttering' minor literature and cinema in earlier chapters. If one makes stutter not just a particular language, but language itself, then what would be the result? Would it not be a world in which there is no shared language, but only a world full of different languages, a world in which everyone speaks their own language, or idiolect? In short, a world full of idiots, in which no one would understand the words that come out of their mouths and in which everyone might indeed need interpreters, as Ivitch suggests.

Godard has often played what Daniel Morgan describes as a 'fool or idiot' in his films.[9] That is, as Godard pushes the language of cinema to its extreme – perhaps to the point of incomprehensibility – he makes stutter the mainstream cinematic 'language' of certain (clichéd) techniques and types of image, especially the principles of continuity editing, such that his movies speak a minor language. In making the mainstream language of cinema stutter (in making a God-awful film), Godard runs the risk of failing, and of looking like an idiot. However, Godard is also invested in difference, not only across people, other species and matter more generally, but also over time (I am different from you, but I am also different today from who I was yesterday and who I might be tomorrow). Deliberately to evolve (rather than strictly to ignore) cinematic language is what makes of Godard an ethical film-maker, in the sense that he equalizes cinematic forms of expression by embracing new technologies and imperfect techniques,

thereby making the mainstream stutter.[10] If we all spoke the mainstream/if we all spoke the same language, then difference would be diminished, and we would be in the repetitive world of cinema-capital. With *Adieu au langage*, not only does Godard attempt to renew cinematic language (making of his film an *essai*), but he also endeavours to question language as a whole. Should we say good bye to language? Can we?

A farewell to language

'I hate characters', says Ivitch as she dresses in front of Marcus's television, on which plays a scene from *Metropolis* (Fritz Lang, Germany, 1929). 'From birth, we're mistaken for another.' She sits down on a leather chair. 'We push him, we pull him, we force him to get into character.' The 'him' to which Ivitch refers here is the 'other' for whom we are mistaken from birth. That is, while humans can and indeed do 'reinvent' themselves and give themselves new identities, it is socialization that forces humans to become 'characters' as opposed to 'free' human beings: I behave in what Dussel would call a moral way, accepting/obeying the norms of the time rather than behaving in an ethical manner. It is not that one cannot create a new identity, then; in the online world we have many identities and so the creation of new identities is widely accepted and regular. However, it is the process of identity creation itself that has to be questioned, since the process of identity creation involves reification, because it has at its core giving to each identity a name. Since identity and reification involve naming, they also rely on language. And if reification involves looking at people and the other things that have an identity/name in terms of their use value, and not on their own terms, then so, too, might language reinforce capital. Under capital, either I am forced not to be myself, but indeed to suppress aspects of my being in order to conform to the mores of the day – or I run the risk of becoming an idiot, a madman, a criminal or an artist.

Godard regularly references Jean-Paul Sartre in his work, and Sartre can also help to elaborate the above point here. In *La Nausée/Nausea* (1938), the main character Antoine Roquentin describes a moment of reinvigoration when, he says, 'Things have broken free from their names I am in the midst of Things, which cannot be given names. Alone, wordless, defenceless, they surround me, are under me, behind me, above me. They demand nothing, they don't impose themselves, they are there.'[11] In showing us countless shots of nature, flowers,

the sky and animals, especially Roxy, Godard, too, seems to want to take us beyond seeing these things as images contributing to a story (images as having use value; things as having names), and to see them for what they are: Nameless, beyond language. Or at the very least to see them as if anew. This is achieved not through the objective presentation of objects ('images of'), but through an active intervention and demonstration of entanglement with them, as Godard does in *Adieu au langage* with his manipulated images.

If Godard's film helps us to get beyond language (and helps us to get to God/*à Dieu*/*adieu*?), then it is because Godard eschews using images to tell a story (cinema), and instead presents (or tries to present) to us just images. Language, it would seem, or the process of reification and the assignation of use value, is in the services of cinema-capital. Non-cinema is thus beyond language, as Christina Stojanova sees Godard as creating poetic cinema that stretches beyond the utterable.[12]

Can we live in a world without language, especially if the development of language is, after Steven Pinker, an instinct?[13] Surely not if language is a necessary component of being human. And yet if language is 'natural', while at the same time being tied to the processes of capital (to name is to reify is to see something in terms of use value and not in terms of itself), then does this mean, at the last, that capitalism is natural? Furthermore, does the language instinct mean that Godard is being disingenuous when he says goodbye to language? Perhaps. But it also signals what Stojanova identifies as Godard's romanticism through the very impossibility of the task that he sets himself (getting beyond the human and away from language).[14] However, there are aspects of this argument to finesse here – aspects that may in fact reinforce the notion that a world without language is possible – and over a long enough timeline perhaps even inevitable.

For, while the language instinct might be naturally human, neither nature nor humanity is static, with each evolving, or becoming (as well as being entangled). With becoming, then, there is difference both across space (here is not there) and across time (now is not then). For this reason, Josette's voice announces over archive images of bombs dropping during the Second World War that 'Hitler invented nothing'. That is, as Hitler tried to eradicate difference (Jews, Roma, homosexuals) and to create a homogenous supposedly Aryan world, Hitler functions as the attempted realization of stasis, of repetition, of a world under control. (Cut to images of uniform crowds all giving a Nazi salute.) Hitler is the antithesis of invention, of poetry and of becoming. Humans, then, must embrace becoming and invent – invent not things that are necessarily useful to the world of cinema-capital, but to invent without goal, heuristically and heretically.

To invent involves embracing not what is, but the immanence of potential, or what could be. In becoming, the human is always evolving into the 'posthuman', with cinema even playing a role in this as we become with the films that we watch. In some senses, then, humans are and only ever have been posthuman, in the sense that we are not alone and isolated from the world (humans in contradistinction to the world), but entangled with the world (humans do not exist without that which is not human) – hence the emphasis on nature and animals in Godard's film.

Since becoming involves change, in some respects becoming also involves violence, since to exist is by definition to modify what has come before. As a human is born, it does violence to the matter that previously was not human. As humans kill bacteria and viruses in order to survive, as they take from plants and animals in order to eat, and as they kill insects and other life forms that try to share with them their living spaces, so is violence an inevitable part of existence – even before we include criminal violence against protected species, other humans and their property. Given the inevitability of violence in a universe of becoming (it constitutes an 'original' sin in the sense that it is inevitable?), the idea is not simply to accept this, and thus to exact violence in an unknowing or even in a systematic fashion. That is, the violence of becoming does not excuse or validate Hitler, since Hitler did not, as Josette says, invent anything, but only destroyed things. Instead, if violence is inevitable, ethics must nonetheless involve not just the realization of this, but also the attempt (and failure) not to destroy, but to create, or invent.

Over images of Roxy beside a stream in the snow, Davidson says in voice-over that it is difficult to remain alone (humans are entangled). As the film cuts to an extreme slow motion shot of Roxy in a field, the voice-over continues: 'It is not the animal that is blind. It is man, blinded by conscience, who is incapable of seeing the world.' The slow motion encourages us properly to look at Roxy, to see not Roxy as a pet (a thing), but to see Roxy for himself. The footage of the dog resumes normal speed. Davidson's voice-over: 'What is outside, wrote [Rainer Maria] Rilke', as the colourization of the image goes from bright greens and brown to a rather matt colour palette, 'can be known only via the animal's gaze'. A freeze frame on Roxy's face. The extreme slow motion resumes, each frame stopping for an instant before progressing to the next. '[Charles] Darwin, citing [Georges Louis Leclerc de] Buffon, maintains that the dog is the only living creature that loves you more than it loves itself.' The image freezes again on Roxy's face.

In this sequence, we get a sense of how the animal helps us to understand or to sense what we might refer to as the black whole, difference, or 'the outside'. The reference to Darwin seems particularly apt. For Darwin's understanding of evolution has in the contemporary world of cinema-capital been bastardized into 'social Darwinism', in which 'survival of the fittest' is transformed into the maniacal language of 'elimination of the weakest', with the 'weakest' being not those who simply succumb to the hazards of nature but those whom certain humans perceive as being inferior (a perceived inferiority that is internalized through economic and other processes of separation, e.g. national and racial processes). Ethically, then, we might come to think outside of ourselves (to be beside ourselves) and to love our conspecifics, our companion species and our planet. Humans cannot know what the 'fittest' really means. All those who have survived until now have been fit enough to survive – meaning that every single human and other creature breathing on this planet is equally 'fit' – as is suggested when *Adieu au langage* ends with the sound of a dog barking and a baby crying.

And Africa ...

'Yet again, we have abandoned Africa', says Constance in *Film Socialisme* as we see Mathias holding his camera. The film cuts to Constance looking out to sea, and we hear a discussion of how she had no choice but to head north into Europe in order to avoid the crimes and bloodshed that were taking place in Kigali, the capital of Rwanda and which presumably is Constance's 'original' home. Constance, in a similar pose but this time at night, later turns to the camera and explains how she feels sorry for Europe, since it has suffered numerous wars and yet is humiliated by its renewed liberty. That is, Europe as a whole is, or should, feel shame for the way in which it uses liberty after the two great wars of the twentieth century not to liberate other parts of the world, but in order to further their poverty.

The camerawoman seems to affirm as much when she says, on the topic of television, that 'nerve connections have become raw material today. So in my humble opinion once again, Africa is out of luck.' The journalist replies: 'You mean, not part of history, that's what you think. What hasn't changed is that there will always be bastards. And what has changed today is that the bastards are sincere.' The camerawoman: 'They sincerely believe in Europe, that's true.' In

other words, Godard here seems to be referencing the fact that Africa is indeed left out of history, an ignored continent that is signally not part of Europe, an imagined community that deliberately excludes outsiders, including perhaps especially from Africa.

Meanwhile, barely two minutes into *Adieu au langage*, we hear a voice (that of Marie, one of Davidson's students) over saturated images of flowers and then of sky asking if it is possible to produce a concept about Africa. The image cuts to a shot of Marie drinking water from a fountain, an image that flashes from black and white to colour and back again. The question is not answered, but it is half-reiterated later on and cut short, before Marie and her boyfriend announce their departure for Africa after Davidson asks them if happiness is a new concept in Europe.

Finally, Josette has come to Europe from Kinshasa, the capital of the Democratic Republic of the Congo. 'In Africa, you were coming out of what?' asks Gédéon. Josette: 'The silence. There are a thousand sounds. There is war. There are animals. Silence arrives, and then another country. They're at the door speaking to you.' While the meaning of Josette's words is not wholly clear, Africa remains nonetheless a constant point of reference in these two films. As the camerawoman speaks with Lulu in *Film Socialisme*, a radio report announces that France is 'a so-called developed nation that leaves the weak to their fate'. Given the camerawoman's earlier discussion of Africa, the sequence perhaps indicates that the 'weak' includes Africa and its people. But this is not a continent that is essentially weak, in the sense that 'weakness' is the 'natural condition' of Africa and Africans. On the contrary, if Africa is weak in the sense of poor, then this is as a result of colonial and imperial exploitation, and the imposition of ongoing dependence on the global north, while at the same time suffering political instability and corruption that is in large part a consequence of western influence. If Godard is to try to get a grasp of the black whole, then it makes sense that his films would reference Africa.[15]

And yet, in terms of film-making, parts of Africa have experienced a boom since the advent of digital film-making technology, especially the industry known as Nollywood. If Africa as a whole is 'weak', then, Nollywood would suggest the potential for great strength in Africa, but this strength comes not necessarily from Africa producing cinema and/or becoming an included part of the world of cinema-capital. Rather, this strength is expressed by embracing its status outside of cinema-capital and in the production of non-cinema, as we shall see below in relation to the Nollywood classic, *Osuofia in London*. First, however, let us look briefly at Nollywood as a whole.

Nollywood as non-cinema?

The production of video films began in Nigeria in at least the early 1990s, with *Living in Bondage* (Vic Mordi, Nigeria, 1992) being a landmark production. Video-based film-making then became so widespread that an edited collection on the phenomenon had appeared even before the term Nollywood was coined in 2002.[16] Nollywood is vast and complex, and there is debate regarding both what constitutes a Nollywood film and the term itself.[17] Nollywood is hugely successful not just in Nigeria but throughout Africa, especially in Ghana, Cameroon, Niger and Benin.[18] Indeed, Nollywood is so successful that the 'Democratic Republic of Congo has tried to ban Nigerian films altogether'.[19] Meanwhile, Nollywood has also been detrimental to and bred resentment from the Ghanaian film industry.[20] It is even debated that Nollywood constitutes a kind of 'intra-African' colonial force – even if it remains little more than a 'curio' in Europe and North America.[21]

A major reason for its status as a 'curio' might be to do with how Nollywood has sprung up as a result of video and DV, that is, technology typically used not for production but for distribution and/or piracy.[22] The productions made using video and DV thus have a 'low technical quality' and 'egregious' sound and lighting, with a melodramatic acting style that partially springs from Yoruba travelling theatre traditions.[23] Typically, Nollywood films do not circulate in theatrical venues, but on cassettes, DVDs and, latterly, online.[24] In other words, Nollywood possesses many of the qualities that we have so far used to describe non-cinema.

That said, while traditionally piecemeal and informal (a reality that undermines the idea that Nollywood is colonial; it simply has not been organized enough to have systematic 'colonial' intentions), Nollywood is also an industry in the process of formalization.[25] Jonathan Haynes sees the emergence of films like *Phone Swap* (Kunle Afolayan, Nigeria, 2012) as a move towards a more polished aesthetic, while there is even burgeoning government support for film productions.[26] In this way, it is not that Nollywood is de facto or will always remain non-cinema. But in being a 'folk' cinema, popular in the Brechtian sense (i.e. of the people), contemporary Nollywood reaches far larger audiences, especially in Africa, than the films of the 'great' African cineastes like Ousmane Sembène, Djibril Diop Mambéty and Med Hondo, or, more recently, Abderrahmane Sissako and Mahomet Saleh Haroun.[27] Nollywood and its regional imitators constitute 'grassroots' film industries, which rely in particular

on digital technology.[28] Furthermore, as Gayatri Spivak said as early as 1991: 'The emergence of a vital and prolific popular cinema in Nigeria could be regarded as an important African response to the encroachment of Western pop culture in this age of global information, one that does not "ape foreign models".'[29] That is, Nollywood constitutes a political cinema that asserts a distinctly African (a problematic Nigerian-as-African?) identity via its 'poor' aesthetics – but which is not inferior to western film-making, but simply different. This can be seen in *Osuofia in London*, which although described as 'one of a kind in Nollywood' as a result of its self-reflexivity, is also 'the most successful [Nollywood] video comedy ever produced'.[30]

Osuofia as non-cinema

Osuofia in London tells the story of an impoverished man, Mazi Osuofia Nwokorie (Nkem Owoh), who in the east Nigerian village of Neke Ama Nasa is struggling to find food and to pay both for the education of his five children and for the burial costs of others people in his community (an early scene involves Osuofia losing an appeal to forego community payments to Union members in a meeting with the local *igwe*, or elder, played by Romanus Amunta).

A messenger (Stephen Ahanonu) arrives with a school teacher, Charles (Paul U. U. Udonsi), announcing that Osuofia has inherited millions of pounds from his dead brother, Donatus, who years ago moved to England thanks to the sale of family property. Initially sceptical, Osuofia goes to London, where he is met by a chauffeur, Ted (Graham Webster), and a stretched limousine. Osuofia gets lost and wanders London, remarking on various aspects of the city – from marvelling at Tower Bridge to disapproving of the dress of young women. Osuofia gets arrested for trying to capture pigeons in St James's Park, and uses his father's 'oracle' – a small wooden charm – to freeze the shoulder of one of the officers, Jeff (John Lisle), before they take him to Donatus's mansion somewhere in the suburbs.

Osuofia meets and takes a shine to Donatus's white fiancée, Samantha (Mara Derwent), even though she does not cook. Samantha is plotting with Donatus's lawyer, Ben Okafor (Charles Angiama), to defraud Osuofia of his inheritance, although this dastardly trick unravels when Okafor tries in turn to defraud Samantha. Samantha destroys the contract that would have seen Osuofia lose his inheritance, and the two decide to return to Africa. The film ends with Okafor

chasing them to the airport, the police also in tow. Although we never see as much, a voice-over suggests that the escape back to Africa is a clean one.

Osuofia in London contains many of the vestiges of non-cinema: the sound is varied, while in some shots, e.g. in Okafor's office, the mic boom dips visibly into frame. The acting is 'over the top' and 'bad', while the editing is often 'choppy' – both in terms of how one gets from one scene to another and within scenes. For example, Osuofia has an argument with Samantha about paying a local shopkeeper for bread that he has taken. He eats the bread with water from an ice bucket while dressed in a white T-shirt, grey suit jacket and colourful, loose sokoto trousers. After Samantha storms off, we see a shot of a 159 bus passing in front of the Houses of Parliament, before Osuofia turns up at Okafor's office dressed in traditional Nigerian attire: a red taqiyah skullcap, a red-and-white agbada robe, a white feather stick and a white bead necklace. How Osuofia has got there – and where his traditional robes have come from – is entirely uncertain. Even within scenes, there are jumps in continuity, e.g. near the film's opening when Osuofia's daughters return home from a hunting trip in which their father fails to shoot a duiker. As they slump down with fatigue, one daughter's voice is silenced as the film cuts to a close-up of Adaku (Chiwenda Onaga), another daughter, who tells her mother, Uremma (Cynthia Okereke), about the trip. Cutting out the dialogue creates an odd mis-match between the two shots (as does the fact that in some scenes only three daughters feature, while in this one there are five). Furthermore, the film's geography of London is questionable, as Osuofia is one minute by Tower Bridge, then clearly in a more residential part of London, before being back near Tower Bridge and the centre of the city. And when arrested, the police interrogation room is clearly a set, with a Scottish police officer later putting on an obviously fake police helmet before he and Jeff give chase to a speeding Okafor. Finally, that the film ends without any real resolution – mid-chase! – also suggests that narrative coherence is not the aim of the film. In other words, *Osuofia in London* is an example of 'weak' or amateurish film-making of the sort that pushes it in the direction of non-cinema.

That said, the so-called 'weaknesses' of the film are also deployed in a self-conscious and/or carefree fashion, thereby 'redeeming' the film in certain respects. Even without a knowledge of, say, local theatrical traditions that might help us to understand the acting not as poor but as stylized and thus different to the conventions of mainstream western cinema, *Osuofia in London* self-consciously draws attention to its performance style in the scene when Donatus's

death is announced to Osuofia. Osuofia has not seen Donatus for many years and initially suggests that Donatus has long since been dead to him. However, when finally convinced that the messenger and Charles are not trying to scam him, Osuofia engages in prolonged mourning, clutching his shoulders and wailing loudly. He also forces his daughters and his wife to 'grieve' in an overt fashion. 'It is tradition', Osuofia insists as Charles and the messenger look on, bemused. In other words, if grief is a performance, then we might extrapolate from this not that some moments are more authentic than others, in that at times one is 'acting' and that at others one is not, but that all moments in life are in some respects performative (all moments involve awareness of an audience and thus suggest entanglement).

This is made even clearer when Osuofia rebukes first Ted and then Okafor for not enunciating properly (Osuofia also mocks Adaku for the way in which she pronounces 'big meat' and 'make-ups'). The implication is that Ted and Okafor do not speak as if they were talking to anyone else – they are communicating nothing. Speech for Osuofia, on the other hand, is precisely performative. The British mumbling – which typically passes for 'proper', 'natural' and thus 'unaccented' and unperformative speech – takes on a cultural dimension when it transpires that Okafor reverts to the performative tones of his Nigerian heritage when he is angry. As Okafor directly addresses the camera in his office bathroom, we understand that the supposedly 'natural' mannerisms of the bourgeois lawyer are as much a performance as Osuofia's grief. Furthermore, Okafor's desire to be integrated into the English society via his accent and mannerisms seems linked to his desire to defraud Osuofia of his money. That is, greed is linked to isolation and separation, while Osuofia is more 'generous' in the way that he speaks.

We might accuse Osuofia himself of being greedy, in that he is like Samantha and Okafor after Donatus's money. However, he promises to use the money to help his fellow villagers finish their houses and educate their children, something that comes to pass in the sequel as he gives money to his friends and neighbours, and even half a million pounds to Samantha as recompense for the seed money that she supposedly put into Donatus's business.

The film's 'choppy' editing might also serve a political purpose. Before he leaves for the airport, Osuofia performs for the assembled friends and family (including Obiekwe, played by Francis Odega, who has designs on Uremma) a walk that he describes as a 'London groove'. What Osuofia references here are the different rhythms of movement that different cultures possess. And as London possesses a different rhythm of walking (regardless of how accurate Osuofia's

impression is), so, too, might different films from different places equally possess different rhythms in their editing. In this way, the fact that *Osuofia in London* revels in various scenes (the *faux* grieving scene, for example, seems to have a prolonged duration), while others pass by without much care, suggests not 'bad' film-making but simply a different set of concerns beyond the demands of narrative and getting on with the story.

With regard to the plot, numerous of the scenes of *Osuofia in London* are superfluous, but instead are included for comic purposes. For example, Osuofia supposedly enters a McDonald's restaurant and is disappointed when they will not serve him pounded yam and *egusi* soup. Neither do they have *gari* or *ogbonna* soup. Osuofia then asks for *abacha* and *okporoko*, before settling for some bread – but not the *agege* bread that he desires. The scene is clearly designed to demonstrate a clash of cultures – as McDonald's does not serve what Osuofia wants. Not only do we get a sense of this film being structured not around plot but around gags – structurally making of *Osuofia in London* a comedy along the lines of Giuseppe Andrews's films – but importantly this scene which is supposed to take place in a McDonald's restaurant clearly does not. That is, while the scene is interspersed with footage of real diners in a real McDonald's, as the prominence of golden arches branding makes clear, the server with whom Osuofia argues clearly is not (he wears a cap with the words 'Fish Bar' written on it).

Structured for comic as opposed to narrative purposes, we also see here how the film mixes fiction with documentary in order to create something in between. As much also is visible when Osuofia talks to strangers as he marvels at the raising of Tower Bridge. Nkem Owoh is clearly performing as Osuofia, while others participate unawares that they are in fact in a film – clearly a shooting style enabled by lightweight and discreet digital cameras. With this in mind, what matter the geography of London when the film is really designed around Osuofia's comic adventures? We see archive footage of airports, police cars and London architecture – but it does not matter that these clearly are images brought in from other sources, likely the internet. The film as a whole gains life through its unpredictability, while at the same time destabilizing narrative coherence in a way that might encourage some viewers to think about difference. That is, as Osuofia is a foreigner somewhat confused by London, so, too, does the editing defamiliarize both a particular city (London) and the kinds of globalized/ repeated spaces (McDonald's) that are familiar to people from probably every other city in the western world.

'I came. I saw. I conquered'

As is fitting for non-cinema, *Osuofia in London* features some bawdy, scatological humour such that we are incapable of forgetting about the appetites of the body. Arriving at Donatus's mansion, Osuofia needs the loo, but he does not know how the water closet system works, nor does he even recognize it as a toilet. He asks Donatus's servant Jeeves (Sebastian Hall) to show him where the hole in the ground is. Jeeves demonstrates the lavatory: in this country this is where you do your business (Osuofia: 'I am not a businessman!'). Osuofia then explains that he will break the toilet because he has been holding back his 'cannons' since the airport, and that now – hours later – when he passes those cannons, smoke will chase Jeeves out of the bathroom. In addition to this amusing image, when Osuofia believes that he is going to get lucky with Samantha, having finally signed (with a thumb print) the contract that will in fact give Donatus's money to her and Okafor, he lies back on a bed, closing his eyes. 'You'll sweat buckets when I finish with you', he promises. 'All the juices from Africa, I'll use on you today. You will see what one gallon will do inside of you!' Again, this sort of language would not be out of place in a Giuseppe Andrews film.

However, beyond defecation and sexual desire, the bodily dimension of *Osuofia in London* is most clearly expressed in its consistent treatment of food. The film opens with Osuofia and his daughters trying to shoot the duiker. Back home, Osuofia then threatens to eat one of his daughters since there is no meat left – the animals and the birds disappear when he goes out hunting. Shortly afterwards, Osuofia is trying to eat when Obiekwe comes round to summon Osuofia to the *igwe*. Obiekwe has a habit, mutters Osuofia, of coming round and eating his food – and so out of spite he refuses to eat in front of him, thereby foregoing his own meal. Once in London, we see Osuofia in the McDonald's, where he is served only some bread buns (for which he refuses to pay). He then tries to capture the pigeon in St James's Park in order to eat it. And during their first meeting, Osuofia asks Samantha to cook for him, which she refuses to do since she does not know how. The next morning Jeeves makes for Osuofia a full English breakfast, which he refuses to eat, saying that the tomatoes are crumpled, the mini-sausages look like testicles and that the toast looks like 'paper bread'. Going to a local shop in search of his beloved *agege* bread, Osuofia again takes an English-style loaf (for which he does not pay) and, as mentioned, eats it with water out of an ice bucket. The only time that we see Osuofia happy and eating is when Samantha, in trying to seduce him into signing his money

over to her and Okafor, takes him to an African restaurant (Osuofia is delighted that they have palm wine). Otherwise Osuofia seems to spend the film hungry, with cannibalism perhaps being his only recourse to satisfy his belly.

The constant presence of hunger suggests that *Osuofia in London* might also involve what Glauber Rocha terms an 'aesthetic of hunger', in that the film gives expression to a Third World reality of deprivation, even if via humour (more forcefully via humour?). Glauber described Cinema Nôvo as 'a project that has grown out of the politics of hunger and suffers, for that very reason, all the consequent weaknesses which are a product of its particular situation'.[31] Not only might *Osuofia in London* (and Nollywood more generally?) be a 'weak' film because of Africa's colonial legacy, but the references to cannibalism, even if a joke, suggest that in a situation of hunger, humans are forced to consume each other. This cannibalism functions not just on a literal level. It also suggests that capitalism induces hunger and the consumption of other humans on an economic level, as Samantha and Okafor try to scam Osuofia. How Donatus made his money is never revealed, and the fact that he never bothered to share his wealth with the family that sold its property for him to get to England remains unexplored. Nonetheless, we get the impression that white Europeans (Samantha) and Europeanized Africans (Okafor and Donatus) have got rich off Africa, and will continue to do so by exploiting Osuofia.

However, both Osuofia and *Osuofia in London* are defiant of this exploitation. For, while Osuofia is the target of various scams in the film, he is no one's fool – even if he is foolish. While he does agree at the *igwe*'s behest to pay money to the Union, Osuofia clearly suspects that the Union members siphon off money for their own furtherance. What is more, Osuofia does not trust Charles and the messenger when they come to tell him about his inheritance. Finally, while Osuofia does not understand the scam in which Samantha and Okafor are trying to embroil him, he nonetheless is wary about being suckered into giving up his money; he refuses to sign for Okafor, and it is only Samantha's promise of sex and then marriage that seduces him.

In *Osuofia in London 2* (Kingsley Ogoro, Nigeria, 2004), one of various sequels, including unofficial ones, Osuofia similarly is 'not fooled by her [Samantha's] show of love and devotion, [and] scuttles her various plans' after she comes back to Africa with him ostensibly to be his wife.[32] As Akin Adesokan points out, 'the film does not specify ... the reversal of the order of criminality in which a citizen of Nigeria, a country with an international notoriety as the originating point for acts of Advance Fee Fraud, or "419", is not the potential victim!'[33] In other words,

Osuofia in London does not tell the story of a westerner caught up in a Nigerian scam, but of a Nigerian caught up in the exploitative scam of Europeans and Europeanized Africans.

'I came. I saw. I conquered', announces Osuofia soon after his arrival in London. And yet this conquest, which Onookome Okome regards as a 'reversal of the [typical] filmic gaze', is not simply a reverse-exploitation of Europe in the way that Europe has exploited Africa.[34] The film has been criticized for the stereotyping of Africans as 'timid and uncivilised' and Okafor as 'a corrupt man, another Euro American image of Africans', with Osuofia himself being 'a dumb idiot who would sign off every of his brother's property [*sic*] for a kiss from a white lady'.[35] Furthermore, the portrayal of Samantha has been perceived as regressive, while the film's 'images are vulgar and reflect an uncritical filmmaking practice'.[36] Nonetheless, I stand with Okome in believing that the film is smarter than these critics allege. For, it is a sense of love that ultimately 'redeems' both Osuofia and the film itself.

Let us return to Glauber Rocha:

> Cinema Nôvo reveals that violence is normal behaviour for the starving ... this violence is not filled with hatred; nor is it linked to the old, colonising humanism. The love that this violence encompasses is as brutal as violence itself, because it is not the kind of love which derives from complacency or contemplation, but rather a love of action and transformation.[37]

If Cinema Nôvo is a cinema defined by violence, *Osuofia in London* is not. Or at least, if there is violence done in or by the film, it is not a brutal violence – even if Osuofia freezes Jeff's shoulder. Osuofia may profess to care only for money, and he may renounce his wife and daughters to Samantha. However, Osuofia ultimately does, as mentioned, help his community with Donatus's money, even if he calls out and does not pay the corrupt Union officials.

More than this, though, the film's first sequel undertakes a conversion in Samantha such that she renounces her murderous intent (and is forgiven for it). As Gideon Tanimonore points out, she 'expresses her regrets about her poor opinion of black people, saying that she has been wrong in thinking that Nigerians are dubious and unkind people'.[38] Tanimonore quotes Samantha at length:

> I've been so ignorant, maybe blind to truth, to reality. I've had my eyes opened here but never really my heart. We make judgements on people without really knowing them. I'm guilty of that, too. But now I know better. I heard so many

things about your country, your people, so many horrible, negative things and I thought it was all true. But it's not. I came here and I saw loving people. People don't sit in judgment on you. They are not bothered about where you come from, the colour of your skin, how much money you have or don't have. But from the first time they met me, they opened up their hearts with true love ... and I just wish more people could experience this and try to see with their hearts before they judge.

Given the limitations of Mara Derwent as a performer, it is hard to tell if Samantha is supposed to mean these words. Furthermore, while in the sequel we do see the people of Neke Ama Nasa being generous to Samantha, they also consistently mock her, with Osuofia lying to her about this fact, telling her that the locals are just jealous (at one point Uremma refers to Samantha as an *ashawo*, or slut, with Osuofia explaining that it is a term of praise and that Nigerians even called the Queen an *ashawo* when she visited the country – a subversive joke about Nigeria's ongoing relationship with its former colonizer if ever there was one). And so while her speech might be critiqued for offering a romanticized/touristic view of Nigeria, as well as for its twee implied association of poverty with goodness, Osuofia ultimately does conquer, but with love instead of violence. If violence is done, it is done in Osuofia learning to get over 'the attractions that local Africans have for Europe and America', and in Samantha learning to become a better, more loving person.[39] This is done through contact with difference. And it is also done precisely through a 'vulgar' cinematic language and through Osuofia's 'bush English', or what Akin Adesokan calls his 'idiolectic tools'.[40] In this way, *Osuofia in London* is far from being an example of 'unthinking filmmaking practice'. On the contrary, the film seems intelligently to use its stylistic 'poverty' in order to achieve a conquest similar to Osuofia's: brazenly it is itself and all the more winning for it.

Okome points out that the film opens with an unaccented voice-over in which we have an anthropological, documentary-style comparison between the hustle and bustle of London (defined, as Adesokan notes, by vertical structures) and the quiet life of Neke Ama Nasa (defined by horizontal structures): 'The planet Earth, a solid mass of land and water mysteriously afloat in a vast and unknowable universe. In fact, some days became quite complex and confusing, like today, a day when a man might be anything else but a hunter.'[41] After Osuofia fails to bag the duiker, the voice-over continues: 'In our small and peaceful village, big cities and fast lifestyles never entered their wildest dreams.' We cut from a shot of Big Ben as seen from Trafalgar Square to images of Osuofia's

daughters in traditional dress walking through the bush. 'Politics and confusion remained unknown', the voice-over concludes.

Read negatively, this voice-over demonstrates that *Osuofia in London* is not really aimed at a Nigerian audience, but instead at an international audience that can look condescendingly at the 'simple' lives of African villagers – in a way reminiscent of *The Gods Must Be Crazy* (Jamie Uys, Botswana/South Africa, 1980). However, not only does the voice-over seek to relativize London and Neke Ama Nasa by situating both within a 'vast and unknowable universe', but the voice-over is also revealed as just plain ill-informed. For, not only do we quickly see politics emerge in the form of the Union reps, but Osuofia's life is one defined by confusion – and not because he will become a foreigner in London, but because he is hungry.

Cassis Kilian has compared *Osuofia in London* with *Xala* (Ousmane Sembène, Senegal, 1975).[42] However, in its trajectory to Europe in search of riches, a comparison with Sembène's *La Noire de...*/*Black Girl* (France/Senegal, 1966) seems more fitting. Where in Sembène's film, Diouana (Mbissine Thérèse Diop), is taken to France and forced to work in such miserable conditions that she eventually commits suicide, nearly forty years later and in the digital age, Osuofia goes to Europe and returns with millions and a white wife. The film may in some senses be a fantasy of empowerment, and as such more properly an expression of disempowerment (because only a fantasy). And yet, set within the context of a burgeoning film industry, Nollywood, that is inspiring other film industries throughout Africa to take up digital cameras and to make films, and which is growing not just as a domestic but as a global force, *Osuofia in London* is also a tale precisely of empowerment and of learning to love by loving difference. In sharing his wealth, even with Samantha, Osuofia learns not to see money as an end, such that people become objects or exploited, but to see money as only a means for improving the lot of all. As such, the film is an exercise in empowerment through commiseration, displaying an ethics of liberation, in which the liberation of the poor is achieved.

If a hierarchy persists whereby we view low budget, amateurish and 'weak' or 'poor' film-making as non-cinema, then the argument put forward here has been to suggest that non-cinema is equally as cinematic as cinema 'proper'. Digitally enabled non-cinema, be it from Afghanistan, Iran, China, the Philippines, France, the United Kingdom, the United States, Uruguay or Nigeria, is the equal of cinema. Indeed, without non-cinema, cinema as such could not exist, since the two are ecologically entangled just as we are entangled in a universe

of becoming. Whenever we decide on what cinema is, then we must also ask ourselves what exclusions we are making and what it is that we are defining as not cinema, especially in an age when cinema is, under cinema-capital, the supposed measure of reality. For this reason, let us come to the following conclusion:

Non-cinema = cinema.

Notes

1. J. Andrew Pruszynski and Roland S. Johansson, 'Edge-orientation Processing in First-order Tactile Neurons', *Nature Neuroscience*, 17 (2014), 1404–9.
2. *The Lord of the Rings* films (Peter Jackson, USA/New Zealand, 2001–3) involve hairy warriors – bearded dwarves, long-haired elves, long-tressed and stubbled humans and hobbits, who famously have hair on their feet – fighting against hairless orcs, goblins and cave trolls. Sauron, whose name is the Greek word for 'lizard', a hairless creature, stands for greed: capital removes excess, including hair, while the Fellowship of the Ring stands for, precisely, fellowship and the belief of Gandalf (Sir Ian McKellen) that even the smallest thing, like a hobbit, can make the biggest difference. Meanwhile in *Fur: An Imaginary Portrait of Diane Arbus* (Steven Shainberg, USA, 2006), the eponymous photographer (Nicole Kidman) develops a fascination for the excessively hirsute Lionel Sweeney (Robert Downey Jr). However, the film undermines any validation of hair, since Arbus only consummates her relationship with Sweeney once he has shaved his hair off (and, lucky for her, it turns out that Sweeney looks just like Robert Downey Jr). In other words, where *The Lord of the Rings* validates hair, *Fur* resorts at the last to a conformist story about cinematic good looks and the removal of 'excess' hair – even though it promises to explore the possibilities of 'perverse' sexual desire/behaviour.
3. See Dyer, *White*, 145–83.
4. See Marks, *The Skin of the Film*, and Tarja Laine, 'Cinema as Second Skin: Under the Membrane of Horror Film', *New Review of Film and Television Studies*, 4:2 (2006), 93–106.
5. See Michel Chion, *The Voice in Cinema*, trans. Claudia Gorbman (New York: Columbia University Press, 1999).
6. See Ó Maoilearca, *All Thoughts Are Equal*, 22.
7. Jean-Luc Nancy, *Au fond des images* (Paris: Galilée, 2003).
8. Badiou with Truong, *In Praise of Love*, 28.
9. Morgan, *Late Godard and the Possibilities of Cinema*, 8.

10 Both Miriam Ross and Andrew Utterson see *Adieu au langage* as also taking part in a tradition of imperfect cinema. See Miriam Ross, 'Godard's Stereoscopic Illusions: Against a Total Cinema', *screening the past*, 41 (2016), http://www.ScreeningthePast.com/2016/12/godards-stereoscopic-illusions-against-a-total-cinema/; Andrew Utterson, 'Practice Makes Imperfect: Technology and the Creative Imperfections of Jean-Luc Godard's Three-Dimensional (3D) Cinema', *Quarterly Review of Film and Television*, 34:3 (2017), 295–308.

11 Jean-Paul Sartre, *Nausea*, trans. Robert Baldick (London: Penguin, 2000), 180.

12 Christina Stojanova, 'Jean-Luc Godard and Ludwig Wittgenstein in New Contexts', in *The Legacies of Jean-Luc Godard*, ed. Morrey, Stojanova and Côté, 137.

13 See Steven Pinker, *The Language Instinct: How the Mind Creates Language* (London: Penguin, 1994).

14 See Stojanova, 'Jean-Luc Godard and Ludwig Wittgenstein in New Contexts', 137.

15 For more on the treatment of Africa in *Film Socialisme* and *Adieu au langage*, see Samuel Lelievre, 'Africa and Cinema in the Mirror of Godard's *Film Socialisme*', *Journal of African Cinemas*, 5:1 (2013), 123–7; and Sarinah Masukor, 'An Imaginary Africa', *Screening the Past*, 41 (2016), http://www.screeningthepast.com/2016/12/an-imaginary-africa/.

16 For a history of the term Nollywood, see Jonathan Haynes, '"Nollywood": What's in a Name?' *Film International*, 5:4 (2007), 106. For the first edited collection on Nigerian video-based film-making, see Jonathan Haynes (ed.), *Nigerian Video Films* (Athens: Ohio University Press, 2000).

17 See Ralph A. Austen and Mahir Şaul, 'Introduction', in *Viewing African Cinema in the Twenty-First Century: Art Films and the Nollywood Video Revolution*, ed. Mahir Şaul and Ralph A. Austen (Athens: University of Ohio Press, 2010), 1–8; and Akin Adesokan, 'Nollywood: Outline of a Trans-Ethnic Practice', *Black Camera, An International Film Journal*, 5:2 (Spring 2014), 116–33.

18 See Onookome Okome, 'Nollywood and its Critics', in *Viewing African Cinema in the Twenty-First Century*, ed. Şaul and Austen, 26–41.

19 Anonymous, 'Light, Camera, Africa', *The Economist*, 16 December 2010, http://www.economist.com/node/17723124.

20 See Moradewun A. Adejunmobi, 'Nigerian Video Film as Minor Transnational Practice', *Postcolonial Text*, 3:2 (2007), 1–16; Jonathan Haynes, 'Video Boom: Nigeria and Ghana', *Postcolonial Text*, 3:2 (2007), 1–10; Jonathan Haynes, 'What Is To Be Done? Film Studies and Nigerian and Ghanaian Videos', in *Viewing African Cinema in the Twenty-First Century*, ed. Şaul and Austen, 11–25.

21 See Haynes, 'Nollywood', 108; Olivier Barlet, 'Is the Nigerian model fit for export?' in *Nollywood: The Video Phenomenon in Nigeria*, ed. Pierre Barrot (Bloomington: Indiana University Press, 2008), 126; Sheila Petty, 'Digital Video

Films as "Independent" African Cinema', in *Independent Filmmaking around the Globe*, ed. Doris Baltruschat and Mary P. Erickson (Toronto: University of Toronto Press, 2015), 260. The term 'curio' is used in Onookome Okome, 'Nollywood: Spectatorship, Audience and the Sites of Consumption', *Postcolonial Text*, 3:2 (2007), 2.

22 See Brian Larkin, 'Degraded Images, Distorted Sounds: Nigerian Video and the Infrastructure of Piracy', *Public Culture*, 16:2 (2004), 289–314; Babson Ajibade, 'From Lagos to Douala: the Video Film and its Spaces of Seeing', *Postcolonial Text*, 3:2 (2007), 1–14.

23 See Haynes, 'Video Boom', 2; Haynes, 'Nollywood', 108; Abiodun Olayiwola, 'Nollywood at the Borders of History: Yoruba Travelling Theatre and Video Film Development in Nigeria', *The Journal of Pan African Studies*, 4:5 (September 2011), 183–95.

24 See Ikechukwu Obiaya, 'Nollywood on the Internet: A Preliminary Analysis of an Online Nigerian Video-film Audience', *Journal of African Media Studies*, 2:3 (November 2010), 321–38.

25 Lobato, *Shadow Economies of Cinema*, 55–67.

26 See Jonathan Haynes, '"New Nollywood": Kunle Afolayan', *Black Camera, An International Film Journal*, 5:2 (Spring 2014), 53–73; Jude Akudinobi, 'Nollywood: Prisms and Paradigms', *Cinema Journal*, 54:2 (Winter 2015), 133–40.

27 See Martin Mhando, 'Independent Filmmaking in Africa: New Voices and Challenges', in *Independent Filmmaking around the Globe*, ed. Baltruschat and Erickson, 190 and 207.

28 See Jyoti Mistry and Jordache A. Ellapen, 'Nollywood's Transportability: The Politics and Economics of Video Films as Cultural Products', in *Global Nollywood: The Transnational Dimensions of an African Video Film Industry*, ed. Matthias Krings and Onookome Okome (Bloomington: Indiana University Press, 2013), 47; Lizelle Bisschoff and Ann Overbergh, 'Digital as the New Popular in African Cinema?: Case Studies from the Continent', *Research in African Literatures*, 43:4 (Winter 2012), 112–27.

29 Gayatri Spivak, 'Identity and Alterity: An Interview with Nicos Papastergiadis', *Arena*, 97 (1991), 66. Quoted in Martin Mhando, 'Globalisation and African Cinema: Distribution and Reception in the Anglophone Region', *Journal of African Cinemas*, 1:1 (2009), 31.

30 See Onookome Okome, 'Reversing the Filmic Gaze: Comedy and the Critique of the Postcolony in *Osuofia in London*', in *Global Nollywood*, ed. Krings and Okome, 153; Cassis Kilian, 'Glimmering Utopias: 50 Years of African Film', *Africa Spectrum*, 3 (2010), 151.

31 Rocha, 'An Esthetic of Hunger', 61.

32 Gideon Tanimonore, 'Nollywood and the Discursive Mediation of Identity, Nationhood and Social Anxiety', in *Auteuring Nollywood: Critical Perspectives on the Figurine*, ed. Adeshina Afolayan (Ibadan: University Press Nigeria, 2014), 315.
33 Akin Adesokan, 'Excess Luggage: Nigerian Films and the World of Immigrants', in *The New African Diaspora*, ed. Isidore Okpewho and Nkiru Nzegwu (Bloomington: Indiana University Press, 2009), 409.
34 See Okome, 'Reversing the Filmic Gaze'.
35 Quoted in Okome, 'Reversing the Filmic Gaze', 145.
36 Mistry and Ellapen, 'Nollywood's Transportability', 54.
37 Rocha, 'An Esthetic of Hunger', 60.
38 Tanimonore, 'Nollywood and the Discursive Mediation of Identity, Nationhood and Social Anxiety', 315.
39 Ajibade, 'From Lagos to Douala', 12.
40 Adesokan, 'Nollywood', 128.
41 See Adesokan, 'Excess Luggage', 408–9.
42 Cassis Kilian, 'Worth a Closer Look: A Comparative Study of *Xala* and *Osuofia in London*', *Journal of African Cinemas*, 5:1 (2013), 55–71.

Conclusion

The logic of capital is the logic of separation: the separation of the human from other species, the separation of the human from the world, the separation of humans from each other through the development of nations, through the development of the perceived sovereignty of the subject and so on. This logic also involves the separation of objects from each other, not least through language, which as a tool involves definitions of discreet objects and ideas. This logic is also the logic of cinema, which traditionally reflects the separation of man from world both thematically (the world is a threatening wilderness that in the western must be brought to order), and technically: as philosophy involves cutting things off from each other, or what Laruelle calls making a decision, so does cinema involve cutting times and spaces off from each other through the fragmentary processes of editing and the frame.[1] Each separation thus puts something like a wall in between things, a medium or a border that one then can monitor and perhaps even charge people to pass through. It is perhaps no surprise, then, that a capitalist world involves the proliferation of both media and middle men who create barriers and borders in endless situations and permutations, charging money to pass across or through them, thereby creating a logic of inclusion and exclusion, with those excluded being pushed towards the realm of the unreal, perhaps even of the dead. That is, the excluded are barbarians, others, what Giorgio Agamben calls the *homo sacer* and which Eric Cazdyn might cast as the 'already dead'.[2] In contrast to this, non-cinema helps us to think not about separation but about inclusion. It helps us to shift from a logic of stasis, the state and of closure, to a logic of becoming, openness and of love. This involves the breaking down of barriers and borders – exposing the all too human and both capitalist and cinematic logic of separating humans into different nations and states, and perhaps even separating humans from animals and from the world more generally – and replacing this with a logic of entanglement and enworldment, a logic of the multitude, and in which being and non-being are considered equal. This is a world beyond capital, a world perhaps beyond language, and a world beyond cinema: it is a world with non-cinema.

If some religions have functioned historically as precisely media that separate humans from the heavens, and which require payment in the form of labour, discipline and perhaps also in terms of financial contributions in order to cross from the human and into the divine realm, then we can see that these religions, too, function as capitalist entities, employing proto-cinematic tools, especially images and icons, in order to reinforce their seeming authority over humans. Non-cinema, meanwhile, does not wish to separate heaven from Earth, nor to create a heaven that is the preserve only of the rich. Instead, it is a world of what Hito Steyerl calls the 'poor image', and where the 'wretched of the screen' are the equal of the glamorous rich, the image of which seems to determine the kinocentric values of our age as we are all encouraged not only to exist in images, but also to exist in images that through high definition, a mise en scène that connotes wealth and various other techniques associated with the cinema (including being seen with celebrities, at celebrity events and/or being rich enough not to work) suggest that if you are not cinematic then in some senses you are a failure, and thus are not as valid or real a person as the one who exists in images.[3] In this way, non-cinema is eschatological in wanting to bring an end to this world, throwing over the tables of commerce that have not so much infiltrated but which perhaps define the temple of cinema. And it seeks to immanentize this eschaton by bringing about what Enrique Dussel would call a liberation of the poor image.[4] Since we live in a kinocentric age in which the values of the cinema hold sway (in which everyone aspires to be cinematic, even if the techniques of cinema have proliferated out of movie theatres and on to near-ubiquitous screens that numerous people even hold in their hands and which accompany them to bed, being for many the last thing that they see at night and the first thing that they see in the morning, their alpha and omega, as it were), this liberation of the poor image is not just an ethics of aesthetics or an aesthetics of ethics. It is also connected to the political realm, as Jacques Rancière has argued in relation to the inseparability of aesthetics and politics, or what he terms the 'distribution of the sensible'.[5] That is, the liberation of the poor image is connected to the liberation of the poor in a world where cinema has become the measure of the real as opposed to reality being the measure of cinema.

I am always too late in my readings, not least because I read quite slowly, and so it is typical for me that I only found Akira Mizuta Lippit's 1999 essay 'Three Phantasies of Cinema – Reproduction, Mimesis, Annihilation' in April 2017. Long after having thought myself clever for developing the concept of a

'supercinema', and long after having thought myself clever for since devising a complementary 'non-cinema', here is Lippit writing about how stereoscopy ties in with the idea that cinema can provide a total reproduction of the world, 'promising the transformation of flat cinema into a voluminous *supercinema*, and ultimately a form of anti-cinema'.[6] While *Non-Cinema: Global Digital Filmmaking and the Multitude* is not specifically about stereoscopy, and while it does not make claims about cinema being able to reproduce the world perfectly (André Bazin's myth of total cinema), nonetheless it is pre-empted by Lippit's prescient understanding that cinema aims to be beyond itself, and that it must always be preoccupied with that which it is not, or its outside.[7] Equally, Lúcia Nagib has used the term non-cinema as a way of recasting Bazinian film theory, especially the Frenchman's notion of an impure cinema and his predilection for a cinema defined by chance (akin to the concept of *xianchang*), long shots, long takes and a 'theatricality' that potentially involves viewers as per my conception of the diegetic spectator.[8] Even though Nagib argues that these elements of film also allow us to think beyond cinema, her theory straddles both the analogue and the digital. The aim of *Non-Cinema*, meanwhile, has been to focus specifically on the role of the digital in order to help us to engage with how that which we typically think of as being outside of cinema, as well as outside of capital and outside of the human, is really deeply entangled with cinema, with entanglement challenging the division of inside and outside as a whole. Even with its focus on the digital, though, the theories developed here hopefully also allow us to think about cinema throughout its history, both analogue and digital.

In this way, then, we have travelled from Afghanistan, where we saw expressions of multitude in micro-budget action films, to Iran, where we saw a similarly inclusive cinema that strives to make clear the inclusion of the spectator. We then travelled through China, where we understood the entangled nature of film-maker and that which they film – across both documentary and fiction work, before heading to the Philippines, where we came to understand the constitutive role that darkness plays in non-cinema and perhaps in the world more generally – even though darkness is in effect antithetical to cinema, which requires light in order to exist. That constitutive darkness becomes embodied in post-colonial French cinema, where we also began to understand non-cinema as a digital-era extension of acinema. In contemporary British digital cinema we also saw a reworking of notions of imperfect cinema, together with a cinema that risks failure, or which essays, in making connections between humans and humans and between humans and the material world more generally. We then

saw how even in the United States there is a carnivalesque and scatological non-cinema that uses comedy to further break down barriers put in place by society, before next going to Uruguay in order to consider further the geopolitics of cinema and the cinematic nature of contemporary geopolitics – arguing for a cinephilia that includes the poor image and an ethics that includes the poor, rather than a cinephilia and a morality of only the rich. We then turned our attention to films shot on smartphones, suggesting that there is value to be found in films that deliberately eschew high-definition images, while also suggesting that non-cinema is a kind of cinema out of control and an entangled cinema of love. Finally, we looked at how stereoscopic images do indeed have a role to play in non-cinema, moving it away from the separating dimension of the frame, before then turning our attention to the giant non-cinema movement that is Nollywood – a movement the vibrancy of which is so vivid that it represents not a cinema lagging behind that of the global north, but perhaps its very future. In this way, we hopefully have learnt to understand that all films, like all thoughts, all humans, all life-forms, and perhaps all that is both alive and not, the black (w)hole of reality and non-reality itself, is not all the same, but certainly is all equal.

This is not quite the same as a 'post-factual' world in which we are inundated with 'fake news', and in which we see different moralities competing to replace one another. That is a world defined by the imposition of borders, by exclusions and by hate. Rather, this is an ethical world of liberation and inclusion, an open rather than a closed world. It is a world of love – not an exclusive 'love of' one thing over another, but a world of just love, of love as justice, and a world defined by what in *Supercinema* I defined as sophophily, or what I might recast here as the slightly more 'classical' sounding sophophilia: not so much a love of wisdom as the wisdom of loving.[9] The wisdom of loving and being open to others and to otherness in general. Otherwise love. Love otherwise.

Notes

1 Ó Maoilearca, *All Thoughts Are Equal*, 22.
2 See Agamben, *Homo Sacer*; Eric Cazdyn, *The Already Dead: The New Time of Politics, Culture and Illness* (Durham, NC: Duke University Press, 2012).
3 Steyerl, *The Wretched of the Screen*.
4 Dussel, *Ethics and Community*.

5 Jacques Rancière, *The Politics of Aesthetics: The Distribution of the Sensible*, trans. Gabriel Rockhill (London: Continuum, 2004).
6 Akira Mizuta Lippit, 'Three Phantasies of Cinema – Reproduction, Mimesis, Annihilation', *Paragraph: A Journal of Modern Critical Theory*, 22:3 (November 1999), 213–27.
7 Bazin, *What is Cinema?*, 17–22.
8 Lúcia Nagib, 'Non-Cinema, or The Location of Politics in Film', *Film-Philosophy*, 20 (2016), 131–48.
9 Brown, *Supercinema*, 156.

Bibliography

Adejunmobi, Moradewun A. (2007), 'Nigerian Video Film as Minor Transnational Practice', *Postcolonial Text*, 3:2, 1–16.

Adesokan, Akin (2009), 'Excess Luggage: Nigerian Films and the World of Immigrants', in Isidore Okpewho and Nkiru Nzegwu (eds), *The New African Diaspora*, Bloomington: Indiana University Press, 401–21.

Adesokan, Akin (2014), 'Nollywood: Outline of a Trans-Ethnic Practice', *Black Camera, An International Film Journal*, 5:2 (Spring), 116–33.

Adorno, Theodor W. (1991), *Notes to Literature Volume One* (trans. Shierry Weber Nicholsen), New York: Columbia University Press.

Agamben, Giorgio (1998), *Homo Sacer: Sovereign Power and Bare Life* (trans. Daniel Heller-Roazen), Stanford: Stanford University Press.

Agamben, Giorgio (2004), *The Open: Man and Animal* (trans. Kevin Attell), Stanford: Stanford University Press.

Ai, Xiaoming (2011), 'The Citizen Camera', *New Left Review*, 72 (November/December), 63–79.

Ajibade, Babson (2007), 'From Lagos to Douala: The Video Film and its Spaces of Seeing', *Postcolonial Text*, 3:2, 1–14.

Akudinobi, Jude (2015), 'Nollywood: Prisms and Paradigms', *Cinema Journal*, 54:2 (Winter), 133–40.

Allan, Julie (2013), 'Staged Interventions: Deleuze, Arts and Education', in Inna Semetsky and Diana Masny (eds), *Deleuze and Education*, Edinburgh: Edinburgh University Press, 37–53.

Althusser, Louis (1971), *Lenin and Philosophy and other Essays* (trans. Ben Brewster), New York: Monthly Review Press.

Anderson, Benedict (2006), *Imagined Communities: Reflections on the Origin and Spread of Nationalism*, London: Verso.

Andersson, Siv G. E., Olof Karlberg, Björn Canbäck and Charles G. Kurland (2003), 'On the Origin of Mitochondria: A Genomics Perspective', *Philosophical Transactions of the Royal Society of London B: Biological Sciences*, 358:1429 (January), 165–79.

Andrew, Dudley (2000), 'The Roots of the Nomadic: Gilles Deleuze and the Cinema of West Africa', in Gregory Flaxman (ed.), *The Brain is the Screen: Deleuze and the Philosophy of Cinema*, Minneapolis: University of Minnesota Press, 215–49.

Andrew, Geoff (2002), 'Drive, he said', *Sight & Sound*, October, 31.

Anonymous (2010), 'Light, Camera, Africa', *The Economist*, 16 December, http://www.economist.com/node/17723124. Accessed 7 September 2015.

Anonymous (2013), 'Iranian Film Wins Best Screenplay Award At Berlin Film Festival', *Radio Free Europe/Radio Liberty*, 17 February, http://www.rferl.org/content/iran-film-berlinale-screenplay-award-panahi/24904546.html. Accessed 28 August 2015.

Austen, Ralph A., and Mahir Şaul (2010), 'Introduction', in Mahir Şaul and Ralph A. Austen (eds), *Viewing African Cinema in the Twenty-First Century: Art Films and the Nollywood Video Revolution*, Athens: University of Ohio Press, 1–8.

Backman Rogers, Anna (2015), *American Independent Cinema: Rites of Passage and the Crisis Image*, Edinburgh: Edinburgh University Press.

Badiou, Alain, with Nicolas Truong (2009), *In Praise of Love* (trans. Peter Bush), London: Serpents Tail.

Bakhtin, Mikhail (1984), *Rabelais and His World* (trans. Hélène Iswolksy), Bloomington: Indiana University Press.

Barad, Karen (2007), *Meeting the Universe Halfway: Quantum Physics and the Entanglement of Matter and Meaning*, Durham, NC: Duke University Press.

Barlet, Olivier (2008), 'Is the Nigerian model fit for export?' in Pierre Barrot (ed.), *Nollywood: The Video Phenomenon in Nigeria*, Bloomington: Indiana University Press, 121–9.

Barlet, Olivier (2010), 'Africultures Dossier', *Black Camera: An International Film Journal*, 1:2 (Summer), 63–102.

Bazin, André (1967), *What is Cinema? Volume One* (trans. Hugh Gray), Berkeley: University of California Press.

Bazin, André (1982), *The Cinema of Cruelty: From Buñuel to Hitchcock* (trans. Sabine d'Estrée), New York: Seaver Books.

Bazin, André (2003), 'Bazin on Marker', (trans. Dave Kehr), *Film Comment*, 39:4, 44–5.

Beckett, Samuel (1995), *Nohow On: Company, Ill Seen Ill Said, Worstward Ho*, New York: Grove Press.

Beller, Jonathan (2006a), *The Cinematic Mode of Production: Attention Economy and the Society of the Spectacle*, Lebanon, NH: Dartmouth College Press.

Beller, Jonathan (2006b), *Acquiring Eyes: Philippine Visuality, Nationalist Struggle, and the World Media System*, Manila: Ateneo de Manila University Press.

Beller, Jonathan (2008), 'Iterations of the Impossible: Questions of a Digital Revolution in the Philippines', *Postcolonial Studies*, 11:4, 435–50.

Beller, Jonathan (2012), 'Camera Obscura After All: The Racist Writing With Light', *Scholar & Feminist Online*, 10:3 (Summer), http://sfonline.barnard.edu/feminist-media-theory/camera-obscura-after-all-the-racist-writing-with-light/. Accessed 27 May 2015.

Bennett, Bruce (2007), 'Very Un-British Films: Michael Winterbottom and the Cinema of Incompatibility', in Yan Liu (ed.), *Rereading Britain Today: Essays in British Literary and Cultural Studies*, Shanghai: Shanghai Foreign Language Education Press, 285–99.

Bennett, Bruce (2014), *The Cinema of Michael Winterbottom: Borders, Intimacy, Terror*, London: Wallflower.

Bennett, Jane (2010), *Vibrant Matter: A Political Ecology of Things*, Durham, NC: Duke University Press.
Berger, John (1980), *About Looking*, London: Penguin.
Berry, Chris (2006a), 'Independently Chinese: Duan Jinchuan, Jiang Yue, and Chinese Documentary', in Paul G. Pickowicz and Yingjin Zhang (eds), *From Underground to Independent: Alternative Film Culture in Contemporary China*, Lanham: Rowman & Littlefield, 109–22.
Berry, Chris (2006b), 'Wu Wenguang: An Introduction', *Cinema Journal*, 46:1 (Fall), 133–6.
Berry, Chris, and Mary Farquhar (2006), *China on Screen: Cinema and Nation*, New York: Columbia University Press.
Beugnet, Martine (2007), *Cinema and Sensation: French Film and the Art of Transgression*, Edinburgh: Edinburgh University Press.
Bisschoff, Lizelle, and Ann Overbergh (2012), 'Digital as the New Popular in African Cinema?: Case Studies from the Continent', *Research in African Literatures*, 43:4 (Winter), 112–27.
Bordwell, David (1985), *Narration in the Fiction Film*, London: Routledge.
Bordwell, David (1996), 'Convention, Construction, and Cinematic Vision', in David Bordwell and Noël Carroll (eds), *Post-Theory: Reconstructing Film Studies*, Madison: University of Wisconsin Press, 87–108.
Bordwell, David (2006), *The Way Hollywood Tells It: Story and Style in Modern Movies*, Berkeley: University of California Press.
BoxOfficeMojo (n.d. a), 'La Casa Muda (The Silent House)', *BoxOfficeMojo*, http://www.boxofficemojo.com/movies/intl/?page=&id=_fLACASAMUDATHESI01. Accessed 21 August 2015.
BoxOfficeMojo (n.d. b), '2011 Uruguay Yearly Box Office Results', *BoxOfficeMojo*, http://www.boxofficemojo.com/intl/uruguay/yearly/?yr=2011&p=.htm. Accessed 21 August 2015.
BoxOfficeMojo (n.d. c), 'Silent House', *BoxOfficeMojo*, http://www.boxofficemojo.com/movies/?page=main&id=silenthouse.htm. Accessed 21 August 2015.
Bradshaw, Peter (2010), 'No One Knows About Persian Cats', *The Guardian*, 25 March, http://www.theguardian.com/film/2010/mar/25/no-one-knows-about-persian-cats. Accessed 17 February 2015.
Braester, Yomi (2004), 'From Real Time to Virtual Reality: Chinese Cinema in the Internet Age', *Journal of Contemporary China*, 13:38, 89–104.
Branigan, Edward (1992), *Narrative Comprehension and Film*, London: Routledge.
Brecht, Bertolt (1964), *Brecht on Theatre: The Development of an Aesthetic* (ed. and trans. John Willett), New York: Hill and Wang.
Brenez, Nicole (2002), 'The Body's Night: An Interview with Philippe Grandrieux' (trans. Adrian Martin), *Rouge*, 1, http://www.rouge.com.au/1/grandrieux.html. Accessed 8 June 2015.

Brown, William (2009), 'Lost in Transnation', in Ruby Cheung with D. H. Fleming (eds), *Cinemas, Identities and Beyond*, Cambridge: Cambridge Scholars Press, 16–32.

Brown, William (2011a), '*Cease Fire*: Rethinking Iranian Cinema through its Mainstream', *Third Text*, 25:3, 335–41.

Brown, William (2011b), 'Resisting the Psycho-Logic of Intensified Continuity', *Projections: The Journal for Movies and Mind*, 5:1, 69–86.

Brown, William (2011c), 'The Pre-Narrative Monstrosity of Images: How Images Demand Narrative', *Image [&] Narrative*, 12:4, 43–55.

Brown, William (2012a), 'There are as Many Paths to the Time-Image as There are Films in the World: Deleuze and *The Lizard*', in David Martin-Jones and William Brown (eds), *Deleuze and Film*, Edinburgh: Edinburgh University Press, 88–103.

Brown, William (2012b), 'A Monstrous Cinema', *New Review of Film and Television Studies*, 10:4, 409–24.

Brown, William (2013), *Supercinema: Film-Philosophy for the Digital Age*, Oxford: Berghahn.

Brown, William (2014), 'Complexity and Simplicity in *Inception* and *Five Dedicated to Ozu*', in Warren Buckland (ed.), *Hollywood Puzzle Films*, London: AFI/Routledge, 125–40.

Brown, William (2016), 'Non-cinema: Digital, Ethics, Multitude', *Film-Philosophy*, 20, 104–30.

Brown, William (Forthcoming a), 'He(u)retical Film Theory: When Cognitivism Meets Theory', in Tom Conley and Hunter Vaughan (eds.), *Film Theory Handbook*, London: Anthem Books.

Brown, William (Forthcoming b), '¡*Ataque de pánico!* and the Impossibility of Uruguayan Cinema', *Journal of Latin American Cultural Studies*.

Brown, William, and David H. Fleming (2015), 'Cinema Beside Itself, or Unbecoming Cinema: *Enter the Void*', *Film-Philosophy*, 19, 124–45.

Brown, William, Dina Iordanova and Leshu Torchin (2010), *Moving People, Moving Images: Cinema and Trafficking in the New Europe*, St Andrews: St Andrews Film Studies.

Capino, José B. (2006), 'Philippines: Cinema and Its Hybridity (or "You're nothing but a second-rate trying hard copycat!")', in Anne Tereska Ciecko (ed.), *Contemporary Asian Cinema*, Oxford: Berg, 32–44.

Casetti, Francesco (2015), *The Lumière Galaxy: Seven Key Words for the Cinema to Come*, New York: Columbia University Press.

Cazdyn, Eric (2012), *The Already Dead: The New Time of Politics, Culture and Illness*, Durham, NC: Duke University Press.

Chamarette, Jenny (2011), 'Shadows of Being in Sombre: Archetypes, Wolf-men and Bare Life', in Tanya Horeck and Tina Kendall (eds), *The New Extremism in Cinema: From France to Europe*, Edinburgh: Edinburgh University Press, 69–81.

Cheshire, Godfrey (2012), 'Iran's Cinematic Spring', *Dissent*, 59:2 (Spring), 76–80.

Chion, Michel (1999), *The Voice in Cinema* (trans. Claudia Gorbman), New York: Columbia University Press.
Chomsky, Noam, with Heinz Dieterich (1999), *Latin America: From Colonisation to Globalisation*, Melbourne: Ocean Press.
Chow, Rey, and Julian Rohrhuber (2011), 'On Captivation: A Remainder from the "Indistinction of Art and Nonart"', in Paul Bowman and Richard Stamp (eds), *Reading Rancière: Critical Dissensus*, London: Continuum, 44–72.
Christian, Aymar Jean (2011), 'Joe Swanberg, Intimacy, and the Digital Aesthetic', *Cinema Journal*, 50:4 (Summer), 117–35.
Comolli, Jean-Louis (2015), *Cinema Against Spectacle: Technique and Ideology Revisited* (trans. Daniel Fairfax), Amsterdam: Amsterdam University Press.
Cornelius, Sheila, with Ian Haydn Smith (2002), *New Chinese Cinema: Challenging Representations*, London: Wallflower.
Corrigan, Timothy (2011), *The Essay Film: From Montaigne, After Marker*, Oxford: Oxford University Press.
Creed, Barbara, and Maarten Reesink (2015), 'Animals, Images, Anthropocentrism', *NECSUS European Journal of Media Studies*, Spring, http://www.necsus-ejms.org/animals-images-anthropocentrism/. Accessed 11 September 2015.
Cui, Shuqin (2000), 'Working from the Margins: Urban Cinema and Independent Directors in Contemporary China', *Post Script*, 2–3, 77–93.
Cui, Shuqin (2010), 'Alternative Visions and Representation: Independent Documentary Film-making in Contemporary China', *Studies in Documentary Film*, 4:1, 3–20.
Dabashi, Hamid (2002a), *Iran: A People Interrupted*, London: The New Press.
Dabashi, Hamid (2002b), 'Dead Certainties: The Early Makhmalbaf', in Richard Tapper (ed.), *The New Iranian Cinema: Politics, Representation and Identity*, London: IB Tauris, 117–53.
Dabashi, Hamid (2013), 'The tragic endings of Iranian cinema', *Al Jazeera*, 21 March, http://www.aljazeera.com/indepth/opinion/2013/03/2013320175739100357.html. Accessed 28 August 2015.
Dai, Jinhua (2009), 'Celebratory Screens: Chinese Cinema in the New Millennium', in Olivia Khoo and Sean Metzger (eds), *Futures of Chinese Cinema: Technologies and Temporalities in Chinese Screen Cultures*, Bristol: Intellect, 37–55.
Daston, Lorraine, and Peter Galison (1992), 'The Image of Objectivity', *Representations*, 0:40 (Autumn), 81–128.
David, Joel (2012), 'Film Plastics in *Manila by Night*', *Kritika Kultura*, 19, 36–69.
De Landa, Manuel (1992), 'Nonorganic Life', in Jonathan Crary and Sanford Kwinter (eds), *Zone 6: Incorporations*, New York: Urzone, 129–67.
de Montaigne, Michel (1965), *Essais II*, Paris: Gallimard.
Debord, Guy (1995), *The Society of the Spectacle* (trans. Donald Nicholson-Smith), New York: Zone Books.

del Mundo Jr., Clotualdo (2003), 'Philippine Movies in 2001: The Film Industry is Dead! Long Live Philippine Cinema!' *Asian Cinema*, Spring/Summer, 167–74.
Deleuze, Gilles (1992), 'Postscript on the Societies of Control', *October*, 59 (Winter), 3–7.
Deleuze, Gilles (1995), 'The Exhausted' (trans. Anthony Uhlmann), *Substance*, 24:3 (78), 3–28.
Deleuze, Gilles (1998), *Essays Critical and Clinical* (trans. Daniel W. Smith and Michael A. Greco), London: Verso.
Deleuze, Gilles (2005), *Cinema 2: The Time-Image* (trans. Hugh Tomlinson and Robert Galeta), London: Continuum.
Deleuze, Gilles, and Félix Guattari (1986), *Kafka: Towards a Minor Literature* (trans. Dana Polan), Minneapolis: University of Minnesota Press.
Deleuze, Gilles, and Félix Guattari (1983), *Anti-Oedipus: Capitalism and Schizophrenia* (trans. Robert Hurley, Mark Seem and Helen R. Lane), London: Athlone.
Deleuze, Gilles, and Félix Guattari (2004), *A Thousand Plateaux* (trans. Brian Massumi), London: Continuum.
Dennison, Stephanie, and Lisa Shaw (2004), *Popular Cinema in Brazil*, Manchester: Manchester University Press.
Dirlik, Arif (1989), 'Postsocialism? Reflections on "Social with Chinese Characteristics"', *Critical Asian Studies*, 21:1, 33–44.
Dirlik, Arif, and Zhang Xudong (2000), 'Introduction', in Arif Dirlik and Zhang Xudong (eds), *Post-Modernism and China*, Durham, NC: Duke University Press, 1–18.
Dix, Andrew (2009), '"Do you want this world left on?": Global Imaginaries in the Films of Michael Winterbottom', *Style*, 43:1 (Spring), 3–25.
Dönmez-Colin, Gönül (2004), *Women, Islam and Cinema*, London: Reaktion.
Dussel, Enrique (1985), *Philosophy of Liberation* (trans. Aquilina Martinez and Christine Morkovsky), Eugene: Wipf & Stock.
Dussel, Enrique (1988), *Ethics and Community* (trans. Robert Barr), Maryknoll: Orbis.
Dussel, Enrique (2008), *Twenty Theses on Politics* (trans. George Ciccariello-Maher), Durham, NC: Duke University Press.
Dussel, Enrique (2013), *Ethics of Liberation in the Age of Globalization and Exclusion* (trans. Eduardo Mendieta, Camilo Pérez Bustillo, Yolanda Angulo and Nelson Maldonado-Torres), Durham, NC: Duke University Press.
Dyer, Richard (1997), *White*, London: Routledge.
Ehrick, Christine (2006), 'Beneficient Cinema: State Formation, Elite Reproduction, and Silent Film in Uruguay, 1910s-1920s', *The Americas*, 63:2 (October), 205–24.
Esfandiary, Shahab (2012), *Iranian Cinema and Globalization: National, Transnational and Islamic Dimensions*, Bristol: Intellect.
Fairbanks, Eve (2015), 'José Mujica Was Every Liberal's Dream President. He Was Too Good to Be True', *New Republic*, 5 February, http://www.newrepublic.com/

article/120912/uruguays-jose-mujica-was-liberals-dream-too-good-be-true. Accessed 22 August 2015.
Falicov, Tamara L. (2002), 'Film Policy under MERCOSUR: The Case of Uruguay', *Canadian Journal of Communication*, 27:1, http://www.cjc-online.ca/index.php/journal/article/view/1270/1282. Accessed 16 August 2015.
Fanon, Frantz (1963), *The Wretched of the Earth* (trans. Constance Farrington), New York: Grove Press.
Fanon, Frantz (1993), *Black Skin, White Masks* (trans. Charles Lam Markmann), London: Pluto Press.
Farahmand, Azadeh (2002), 'Perspectives on Recent (International Acclaim for) Iranian Cinema', in Richard Tapper (ed.), *The New Iranian Cinema: Politics, Representation and Identity*, London: I. B. Tauris, 86–108.
Farrokhzad, Forugh (2010), *Another Birth and Other Poems* (trans. Hasan Javadi and Susan Sallée), New York: Mage.
Feng, Yunda Eddie (2009), 'Revitalizing the Thriller Genre: Lou Ye's *Suzhou River* and *Purple Butterfly*', in Warren Buckland (ed.), *Puzzle Films: Complex Storytelling in Contemporary Cinema*, Chichester: Wiley Blackwell, 187–202.
Fleming, David H. (2014), 'Deleuze, the "(Si)neo-realist" Break and the Emergence of Chinese Any-now(here)-spaces', *Deleuze Studies*, 8:4, 509–41.
Fleming, David H. (2017), *Unbecoming Cinema: Unsettling Encounters with Ethical Event Films*, Bristol: Intellect.
Flores, Patrick D. (2000), 'The Dissemination of Nora Aunor', in Rolando B. Tolentino (ed.), *Geopolitics of the Visible: Essays on Philippine Film Cultures*, Manila: Ateneo de Manila University Press, 77–95.
Flores, Patrick D. (2012), 'The Long Take: Passage as Form in the Philippine Film', *Kritika Kultura*, 19, 70–89.
Frenetic Films (2010), *No One Knows About Persian Cats*. Press Kit. http://www.frenetic.ch/films/724/pro/NO%20ONE%20KNOWS-presskit-de.pdf. Accessed 12 February 2015.
Galeano, Eduardo (2009), *The Open Veins of Latin America: Five Centuries of the Pillage of a Continent* (trans. Cedric Belfrage), London: Serpent's Tail.
Ganz, Adam, and Lina Khatib (2006), 'Digital Cinema: The Transformation of Film Practice and Aesthetics', *New Cinemas: Journal of Contemporary Film*, 4:1, 21–36.
García Espinosa, Julio (1979), 'For an imperfect cinema' (trans. Julianne Burton), *Jump Cut*, 20, 24–6, http://www.ejumpcut.org/archive/onlinessays/JC20folder/ImperfectCinema.html. Accessed 4 July 2015.
Gaudreault, André (1990), 'Showing and Telling: Image and World in Early Cinema' (trans. John Howe), in Thomas Elsaesser and Adam Barker (eds), *Early Cinema: Space, Frame, Narrative*, London: BFI, 274–81.
Ghorab-Volta, Zaïda (2007), 'The Experience of a Maghrebi-French Filmmaker: The Case of Zaïda Ghorab-Volta' (trans. Martin O'Shaughnessy), *Cineaste*, 3:1 (Winter), 52–3.

Gibron, Bill (2008), 'Giuseppe Andrews' *Orzo*', *Pop Matters*, 2 February, http://www.popmatters.com/post/giuseppe-andrews-orzo/. Accessed 11 August 2015.

Gilbey, Ryan (2013), 'Mumblecore: "It was never a unified movement. There was no manifesto"', *The Guardian*, 7 November, http://www.theguardian.com/film/2013/nov/07/mumblecore-andrew-bujalski-computer-chess. Accessed 27 July 2015.

Godard, Jean-Luc (1972), *Godard on Godard: Critical Writings* (eds Tom Milne and Jean Narboni), London: Secker & Warburg.

Goddard, Michael (2011), 'Eastern Extreme: The Presentation of Eastern Europe as a Site of Monstrosity in *La Vie nouvelle* and *Import/Export*', in Tanya Horeck and Tina Kendall (eds), *The New Extremism in Cinema: From France to Europe*, Edinburgh: Edinburgh University Press, 82–92.

Gow, Christopher (2011), *From Iran to Hollywood and Some Place In-Between: Reframing Post-Revolutionary Iranian Cinema*, London: IB Tauris.

Graham, Mark (2010), *Afghanistan in the Cinema*, Chicago: University of Illinois Press.

Grandy, David A. (2009), *The Speed of Light: Constancy + Cosmos*, Princeton: Princeton University Press.

Grant, Catherine (2014), 'Single Take Horror Film Mutations', *Vimeo*, https://vimeo.com/89730868. Accessed 21 August 2015.

Greene, Brian (2000), *The Elegant Universe: Superstrings, Hidden Dimensions, and the Quest for the Ultimate Theory*, London: Vintage.

Griggers, Camilla Benolirao (2000), 'Goodbye America (The Bride Is Walking...)', in Rolando B. Tolentino (ed.), *Geopolitics of the Visible: Essays on Philippine Film Cultures*, Manila: Ateneo de Manila University Press, 290–318.

Guerrasio, Jason (2015), 'Forgotten Mavericks: Ten Years Later, What Happened to *Four Eyed Monsters*?', *Indiewire*, 21 January, http://www.indiewire.com/article/forgotten-mavericks-ten-years-later-what-happened-to-four-eyed-monsters-20150121. Accessed 10 August 2015.

Habib, André (2014), 'Godard's Utopia(s) or the Performance of Failure', in Douglas Morrey, Christina Stojanova and Nicole Côté (eds), *The Legacies of Jean-Luc Godard*, Waterloo: Wilfred Laurier University Press, 217–34.

Hainge, Greg (2007), 'Le corps concret: Of Bodily and Filmic Material Excess in Philippe Grandrieux's Cinema', *Australian Journal of French Studies*, 44:2 (May), 153–71.

Hanson, Brad (1983), 'The "Westoxication" of Iran: Depictions and Reactions of Behrangi, al-e Ahmad, and Shariati', *International Journal of Middle East Studies*, 15:1 (February), 1–23.

Haraway, Donna J. (2008), *When Species Meet*, Minneapolis: University of Minnesota Press.

Hardt, Michael, and Antonio Negri (2000), *Empire*, Cambridge, MA: Harvard University Press.

Hardt, Michael, and Antonio Negri (2004), *Multitude: War and Democracy in the Age of Empire*, London/New York: Penguin.

Hargreaves, Alec G. (2007), 'Translator's Introduction', in Azouz Begag, *Ethnicity & Equality: France in Balance* (trans. Alec G. Hargreaves), London: University of Nebraska Press, vii–xxii.

Harvey-Davitt, James (2014), '"Non-Film": A Dialogue between Rancière and Panahi on Asceticism as a Political Aesthetic', *Evental Aesthetics*, 2:4, 92–8. Also at: http://eventalaesthetics.net/poverty-and-asceticism-vol-2-no-4-2014/james-harvey-davitt-non-film-ranciere-and-panahi-on-asceticism/. Accessed 30 August 2015.

Hau, Caroline S. (2000), 'The Criminal State and the Chinese in Post-1986 Philippines', in Rolando B. Tolentino (ed.), *Geopolitics of the Visible: Essays on Philippine Film Cultures*, Manila: Ateneo de Manila University Press, 217–41.

Haynes, Jonathan (ed.) (2000), *Nigerian Video Films*, Athens: Ohio University Press.

Haynes, Jonathan (2007a), '"Nollywood": What's in a Name?' *Film International*, 5:4 (28), 106–8.

Haynes, Jonathan (2007b), 'Video Boom: Nigeria and Ghana', *Postcolonial Text*, 3:2, 1–10.

Haynes, Jonathan (2010), 'What Is To Be Done? Film Studies and Nigerian and Ghanaian Videos', in Mahir Şaul and Ralph A. Austen (eds), *Viewing African Cinema in the Twenty-First Century: Art Films and the Nollywood Video Revolution*, Athens: University of Ohio Press, 11–25.

Haynes, Jonathan (2014), '"New Nollywood": Kunle Afolayan', *Black Camera, An International Film Journal*, 5:2 (Spring), 53–73.

Henry, Michel (2005), *Seeing the Invisible: On Kandinsky* (trans. Scott Davidson), London: Continuum.

Hernandez, Vladimir (2012), 'Jose Mujica: The world's "poorest" president', *BBC News Magazine*, 15 November, http://www.bbc.co.uk/news/magazine-20243493. Accessed 22 August 2015.

Higbee, Will (2013), *Post-Beur Cinema: North African Émigré and Maghrebi-French Filmmaking in France Since 2000*, Edinburgh: Edinburgh University Press.

Hjort, Mette (2005), *Small Nation, Global Cinema: The New Danish Cinema*, Minneapolis: University of Minnesota Press.

Holtmeier, Matthew A. (2010), 'Post-Pandoran Depression or Na'vi Sympathy: Avatar, Affect, and Audience Reception', *Journal of the Study of Religion, Nature and Culture*, 4:4, 414–24.

Hornaday, Ann (2013), '*12 Years a Slave, Mother of George* and the Aesthetic Politics of Filming Black Skin', *The Washington Post*, 17 October, http://www.washingtonpost.com/entertainment/movies/12-years-a-slave-mother-of-george-and-the-aesthetic-politics-of-filming-black-skin/2013/10/17/282af868-35cd-11e3-80c6-7e6dd8d22d8f_story.html. Accessed 27 May 2015.

IMDb (n.d.), 'Top-US-Grossing Titles With Country of Origin Uruguay', *Internet Movie Database*, http://www.imdb.com/search/title?countries=uy&sort=boxoffice_gross_us,desc. Accessed 21 August 2015.

Jaffee, Valerie (2006), '"Every Man a Star": The Ambivalent Cult of Amateur Art in New Chinese Documentaries', in Paul G. Pickowicz and Yingjin Zhang (eds), *From Underground to Independent: Alternative Film Culture in Contemporary China*, Lanham: Rowman & Littlefield, 77–108.

James, David E. (2005), *The Most Typical Avant-Garde: History and Geography of Minor Cinemas in Los Angeles*, Berkeley: University of California Press.

Jameson, Fredric (1992), *The Geopolitical Aesthetic: Cinema and Space in the World System*, London: British Film Institute.

Jenkins, Henry (2008), *Convergence Culture: Where Old and New Media Collide*, New York: New York University Press.

Jia, Zhangke (2010), 'The Age of Amateur Cinema Will Return' (trans. Yan Yuqian), *DGenerate Films*, 3 March, http://dgeneratefilms.com/critical-essays/jia-zhangke-the-age-of-amateur-cinema-will-return. Accessed 9 April 2015.

Johnson, Matthew David (2006), '"A Scene beyond Our Line of Sight": Wu Wenguang and New Documentary Cinema's Politics of Independence', in Paul G. Pickowicz and Yingjin Zhang (eds), *From Underground to Independent: Alternative Film Culture in Contemporary China*, Lanham: Rowman & Littlefield, 47–76.

Johnson, Matthew D., Keith B. Wagner, Kiki Tianqi Yu and Luke Vulpiani (eds), *China's iGeneration: Cinema and Moving Image Culture for the Twenty-First Century* (London: Bloomsbury, 2014).

Johnston, Cristina (2010), *French Minority Cinema*, Amsterdam: Rodopi.

Johnston, Nessa (2014), 'Theorizing "Bad" Sound: What Puts the "Mumble" into Mumblecore?' *The Velvet Light Trap*, 74 (Fall), 67–79.

Kafka, Franz (2007), *Metamorphosis and Other Stories* (trans. Michael Hofmann), London: Penguin.

Kafka, Franz (2008), *The Trial* (trans. John Williams), London: Wordsworth.

Kaplan, Robert (2000), *The Nothing that Is: A Natural History of Zero*, Oxford: Oxford University Press.

Kedir, Djelal (1993), *The Other Writing: Postcolonial Essays in Latin America's Writing Culture*, West Lafayette: Purdue University Press.

Kilian, Cassis (2010), 'Glimmering Utopias: 50 Years of African Film', *Africa Spectrum*, 3, 147–59

Kilian, Cassis (2013), 'Worth a Closer Look: A Comparative Study of *Xala* and *Osuofia in London*', *Journal of African Cinemas*, 5:1, 55–71.

Kipp, Jeremiah (2010), 'Anarchy in the UK: An Interview with *24 Hour Party People* Director Michael Winterbottom', in Damon Smith (ed.), *Michael Winterbottom: Interviews*, Jackson: University Press of Mississippi, 56–9.

Knox, Simone (2013), 'Eye Candy for the Blind: Re-introducing Lyotard's Acinema into Discourses on Excess, Motion, and Spectacle in Contemporary Hollywood', *New Review of Film and Television Studies*, 11:3, 374–89.

Koehler, Robert (2007), 'Review: *Garbanzo Gas*', *Variety*, 10 July, http://variety.com/2007/film/reviews/garbanzo-gas-1200557911/. Accessed 10 August 2015.

Laine, Tarja (2006), 'Cinema as Second Skin: Under the Membrane of Horror Film', *New Review of Film and Television Studies*, 4:2, 93–106.

Laine, Tarja (2007), *Shame and Desire: Emotion, Intersubjectivity, Cinema*, Brussels: Peter Lang.

Lalanne, Jean-Marc (2010), '"Le droit d'auteur? Un auteur n'a que des devoirs" Jean-Luc Godard', *Les Inrockuptibles*, 18 May, http://blogs.lesinrocks.com/cannes2010/2010/05/18/le-droit-dauteur-un-auteur-na-que-des-devoirs-jean-luc-godard/. Accessed 31 August 2015.

Larkin, Brian (2004), 'Degraded Images, Distorted Sounds: Nigerian Video and the Infrastructure of Piracy', *Public Culture*, 16:2, 289–314.

Laruelle, François (2013a), *Introduction to Non-Marxism* (trans. Anthony Paul Smith), Minneapolis: Univocal Press.

Laruelle, François (2013b), *Principles of Non-Philosophy* (trans. Nicola Rubczak and Anthony Paul Smith), London, Bloomsbury.

Lazzarato, Maurizio (2006), 'Immaterial Labour' (trans. Paul Colilli and Ed Emory), in Paolo Virno and Michael Hardt (eds), *Radical Thought in Italy: A Potential Politics*, Minneapolis: University of Minnesota Press, 132–46.

Lazzarato, Maurizio (2012), *The Making of the Indebted Man: Essay on the Neoliberal Condition* (trans. Joshua David Jordan), Los Angeles: Semiotext(e).

Lelievre, Samuel (2013), 'Africa and cinema in the mirror of Godard's Film Socialisme', *Journal of African Cinemas*, 5:1, 123–7.

Lin, Xiaoping (2009), *Children of Marx and Coca-Cola: Chinese Avant-Garde and Independent Cinema*, Honolulu: University of Hawai'i Press.

Lippit, Akira Mizura (1999), 'Three Phantasies of Cinema – Reproduction, Mimesis, Annihilation', *Paragraph: A Journal of Modern Critical Theory*, 22:3 (November), 213–27.

Lippit, Akira Mizuta (2000), *Electric Animal: Toward a Rhetoric of Wildlife*, Minneapolis: University of Minnesota Press.

Lippit, Akira Mizuta (2012), *Ex-Cinema: From a Theory of Experimental Film and Video*, Berkeley: University of California Press.

Lobato, Ramon (2007), 'Subcinema: Theorising Marginal Film Distribution', *Limina: A Journal of Historical and Cultural Studies*, 13, 113–20. Also available at http://www.archive.limina.arts.uwa.edu.au/__data/page/186591/Lobato.pdf. Accessed 17 February 2015.

Lobato, Ramon (2012), *Shadow Economies of Cinema: Mapping Informal Film Distribution*, London: British Film Institute.

Lopate, Philip (1992), 'In Search of the Centaur: The Essay-Film', *The Threepenny Review*, 48 (Winter), 19–22.

Loshitzky, Yosefa (2010), *Screening Strangers: Migration and Diaspora in Contemporary European Cinema*, Bloomington: Indiana University Press.

Lu, Hongwei (2010), 'Shanghai and Globalization through the Lens of Film Noir: Lou Ye's 2000 Film, *Suzhou River*', *ASIANetwork Exchange*, 17:1 (Fall), 116–27.

Lu, Tonglin (2006), 'Trapped Freedom and Localised Globalism', in Paul G. Pickowicz and Yingjin Zhang (eds), *From Underground to Independent: Alternative Film Culture in Contemporary China*, Lanham: Rowman & Littlefield, 123–41.

Lu, Sheldon H. (2008), 'Popular Culture and Body Politics: Beauty Writers in Contemporary China', *Modern Language Quarterly*, 69:1, 167–85.

Lynes, Krista Geneviève (2013), *Prismatic Media, Transnational Circuits: Feminism in a Globalized Present*, New York: Palgrave Macmillan.

Lyotard, Jean-François (1978), 'Acinema', *Wide Angle*, 2, 52–9.

Maimon, Vered (2012), 'Beyond Representation: Abbas Kiarostami's and Pedro Costa's Minor Cinema', *Third Text*, 26:3, 331–44.

Manovich, Lev (2001), *The Language of New Media*, Cambridge, MA: MIT Press.

Mao, Zedong (1937), 'On Practice', *Selected Works Volume 1*, 299–300. Available at: https://www.marxists.org/reference/archive/mao/works/red-book/ch22.htm. Accessed 9 April 2015.

Marks, Laura U. (2000), *The Skin of the Film: Intercultural Cinema, Embodiment and the Senses*, Durham, NC: Duke University Press.

Marshall, Bill (2001), *Québec National Cinema*, Montreal: McGill-Queen's University Press.

Marshall, Bill (2008), 'Cinemas of Minor Frenchness', in Ian Buchanan and Patricia MacCormack (eds), *Deleuze and the Schizoanalysis of Cinema*, London: Continuum, 89–101.

Martin-Jones, David (2004), '*Orphans*: A Work of Minor Cinema from Post-Devolutionary Scotland', *Journal of British Cinema and Television*, 1, 226–41.

Martin-Jones, David (2016), '"Trolls, Tigers and Transmodern Ecological Encounters" Enrique Dussel and a Cine-ethics for the Anthropocene', *Film-Philosophy*, 20:1, 63–103.

Martin-Jones, David, and Montañez, María Soledad (2009), 'Cinema in Progress: New Uruguayan Cinema', *Screen*, 50:3, 334–44.

Martin-Jones, David, and Montañez, María Soledad (2013a), 'Uruguay Disappears: Small Cinemas, Control Z Films, and the Aesthetics and Politics of Auto-Erasure', *Cinema Journal*, 53:1 (Fall), 26–51.

Martin-Jones, David, and Montanez, María Soledad (Forthcoming), 'What is the "Silent House"? Interpreting the international appeal of Tokio Films' Uruguayan horror *La casa muda/The Silent House* (2010)', *Journal of Latin American Cultural Studies*.

Marx, Karl (1993), *Grundrisse* (trans. Martin Nicolaus), London: Penguin.

Marx, Karl (2008), *Capital: A New Abridgement*, Oxford: Oxford University Press.

Marx, Karl, and Friedrich Engels (2004), *The Communist Manifesto*, London: Penguin.

Masukor, Sarinah (2016), 'An Imaginary Africa', *Screening the Past*, 41, http://www.screeningthepast.com/2016/12/an-imaginary-africa/. Accessed 17 April 2017.

Mazierska, Ewa (2015), *From Self-Fulfilment to Survival of the Fittest: Work in European Cinema from the 1960s to the Present*, Oxford: Berghahn.
McCoy, Alfred W. (2000), 'RAM and the Filipino Action Film', in Rolando B. Tolentino (ed.), *Geopolitics of the Visible: Essays on Philippine Film Cultures*, Manila: Ateneo de Manila University Press, 194–216.
McGrath, Jason (2007), 'The Independent Cinema of Jia Zhangke: From Postsocialist Realism to a Transnational Aesthetic', in Zhang Zhen (ed.), *The Urban Generation: Chinese Cinema and Society at the Turn of the Twenty-First Century*, Durham, NC: Duke University Press, 81–114.
McHugh, Susan (2004), *Dog*, London: Reaktion.
McMahon, Laura (2015a), 'Screen Animals Dossier: Introduction', *Screen*, 56:1 (Spring), 81–7.
McMahon, Laura (2015b), 'Cinematic Slowness, Political Paralysis? Animal Life in 'Bovines', With Deleuze and Guattari', *NECSUS European Journal of Media Studies*, Spring, http://www.necsus-ejms.org/cinematic-slowness-political-paralysis-animal-life-in-bovines-with-deleuze-and-guattari/. Accessed 11 September 2015.
Meisner, Maurice (1999), *Mao's China and After: A History of the People's Republic*, New York: Free Press.
Mhando, Martin (2009), 'Globalisation and African Cinema: Distribution and Reception in the Anglophone Region', *Journal of African Cinemas*, 1:1, 19–34.
Mhando, Martin (2015), 'Independent Filmmaking in Africa: New Voices and Challenges', in Doris Baltruschat and Mary P. Erickson (eds), *Independent Filmmaking around the Globe*, Toronto: University of Toronto Press, 188–210.
Mistry, Jyoti, and Jordache A. Ellapen (2013), 'Nollywood's Transportability: The Politics and Economics of Video Films as Cultural Products', in Matthias Krings and Onookome Okome (eds), *Global Nollywood: The Transnational Dimensions of an African Video Film Industry*, Bloomington: Indiana University Press, 46–69.
Montero, David (2012), *Thinking Images: The Essay Film as a Dialogic Form in European Cinema*, Oxford: Peter Lang.
Morgan, Daniel (2012), *Late Godard and the Possibilities of Cinema*, Berkeley: University of California Press.
Mumbai Boss (2012), 'Ai Weiwei's Documentaries to be Screened at Clark House', *Mumbai Boss*, 12 April, http://mumbaiboss.com/2012/04/12/ai-weiweis-documentaries-to-be-screened-at-clark-house/. Accessed 9 April 2015.
Murray Levine, Alison J. (2008), 'Mapping Beur Cinema in the New Millennium', *Journal of Film and Video*, 60:3–4 (Fall/Winter), 42–59.
Naficy, Hamid (1999), 'Veiled Vision/Powerful Presences: Women in Post-revolutionary Iranian Cinema', in Rose Issa and Sheila Whitaker (eds), *Life and Art: The New Iranian Cinema*, London: British Film Institute, 44–65.
Naficy, Hamid (2001), *An Accented Cinema: Exilic and Diasporic Filmmaking*, Princeton: Princeton University Press.

Naficy, Hamid (2002), 'Islamizing Film Culture in Iran: A Post-Khatami Update', in Richard Tapper (ed.), *The New Iranian Cinema: Politics, Representation and Identity*, London: IB Tauris, 26–65.

Naficy, Hamid (2012), *A Social History of Iranian Cinema, Volume 4: The Globalizing Era, 1984–2010*, Durham, NC: Duke University Press.

Nagib, Lúcia (2016), 'Non-Cinema, or The Location of Politics in Film', *Film-Philosophy*, 20, 131–48.

Nakajima, Seio (2006), 'Film Clubs in Beijing: The Cultural Consumption of Chinese Independent Films', in Paul G. Pickowicz and Yingjin Zhang (eds), *From Underground to Independent: Alternative Film Culture in Contemporary China*, Lanham: Rowman & Littlefield, 161–87.

Nancy, Jean-Luc (2000), *Being Singular Plural* (trans. Robert Richardson and Anne O'Byrne), Stanford: Stanford University Press.

Nancy, Jean-Luc (2003), *Au fond des images*, Paris: Galilée.

Negri, Antonio (2012), *Art and Multitude* (trans. Ed Emery), Cambridge: Polity Press.

Ó Maoilearca, John (2015), *All Thoughts Are Equal: Laruelle and Non-Human Philosophy*, Minneapolis: University of Minnesota Press.

O'Shaughnessy, Martin (2007), *The New Face of Political Cinema: Commitment in French Film Since 1995*, Oxford: Berghahn.

Obiaya, Ikechukwu (2010), 'Nollywood on the Internet: A Preliminary Analysis of An Online Nigerian Video-film Audience', *Journal of African Media Studies*, 2:3 (November), 321–38.

Obrist, Hans Ulrich (2011), *Ai Weiwei Speaks with Hans Ulrich Obrist*, London: Penguin.

Okome, Onookome (2007), 'Nollywood: Spectatorship, Audience and the Sites of Consumption', *Postcolonial Text*, 3:2, 1–21.

Okome, Onookome (2010), 'Nollywood and its Critics', in Mahir Şaul and Ralph A. Austen (eds), *Viewing African Cinema in the Twenty-First Century: Art Films and the Nollywood Video Revolution*, Athens: University of Ohio Press, 26–41.

Okome, Onookome (2013), 'Reversing the Filmic Gaze: Comedy and the Critique of the Postcolony in Osuofia in London', in Matthias Krings and Onookome Okome (eds), *Global Nollywood: The Transnational Dimensions of an African Video Film Industry*, Bloomington: Indiana University Press, 139–57.

Olayiwola, Abiodun (2011), 'Nollywood at the Borders of History: Yoruba Travelling Theatre and Video Film Development in Nigeria', *The Journal of Pan African Studies*, 4:5 (September), 183–95.

Ostria, Vincent (2002), 'Rabah Ameur-Zaïmeche: Belle Saga Cité', *Les Inrockuptibles*, 30 April, http://www.lesinrocks.com/2002/04/30/cinema/actualite-cinema/rabah-ameur-zaimeche-belle-saga-cite-11115203/. Accessed 11 September 2015.

Pak-Shiraz, Nacim (2011), *Shi'i Islam in Iranian Cinema: Religion and Spirituality in Film*, London: IB Tauris.

Palmer, Tim (2011), *Brutal Intimacy: Analyzing Contemporary French Cinema*, Middletown: Wesleyan University Press.

Pang, Laikwan (2004), 'Piracy/Privacy: The Despair of Cinema and Collectivity in China', *Boundary 2*, 31:3 (Fall), 101–24.

Paraskevaídis, Graciela (1992), *Eduardo Fabini*, Montevideo: Trilce.

Partovi, Pedram (2008), 'Martyrdom and the "Good Life" in the Iranian Cinema of Sacred Defense', *Comparative Studies of South Asia, Africa and the Middle East*, 28:3, 513–32.

Pavsek, Christopher (2013), *The Utopia of Film: Cinema and Its Futures in Godard, Kluge, and Tahimik*, New York: Columbia University Press.

Petty, Sheila (2015), 'Digital Video Films as "Independent" African Cinema', in Doris Baltruschat and Mary P. Erickson (eds), *Independent Filmmaking around the Globe*, Toronto: University of Toronto Press, 255–69.

Pick, Anat (2011), *Creaturely Poetics: Animality and Vulnerability in Literature and Film*, New York: Columbia University Press.

Pick, Anat (2015), 'Why not look at animals?' *NECSUS European Journal of Media Studies*, Spring, http://www.necsus-ejms.org/why-not-look-at-animals/. Accessed 11 September 2015.

Pickowicz, Paul G. (2006), 'Social and Political Dynamics of Underground Filmmaking in China', in Paul G. Pickowicz and Yingjin Zhang (eds), *From Underground to Independent: Alternative Film Culture in Contemporary China*, Lanham: Rowman & Littlefield, 1–21.

Pinker, Steven (1994), *The Language Instinct: How the Mind Creates Language*, London: Penguin.

Plato (1987), *The Republic* (trans. Desmond Lee), London: Penguin.

Polan, Dana (1986), 'Translator's Introduction', in Gilles Deleuze and Félix Guattari, *Kafka: Toward a Minor Literature* (trans. Dana Polan), Minneapolis: University of Minnesota Press, xxii–xxix.

Porton, Richard (2010), 'In Praise of Folly: An Interview with Michael Winterbottom', in Damon Smith (ed.), *Michael Winterbottom: Interviews*, Jackson: University Press of Mississippi, 97–105.

Pruszynski, J. Andrew and Roland S. Johansson (2014), 'Edge-orientation processing in first-order tactile neurons', *Nature Neuroscience*, 17, 1404–9.

Rabelais, François (2006), *Gargantua and Pantagruel* (trans. M. A. Screech), London: Penguin.

Rahbaran, Shiva (2012), 'An Interview with Jafar Panahi', *Wasafiri*, 27:3, 5–11.

Rama, Ángel (1996), *The Lettered City* (trans. John Charles Chasteen), Durham, NC: Duke University Press.

Ramdas, Rodney (2014), 'The Acinema of Grandrieux: On *Un Lac*', *Lumen*, http://lumenjournal.org/i-forests/ramdas-grandrieux/. Accessed 30 July 2014.

Rancière, Jacques (2004), *The Politics of Aesthetics: The Distribution of the Sensible* (trans. Gabriel Rockhill), London: Continuum.

Rancière, Jacques (2009a), *The Emancipated Spectator* (trans. Gregory Elliott), London: Verso.

Rancière, Jacques (2009b), *Aesthetics and Its Discontents* (trans. Steven Corcoran), Cambridge: Polity Press.

Rascaroli, Laura (2009), *The Personal Camera: Subjective Cinema and the Essay Film*, London: Wallflower.

Rastegar, Kamran (2011), 'The Iranian Mediation of Afghanistan in International Art House Cinema after September 11, 2001', in Zubeda Jalalzai and David Jefferess (eds), *Globalizing Afghanistan: Terrorism, War, and the Rhetoric of Nation Building*, Durham, NC: Duke University Press, 145–64.

Reynaud, Bérénice (2003), 'Dancing with Myself, Drifting with My Camera: The Emotional Vagabonds of China's New Documentary', *Senses of Cinema*, 28 (October), http://sensesofcinema.com/2003/feature-articles/chinas_new_documentary/. Accessed 9 April 2015.

Reynaud, Bérénice (2010), 'Translating the Unspeakable: On-Screen and Off-Screen Voices in Wu Wenguang's Documentary Work', in Chris Berry, Lu Xinyu and Lisa Rofel (eds), *The New Chinese Documentary Film Movement: For the Public Record*, Hong Kong: University of Hong Kong Press, 157–76.

Reynaud, Bérénice (2011), 'Le cinéma de la Chine continentale: les multiples voix du nouveau cinéma numérique chinois', *24 images*, 155, 12–15.

Richards, Keith (2005), 'Born at Last? Cinema and Social Imaginary in 21st-Century Uruguay', in Lisa Shaw and Stephanie Dennison (eds), *Latin American Cinema: Essays on Modernity, Gender and National Identity*, Jefferson: MacFarland & Company, 137–59.

Rivette, Jacques (1985), 'Letter on Rossellini/Lettre sur Rossellini (Cahiers du Cinéma, 46, April 1955)' (trans. Tom Milne), in Jim Hillier (ed.), *Cahiers du Cinéma: The 1950s – Neo-Realism, Hollywood, New Wave*, London: British Film Institute, 192–205.

Robinson, Luke (2013), *Independent Chinese Documentary: From the Studio to the Street*, Basingstoke: Palgrave Macmillan.

Rocha, Glauber (1997), 'An Esthetic of Hunger' (trans. Randal Johnson and Burnes Hollyman), in Michael Martin (ed.), *New Latin American Cinema*, Detroit: Wayne State University Press, 59–61.

Rodríguez Ortega, Vicente (2011), 'Digital Technology, Aesthetic Imperfection and Political Film-making: Illegal Bodies in Motion', *Transnational Cinemas*, 2:1, 3–19.

Ross, Miriam (2016), 'Godard's Stereoscopic Illusions: Against a Total Cinema', *Screening the Past*, 41, http://www.screeningthepast.com/2016/12/godards-stereoscopic-illusions-against-a-total-cinema/. Accessed 17 April 2017.

Roth, Lorna (2009), 'Looking at Shirley, the Ultimate Norm: Colour Balance, Image Technologies, and Cognitive Equity', *Canadian Journal of Communication*, 34, 111–36.

Rubio, Steve (2005), 'Making it Real', in Nicholas Rombes (ed.), *New Punk Cinema*, Edinburgh: Edinburgh University Press, 138–49.

Ruffinelli, Jorge (2013), 'Uruguay 2008: The Year of the Political Documentary', *Latin American Perspectives*, 40:1 (January), 60–72.
Rugo, Daniele (2013), 'Truth After Cinema: The Explosion of Facts in the Documentary Films of Jia Zhangke', *Asian Cinema*, 24:2, 195–208.
Saeed-Vafa, Mehrnaz, and Jonathan Rosenbaum (2003), *Abbas Kiarostami*, Chicago: University of Illinois Press.
Saïd, Edward W. (1978), *Orientalism*, London: Vintage.
San Filippo, Maria (2011), 'A Cinema of Recession: Micro-Budgeting, Micro-Drama, and the "Mumblecore" Movement', *Cineaction*, 85, http://www.cineaction.ca/wp-content/uploads/2014/04/issue85sample1.pdf. Accessed 27 July 2015.
San Juan Jr., E. (2000), 'Cinema of the "Naïve" Subaltern in Search of an Audience', in Rolando B. Tolentino (ed.), *Geopolitics of the Visible: Essays on Philippine Film Cultures*, Manila: Ateneo de Manila University Press, 264–76.
Sardar, Ziauddin, and Merryl Wyn Davies (2004), *American Terminator: Myths, Movies and Global Power*, New York: Disinformation.
Sartre, Jean-Paul (2000), *Nausea* (trans. Robert Baldick), London: Penguin.
Sconce, Jeffrey (1995), '"Trashing" the Academy: Taste, Excess, and An Emerging Politics of Cinematic Style', *Screen*, 36:4, 371–93.
Sheibani, Khatereh (2011), *The Poetics of Iranian Cinema: Aesthetics, Modernity and Film after the Revolution*, London: I. B. Tauris.
Shi, Liang (2012), 'Contextualising Chinese Lesbian Cinema: Global Queerness and Independent Films', *New Cinemas: Journal of Contemporary Film*, 10:2/3, 127–43.
Shukin, Nicole (2009), *Animal Capital: Rendering Life in Biopolitical Times*, Minneapolis: University of Minnesota Press.
Silbergeld, Jerome (2004), *Hitchcock with a Chinese Face: Cinematic Doubles, Oedipal Triangles, and China's Moral Voice*, Seattle: University of Washington Press.
Silberman, Robert (2000), '*Aliwan Paradise* and the Work of Satire in the Age of Geopolitical Entertainment', in Rolando B. Tolentino (ed.), *Geopolitics of the Visible: Essays on Philippine Film Cultures*, Manila: Ateneo de Manila University Press, 277–89.
Smith, Iain Robert (2016), *The Hollywood Meme: Transnational Adaptations in World Cinema*, Edinburgh: Edinburgh University Press.
Smith, Tim J., and John M. Henderson (2008), 'Edit Blindness: The Relationship between Attention and Global Change Blindness in Dynamic Scenes', *Journal of Eye Movement Research*, 2:2 (6), 1–17.
Sobchack, Vivian (1992), *The Address of the Eye: A Phenomenology of Film Experience*, Princeton: Princeton University Press.
Solanas, Fernando E., and Octavio Getino (1976), 'Towards a Third Cinema', in Bill Nichols (ed.), *Movies and Methods Volume 1*, Berkeley: University of California Press, 44–64.

Spivak, Gayatri (1991), 'Identity and Alterity: An interview with Nicos Papastergiadis', *Arena*, 97, 65–7.
Stam, Robert (1989), *Subversive Pleasures: Bakhtin, Cultural Criticism and Film*, Baltimore: Johns Hopkins University Press.
Sterritt, David (1999), *The Films of Jean-Luc Godard: Seeing the Invisible*, Cambridge: Cambridge University Press.
Sterritt, David (2014), 'Godard, Schizoanalysis, and the Immaculate Conception of the Frame', in Douglas Morrey, Christina Stojanova and Nicole Côté (eds), *The Legacies of Jean-Luc Godard*, Waterloo: Wilfred Laurier University Press, 143–56.
Steyerl, Hito (2012), *The Wretched of the Screen*, New York: Sternberg Press.
Stojanova, Christina (2014), 'Jean-Luc Godard and Ludwig Wittgenstein in New Contexts', in Douglas Morrey, Christina Stojanova and Nicole Côté (eds), *The Legacies of Jean-Luc Godard*, Waterloo: Wilfred Laurier University Press, 127–41.
Tanimonore, Gideon (2014), 'Nollywood and the Discursive Mediation of Identity, Nationhood and Social Anxiety', in Adeshina Afolayan (ed.), *Auteuring Nollywood: Critical Perspectives on the Figurine*, Ibadan: University Press Nigeria, 298–324.
Tarr, Carrie (2005), *Reframing Difference: Beur and Banlieue Filmmaking in France*, Manchester: Manchester University Press.
Tarr, Carrie (2007a), 'Transnational Identities, Transnational Spaces: West Africans in Paris in Contemporary French Cinema', *Modern & Contemporary France*, 15:1 (February), 65–76.
Tarr, Carrie (2007b), 'The Porosity of the Hexagon: Border Crossings in Contemporary French Cinema', *Studies in European Cinema*, 4:1, 7–20.
Taubin, Amy (2007), 'Mumblecore: All Talk?' *Film Comment*, November/December, http://www.filmcomment.com/article/all-talk-mumblecore. Accessed 27 July 2015.
Teo, Stephen (2003), '"There Is No Sixth Generation!" Director Li Yang on *Blind Shaft* and His Place in Chinese Cinema', *Senses of Cinema*, 27 (July), http://sensesofcinema.com/2003/feature-articles/li_yang/. Accessed 9 April 2015.
Thackway, Melissa (2014), 'Exile and the "Burden of Representation": Trends in Contemporary Sub-Saharan Francophone African Filmmaking', *Black Camera: An International Film Journal*, 5:2 (Spring), 5–20.
Tolentino, Rolando B. (2000), 'Introduction', in Rolando B. Tolentino (ed.), *Geopolitics of the Visible: Essays on Philippine Film Cultures*, Manila: Ateneo de Manila University Press, vii–xxi.
Tolentino, Rolando B. (2001), 'Cityscape: The Capital Infrastructuring and Technologisation of Manila', in Mark Shiel and Tony Fitzmaurice (eds), *Cinema and the City: Film and Urban Societies in a Global Context*, Oxford: Blackwell, 158–70.
Tolentino, Rolando B. (2012), 'Marcos, Brocka, Bernal, City Films, and the Contestation for Imagery of Nation', *Kritika Kultura*, 19, 115–38.

Trahair, Lisa (2007), *The Comedy of Philosophy: Sense and Nonsense in Early Cinematic Slapstick*, Ithaca: State University of New York Press.

Trice, Jasmine Nadua (2009), *Transnational Cinema, Transcultural Capital: Cinema Distribution and Exhibition in Metro-Manila, Philippines, 2006-2009*, PhD thesis, submitted to the Department of Communication and Culture, Indiana University, August.

Truffaut, François (1986), *Hitchcock*, New York: Simon & Schuster.

Tryon, Chuck (2009), *Reinventing Cinema: Movies in the Age of Media Convergence*, New Brunswick: Rutgers University Press.

Tzioumakis, Yannis (2013), *Hollywood's Indies: Classics Divisions, Specialty Labels and the American Film Market*, Edinburgh: Edinburgh University Press.

Underwood, Adam (2015), 'The Trip as Mourning Comedy', *Senses of Cinema*, 74 (March), http://sensesofcinema.com/2015/feature-articles/the-trip-as-mourning-comedy/. Accessed 4 July 2015.

Utterson, Andrew (2017), 'Practice Makes Imperfect: Technology and the Creative Imperfections of Jean-Luc Godard's Three-Dimensional (3D) Cinema', *Quarterly Review of Film and Television*, 34:3, 295-308.

Varzi, Roxane (2006), *Warring Souls: Youth, Media, and Martyrdom in Post-Revolution Iran*, Durham, NC: Duke University Press.

Vengua Gier, Jean (2000), 'The Filipino Presence in Hollywood's Bataan Films', in Rolando B. Tolentino (ed.), *Geopolitics of the Visible: Essays on Philippine Film Cultures*, Manila: Ateneo de Manila University Press, 35-57.

Virno, Paolo (2004), *A Grammar of the Multitude: For an Analysis of Contemporary Forms of Life* (trans. Isabella Bertoletti, James Cascuito and Andrea Casson), New York: Semiotext(e).

Viviani, Margherita (2014), 'Chinese Independent Documentary Films: Alternative Media, Public Spheres and the Emergence of the Citizen Activist', *Asian Studies Review*, 38:1, 107-23.

Vogel, Amos (2005), *Film as a Subversive Art*, London: C.T.

Wang, Qi (2006), 'Navigating on the Ruins: Space, Power, and History in Contemporary Chinese Independent Documentaries', *Asian Cinema*, Spring/Summer, 246-55.

Wang, Qi (2012), 'Performing Documentation: Wu Wenguang and the Performative Turn of New Chinese Documentary', in Zhang Yingjin (ed.), *A Companion to Chinese Cinema*, Oxford: Blackwell, 299-317.

Wang, Qi (2014), *Memory, Subjectivity and Independent Chinese Cinema*, Edinburgh: Edinburgh University Press.

Wang, Yiman (2006), 'The Amateur's Lightning Rod: DV Documentary in Postsocialist China', *Film Quarterly*, 58:4 (Summer), 16-26.

Williams, Linda (2001), 'Cinema and the Sex Act', *Cineaste*, 27:1 (Winter), 20-5.

Wilson, Robert Anton, and Robert Shea (1998), *The Illuminatus! Trilogy*, London: Raven Books.

Winter, Jessica (2010), 'World in Motion', in Damon Smith (ed.), *Michael Winterbottom: Interviews*, Jackson: University Press of Mississippi, 60–3.

Woyczuk, Montana (2010), 'In Sight: An Interview with Bahman Ghobadi', *BOMB – Artists in Conversation*, 21 April, http://bombmagazine.org/article/4375/. Accessed 10 February 2015.

Wu, Wenguang (2006), 'DV: Individual Filmmaking' (trans. Cathryn Clayton), *Cinema Journal*, 46:1 (Fall), 136–40.

Xu, Gary G. (2008), 'Remaking East Asia, Outsourcing Hollywood', in Leon Hunt and Leung Wing-Fai (eds), *East Asian Cinemas: Exploring Transnational Connections on Film*, New York: I. B. Tauris, 191–202.

Yau, Ka-Fai (2001), 'Cinema 3: Towards a Minor Hong Kong Cinema', *Cultural Studies*, 15:3–4, 543–63.

Ying, Qian (2012), 'Power in the Frame: China's Independent Documentary Movement', *New Left Review*, 74 (March/April), 105–23.

Ying, Xiao (2011), '"Leitmotif": State, Market, and Postsocialist Film Industry under Neoliberal Globalization', in Jyotsna Kapur and Keith B. Wagner (eds), *Neoliberalism and Global Cinema*, London: Routledge, 157–79.

Zeydabadi-Nejad, Saeed (2009), *The Politics of Iranian Cinema: Film and Society in the Islamic Republic*, London: Routledge.

Zhang, Xudong (2010), 'Poetics of Vanishing: The Films of Jia Zhangke', *New Left Review*, 63 (May/June), 71–88.

Zhang, Yingjin (2004), 'Styles, Subjects, and Special Points of View: A Study of Contemporary Chinese Independent Documentary', *New Cinemas: Journal of Contemporary Film*, 2:2, 119–35.

Zhang, Yingjin (2007), 'Rebel Without a Cause? China's New Urban Generation and Postsocialist Filmmaking', in Zhen Zhang (ed.), *The Urban Generation: Chinese Cinema and Society at the Turn of the Twenty-First Century*, Durham, NC: Duke University Press, 49–80.

Zhang, Yingjin (2010), *Cinema, Space, and Polylocality in a Globalizing China*, Honolulu: University of Hawai'i Press.

Zhang, Zhen (2007), 'Introduction: Bearing Witness – Chinese Urban Cinema in the Era of "Transformation" (Zhuanxing)', in Zhen Zhang (ed.), *The Urban Generation: Chinese Cinema and Society at the Turn of the Twenty-First Century*, Durham, NC: Duke University Press, 1–45.

Zimmermann, Patricia R. (1995), *Reel Families: A Social History of Amateur Film*, Bloomington: Indiana University Press.

Index

20 Fingers (Akbari) 150
24 Hour Party People
 (Winterbottom) 140, 142
3D 10, 237, 241–3
3 Millones (Roos) 191
4851 (Ai) 77
8½ (Fellini) 131
9 Songs (Winterbottom) 137

acinema. *See* Lyotard, Jean-François
Adieu au langage (Godard) 10, 213, 224, 234, 237–50, 262 n.10
Adorno, Theodor W. 148–9
Afrance, L' (Gomis) 9, 113–21, 133
Aftershock (Feng) 75
Agamben, Giorgio 27, 29, 43, 131, 171, 265
Aguinaldo, Rodolfo 89
Aguinaldo: The True-To-Life Story of Gov. Rodolfo Aguinaldo of Cagayan (Mayo) 89
Ai Weiwei 8, 55, 60, 66, 72–7, 101
Ai Xiaoming 75, 77
Akbari, Mania 9, 44, 137, 150–1, 158
Aliwan Paradise (De Leon) 91–2
Alix Jr, Adolfo 87, 92
Althusser, Louis 204
Alvarez, Fede 186, 191–2, 194, 208
Ameur-Zaïmeche, Rabah 9, 114, 122–5, 132
Anderson, Benedict 16, 88
Andrews, Giuseppe 10, 162–70, 173–81, 255, 256
Anger, Kenneth 163
animals 9, 11, 46, 131, 137, 152–8, 160 n.36, 168, 217–18, 226, 228, 239, 247, 248, 250, 256, 265
Anjaam 20
Anjam (Mujahid) 15, 17–26, 28–30, 36
Anne and Muriel (Truffaut) 137
Another Girl, Another Planet (Almereyda) 234
Aquino, Corazon 89

At Five in the Afternoon (Makhmalbaf) 15
Avatar (Cameron) 221, 242, 244

Badiou, Alain 225–6, 232, 239, 245
Bahag Kings (Khavn) 101–2
Bahrani, Ramin 181 n.12
Baise-moi (Despentes and Trinh-Thi) 114, 121, 125–7, 133, 137, 138
Bakhtin, Mikhail 177–8, 180, 220
Bale, Christian 139
Barad, Karen 2, 8, 60–6, 103, 105, 230
Bani-Etemad, Rakhshan 33, 216
barbarians 1, 2, 10, 231, 265
Barthes, Roland 101
Bataille, Georges 171, 173
Battleship Potemkin (Eisenstein) 226
Baumbach, Noah 166, 181 n.10
Bazin, André 11–12, 64–5, 127, 149, 230, 267
Beckett, Samuel 5, 166
Beller, Jonathan 1, 24, 29, 37, 69, 90–2, 94, 98–9, 101, 105, 107, 108–9, 114, 115, 143, 189
Berger, John 152–3, 157
Bernal, Ishmael 90, 92–4
Beyzai, Bahram 33
blackness 4, 9, 11, 12, 41, 42, 77, 106–8, 113–21, 129, 132–4, 143, 166, 220, 231, 238, 239, 258, 268
Blair Witch Project, The (Myrick and Sanchez) 179
Blindness (Meirelles) 186
Blind Shaft (Li) 58
Blossoming of Maximo Oliveros, The (Solito) 93
Bohm, David 104
Bohr, Niels 2, 60–2, 64, 103, 105
Bosch, Hieronymus 96
Brakhage, Stan 163
Brando, Marlon 40, 139
Brecht, Bertolt 21–2, 27, 48, 144, 251

Index

Brocka, Lino 90, 92, 93, 94, 97, 100, 102
Brydon, Rob 139–42, 147, 157, 158 n.5
Bubble (Soderbergh) 182 n.12
Buddha Collapsed Out of Shame (Makhmalbaf) 15
Bujalski, Andrew 164
Buried (Cortés) 225
Burnett, Charles 22–3
Butterfly Kiss (Winterbottom) 138
Byron, Lord 238
By the Bluest of Seas (Barnet) 238

'Caballos perdidos' (Maslíah) 199, 202
Caine, Michael 139
Canyons, The (Schrader) 181–2 n.12
Casa muda, La (Hernández) 185, 187–94, 197, 206, 208
Cease Fire (Milani) 35, 37, 39, 51 n.17
Century of Birthing (Diaz) 93
China Village Self-Governance Film Project: Villagers' Documentary Films (Wu) 72
Chronicle (Trank) 179
Circle, The (Panahi) 215
Citizen Kane (Welles) ix, 87–8, 200
City of Your Final Destination, The (Ivory) 186
Clark, Larry 163, 181 n.12
Clerks (Smith) 164
Closed Curtain (Panahi) 214
Cloverfield (Reeves) 179
Cock and Bull Story, A (Winterbottom) 139–43, 144, 147, 148, 158 n.1, 159 n.5
comedy 10, 163, 170–6, 179, 180, 255, 268
Coogan, Steven 9, 139–42, 147, 157, 158–9 n.5
Coppola, Sofia 164, 166
Courbet, Gustave 239
Cousins, Mark 9, 137, 150–2, 158
Crimson Gold (Panahi) 215
Curacha ang babaeng walang pahinga (Roño) 94

Dabashi, Hamid 35, 36, 215, 217, 218, 222, 224
darkness 4, 7, 8–9, 11, 12, 30, 41–2, 45, 46, 49, 55, 81–2, 87, 94, 102–7, 113, 129–33, 143, 144, 145, 151, 166, 220, 267

Day for Night (Truffaut) 140, 158 n.1
Deanimated (Arnold) 132
Debussy, Claude 202
Decasia (Morrison) 128
De Leon, Mike 90
Deleuze, Gilles 3, 22–3, 25, 26, 27, 42, 65–6, 68, 107, 166, 169, 170, 172, 222, 223, 230
 and Félix Guattari 22–3, 42, 98, 127, 188, 202
Deng Xiaoping 56, 57
de Oliveira, Manoel 199, 200, 206
Deren, Maya 163
Derrida, Jacques 171
Despentes, Virginie
 and Coralie Trinh-Thi 9, 114, 142
de Staël, Nicolas 238, 242–4
Diary (Andrews) 179
Diaz, Lav 87, 89, 93, 100
Dickson, W. K. L. 227
Disturbing the Peace (Ai) 72, 74–7, 81, 101
Draughtsman's Contract, The (Greenaway) 141
Dr Jekyll and Mr Hyde (Mamoulian) 238
Dress/Video (Wu) 72
Drumbeat (Alix Jr) 92
Duplass, Mark and Jay 164, 166, 167
Dussel, Enrique 2, 4–5, 10, 27, 185, 192–8, 201, 203, 206–8, 231, 246, 266
Dyer, Richard 114–16, 121, 240

East Palace, West Palace (Zhang) 78
Eco, Umberto 180
Edison, Thomas 89, 227
Ehsaas (Faiz) 15, 17–26, 28–30, 36
Ehsaas: The Feeling (2001) 20
Eliot, T. S. 233
Enfants terribles, Les (Melville) 238
Engels, Friedrich. *See* Marx, Karl
Engkwentro (Diokno) 93
entanglement 3, 7, 8, 11, 48, 50, 55, 60–4, 68, 72, 76, 78, 81, 92, 103–4, 106, 117, 118, 131, 134 n.17, 144, 149, 170, 172, 187–8, 194, 195, 197, 217, 218, 223, 229, 230, 231, 233, 240, 244, 247, 254, 265, 267
Enter the Void (Noé) 110 n.34

essay/essay-film 3, 5, 9, 12, 83 n.22, 128, 137, 146–52, 154, 157, 158, 196, 197, 222, 239, 267
ethics 34, 64–6, 195–7, 218–24, 248, 260, 266
Evil Dead (Alvarez) 186
Evil Dead, The (Raimi) 186

Fabini, Eduardo 202–3
Fahrenheit 451 (Truffaut) 137
Fairytale (Ai) 72
Fando and Lis (Jodorowsky) 110 n.34
Fanon, Frantz 116–20, 197
Fantasma (Alonso) 203
Farhadi, Asghar 33
Farrokhzad, Forugh 150
Filming 'Othello' (Welles) 147
Film Socialisme (Godard) ix, 10–11, 213, 224–34, 237, 239, 241, 249, 250
Five Dedicated to Ozu (Kiarostami) 34, 44–6
floccinaucinihilipilification 11, 239, 241
Florey, Robert 163
Four Eyed Monsters (Crumley and Buice) 166–7
Frances Ha (Baumbach) 181 n.10
Fuck Cinema (Wu) 55, 60, 66–72, 76, 77, 81, 85 n.52
Fur: An Imagined Portrait of Diane Arbus (Shainberg) 261 n.2

Galeano, Eduardo 194
Ganito Kami Noon, Paano Kaya Ngayon (Romero) 97–8
Garbanzo Gas (Andrews) 167–70, 178
García Espinosa, Julio 3, 9, 91, 137, 144–6
García Márquez, Gabriel 177
Getino, Octavio. *See* Solanas, Fernando E.
Ghobadi, Bahman 8, 33, 35, 36, 37, 38–42, 51 n.21
Gigante (Biniez) 186
Girl Power (Benning) 234
Glass Agency, The (Hatami-kia) 37
Gleaners and I, The (Varda) 154–5
Godard, Jean-Luc 5, 6, 7, 10, 11, 21, 147, 148, 213, 224–34, 237–50
Gods Must Be Crazy, The (Uys) 260
Go Fish (Troche and Turner) 164

Gomis, Alain 9, 113, 114, 119–21, 132, 134 n.17
Good Bye, Dragon Inn (Tsai) 203
Goodfellas (Scorsese) 39–40
Grandrieux, Philippe 7, 9, 114, 128–33, 145, 170
Grandy, David A. 8, 103–7
Greed (Von Stroheim) 199–200
Guattari, Félix. *See* Deleuze, Gilles

Half Moon (Ghobadi) 51 n.21
Hardt, Michael. *See* Negri, Antonio
Haroun, Mahomet Saleh 251
Heisenberg, Werner 61–2
Hellman, Monte 182 n.12
Hero (Zhang) 81
Hondo, Med 251
Hour of the Furnaces, The (Solanas and Getino) 94, 97
House is Black, The (Farrokhzad) 150

"*IDOL*" (Khavn) 98–9
Ikiru (Kurosawa) 199, 200
imperfect cinema (García Espinosa) 3, 9, 91, 124, 127, 137, 143–6, 157, 178, 240, 255, 262 n.10, 267
Insiang (Brocka) 90
In This World (Winterbottom) 143–6
Investigation by Citizens, An (Ai) 75
It's All Not So Tragic (Andrews) 168–70, 177

Jameson, Fredric 90–1, 92
Jarmusch, Jim 158–9 n.5, 164, 166
Jetée, La (Marker) 7
Jeturian, Jeffrey 87, 93
Jeunesse dorée (Ghorab-Volta) 124, 125
Jiang Hu: Life on the Road (Wu) 71
Jia Zhangke 57–8, 59–60, 70, 145
Joe (Avildsen) 131
Journey to Italy (Rossellini) 146–7
Joy of Madness (Makhmalbaf) 15

Kafka, Franz 22–5, 42, 98
Kamias: Memory of Forgetting (Khavn) 90, 95, 97, 102, 103
Kandahar (Makhmalbaf) 15–17, 20, 23–5, 28, 30, 36
Kandinsky, Wassily 229–30

Katz, Aaron 164
Kaufman, Lloyd 163
Kaul, Mani 170–1
Keaton, Buster 173
Khatami, Seyyed Mohammad 37, 45
Khavn de la Cruz ix, 9, 87, 90–109, 131, 166
Khomeini, Ayatollah 33, 37
Kiarostami, Abbas 8, 33–7, 44–50, 150, 203, 214
Kimiavi, Parviz 33
Kinatay (Mendoza) 90
kinocentrism 6, 266
Kipling, Rudyard 69
Kite Runner, The (Forster) 15
Kommander Kulas (Khavn) 95–8
Korine, Harmony 163, 181 n.12
Krasna, Sandor. *See* Marker, Chris
Kubrador (Jeturian) 93–4
Kuchar, George and Mike 163

Laruelle, François 5, 6, 160 n.36, 173, 241–2, 265
Lazzarato, Maurizio 165–6, 204, 205
Letter from Siberia (Marker) 149
Lévinas, Emmanuel 66
Life May Be (Cousins and Akbari) 137, 150–2, 158
light/lighting 4, 8, 11, 17, 41, 55, 63, 80–2, 87, 102–7, 108, 114–15, 116, 119, 121, 129, 133, 138, 143, 145–6, 215, 220, 233, 239, 250, 267
Lippit, Akira Mizuta 128, 131–2, 152–3, 266–7
Living in Bondage (Mordi) 251
Lizard, The (Tabrizi) 35, 51 n17
LOL (Swanberg) 165
Look of Love, The (Winterbottom) 138
Look at Tazieh, A (Kiarostami) 47–8
Lord of the Rings, The (Jackson) 261 n2
Lumière, Auguste and Louis 119, 153, 227, 233
Lynch, David 182 n.12
Lyotard, Jean-François
 acinema 9, 114, 127–32, 171, 177

M (Lang) 100
McMahon, Laura 153
Magritte, René 214
Majidi, Majid 33

Makhmalbaf, Mohsen 15–17, 20, 23, 36, 49
 and family 15–17, 20, 33
Mambéty, Djibril Diop 251
Manila By Night (Bernal) 90, 93–4
Manila in the Claws of Night (Brocka) 90, 102
Manila in the Fangs of Darkness (Khavn) 102
Manovich, Lev 63, 233
Manyas La Película (Benvenuto) 191
Marker, Chris 7, 11–12, 149, 154
 and Sandor Krasna 11–12
Marks, Laura U. 47, 120, 240
Marooned in Iraq (Ghobadi) 51 n.21
Martin, Raya 87, 92
Martin-Jones, David viii, 186, 188, 194
Marx, Karl 5, 12, 30, 63, 198
 and Friedrich Engels 5, 12
Mehrjui, Dariush 33, 36
Mekas, Jonas 163
Mendoza, Brillante 87, 89–90, 93, 203
Metropolis (Lang) 246
Meyer, Russ 163
Miami Vice (Mann) 190
Mian Mian 77–8
Michael Hardt 8, 28, 29, 43, 96, 171
Middle Mystery of Kristo Negro, The (Khavn) 102
Milani, Tahmineh 33, 35
minor cinema 2, 21–6, 34, 42–3, 44, 98, 108, 163, 207, 245
Mirror, The (Panahi) 216–18
Mirtahmasb, Mojtaba. *See* Panahi, Jafar
Mondomanila (Khavn) 95–7, 101
Montaigne, Michel de 154
Mujica, José 188, 207–8
multitude 2, 7–8, 25, 26–30, 34, 43, 46, 49, 60, 63, 69, 100–1, 108, 170, 171, 207, 265, 267

Naderi, Amir 33
Naficy, Hamid 25, 34–5, 45
Nagib, Lúcia ix, 267
Nancy, Jean-Luc 8, 43, 244
Negri, Antonio 43
Ning Ying 67
Noire de..., La (Sembène) 260
Nollywood 11, 213, 237, 250–2, 257, 260, 268

No One Knows About Persian Cats
 (Ghobadi) 33–4, 36–42, 44, 52
 n.22
Nouvelle vague (Godard) 228–9
Now Showing (Martin) 92

objectivity 3, 60, 62–6, 76, 244, 245
Ogawa Shinsuke 60
Ó Maoilearca, John ix, 6, 160 n.36
One Recluse (Ai) 72
One. Two. One (Akbari) 150
Ordos 100 (Ai) 73
Orzo (Andrews) 168, 169–70, 173–6, 177
Osama (Barmak) 15–18, 20, 23, 24, 25, 30, 36
Osuofia in London (Ogoro) 237, 250, 252–60
Osuofia in London 2 (Ogoro) 257–9
Othello (Welles) 147
Ott, Mike ix, 182 n12
Our Children (Ai) 75
Out of the Ashes (Albone) 15

Pacino, Al 40
Pahlavi, Shah Reza 36
Panahi, Jafar 10, 33, 35, 213–24
Panic Attack! (Alvarez) 186, 187, 192, 197, 206
Paranormal Activity (Peli) 179
Passion (Godard) 147
Perfumed Nightmare, The (Tahimik) 91, 98
Perrault, Pierre 22, 23
Philippine New Wave: This is Not a Film Movement (Khavn) 87, 106
Phone Swap (Afolayan) 251
Picasso, Pablo 244
Pink Flamingos (Waters) 163–4
piracy 70, 92, 251
Pitts, Rafi 33
Plato 227–8, 243
Polan, Dana 25
poor, the 2, 4–6, 10, 11, 20, 25, 27, 41, 57, 70, 91–3, 100, 156, 166, 173, 178, 193, 194–7, 203, 205, 207–8, 213, 221, 223, 232, 250, 260, 268
'poor image' (Steyerl) 2, 5, 11, 222, 228, 234, 252, 260, 266, 268
Project X (Nourizadeh) 179

Rabelais, François 177, 180
Raid 2: Berandal, The (Evans) 18
Rafsanjani, Ali Akbar Hashemi 37
Rama, Ángel 204, 205–6
Ran (Kurosawa) 199
Rancière, Jacques 222–4, 266
Rasoulof, Mohamad 33
[REC.] (Balagueró and Plaza) 179
Red Hat (Tahmasb and Jebelli) 219
Refn, Nicolas Winding 80, 82
Reichardt, Kelly 182 n.12
Rhino Season (Ghobadi) 51 n.21
Renoir, Pierre-Auguste 233
Rizal, José 88, 100
Road to Nowhere (Hellman) 182 n.12
Rocha, Glauber 26, 178, 257–8
Rodin, Auguste 239
Roxlee 87, 101

Saïd, Edward W. 16
Sanchez, Sherad Anthony 87
Sans soleil (Marker) 11–12
Sarkozy, Nicolas 124
Sartre, Jean-Paul 246–7
scatology 6, 10, 162, 173–6, 177, 179, 180, 239, 256, 268
Scénario du Film 'Passion' (Godard) 147
Schrader, Paul 182 n.12
Sconce, Jeffrey 21, 179
Seagal, Steven 19
Sékou Touré, Ahmed 117–18, 120
Sembène, Ousmane 251, 260
Serbis (Mendoza) 93, 203
Separation, A (Farhadi) 33
Shahid-Saless, Sohrab 33
Shanghai Panic (Cheng) 55, 77–81
Shelley, Percy Bysshe 238
Shelton, Lynn 164, 166, 167
Shirin (Kiarostami) 34, 48–9, 150, 203
Silent House (Kentis and Lau) 185, 190–2, 197
Sissako, Abderrahmane 251
Slacker (Linklater) 164
Snow, Michael 163
Sobchack, Vivian 47
Soderbergh, Steven 182 n.12
Solanas, Fernando E.
 and Octavio Getino 94, 97

Solito, Auraeus 97
Solzhenitsyn, Aleksandr 238
Sombre (Grandrieux) 114, 127–30, 131, 133, 136
So Sorry (Ai) 72–3
sound 1, 2, 25, 48, 74, 78, 101, 122, 123, 129, 130, 131, 141, 164, 171, 180, 199–200, 201, 202, 226, 228, 229, 239, 241, 249, 250, 251, 253
Squatterpunk (Khavn) 100–1
Sterne, Laurence 140, 143
Steyerl, Hito 2, 197, 266
Stray Dogs (Meshkini) 15
Supercinema (Brown) viii, 5, 267, 268
Suzhou River (Lou) 55, 77, 79–81, 87
Swanberg, Joe 164–7

Tahimik, Kidlat 87, 90, 101, 134 n.17
Tangerine (Baker) 234
Tan Zuoren 74, 75
Taşkafa, Stories of the Street (Zimmerman) 137, 150, 152–8
Taxi Tehran (Panahi) 214
ta'ziyeh 8, 34, 46–9
Ten (Kiarostami) 34, 44–6, 150, 214
Tey (Gomis) 113
Third Cinema 26, 97–8
This is Not a Film (Panahi and Mirtahmasb) 10, 33, 35, 213, 214–24
Three Days of Darkness (Khavn) 102
Time for Drunken Horses, A (Ghobadi) 51 n.21
Todo Todo Teros (Torres) 92
Torres, John 87, 92
Touch Me in the Morning (Andrews) 167
Touch of Sin, A (Jia) 58
Tout Va Bien (Godard and Gorin) 21
Trahair, Lisa 170–3, 174, 175, 177, 178
Treatment (Wu) 71
Trinh-Thi, Coralie. *See* Despentes, Virginie
Trip, The (Winterbottom) 139, 140, 141, 159n
Trip to Italy, The (Winterbottom) 139, 141, 146–7, 158–9 n.5
Truffaut, François 9, 137–8, 157, 158 n.1
Twain, Mark 202, 203
Two-Legged Horse (Makhmalbaf) 15

Ultimo (Khavn) 100

Van Damme, Jean-Claude 19
Vanishing, The (Sluizer) 136 n.55
Van Sant, Gus 164, 166
Vargas Llosa, Mario 177
Vida útil, La (Veiroj) 10, 185, 197–207
Vie nouvelle, La (Grandrieux) 7, 133, 145–6
Veiroj, Federico 10, 185, 200, 202
Vertigo (Hitchcock) 80
Virno, Paolo 26–7, 29, 43, 99–100
Vogel, Amos 13

Wangchuan (Ai) 75
Warhol, Andy 73, 163
weather 9, 137–9, 157
Welles, Orson 87, 147–8
Wendy and Lucy (Reichardt) 182 n.12
Wesh wesh, qu'est-ce qui se passe (Ameur-Zaïmeche) 114, 121–5, 133
Who Killed Our Children (Pan) 75
Why are the Flowers So Red? (Ai) 75
Wild One, The (Benedek) 40
Winterbottom, Michael 9, 137–48, 157, 158
Wiseman, Frederick 60
Wollstonecraft Shelley, Mary 238
Wood Jr, Edward D. 21, 163
Wonderland (Winterbottom) 138
Wordsworth, William 139
Workers Leaving the Factory (Lumière) 153
Wu Wenguang 8, 55, 58–60, 66, 67–8, 72, 78, 134 n.17, 171

Xala (Sembène) 260
xianchang 74, 221, 267
Xiao Wu (Jia) 58, 70
Yamaneko, Hayao 11–12

Zhang Yimou 74, 75, 81
Zhang Yuan 67, 78
Zimmerman, Andrea Luka ix, 9, 137, 152, 157, 158
Zimmermann, Patricia R. 21
Zworykin, Vladimir 238